ART AS REVOLT

ART AS REVOLT

Thinking Politics through Immanent Aesthetics

Edited by

DAVID FANCY AND HANS SKOTT-MYHRE

McGill-Queen's University Press

Montreal & Kingston • London • Chicago

ISBN 978-0-7735-5728-4 (cloth)
ISBN 978-0-7735-5729-1 (paper)
ISBN 978-0-7735-5785-7 (ePDF)
ISBN 978-0-7735-5786-4 (ePUB)

Legal deposit third quarter 2019
Bibliothèque nationale du Québec

Printed in Canada on acid-free paper that is 100% ancient forest free
(100% post-consumer recycled), processed chlorine free

This book has been published with the help of a grant from the Humanities
Research Institute, Brock University, and from Kennesaw State University.

Funded by the Government of Canada Financé par le gouvernement du Canada Canada Canada Council for the Arts Conseil des arts du Canada

We acknowledge the support of the Canada Council for the Arts.

Nous remercions le Conseil des arts du Canada de son soutien.

Library and Archives Canada Cataloguing in Publication

Title: Art as revolt: thinking politics through immanent aesthetics/edited
 by David Fancy and Hans Skott-Myhre.

Names: Fancy, David, editor. | Skott-Myhre, Hans Arthur, editor.

Description: Includes bibliographical references and index.

Identifiers: Canadiana (print) 20190086920 | Canadiana (eBOOK)
 20190086998 | ISBN 9780773557291 (softcover) | ISBN 9780773557284
 (hardcover) | ISBN 9780773557857 (ePDF) | ISBN 9780773557864
 (ePUB)

Subjects: LCSH: Aesthetics—Political aspects. | LCSH: Arts—Political aspects. |
 LCSH: Popular culture.

Classification: LCC BH301.P64 A78 2019 | DDC 111/.85—dc23

This book was typeset by Marquis Interscript in 10.5/13 Sabon.

Contents

ART AS REVOLT

Introduction

David Fancy and Hans Skott-Myhre

This edited collection is an effort to think about the force of Art writ large as popular culture in the most inclusive sense. We have gathered pieces on blues and hip hop, virtual reality, postcolonial science fiction, virtual gaming, riot girls and punk, raku pottery, post-pornography fanzines, zombie films, and role playing. We have imagined these divergent and diverse incursions into pop culture as clustering around themes such technology and the future, aesthetics and resistance, and auto-ethnographies of the post-identitarian. Of course, we realize that these assemblages engage the lines of inquiry we and our authors have foregrounded as being of interest, but, like artists, we have reserved the option to bricolage and pastiche our investigations while seeking to inhabit a broader canvas.

The surface onto which we project our collage in this volume is that of twenty-first-century politics, which we argue is now imbued and entangled with the aesthetic in a manner more powerful, troubling, and evocative of possibility than at any other time in history. We make this argument on the basis of the emerging system of rule that is global postmodern capitalism and its aggressive production and circulation of semiocapital (Hardt and Negri 2000, 2004, 2009; Lazzarato 1996, 2014; Srnicek 2016; Stiegler 2014). This brutal and predatory system of absolute simulacrum, with its ever-shifting panorama of symbolic representations of value, presents the very real possibility of appropriating and eviscerating the realm of the aesthetic by producing it as radically scissioned from any material relation to living things.

With broad-reaching imperatives in the arenas of education, psychology, social and economic theory as well the production of what Antonio Negri (1996) and Maurizio Lazzarato (1996) call immaterial

labour, twenty-first-century capitalism extends its filaments of the purely symbolic into the very fabric of our desiring capacities. Desire in this instance might be thought of either in terms of what Deleuze and Guattari (1977) term desiring production – that agentless force of sheer productive force that imbues life with what Gregory Bateson (1972) calls the pattern which connects – or we might think of it as what Eve Tuck (2010) refers to as that collective and cultural force operating both inside and outside of history that allows each of us to sustain modes of cultural subjectivity in the midst of what is now an ongoing global cultural genocide. In Negri's (2011, 18, emphasis in original) words:

> The market and its power [*potere*] have absorbed every potenti-ality [*potenza*] in order to deny them the possibility of becoming singular, of being valid for someone or for something. Of pro-ducing. Creativity is withdrawn. Impotence is the very fabric of discoursing, of communicating, of doing. Not emptiness but impotence. The great circulatory machine of the market produces the nothing of subjectivity. The market destroys creativity. Potenza is withdrawn.

Whether we think of such a cultural and social crisis in terms of what Guattari (2005) refers to as the escalating extinction of social and cultural forms such as collectivity, compassion, and non-monetary forms of value, or in terms of what Michael Hardt (1995) delineates as the evacuation of social forms of civil society such as the family, the church, and democratic forms of governance, it seems clear to us that the factional politics of the twentieth century are no longer ade-quate to the challenges of the twenty-first. To this end, we offer this book as a series of propositions that highlight politicized strategies that deploy the aesthetic under current conditions of late liberal capi-talism with its economies of attention and affect. Our intention is to interrogate the capacities of art, as Deleuze and Guattari (2014) would have it, as an encounter and opportunity for experimentation.

What follows is premised on two integrally related philosophical concepts: immanence and aesthetics. We use these terms as theoretical frameworks because their interaction affords the opportunity for complex experimental connectivities and relationalities that open intersections and entanglements of subjectivity, creativity, perception, and culture. Immanence has a long history, from the work of Spinoza

forward, as having the capacity to formulate a politics anchored in the inseparable relations of living force. Whether it is the neo-vitalist readings of Braidotti (2006), the posthumanism of Gatens (1996), the transversality of Guattari (2008), the dynamics of individuation in Simondon (2005), the affect of Massumi (2002), or the politics of sense to be found in Deleuze (2004), immanence seems to open the capacity to access indeterminate vistas of creative capacity produced in the confluence of sheer agential materiality and thought.

Following Spinoza (2000) we would suggest immanence as any system capable of producing itself without reference to an outside. That is to say, immanence is utterly autopoietic or self-generating and self-sustaining, not so much constructivist as inventivist (Massumi 2002). According to Spinoza, the impetus for an immanent system is the expression of it own capacities. This set of capacities is both infinite and utterly contingent. Immanence is an infinitely emergent system composed of elements each of which has an idiosyncratic capacity of singular expression. Each unit of infinite and singular expression can only discover what it can do through an encounter with another element. The sole determinate for immanence is the force of expression. What is expressed, how it is expressed, how long that expression is sustained, and what combinations and variations are extended across time and space are completely dependent upon the instant of encounter. Of course, in the human realm that instant of encounter is occurring within broader cultural and social assemblages and connectivities, but, on a more expansive and inclusive level, it is also occurring within each atomic second at an infinite rate. For Spinoza all systems, from galaxies to subatomic particles, are variations of the possibilities of complex assemblages. Put simply, immanence is the condition and potential for all creation and destruction.

In this formulation, unlike alternate conceptual frameworks – for example, the dialectic – there is no absence, no fundamental *lack* driving a system forward. Instead, what is produced immanently is composed of all the elements in a single instance of time, entangled in an infinitude of capacity that produces things precisely and exactly as they are and as all they can be. Since there is no reference to an outside (ideal or otherwise) there is no sense of progress or teleological imperative. History is not driven forward. History is simply produced in this moment and then the next with the kinds of ruptures and fractures so beautifully described by Foucault (2002). There is no better world, but there are infinite options for the world. Spinoza's

project has been extended most notably by thinkers such as Simondon, Deleuze, and Guattari in order to articulate the precise crystallizations of and interactions between psychic, social, collective, and material modes of individuation. Given that such immanent and differential production is always already creative in its capacity to actualize new potentialities, we would argue that this reading of production mirrors much of what happens in the production of art and the aesthetic as indeterminate and never-completed production that is not driven so much by a notion of perfection as by an informed and focused calculation of what might be.

In what follows, the chapters in this volume deploy immanence as a mode of analysis that seeks to avoid lack, hierarchies, dualisms, and teleological illusions of progress. In attempting to think art and aesthetics as revolutionary possibilities for the twenty-first century we hope to direct our efforts to rethinking the relation of the symbolic to the Real à la Lacan (1988) in hopes of producing a radical aesthetic that opens code to what Deleuze and Guattari (1987) call vacuoles of non-communication, stuttering, or static. We argue that this is crucial given that, to some degree, global capitalism is also an immanent system of self-production (Luhmann 1995).

That capitalism is an immanent system, albeit an utterly abstract one, creates immense problems for contesting its rule. As Luhmann (1995) points out, current modes of society operate as self-producing systems of code that have little or no regard or relation to livings things. Like all immanent systems, capitalism's sole impetus is to express the various codes within the function systems that comprise its social form. The tricky thing is that it needs human communication as raw data to produce its code. In this sense, although it is immanent as a self-producing system, it is also parasitic. It co-evolves with human language as a nominalized coding system. Put in Deleuzo-Guattarian terms, it functions by overcoding and appropriating linguistic codes, eviscerating any connection to living function, foreclosing a whole range of potentialities available in the always unfolding moments of encounter that constitute cosmic production, and instead inserting the reductive mono-code of profit (Deluze and Guattari 1977, 1987).

Capital, in this sense, is certainly a differentiating system and functions, as Bateson (1972, 459) would have it, as information or "the difference that makes a difference." However, Bateson also tells us that difference can intensify into an escalatory runaway system in which differentiation becomes its single impetus and it loses any capacity to hold a coherent definition of itself as a system. Capital in

the twenty-first century may well be in just such a pattern. Its binary predisposition – profit/non-profit, use/exchange, growth/decline – opens it to difference as its primary code. It needs to constantly differentiate this value from that value in order to justify an infinite escalation of profit as summary difference.

In this, however, capitalism opens itself up to a field of vulnerability. That field is the seemingly ineffable aspect of human experience. The sorts of experiences that Deleuze (2004) termed "sense." That is, the sense of the Real that precedes and recedes leaving a surplus of potential knowing at the edge of all experience. We would argue that art and the aesthetic open specifically onto the field of sense that eludes any possibility of full overcoding. It is Deleuze and Guattari (2014) who point out that all art is produced in relation to chaos and that while capitalism as a social system certainly produces a great deal of social disturbance, it is not truly chaotic given its axiomatic character. While, in its aspect as pure contingency, art melds the chaos of the universe into bundles of pre- and extra-individual affects and percepts that evoke the sensate as an indeterminate field (Deleuze and Guattari 2014), capital only operates on a binary coding that takes chaos and turns it into profit/not profit. Differently or differentially generative, art transmutes chaos into form that is evocative of living capacity. It stimulates patterns that operate kaleidoscopically rather than mutagenically. In this sense, we would suggest that art as an expressive capacity of living immanence holds a counter weight to capital as abstract, overcoding, and mutagenic immanence, thereby resisting, in Negri's (2011, viii) words, capitalism's determination to create a world which "annuls passions, that is, the only forces which render life worth living."

This understanding of a far-reaching capacity of artistic expression situates art as being central to the overall ontological dynamics operating in immanent systems. Zepke (2005, 496) uses Deleuze and Guattari's (1987) notion of "Art as abstract machine" to show how only art, opening (as is does) out on to chaos, has the capacity to generate a newness that can destabilize capital's axiomatic of capture. The abstract machine is the directed, vital, differentiating energy of becoming that Deleuze and Guattari develop from Spinoza and Nietzsche. It is abstract because it inheres within processes rather than simply being a discernable object or representation. Importantly, and unlike the reductive and stratifying axiomatic of capital, the abstract machine remains "entirely unaffected by any transcendent ambitions" (Zepke 2005, 2). Instead, it remains open

to experimentation and expression in the living materiality and processes of the world: the abstract machine is simply the unfolding of complexity of the world of which art, with its tendencies towards counterpoint, improvisation, and actualization of the new within the real (Deleuze and Guattari 1987), is ontology's, and thus the world's, most intense and "purest" manifestation. The abstract machine "does not function to represent, even something real, but constructs a real that is yet to come, a new type of reality" (Deleuze and Guattari 1987 142). It revolts against a constraining present composed of captured possibilities with the continuous promise of the generation of potential.

It follows, then, that central to an understanding of art's function is the ability to recognize its distribution over a wide variety of phenomena, including non-human activities (Deleuze and Guattari 1987). This distributed and de-individuated capacity or potential can be best understood, Deleuze (2004, 297) suggests, if the "wrenching duality" to which the notion of aesthetics has been subject is overcome. From the traditional Kantian perspective, aesthetics has been seen as a "form of possible experience," on one hand, and as "art as reflection of real experience" (Deleuze 2004, 297–8), on the other. If we are to understand these perspectives as overlapping on a continuum, Deleuze argues, "the work of art would really appear as experimentation," with not only materials traditionally conceived as being "artistic" leading to art practice (paint, rarified language, codified forms of sound and movement, etc.) but also with an extensive array of quotidian kinds of sensory experiences contributing to the human experience of the artistic. The fusion Deleuze invites here serves to overcome a notion supported by all manner of historical and current cultural capitalization that would separate a rarified realm of "high" culture from its lower "baser" forms of popular cultural activities and artistic impulses and expressions to be found in everyday life. For Deleuze, and later Deleuze and Guattari, art can be found everywhere, and, as the chapters in this collection argue, these practices need to be understood in their capacity to intervene in capital's attempts to commercialize everything.

Informing the writing in this volume is a conviction that methodological premises responsive to the complex materialisms of immanence need to be engaged when analyzing and discussing works of art. Traditional cultural materialist approaches, variously in ascendance in the Euro-American academy since the mid-1960s,

strategically deploy analyses of signs (semiotics) in works in order to map the ways in which cultural production is complicit and/or resistant to dominant discourses that would construct or constrain gendered, racial, classed, and sexualized identities (Williams 1958). In short, cultural studies takes art to be "representation" as a means of better grasping its intersection with wider social and political realities. While many fields of inquiry that engage with popular culture deploy this methodological shorthand to very useful and progressive ends, problems occur when those working in these fields forget that studying and mapping signs is in fact just that: shorthand. What gets lost when this approach is naturalized as the only means of thinking about art is an understanding of what processes and differentiations are frozen and suspended during the methodological foregrounding of semiosis (Massumi 2002). Arrested are the very forces in the "abstract" machine of art that provide it with its potential for disrupting the axiomatic of capital. This is not to say, of course, that signs and processes of signification do not "exist," but they are not islands unto themselves; rather, they are archipelagoes that form part of a much larger process of meaning making involving seas of intensive sense connected intimately to relays of extensive signs of land. Unless viewed in context and extended with immanentist perspectives, cultural materialism – despite its stated and best intentions – risks extending the capitalist epistemological project of capture by being complicit in the "becoming impotent" of art. This volume then seeks to make a wider intervention in fields engaging with popular culture. We aim to make a compelling argument for the necessity of modalities that can engage the immanent, affective, and processual nature of art's effect on bodies and assemblages that, while not denying the matrices of signs and symbols key to traditional cultural materialist analysis, do not stop at these determined points of processual arrest. Immanentist analyses of cultural production do not divest themselves of semiotic approaches but, instead, understand signs to be epiphenomenal realities: the results of a processual unfolding of events, encounters, as well as pre-individual affects and percepts that come up in artistic production. Of course it follows that the Marxist moorings fuelling cultural materialist analyses (at least in their inception in the Birmingham School of British Cultural Studies) are not ignored in immanent analyses of artistic and cultural production. Instead, the question of what constitutes materiality is expanded and refined, playing out onto a much wider, indeed cosmic, scale.

What is ultimately revealed through this kind of artistic production and the thought around it is what Guattari (2008) describes as the ethico-aesthetic qualities of art, the neo-Spinozan capacity to increase potentials of the bodies and assemblages involved in creating and engaging with art. Intersections of immanence, aesthetics, the political, and the ethical: these are the essential zones of intensity where each of the chapters in this volume converge. Despite capitalism's seemingly inexorable and insinuative march, we affirm that the human artist or human encountering art is capable of being resistant to capitalist overcoding and capture of all previous artistic expression as reified and circulatable representation. In the Spinozan language of Negri (2011, xii), these experiences of art "are lodged in the *potenza* of the subject in action, the subject's capacity to deepen knowledge to the point of reinventing the world." Negri is quick to remind the reader that such actions occur in collective settings, that they open out onto wider publics and solidarities:

The beautiful is an invention of singularity which circulates and reveals itself as common in the multiplicity of subjects who participate in the construction of the world. The beautiful is not the act of imagining, but an imagination that has become action. Art, in this sense, is multitude. (xii)

It is in this spirit of collective invention of new futures that the essays in this volume have been gathered. We divide them into three parts: Technology and Futures; Aesthetics and Resistance; and Auto-Ethnographies of the Post-Identitarian. Each part includes an array of approaches to art and aesthetics that addresses what we would argue are key issues for liberatory politics as we move forward in this twenty-first century. Like any volume of collected essays, the chapters are organized not only to draw attention to thematic coherence and resonances between them but also to develop principle themes moving forward through the various parts. Given our overall commitments, it follows that we understand the coherences being proposed here in immanentist terms. Such coherences are generative and open ended, what Deleuze and Guattari (1987) might describe as "rhizomes" or "assemblages." They are structurations defined not by the finality of their determination but, rather, by their processuality and the differential and compositional relationalities that inhere within them. Similarly, rather than referencing a measured, representationally

verifiable and in some sense "linear" growth, the idea of the development and extension of themes in this volume can be understood in terms of Deleuze's notion of the "series" (Deleuze 2004; and see Ord's chapter in this volume). Series provide an opportunity to organize difference in a way not dependent on a representational mode of thought, which usually subjugates thinking to mechanisms of resemblance, identity, analogy, and opposition. Instead, series generate differential potentials because they recognize the opportunity for an infinite number of connections that ultimately refuse governance by a centralized and centralizing structure, even if aspects of the series are marked by elements of repetition: repetition not as the Same, but as the eternal return of difference (Deleuze 1991, 2004). With this in mind, think of our organization of chapters as an unsettled aggregation and, of course, read them in whatever order you please.

PART 1: TECHNOLOGY AND FUTURES

Without a doubt massive shifts in technology have radically altered the field of living politics and relations of power, particularly in, but not limited to, the global economic North. Moving from the labouring bodies in factories to the realm of immaterial labour, in the virtual worlds of the internet, in robotics, artificial intelligence (AI), and related areas, our phenomenological understanding of the world has changed both rapidly and comprehensively. In chapter 1, "Actualization of the Virtual through an Aesthetic Encounter with Virtual Reality Technology," Tim Beck initiates a discussion of gaming in the realm of rapidly emerging "immersive" technologies. He extends the preliminary perspectives on immanence with the useful and necessary work of distinguishing between the broader notion of the virtual that Deleuze (1988) derives from Bergson and the more limited notion of virtual deployed in current technological parlance. While the latter refers to non-fleshed and immaterial digital spaces and constructions supported by networked informational hardware, the former refers to an intensive plane of real potentiality that always already inheres within the extensive actual real. Deleuze's virtual, like other concepts in a series that supplies a similar function (such as sense or the plane of immanence), is instrumental to his ontological project as a key site from which potentiality and newness emerge and are expressed. Resonating with Fancy's exploration of role play in part 3, Beck explores the productive connections between virtuality as a specific

technologically bound mode, on one hand, and the kinds of mediated virtualities necessarily lived as part of human cognition and, indeed, as part and parcel of immanent modes of ontological production, on the other.

Beck's thinking through these conceptual differences as they engage issues of the technology of commercially available virtual reality (VR) gaming devices leads him to draw on Deleuze and Guattari's distinction in *What Is Philosophy?* (1994) between what constitutes scientific and artistic modes of knowledge and production. While science traditionally seeks to present non-varying representations for seemingly predictable phenomena and, in so doing, concretizes the imperceptible forces of the universe (in the form of theorems, laws, rules), artistic acts proceed in a different manner. Indeed, as this overall volume asserts in a range of different ways, Deleuze and Guattari remind us that art proceeds by engaging with the force of pre-individual sensation, affects, and percepts that continuously risk exceeding concretized representation as such. Beck elaborates on how such excessive potentialities inherent in humans' engagement with VR devices offer opportunities for unexpected expressions and interventions in the cultural sphere that can subvert the intended parameters programmed into the platforms supporting them. Working through Ray Bradbury, Deleuze and Guattari, and thoughts about Oculus VR, Beck makes a strong case for VR's ability to "make possible a properly nomadic procedure of auto-poetic subjective reorganization" (50) in the face of otherwise incursive capital.

With this evocation of the figure of the nomad – the powerful answer to fixed and transcendent subjectivity proposed by Deleuze and Guattari (1987) and taken up by many thinkers since (Braidotti 2011) – it repays us for a moment to consider the matter of subjectivity and of agency in contexts of immanent philosophy and theoretical analysis. Above, we reference notions of individuation from Simondon upon which Deleuze and Guattari draw heavily to explain how concatenations of events precipitate and crystallize into durational (if ever-differential) bodies such as human beings and societies. A reader new to theories of immanence, however, might have more questions about how agency is distributed across such bodies and might also notice the differing ways in which the authors in this volume approach the matter. Following Deleuze and Guattari (1977, 1987), we understand human beings to be assemblages constituted by preceding and subtending forces arriving at sustained singular

arrangements (what, in the transcendent language of traditional cultural studies, is described as the "individual") that nonetheless iterate differentially across a wide series of manifestations (many of different "individual" humans) and which are in a continuous state of becoming (the "individual" human in and *as* continuous process). While we recognize the "pressing crowd" (Massumi 2002, 30) of virtual potential and tendencies as well as actual forces that precede and inhere within the human, unlike Massumi we nonetheless ascribe humans the capacity for agency. Indeed, our political commitments, drawn heavily from Deleuzo-Spinozan notions of an ethics of joy referenced above, depend on it. Nonetheless, rather than understanding this agency as being entirely separate from an otherwise non-agential universe, we recognize, as others, including Bignall (2010) and Bowden (2015), have done, that human agency is a localized pooling of agential force within the singularity of human bodies and socialities. It is this perspective that allows the authors in this volume an opportunity to begin from a cautious and provisional notion of human selfhood, singularity, individuality, and sociality and thereby explore how such entities interact with and generate the aesthetic in this political and economic moment. While none of us assumes the preexistence of already constituted subjects as a starting point for analysis (as would be the case if we were cultural materialists), it is clear that we nonetheless all have differing levels of comfort with borrowing inherited shorthand notions of subjectivity and identity given our collective constraint of not wanting to reinvent the immanentist wheel over a series of short chapters.

Rather than being "causal" in the sense that it is entirely or even largely determining of human and nonhuman events and realities, human agency is perhaps best understood as *quasi-causal*, an important concept that Douglas Ord engages with in chapter 2, "Playing with Fire: A Quasi-Causal Machine in Multiple (Mostly Russian) Februaries." Ord works through the complex interplay of force and chance in the relationships between the seemingly unrelated events of Russian punk band and global phenomenon Pussy Riot's suppression by Vladimir Putin, on one hand, and the simultaneous event of the Chelyabinsk meteor landing in Siberia, on the other. Ord draws on Deleuze's reading of Hume to explore "the expressive relations between events themselves," which, although not necessarily recuperable to classical notions of traceable cause and effect are, rather, in Deleuze's words, "an ensemble of non-causal correspondences,

forming a system of echoes, of reprises, and of resonances, a system of signs, in short, an expressive quasi-causality, and not at all a necessitating causality" (54). The circulation of the increasingly recognizable faces of Pussy Riot in a visual global economy of commodified images that orders and reaffirms power relations relates, via this kind of expressive quasi-causality, to the Chelyabinsk event. Ord explores how a series of Pussy Riot performances of the Februaries of 2012 and 2014, and the sky-searing asteroidal meteor of February 2013 that landed at Chelyabinsk, leads to a "repetition with difference across ... successive (Russian) mid-Februaries, spinning an associational network of contiguities and resemblances (though without causality)" (68). This simultaneously shifting but clear relationality leads philosopher Rosi Braidotti to state that "Pussy Riot becomes a meteorite" in the way in which they affect the smooth surface of Vladimir Putin's attempts to suppress their spontaneous punk performances in churches and public squares. Ord uses Deleuze's dialogues with Claire Parnet and other sources to explore how the quasi-causal linkages between these associated series of events are manifestations of an image of thought not predicated on resemblance, verifiability, and analogy. The collision of Pussy Riot with the Putin-machine, the collision of the asteroidal meteor with the earth: these events of the aesthetic and of the cosmic, and particularly the resonative series between them, are some of the types of problems that Ord reminds us Deleuze discusses in his preface to the English translation of *Difference and Repetition*: "problems which point beyond the propositional mode ... involving encounters which escape all recognition ... for[cing] us to think (Deleuze 1994, xvi–xvii).

Moving from celestial-become-terrestrial-become-celestial phenomena, and returning to digital game worlds quasi-causal of singularities both complicit and resistant to capital, Nicole Land, Veronica Pacini-Ketchabaw, and Eric Lochhead engage the world of virtual gaming as a set of performances that cannot be disentangled from historical context, productions of subjectivity, modes of production and colonial appropriation. In chapter 3, "Creepers, Pixels, and the Nether: Performing Minecraft Worlds," they argue that "playing" a game such as Minecraft reiterates both the dominant logic of contemporary and historical capitalism, with its rapacious practices across species and geographies, as well as opening new possibilities for challenging that very logic. Continuing the complex problematizing of subjectivity and sociality afforded by immanentist thought, they

imagine their chapter "to be made entirely of momentary, divergent Minecraft performances, where Steve, Obsidian, Eric, Dog, Veronica, Creepers, Nicole, Theory, and Pixels matter *with/in* Minecraft to imagine the possibilities that might emerge from troubling the spaces of Minecraft" (91). Thinking within theoretical frameworks of the more-than-human, the chapter wrestles with the ethical and political dimensions of gaming in ways that eschew traditional ways of conceiving of young people and of the "virtual" world. The authors write against the grain of developmental, humanist, and consumerist framings of young people's relation to technology in order to open an inquiry into Minecraft performances as experiments in power relations with all the messy and indeterminate aspects such an engagement implies. They wonder about the force of aesthetics in producing virtual figurations that have the capacity to organize power relations in our contemporary world and worlds to come. The Minecraft world, issuing as a projection from late technocapital (Suarez-Villa 2009), is not limited by the spatial concerns of planet earth with its 4-billion-square-kilometre in-world surface area. Instead, there is only regeneration, no end to life or the world. Operating on capital's logic of metastatic permanent growth, Minecraft is clearly an attention-capturing tool of the "attention economy" (Simon 1971), but it may also be a "challenge ... to respond to the Anthropocene through a paradigm shift in the ways in which we think about what it means to be human and about our place in the world, as a species" (95). The authors' interest in the significant geological imprint of human activity warranting the naming of a new geological era (the Anthropocene) resonates with the ongoing series of references throughout the volume to earth, territory, geography, and ethics (see Bishop and Skott-Myhre, as well as Skott-Myrhe, Collins, and Skott-Myhre) that variously refer to Deleuze and Guattari's "Geology of Morals" (1987) and *What Is Philosophy?* (2014), exploring how the percussive and fractal history of the earth's body offers an expression and model for understanding the history of the human body and self. Land, Pacini-Ketchabaw, and Lochhead think through opportunities to leave the Anthropocene and move towards a new earth.

Malisa Kurtz plunges directly into such futurity with an epigraph drawn from Deleuze and Guattari's *What Is Philosophy?* (2014), reminding us that "We lack creation. *We lack resistance to the present.* The creation of concepts in itself calls for a future form, for a new earth and people that do not yet exist" (109). In chapter 4,

"Decolonizing Science Fiction, Performing Postcolonial Lines of Flight," Kurtz emphasizes how the techno-speculative mode of science fiction, or "sf," provides readers/viewers engaging with the genre the opportunity to imagine post-imperial and post-capitalist social configurations and assemblages. She suggests that "postcolonial science fiction is not only a genre but a process, strategy, or mode of relation between people committed to imagining less exploitative futures" (110), emphasizing the role that creative experimentation – a hallmark of immanentist consideration around art practice – plays in postcolonial sf. Kurtz discusses, among other texts, how Larissa Lai's *Salt Fish Girl* (2002) and Lauren Beukes's *Moxyland* (2008) provide opportunities to think through and beyond the political unconscious of a genre that has often replicated normative notions of technoscientific progress and empire. She argues, following Hardt and Negri, that, as a growing body of texts, postcolonial sf "transforms the genre's world building into a *strategy of postcolonial experimentation*" (ibid.), thereby providing the reader/viewer with the experience of a multitude of potential sites of intersection with new socialities that aspire to consign the logics of political and technological supremacy to a distant past. She challenges "techno-orientalism" by using Deleuze and Guattari's affirmative perspective on difference and desire, and she draws on Bignall's (2010) reading of Spinozan and Deleuzian ethics to imagine careful and joyful sociabilities that can lead to "non-imperial interpersonal ethics conducive to creating the postcolonial ethos necessary for less violent, more equitable futures" (122–3).

PART 2: AESTHETICS AND RESISTANCE

The second group of chapters reinitiates questions of the earth, beginning with chapter 5, Bishop and Skott-Myhre's "The Blues as Minoritarian Vernacular." They extend the thinking of the earlier chapters in part 1 on aspects of *What Is Philosophy?* (2014) to complement and intensify James McPherson's notion of "expressive geographies" by including Deleuze and Guattari's speculations on the question of the relationship between artistic expression, geography, and revolt. Bishop and Skott-Myhre explore the work of blues as a genre in order to demonstrate how the artist "must enter fully into chaos and emerge with a sensate composition made up of the elements of a given historical moment in such a way as to produce the infinite" (136). Precisely how artistic expression is an analogue for revolt is

central to this section of chapters. Bishop and Skott-Myhre expand on Deleuze and Guattari (2014) to explore how a mobilization of the powers of the catastrophic allow "the philosopher (and one might infer the artist)" to become "a stranger within his home geography" (141). The net effects is that such a venture into chaos permits the blues artist's work to stage a vitalizing and politically disruptive affect in the listener. These potentializing forces, given their intensive relationalities with specific landscapes, peoples, and cultures, open up a present otherwise constricted by capitalist social relations of "anxiety, subjugation, suffering and alienation" (140). New social and political arrangements can thus arise in the future. Art becomes that which mobilizes minority elements, aspects that are not minor because of their size or status but, rather, are minor in the sense of their being outside majoritarian logics of supremacy (Deleuze 1986). The works of poet Sterling Brown and the band Gov't Mule, among others, are foregrounded as offering minoritarian lines that, via the intensive lyrical and musical spaces that invoke specific geographical locations in the American South, open up affective pathways through and beyond restrictive majoritarian cadences, metres, and rhythms. Echoing Kurtz's concerns in part 1 around empire and racialization, Bishop and Skott-Myhre mobilize Deleuze and Guattari's notion of "musical assemblages" to propose liberatory futures at "the confluence of prisons, slavery, resistance, death, anxiety, terror and the emergence of a new people, a new earth" (150).

In chapter 6, moving into more intimate and localized geographies, Skott-Myhre, Collins, and Skott-Myhre bring the reader through an experience of "immanent raku," a perspective on a pottery practice consisting of an "assemblage of human bodies, metal tongs, thick protective vests, bare hands, clay, metals, smoke, fire, sawdust, chemical compounds called glazes, bricks and mortar, and metal buckets" (152). Resonating with Ord's exploration of the materialities and events of fire, minerality, and composition in part 1, and following Deleuze's notion of "societies of control," they speak to the ways in which contemporary subjectivity is riven with the unconscious logic of the axiomatic of capital, with the effect that this "exploitation and appropriation now strip-mines the unconscious for the sustenance of its mode of production" (153). Via the work of potter Paul Soldner, who undertakes aleatory journeys with and through the assemblage of raku, they explore how the collision of art and science necessary within the assemblage becomes a singular mode of generating resistant

potentiality in the face of capital's overcoding. Central to their argument is the use of schizoanalysis (Deleuze and Guattari 1977). This approach is key to "the actualization of revolutionary potentiality" as it understands the "efficacy of a libidinal break at a precise moment," triggering a rupture in causality "that forces a rewriting of history on a level with the real, and produces this strangely polyvocal moment when everything is possible" (Deleuze and Guattari 1977, 378). Skott-Myhre, Collins, and Skott-Myhre examine the schizoanalytics of Soldner's complementary pedagogical practice and the resulting ways in which the work constitutes a "shamanic encounter with the socially and biologically alchemical aspects of the earth" (159), with Soldner's rakuness containing hints of an insurrectionary politics to come. The authors remind us that the moments of what Deleuze and Guattari describe as the subterranean labour that precedes the decisive libidinal break, the schiz, can lead not only to the rupture of an existing socius "but also to a foreclosing and re-territorializing movement that creates new forms of fascism and social control" (159). Soldner's open-ended approach to making, teaching, and performing his process of artistic creation comprise processes that work to forestall his raku from being recuperated by majoritarian discourses and art worlds (and other logics of supremacy). Considerations around his earth art brings the authors to assert: "we are proposing art … as a politics in and of itself through the capacity for all of us to engage in becoming art and artists" (165). Further: "very possibly, what we are all living now *is* earth art; that is to say that all of our lives today are engaged in global immanent alchemy" (ibid.).

In chapter 7, Peter Rehberg's "Male Becomings: Queer Bodies as Aesthetic Forms in the Post-Pornographic Fanzine *Butt*" continues the exploration of art, desire, and revolt examined through the libidinal rupture of the moment of the schiz in the preceding chapter. For Deleuze and Guattari, central to the understanding of questions of becoming is the understanding that, not dissimilar to the importance of seeking the minor(itarian) over the major(itarian), real change occurs at the molecular rather than at the molar level. Exploring minor and molecular expressions of gender that escape the totalizing molar logic of gender binarization has been an instrumental aspect of feminist and queer Deleuzian theory (Braidotti 2002; Burchill 2010; Grosz 1994; Nigianni and Storr 2009). The position put forward in much of this writing extends Deleuze and Guattari's own perspectives on gender and desire – namely, that gender is not simply social

construction but, more insidiously, the codification of bodies and desire themselves: "The question is not, or not only, that of the organism, history, and subject of enunciation that oppose masculine to feminine in the great dualism machines. The question is fundamentally that of the body – the body they *steal* from us in order to fabricate opposable organisms" (Deleuze and Guattari 1987, 276, emphasis in original). Rehberg renegotiates the space between what has often been presented as an irreconcilable distinction between Butlerian and Deleuzian inspired approaches to accounting for the relationship between representation and materiality, and the relationship to gender and sexuality. Through a discussion of the post-phallic body as presented in *Butt*, Rehberg critiques Butler's articulation of the ways in which bodies become culturally intelligible while also extending Deleuze's understanding of bodies as desiring machines. He argues that the images from *Butt* instantiate the realism of the post-porn of the 2000s as a new avant garde that situates "the inventiveness of sexualities and bodies on the level of everyday culture conditioned by new media" (168). Like porn, post-porn circulates pictures of naked bodies but "simultaneously works on reinventing what these bodies do and what they become" (172). As such, the affective force of post-porn images – pursuing, as they do, "a culture of the ungroomed as a natural aesthetic of the imperfect" (173) – and the work they do in culture serves to inaugurate the thinking and practice of male becomings beyond masculinity that have been generally neglected by queer studies in the post-AIDS generation. Nonetheless, Rehberg cautions against a simplistic reading of Deleuze and Guattari that has led some authors to critique them as irresponsible philosophers of unbridled desire or empty celebrants of a hollow creativity (Hallward 2006; Zizek 2012) by reminding us that "theorizing desire in a post-psychoanalytical fashion should not let us forget the formative impact of gender and sex in sexual cultures and their politics" (171). In other words, capitalism and its cultural practices have captured bodies as desiring machines very capably, and we should not underestimate the struggle to continue liberating them. In this way the chapter establishes its own resonative series with Kurtz's chapter on postcolonial sf in part 1 as both authors engage immanentist perspectives to explore and exceed minoritized identity categories (gender, race, sexual orientation, ability, ethnicity) in art in popular cultural contexts.

Similarly, in chapter 8, the final chapter of part 2, Skott-Myhre and Richardson speak to how the music of rap artist Tupac Shakur, three decades after his death, continues to resist the dominant imperatives

of race and economic marginalization both in the US and internationally. Shakur's work, they argue, addresses the global "hood," consisting of Agambian sites of "bare life" involving refugee camps, favelas, ghettos, and other sites of production. Returning to the relationship between art and the earth, they situate Tupac's expression as a locus of deterritorialization of state and juridical structures that, following Deleuze and Guattari's assertions in *What Is Philosophy?* (2014), is key for revolution, given that insurrectionary art "must be an expression of the earth in its full machinic compositional aspect" (187). This aspect is future oriented, and, "as a creator of objects that allow us to question the planes on which we construct our identities and understandings of the world, Shakur generates 'blocks of space-time' that can inform worlds to come" (186). Skott-Myhre and Richardson situate the revolutionary aspect of Shakur's expression as follows: "If we are to take seriously the link between geography, art, and revolution, then we must ask, what of the artists that engage [the] catastrophe" of the rupture from the present that may represent a chaos from which the artist may not return? There are of course those who "tread carefully around the edges of the catastrophe" or "evoke a certain nostalgia for forms past or seek to valorize neocolonial retreading of fading paths of power and control" (189). But the artists and art that plunge into chaos and catastrophe, what returns do they ask? It is only through the fearless investigation of "spaces in which the abominable sufferings of others create a new people" (139) through what Deleuze and Guattari (2014, 110) describe as their "resistance to death, to servitude, to the intolerable, to shame and to the present," that the artist can summon her strength and aim to create a new people. They conclude that Shakur's vision of the future, one that embraces the minoritarian over the majoritarian, that seeks the molecular within the molar, "renders a momentary revolutionary spark that indeed holds the power to inspire those who will inherit the earth" (197).

PART 3: AUTO-ETHNOGRAPHIES
OF THE POST-IDENTITARIAN

The complexities of writing the self within the ever-shifting landscape of the symbolic that is early twenty-first-century capitalism is undertaken by the authors in part 3. Once again, notions of "self," "subjectivity," and "authorship" inherited from transcendent systems that

privilege identity over difference are problematized by immanent thought, which sees such terms as identitarian shorthand for much more complex processes of individuation that always exceed the individual per se. The question then becomes how can a conscious adoption of specific traditional subjectivities via aesthetic means such as writing and role play provide strategies for exposing the limitations of such subjectivities, limitations that can lead to immanentist pathways and futures? The emerging methodology of autoethnography takes the feminist adage that the personal is political as having an even deeper resonance as we face the appropriation through abstraction of phenomenological productions of the world. To write one's experience, as an evocative explication of discursive power formations in ways that point to a multiplicity of lines of flight and fields of molecular disturbance, is the stuff of autoethnography here. The authors in this part open the process of "self"-"reflection" through an engagement with the aesthetic sensibilities of film, performances of the self, and theatre.

In chapter 9, "Thought beyond Brains: Performing Immanent Zombie Politics through Autoethnography," Joanna Perkins interrogates the implications of a zombie apocalypse on human/non-human subjective distance. Drawing on Marxist theory she asks if we are not already zombies under the regimes of global capital in which the demarcation between the actual and the virtual becomes opaque. Explicating this further through Spinoza, she wonders if this is in fact the wrong question. Instead of binary configurations that propose a sort of true/false dichotomy, she argues that we might think of various configurations of subjectivity as holding degrees of force with which we can engage. "We are living in an apocalyptic world right now," she affirms, and "instead of fighting this zombie, or capitalist, apocalypse, we must face it and see what we can do *with* it instead of against it" (202). When confronted with the radically non-human human form that is the zombie, what are the configurations of political force that can be brought to bear and what relevance does that have to our own capitalist zombie apocalypse? Perkins makes a case for thinking and writing autoethnographically as a way of conceiving of and reanimating forms of zombie politics. These thoughts and words bring the writer and the text into an intimacy in which subjectivity and text are merged and blurred so as to flee the binary dichotomies of the symbolic that is at the heart of postmodern capitalism. Proposing the figure of the Zombie Christ as an exemplar of the Spinozan "free

man" whose adequate understanding of himself leads him to wish good for himself as well as for others, Perkins takes up Skott-Myhre and Skott-Myhre's notion of "political love" as a means of generating a sustainable ethical sociality. She affirms that the figure of a Zombie Christ "reveals an infinite meditation on life" and might be understood "as the epitome of a critical subject of proximity here by accepting even death as a means of producing oneself" (213). This can allow "the adequate knowledge that producing oneself is always interdependent on others – those who precede us and those who would follow us" (ibid.). Such writing, as philosophical as it is theoretical as it is aesthetic, can permit an "uncomsummability" at the heart of a voracious semiocapital.

In chapter 10, "When Simulation Becomes Simulacrum: 'Reversing Platonism' with Deleuze in Live Role Play," David Fancy echoes notions of performance that are apparent throughout this volume. He does so by using an example from his own practice as an actor performing simulated political hostage situations with the Royal Canadian Mounted Police that went significantly out of control. Arguing against a Platonic reading of events that cleanly delineates between real and fictional experiences, he proposes using a Deleuzian lens to explore the ways in which acting, actors, and events can become entangled in ways that have profound impacts both subjectively and politically. Foucault (1970, 168) noted famously: "To reverse Platonism with Deleuze is to displace oneself insidiously within it, to descend a notch, to descend to its smallest gestures." Similarly, Fancy insinuates himself via role play into the heart of the capitalist surveillance-police-war state, taking the process of hostage-taking hostage with political commentary in-fiction that disrupts the state-decreed function of that fiction. Fancy makes the point that role plays such as re-enactments or simulations can provide a kind of improvised and emergent authorship that can lead to unanticipated sets of interactions with real life implications. This aspect of performance as simulation, he argues, *pace* Deleuze, brings the real and fictional into a surprising degree of proximity such that they become enmeshed and entangled, blurring the boundary between the real and the fictional. In these moments, the "triumph of the false pretender" that Deleuze (2004) seeks out in Plato allows readers of Deleuze to reclaim the use of the "simulacrum" from its Baudrilliardian usage, which refers to vacuous signification for a different purpose. The simulacral, following Deleuze's reading of Plato's figure of the Sophist, is that which can convincingly emulate the supposed "real" Socrates, thus

throwing into question the seemingly firm distinction between the model and the copy, the Idea and its manifestation. Fancy notes that "the disruptive power of the simulacrum does not assume the role of a new foundation but, rather, 'engulfs all foundations' and, in so doing, 'assures a universal breakdown,' an 'unfounding,' that is 'a joyful and positive event' (Deleuze 2004, 300)" (233). Fancy uses this oscillatory space of the simulacral in performance as a platform to explore the ways in which social agents captured within compelling affective pathways of late capital can be provoked into generating complex and phenomenologically driven encounters that may well have profound implications for the politics of the future.

Rather than finishing with a "conclusion," which might on some superficial level at least appear to be an attempt to enact a kind of telotic closure, we focus on a final set of observations around art and the people to come. These thoughts come from series and patterns that are discussed throughout this volume and that deal with the move to art and the nonhuman, the limitations of traditional discussions of art and identity politics that immanence provides a way through and beyond, and the continuous potentials available in the face of advanced semiocapitalism in the creative and political revolt of artistic practice.

REFERENCES

Bateson, Gregory. 1972. *Steps to an Ecology of Mind: Collected Essays in Anthropology, Psychiatry, Evolution, and Epistemology*. Chicago: University of Chicago Press.

Bignall, Simone. 2010. "Affective Assemblages: Ethics beyond Enjoyment." In *Deleuze and the Postcolonial*, ed Simone Bignall and Paul Patton, 78–102. Edinburgh: Edinburgh University Press.

Bowden, Sean. 2015. "Human and Nonhuman Agency in Deleuze." In *Deleuze and the Non/Human*, 60–80. London: Palgrave.

Braidotti, Rosi. 2002. *Metamorphoses: Towards a Materialist Theory of Becoming*. Cambridge, UK: Polity.

– 2006. "The Ethics of Becoming Imperceptible." In *Deleuze and Philosophy*, ed. C.V. Boundas, 133–59. Edinburgh: Edinburgh University Press.

– 2011. *Nomadic Subjects: Embodiment and Sexual Difference in Contemporary Feminist Theory*. 2nd ed. New York: Columbia University Press.

Burchill, Louise. 2010. "Becoming-Woman: A Metamorphosis in the Present Relegating Repetition of Gendered Time to the Past." *Time and Society* 19 (1): 81–97.

Deleuze, Gilles. 1986. *Kafka: Towards a Minor Literature*. Minnesota: University of Minnesota Press.

– 1988. *Bergsonism*. Trans. Hugh Tomlinson and Barbara Habberjam. Brooklyn: Zone Books.

– 1991. *Nietzsche and Philosophy*. Trans. Hugh Tomlinson. New York: Columbia University Press.

– 1994. *Difference and Repetition*. Trans. Paul Patton. London: Continuum.

– 2004. *Logic of Sense*. Trans. M. Lester and C.J. Stivale. London: Bloomsbury Publishing.

Deleuze, Gilles, and Félix Guattari. 1977. *Anti-Oedipus: Capitalism and Schizophrenia*. Trans. Robert Hurley, Mark Seem, and Helen R. Lane. New York: Viking Press.

– 1987. *A Thousand Plateaus*. Trans. B. Massumi. Minneapolis: University of Minnesota Press.

– 2014. *What Is Philosophy?* Trans. H. Tomlinson and G. Burchell III. New York: Columbia University Press.

Foucault, Michel. 1970. "Theatrum Philosophicum." *Critique* 282: 885–908.

– 2002. *The Order of Things: An Archaeology of the Human Sciences*. Trans. D. Ihde. London and New York: Psychology Press.

Gatens, Moira. 1996. *Imaginary Bodies: Ethics, Power and Corporeality*. London: Psychology Press.

Grosz, Elizabeth. 1994. *Volatile Bodies. Toward a Corporeal Feminism*. Bloomington: Indiana University Press.

Guattari, Félix. 2005. *The Three Ecologies*. Trans. I. Pindar and P. Sutton. London: Bloomsbury.

– 2008. *Chaosophy: Texts and Interviews 1972–1977*. Ed. S. Lotringer. Los Angeles: Sémiotexte.

Hallward, Peter. 2006. *Out of This World: Deleuze and the Philosophy of Creation*. London: Verso.

Hardt, Michael. 1995. "The Withering of Civil Society." *Social Text* 45: 27–44.

Hardt, Michael, and Antonio Negri. 2000. *Empire*. Cambridge, MA: Harvard University Press.

– 2004. *Multitude: War and Democracy in the Age of Empire*. Cambridge, MA: Harvard University Press.

– 2009. *Commonwealth*. Cambridge, MA: Harvard University Press.

Lazzarato, Maurizio. 1996. "Immaterial Labour." In *Radical Thought in Italy: A Potential Politics*, ed. Paolo Virno and Michael Hardt, 142–57. Minneapolis: University of Minnesota Press.

– 2014. *Signs and Machines: Capitalism and the Production of Subjectivity*. Trans. Joshua David Jordan. Los Angeles: Sémiotexte.

Lacan, Jacques. 1988. *The Seminar of Jacques Lacan Book II: The Ego in Freud's Theory and in the Technique of Psychoanalysis 1954–55*. Trans. S. Tomaselli and ed. J.A. Miller. New York: Norton.

Luhmann, Niklas. 1995. *Social Systems*. Palo Alto: Stanford University Press.

Massumi, Brian. 2002. *Parables for the Virtual: Movement, Affect, Sensation*. Durham, NC: Duke University Press.

Negri, Antonio. 1996. "Twenty Theses on Marx: Interpretation of the Class Situation Today." In *Marxism Beyond Marxism*, ed. S. Makdisi, 149–80. New York: Routledge.

– 2011. *Art and Multitude*. Trans. E. Emery. Cambridge, UK: Polity.

Nigianni, Chrysanthi, and Merl Storr, eds. 2009. *Deleuze and Queer Theory*. Edinburgh: Edinburgh University Press.

Simon, Herbert A. 1971. "Designing Organizations for an Information-Rich World." In *Computers, Communication, and the Public Interest*, ed. Martin Greenberger, 40–1. Baltimore: Johns Hopkins Press.

Simondon, Gilbert. 2005. *L'Individuation à la lumière des notions de forme et d'information*. Grenoble: Jérôme Millon.

Spinoza, Baruch. 2000. *Ethics*. Ed. and trans. GHR Parkinson. Oxford: Oxford University Press.

Srnicek, Nick. 2016. *Platform Capitalism*. London: Polity.

Stiegler, Bernard. 2014. *Symbolic Misery: The Hyper Industrial Epoch*. Cambridge: Polity.

Suarez-Villa, Luis. 2009. *Technocapitalism: A Critical Perspective on Technological Innovation and Corporatism*. Philadelphia: Temple University Press.

Tuck, Eve. 2010. "Breaking up with Deleuze: Desire and Valuing the Irreconcilable." *International Journal of Qualitative Studies in Education* 23 (5): 635–50.

Williams, Raymond. 1958. *Culture and Society*. London: Chatto and Windus.

Zepke, S. 2005. *Art as Abstract Machine: Ontology and Aesthetics in Deleuze and Guattari*. London: Routledge.

Zizek, Slavoj. 2012. *Organs without Bodies: On Deleuze and Consequences*. London: Routledge.

PART ONE

Technology and Futures

1

Actualization of the Virtual through an Aesthetic Encounter with Virtual Reality Technology

Timothy J. Beck

Virtual reality technology (VR), or "immersive multimedia," represents something of a technological turning point after decades of innovations on the part of computer engineers and software designers searching for pragmatic and/or entertaining uses for burgeoning digital technology. As Andrew Murphie (2002) describes, whereas earlier forms of digital media technology (primarily those whose interface consists of a screen and/or speakers) have functioned almost exclusively by way of representing "reality" as accurately as possible to the technologies' users, VR affords a potential for something radically different. Instead of opting for the "common practice of associating VR with the theatre as a form of representation with stories, plots and characters" (188), Murphie underscores the ability of VR to provide a platform for improvisation and artistic performance: forcing the production of a "general emergent series of cultural phenomena – a machinic phylum" (189), which, in rare cases, "expresses what might be called *the shock of the real immanence of the metaphysical*" (195, emphasis in original). Such a shock, he argues, can be described similarly in terms of both an immanent and a metaphysical event – whereas the two might otherwise be positioned in opposition to one another – only because of VR's capacity for spontaneous cultural *expression* beyond acts of representation per se. With computer-generated or augmented environments that respond to the embodied action of their users, as opposed to simply reproducing cultural

representations in a manner that has already been arranged or rehearsed, VR has the potential to enact situations that challenge common sense notions and force an encounter with something beyond what the platform might have been intended to be used for.

According to VR researcher Mychilo Cline (2005, 3), "virtual reality" is generally discussed today in terms of something like "a computer generated environment – a first person, 3D, video game, with sound and possibly, touch, taste, and smell." Even a definition as mundane as this, however, makes VR so dependent on its users' perceptual and attentive processes that one has to wonder whether or not there has not always been a virtual dimension to all activities associated with representation and expression, albeit in a perhaps more general and expansive sense of the term "virtual" than is typically connoted with respect to the digitally specific usages described above. Cline then goes on to describe how the sounds and images associated with taking pictures, or even using the telephone, for example, create domains for communication and thought that almost immediately transcend the limits we tend to place on our propensity to act given personal, taken-for-granted conceptualizations and prior experiences of lived space and time. Virtual domains are, in this sense, not necessarily specific to VR – even if such technologies were configured specifically to produce them – but are fundamental to the human experience as such. I argue that such domains are, in fact, precisely what allow for a general sense of creativity to be possible at all.

Many current discussions about VR tend to place the set of associated technologies at a sort of crossroad of creative invention and cultural expression. As a purely mechanical innovation, for example, it affords a potential to be used for different purposes depending on the situation. And yet, at the same time, specific intentions and expectations can be written into the devices simply through the way in which they have been constructed: the materials out of which they are made, the particulars of the interface design, and even the closed circuit binary code through which their energy transfers are organized (Moreau and Fuchs 2011). Despite Murphie's suggestions for some of the more experimental usages of VR, there will always be the propensity for such platforms to be used in ways that merely capture and sustain the attention of its users in manners not all that different from those utilized by other forms of media. In situations in which "a user's" perception is simply redirected to any set of more or less already constructed cultural narratives subtending their personal identities, for example,

any creative impetus will be largely foreclosed, and the technology risks becoming just another tool for coercive social control.

The inherent tension between what VR is capable of and how it will likely be used is evident through the many different connotations associated with the term "virtual reality" in general. Despite significantly predating the type of digital technologies discussed here, Antonin Artaud (1958, 49) used the term to describe how "the characters, objects, images, and in a general way all that constitutes the virtual reality of the theater" perform a sort of alchemical process within a given group of actors. Later depictions are often more pessimistic (see Cogburn and Silcox 2013 for some of these), however, perhaps closer to Jean Baudrillard's (1994, 160) notion of "simulacra," according to which: "now the media are no longer a stage where something is played, they are a strip, a track, a perforated map of which we are no longer even spectators: receivers." Given the polysemy of the term, the general notion of "virtual reality" is, at this point in time, something of a mere placeholder for the ways associated technologies continue to adapt, with their usages increasingly forced into the everyday lives of a greater number of individuals. The main issue to be discussed in this chapter is, therefore, not so much concerned with figuring out what VR actually *is* but, rather, what VR is capable of *performing* or, in turn, what can be performed with it (Cogburn and Silcox 2013). If it is indeed true that "no one has yet been taught by experience what the body can do merely by the laws of nature" (Spinoza 2000, prop. 2, part 3), the same must apply for similar considerations regarding the body's use of VR.

On another level of artistic production, the various VR-related scientific innovations emerging today also start to make good on promises made by twentieth-century science fiction and fantasy writers, in which literary innovations produced by authors such as Phillip K. Dick and Ray Bradbury consistently challenged common sensibilities and traditional conceptual distinctions. While such fictive worlds were produced with one eye towards contemporary scientific research and technological capacity, their authors always kept the other eye directed towards what was yet to be declared scientifically possible – for a world and people yet to come (Hroch 2014). As Cogburn and Silcox (2013, 562) describe, "contemporary technological innovations and science fictional speculation about VR render live a hypothesis that might otherwise be regarded as only realizable in a very faraway possible world and hence perhaps only of concern to

philosophers." In many of these worlds, such as the one depicted in *Fahrenheit 451* (Bradbury 2013), for example, vr-like technology is depicted as being progressively woven into everyday life activities in such a way as to conceptually challenge the distinction between a specifically *virtual* reality and all others. Virtual reality, in this sense, is positioned as merely one type of reality, but one in which certain physical boundaries, often initially regarded as absolute, become more or less malleable and open to some degree of alteration throughout the course of the narrative. In other instances, however, such as with Dick's (2011) *Valis*, a largely virtual reality is positioned as the most dominant reality, with all other potential realms of experience constituting a sort of ideal-outside that the characters can never seem to reach.

As also discussed by Cogburn and Silcox (2013), popular narratives in circulation with respect to vr are seldom exclusively about the relationship between a particular group of humans and a particular form of technology. Especially in the context of science fiction, multiple levels of discourse are indexed simultaneously through the interplay of scientific terms, philosophical concepts, and artistic modes of production. In this sense, and particularly under the conditions and confines of a networked transnational economic system (Castells 2009), social practices that are conventionally assumed to be separate (e.g., science, philosophy, and literature/art) can be forced into a position that presupposes each other's procedures and problems in a very intricate and open-ended manner. By extension, then, at this point the respective conceptions of vr that each implies can also no longer be considered completely insular, precisely because they are in fact affected by and in turn go on to affect each other in often indeterminate ways. This is not the case by pure chance or coincidence; rather, it is a function of their shared cultural-historical milieux, which afford such common threads of thought and affect regardless of the variable styles through which such an emergence might be engaged.

As described by N. Katherine Hayles (1990, xi), "the concerns underlying [varied social practices] are highly charged within a prevailing cultural context, which in turn implies that scientific theories and models are culturally conditioned, partaking of and rooted in assumptions that can be found at multiple sites throughout the culture." There is thus an analogous sense of urgency or cognitive rupture at the heart of both science and literature – often spurred by common culturally relative factors – forcing those participating in each practice

to react to, or enact various strategies for, engaging the effects of this continuously emerging encounter with cultural tension on their own terms. Each historical period has its corresponding set of cultural or ecological dilemmas (e.g., climate change, terrorism, economic disparity, etc.) that come to influence the development of otherwise distinct social practices in their respective domains. And yet, at the same time, practices as distinct as science and art will each have a respective style of approaching the chaos on the edge of such cultural-historical milieux, which leads to a very different set of tools and unique manners of experimentation.

TWO DISTINCT STYLES OF APPROACHING CHAOS (OR THE VIRTUAL)

In *What Is Philosophy?* Deleuze and Guattari (1994) describe each and every social institution or cultural practice as having a complementary set of appropriate contexts and idiosyncratic styles of replication. By parsing out the subtle distinctions between them, these authors afford themselves the versatility to explore different disciplines on their own terms, without obscuring the elements unique to each. Science, for instance, is described as a unique cultural practice in so far as its theoretical domains are defined in the form of the function (i.e., $F(x)$). Scientific practice, as such, embarks with a painstakingly specified set of axioms and systematically delimits all perceptual and affective possibilities accordingly from that point forward. The aim here is ultimately constructive, with the intended output being scientific propositions with varying scopes of accuracy or truth. This is the manner by which scientific discourse is intimately wedded to logic. Truth, in this figuratively constructive sense, is *performed* by a proposition's capacity to reliably represent objects and their relative force with reference to an already indexed area of space and time. Although a given scientific proposition might be modelled on a circumscribed scope of the universe, it is at best an aleatory effect of an encounter with the forces it represents and could never function in a way that entirely replaces it (Deleuze 1990). With a certain degree of luck, then: "*Science passes from chaotic virtuality to the states of affairs and bodies that actualize it*" (Deleuze and Guattari 1994, 155–6, emphasis in original). That is to say, this particular culturally embedded procedure is typically practised in a way that strives to concretize the imperceptible elements of the universe so as to harness the forces they

produce and, in effect, signify them in accordance to more or less already functioning representational paradigms. From this perspective, the compilation of truthful scientific discourse is the ultimate objective of such procedures, and scientists' various methods of data collection evolve so as to support such an endeavour.

Artistic acts, on the other hand, are discussed by Deleuze and Guattari (1994) as proceeding according to a very different type of trajectory. Instead of dealing primarily with functions in order to produce hypotheses or propositions of fact, art is described as what results from a continued engagement with the power of sensations, affects, and percepts that exceed the representative capacity of propositions as such. What this particular practice leaves behind, concretely, rather than a set of sedimented propositions and functions, as with science, is "a bloc of sensations, that is to say, a compound percepts and affects" (Deleuze and Guattari 2006, 164). If words or symbols are used in artistic acts at all, they are employed strictly as the means whereby such an assemblage of affect and percept might be produced and/or sustained. The *virtual* dimension that emerges here could very well be the same plane of immanence encountered by scientists, but it will nonetheless be approached with a very different structure of desire. According to Deleuze and Guattari (1994, 206), "artists struggle less against chaos (that, in a certain manner, all their wishes summon forth) than against the 'clichés' of opinion . . . [while] science [on the other hand] would relinquish all the rational unity to which it aspires for a little piece of chaos that it could explore." At times art might engage with this encounter with chaos with a more passive touch, perhaps in the form of affective surrender or even masochistic pleasure; while at others it could be met instead with a reckless abandon, the speed of which a procedure like the scientific method would never allow.

There is also, of course, an irreducible sense of violence implied here, whereby subjectivity is decomposed piecemeal while objects in the world are simultaneously made more vivid and detailed than ever before. As Maurice Merleau-Ponty ([1962] 1945, 217) reminds us, "each sensation, being strictly speaking, the first, last and only one of its kind, is a birth and a death." Sensation, in this sense, following Catherine Malabou, always entails a sort of friction with the sheer alterity of a "thing [that] reveals itself in the flesh and stands there before our eyes as something given to itself and in actuality" (Sparrow 2014, 14). To actually be affected by a thing – to even broach our capacity for sensation, in this sense – makes it inevitable that some degree of resistance be experienced at the boundaries of the self, which

is considered here as a mere constellation of "habit, nothing but a habit in a field of immanence, the habit of saying I" (Deleuze and Guattari 1994, 48). It is indeed through just such aesthetic cracks in subjectivity, and only at such ruptures, that "the virtual" in the sense described by Deleuze and Guattari (1987) develops a capacity to affect already actualized bodies and states of affairs and enter into composition with whatever effects stem from this engagement. And this all happens, moreover, in the dimension of "the nonthought within thought. It is the base of all planes, immanent to every thinkable plane that does not succeed in thinking it" (Deleuze and Guattari 1994, 59) – not a conceptual base, nor a starting axiom, but a network of capacities for affects and perceptions.

This is not, of course, to imply that scientific discourse can have absolutely nothing to say about what is going on during such acts. It is simply the case that, because scientists typically focus most of their attention on what they have already defined as included within their scope, their corresponding methods and styles of replication force them, to put it illustratively, into a game of trivial pursuit with their own discipline. In other words, scientific practices are normally structured quite intentionally so that scientists are rewarded for constructing facts that will in some way relate to propositions from earlier empirically researched, and thus discursively operationalized, material situations. As geneticist Richard Lewontin (2001, 104) so aptly suggests:

> When faced with questions that they do not know how to answer – like "How does a single cell turn into a mouse?" or "How did the structure and activity of Beethoven's brain result in Opus 131?" – the only thing that natural scientists know how to do is to turn them into other questions that they do know how to answer. That is, scientists do what they already know how to do.

With science, then, a certain sense of closure could be said to be often assumed at the outset of an experiment, whereby a proposition of fact, or a negation of an affirmative hypothesis, is the intended result within the specific field of possibilities indexed and articulated in accordance with various results of earlier enacted scientific experiences or experiments – in French they are of course denoted by one and the same term. In contrast to this process, art is unique in its potential to reach beyond the capacity of its assumed methods and

materials while nonetheless surrendering its products and procedures
to the gaze of the world: "the thing bec[omes] independent from its
'model' from the start, but is also independent from other possible
personae who are themselves artists-things" (Deleuze and Guattari
1994, 163–4).

 During those incredibly rare moments when the effects of social
practices as distinct as art and science overlap, zones of indeterminate
capacity are made available through technologies, such as VR, irreduc-
ible to the procedures implied in either of the two on their own. And
yet, while VR, as a broad set of digital technologies and multi-media
platforms, can be used in markedly unique ways with respect to the
two types of social practice described above (even to the extent that
their respective usage of the word "virtual" could appear almost com-
pletely unrelated), each time VR is used in any context at all it has a
capacity to produce unanticipated and potentially interesting effects
for its user and beyond. It might not always be entirely clear, further-
more, which use of VR (i.e., the one ascribed by science or the one
produced through art) is necessarily enacted at any given moment in
time. The major variable here is, of course, whatever is brought to bear
on the situation by the user, even though the same binary code might
underlie both sets of situations. Whether the steadily progressing com-
plexity inhering between binary code and capacities of human thought
and/or action is simply considered as a metaphor for the way symbolic
structures are affected by imagination, or it is taken a step further as a
way to think the universe as a sort of virtual construction itself (whereby
each individual perspective represents a singular expression), is relatively
arbitrary at this point. What is of particular interest here, however, is
the way various ongoing discussions regarding VR afford particularly
productive platforms for thinking through several long-standing philo-
sophical and political dichotomies (e.g., idealism vs. materialism, tran-
scendence vs. immanence, individualism vs. collectivism, etc.) in a way
that exemplifies how such historically charged debates permeate con-
temporary cultural milieux.

A RETURN TO THE CAPACITY OF LITERATURE
TO FORESHADOW SOME CULTURAL
EFFECTS OF SCIENTIFIC INNOVATION

Take, for example, the manner in which Ray Bradbury (1950) portrays
the nursery in his short sci-fi story "The Veldt," as referenced by

Deleuze and Guattari (2009) in *Anti-Oedipus*. Written in 1950, the nursery in this story is a room with no specific aesthetic form of its own but whose walls come to take on whatever conditions happen to be imagined by the user. Largely unconsciously, any set of configurations that might be desired at any given time is the one that is projected. The story focuses on how this one room has come to affect the members of a particular family, for whom the technology surrounding them has constructed a wedge between their personal relationships that, in turn, gradually puts considerable strain on both of the parents as they reflect upon the demands required to sustain their everyday routines. And yet the father in this story, on a purely technological level, is utterly

> filled with admiration for the mechanical genius who had conceived this room. A miracle of efficiency selling for an absurdly low price. Every home should have one. Oh, occasionally they frightened you with their clinical accuracy, they startled you, gave you a twinge, but most of the time what fun for everyone, not only your own son and daughter, but for yourself when you felt like a quick jaunt to a foreign land, a quick change of scenery. Well, here it was! (Bradbury 1950, 11)

For him, the nursery represents scientific innovation at its most advanced stage – the crown jewel of a cookie-cutter "Happylife Home" filled to the brim with all the latest technological advancements required for a leisurely modern life. At the same time, however, early on in the narrative the situation for him and his wife is highlighted as anything but ideal. Work is beginning to take its toll on him, and both of his children have begun spending more and more time either in the nursery (where they have become preoccupied with one scene in particular, which represents an ecosystem of African grasslands) or away from home entirely – despite the pleas of their parents.

As for the mother, who is becoming both increasingly disenchanted with the amenities offered by the home and frustrated by the deterioration of each of her familial relationships, a return to a more natural life seems like the only remedy. "I feel like I don't belong here," she exclaims, "the house is wife and mother now, and nursemaid. Can I compete with an African veldt? Can I give a bath and scrub the children as efficiently or quickly as the automatic scrub bath can? I

cannot" (Bradbury 1950, 13). After some reluctance, and a series of consultations with the family psychiatrist, the father eventually comes to accept the "reality" of this as well. But for the children, on the other hand, whose desires and imagination have become irrevocably interwoven with the intricate workings of the nursery, nature has become synonymous with the flows of intensity and affective engagement sustained through their participation in the scenes of the African veldt produced by the technology in the room. In one last ditch effort to re-Oedipalize their children's desires and reorient the family as a whole towards a more idyllic set of interrelationships of which the parents admit they had always dreamed, they abruptly foreclose all engagement on the part of the children with, first, the nursery, and then, finally, the rest of the technology in the home. "Lydia, it's off, and it stays off," the father says to his wife. "And the whole damn house dies as of here and now. The more I see of the mess we've put ourselves in, the more it sickens me. We've been contemplating our mechanical, electronic navels for too long. My God, how we need a breath of honest air!" (Bradbury 1950, 24). But it is, of course, much too late to turn back on the process of "deterritorialization" that has been taken up by the children (Deleuze and Guttari 2009).

For the brother and sister in this story, the African veldt has become something entirely different than a mere depiction of someplace else in the world, suppressing the technological innovation on the part of a group of scientists – in the mechanical manner in which the father understood the nursery, for instance. Much more than a representation of some other set of conditions somewhere, the veldt on the walls has become enacted by the children as a purely virtual plane of immanence – one on which their most repressed desires and capacities to affect and be affected could be played out in a machinic duration. In tandem, the two cultivate a collective power through the technology of the room that goes far beyond what the engineers who constructed that technology could have possibly imagined. "And then [the parents] heard the sounds. The lions on three sides of them, in the yellow veldt grass, padding through the dry straw, rumbling and roaring in their throats." This wasn't supposed to be possible, the parents must have thought. "Mr. Hadley looked at his wife and they turned and looked back at the east edging slowly forward crouching, tails stiff. Mr. and Mrs. Hadley screamed. And suddenly they realized why those other screams [ones they had heard before] had sounded [so] familiar" (Bradbury 1950, 26). They were in fact their own – non-linear – projections of potential acts to come.

The nursery in this short story did indeed come to take the place of the parents, but it was specifically the relationship between each parent and the technology, as described above, that came to determine how the children used the nursery as a prosthesis for their desires. Of course, this narrative also has an alternative reading: a molar interpretation whereby the nursery and its effects on the children signify technological innovation run amok. Given the states of affairs described in the story, either reading is just as plausible a rendition. And this, in a certain sense, is what makes the art of literature such a potentially powerful medium. There will likely always be a generalized social fear expressed through cultural narratives such as these – a fear that more expansive uses of such visually specific platforms, by acting upon human perception with increasingly veiled mediation, will inevitably extend digital technologies' capacities to exert indomitable force over unconscious psychological processes in unpredictable ways. Even within the same story, such as the one by Bradbury described above, two forms of VR are possible, each seemingly just as likely a scenario depending upon where a particular narrative style begins and ends.

In an economic system in which public policy has no other option than to be grounded in the recursion of neoliberal values (e.g., unregulated resource allocation and uninhibited wealth production), it is quite likely that an increasing demand for innovative sources of capital can only be met through expanding commodification into fields of unconscious experience that are more easily controlled and altered in accordance with the interests of transnational corporations (Skott-Myhre 2015). Those already actualized dimensions of experience, on the other hand, where some form of behaviour modification or physical discipline would be required, would no longer function in such a situation as sufficient sources for economic growth (Deleuze 1997). Corporations supported by and supportive of the popularization of digital forms of technology, moreover, are unquestionably the persons (since they are more or less legally equivalent) who most benefit economically in this arena, which means that the narratives encrypted in their technologies will likely subvert any attempts to have the commodities used for alternative political purposes. And as with something as simple as an *Apple User's Agreement*, for example, users will likely be lining up out the door in order to sign their freedoms away.

The final product of this arena of commodification, though, is not necessarily VR technology and its effects per se but, rather, a movement towards absolute idealism in its most perfected and self-recurring

formulation. For the purposes here, "idealism" might be understood as a particular assemblage of intersubjective relations relative to certain historical situations within which associations between bodies are effectively mediated by an external term entirely devoid of the capacity to produce anything other than itself. This can also be thought in terms of a sort of "generalized solipsism": a self-recurring symbolic field capable of producing bodies in relative isolation from each other yet homogenous in form and content. "Consciousness" is one term that has been used to bolster such a symbolic field/assemblage, others being "matter," "capital," or even "proletariat" (at least in its more perverted forms). Essentially, this is what Deleuze and Guattari (2009, 139–40) describe in *Anti-Oedipus* as the "socius": "To code desire – and the fear, the anguish of decoded flows – is the business of the socius … [and at] capitalism's limit the deterritorialized socius gives way to the body without organs, and the decoded flows throw themselves into desiring-production." Such a generalized solipsism thus sustains desire not through creative experimentation, as is the case with art, but solely through narcissistic identifications with only those partial objects indicative of the symbolic determinant at the core of the assemblage.

In those contemporary social situations governed by the transnational rules of exchanging capital, the term, or ideal object, with which its assemblages are held together is specifically the dollar sign, with its culturally relative value being weighed against quarterly economic measures of losses and gains. Similar to the logic of digitalization used by scientists to construct VR technology, this either/or structure of binary coding functions so as to represent actuality in terms of abstract and absolute distinctions, but it is nonetheless experienced concretely and, typically, very fluidly through whatever combination of material and symbolic entities come to order themselves accordingly. The monetary unit of the US dollar, for example, instituted initially as a token symbol to stand in place of actual material exchanges, has in its current state taken on a recursive function of its own, exhibiting a capacity to fold back into the social institutions out of which it emerged while creating particularly powerful, and in many cases novel, effects. The transcendent qualities of this particular type of assemblage of relations persists, at times discreetly, hovering over its material counterpart like a mosquito that cannot quite be shaken off – subtly conditioning the neurology of the bodies on which its surplus value becomes ascribed.

In the short story discussed above, Bradbury ingenuously typifies the two forms of generalized solipsism, or radical idealism, that pose the greatest threat of capturing the unconscious of the next generation of VR users. On the side of the father, we have a somewhat traditional fetishistic fixation on technology as a form of scientific innovation as well as a narcissistic identification with a certain surplus value associated with his own capacity to afford such a magnificent machine. Such a right-wing subject position strips the VR platform of any capacity that has not already been assigned to it by the rules of exchanging global capital. With the mother, on the other hand, we can see a different yet no less insidious form of hypnotic identification and tendency towards solipsism. She could be said to represent the more left-wing, but equally reactionary, subject position, naively maintaining a strict distinction between nature and technology only to watch both, ironically, consume her and her husband in a single act of material, physical decomposition: untimely death on the virtual African grasslands.

For the two children, however, for whom the familiar in their Oedipal structures has become irrevocably displaced – with a becoming-other elicited in its stead – notions of self and other have been supervened by the capacities produced in the encounter with a purely virtual field of movement and raw affective engagement. The affects produced in destabilizing the static filial relations themselves could be said to signify a passage from virtual to actual or, quite simply, an actualization of the virtual that can only occur on a molecular, perhaps even neurological, level of reality. And according to Deleuze and Guatarri (2009, 47), this is in fact the case for all children in general:

> Ray Bradbury demonstrates this very well when he describes the nursery as a place where desire-production and group fantasy occur, as a place where the only connection is that between partial objects and agents. The small child lives with his family around the clock; but within the bosom of the family, and from the very first days of his life, he immediately begins having an amazing nonfamilial experience that psychoanalysis has completely failed to take into account.

The concept of the nursery – both in the Bradbury story and otherwise – thus represents a dimension beyond the confines of traditional rules

and social expectations, where imagination and creativity can be explored on desire's terms as opposed to those of the socious. This is not meant as an attempt to valorize the children's disinterest in their parents' death per se, but simply to mark out an aesthetic trajectory beyond good and evil that can be indexed only in the encounter between a particular type of technology and a cultural milieu calibrated to the extent that such modes of production might be afforded.

The importance of "The Veldt" to the current discussion of VR is, as such, in no way reducible to a particular virtual image or symbol (e.g., the technological nursery) and, especially, not to the knowledge that can be constructed regarding the brain's response to such a set of external stimuli. Rather, the story's relevance here lies in the way interruptions to the organization of such objects and procedures are able to intervene in already actualized series of digital alternations, and what this might mean for aesthetic expression. The virtual dimension that spins off from this inverse engagement in the story is more than enough to produce the children, singularly, in a mode wholly other than either of them, individually, thus surpassing any limits imposed by either the Lacanian big Other or (m)other as structured within the traditional Oedipal triad:

> Everything is not inscribed in Oedipus without everything at its extreme fleeing beyond the reach of Oedipus … [Such] identifications [are] not identifications with persons from the viewpoint of perception, but identifications of names with regions of intensity that provide the impetus toward other still more intense regions, stimuli of one sort or another that set in motion another journey altogether, stases that prepare for other breakthroughs. (Deleuze and Guattari 2009, 26) .

Deleuze, Guattari, and later Braidotti (2010) all use the term "nomad" to refer to a particular configuration of subjectivity that, instead of sustaining an identity based solely upon the relations of familiarity and similarity tied to specific objects and symbols, takes up subjective construction as a process between heterogeneous groups with no coherent thread essentially tying them together. Rules and customs, in such instances, remain in a constant mode of reworking as subjectivity strives to produce itself anew in light of the striated manners by which it has been affected, respectively, in each of the local situations it has inhabited. According to Braidotti (2010, 211): "nomadic subjectivity

moves beyond the mere critique of both the identitarian category of a sovereign self and dominant subject position on the one hand and the image of thought that equates subjectivity with rational conscious- ness on the other." That is to say, because nomadic thought prioritizes the experimentation with affect and desire over and against identifica- tion with a recursive set of symbols – such as a national identity or particular position on the gender spectrum, for example – it serves as an alternative to those conceptual frameworks founded on anthropo- centric models of the universe in which the essence of man is assumed to be the mediator of rational (scientific) thought and discourse.

In any given situation, then, a nomadic subjective procedure takes as its point of departure the assumption that the capacity of any given object or technology, rather than being determined completely by previous manifestations of itself, is instead projected towards the future in such a way as to open chance to previously unforeseen virtual traces that are nonetheless elicited by elements in the local milieu in which it happens to have be employed at that juncture. To be clear, these often imperceptible elements inherent to the ambient milieu ought not be confused with the tendency for human consciousness to colour the environment with its preconfigured and stagnant imagi- nation (which would again amount to idealism). Instead, such capaci- ties subsist on a pre-conscious plane of pure movement – gradient speeds and slownesses – on which events can come to produce con- cepts through various forms of overlap between sense, perception, and affect (Deleuze and Guatarri 2006). These embodied sense events, which do not necessarily privilege humans' consciousness or their bodies over those of any other physical form, are discussed by Deleuze (1990) as precursors of any sort of innovation in thought whatsoever, regardless of the outcome or style by which it is produced. To quote Antonio Negri (1996, 158) on this point, "every innovation is a revo- lution which failed – but also one that was attempted." Even scientific innovations, such as VR, therefore, strive for something beyond the socious – however doomed they are to perpetually fall short of their pre-assigned value or ideal.

THE OVERCODING OF GLOBAL CAPITALISM AND THE INDETERMINATE OVERFLOW OF THE VIRTUAL

As exhibited in Bradbury's "The Veldt," any predetermined purposes and intentions for digital technology could never successfully impose

a permanent limit on the intensive capacity such platforms have to produce desire anew, despite the extensive determinants imposed by the binary logic underlying the innovation. In the most baroque moments of affective engagement, it has been suggested that such platforms might also function to promote artistic manners of experimentation with displaced identification and creative forms of affective expression. While VR software is typically written so as to include relatively pre-defined sets of objects and environmental features reminiscent of already actualized worlds, such a coding schema is inevitably supportive of situations with largely varied degrees of similarity to those realities encountered only in non-computer generated environments (Cline 2005; Moreau and Fuchs 2011). And always, exceeding the digital code as such, VR users invariably have at their disposal unique bodily traces and sets of desires that can potentially alter how such worlds are organized and perceived, even by other VR users.

This indeterminacy with which the capacity of any technology can be known in advance of its implementation begins to delineate the two clearly distinct types of logic implied in the two previously discussed social practices – art and science. It can similarly help make sense of how any given technology can function both in support of the digital framework through which it was constructed and as a source for "a-signifying" points of rupture, or "ruptures in denotation, corurotation and signification – from which a certain number of semiotic chains are put to work in the service of an existential autoreferential effect" (Guattari 2008, 56). In a hypothetical universe within which an already actualized series of objects could be left to its own devices, recursion could continue unperturbed ad infinitum. However, because each and every constituted actual is complemented by relatively chaotic virtual entities, social practices as diverse as art and science can be sustained in a manner that disrupts, alters, or even serves to reinforce already actualized, recursive series of multiples. That the relationship between actuals and virtuals enfolds according to a more expansive logic than digitalization on its own allows for zones of indeterminacy to open up within which experimentation with identity, perception, and affect can produce semiotic innovations in the overlap between perceptual and linguistic fields of reality.

In an increasing number of situations around the planet, media have taken on a central role in facilitating such processes with respect to any number of technological forms. They have, in turn, been transformed into something other than a mere medium for enabling

persons to communicate with each other. At times media serve to produce discourse between bodies, while at others their construction is in fact the primary goal of action or speech. Digitalized fields of experience, such as those enacted by VR, are in many situations being participated in even more ubiquitously than are others, heralding – even demanding – new frameworks for conceiving personhood and sense of community. Take, for example, the following statement by Palmer Lucky, founder of the company Oculus VR: "I think there's a lot of potential for virtual reality in the education industry ... Classrooms are broken. Kids don't learn the best by reading books" (Dredge 2015). VR is, as such, no longer being considered to be an optional tool used strictly for entertainment or specialized training purposes; rather, it is increasingly being proposed as potentially playing a feature role in the future of how children come to learn about themselves in relation to the world. This is reminiscent of Guattari's (2008) description of a new "post-media" age, "where technologies [are positioned as] ecological techniques for the production of subjectivity [that] transform[s] the political and social context in which we live" (Bruner et al. 2013, 10).

Such a budding imperative to experience the virtual in new forms can either be represented or expressed as two alternately distinct and implicated styles of innovation: (1) as a byproduct of the function of innovation in contemporary societies organized around values of economic gains and losses, or (2) as a search for a-signifying modes of creative expression and diffusion of personal identity in light of the logic of the former. The innovative yet recursively operating binary procedures of replication inherent to digital technologies and capitalist relations alike can, in turn, be contrasted with the type of "rupture and innovation in the semiotic field" proposed by Deleuze (2005) and Guattari (2008). These latter processes of subjective production – which Deleuze and Guattari describe as a-signifying and nomadic in contrast with the static recurring logics by which capital is typically exchanged – are proposed here as harbingers of affective reconfigurations bordering on virtual and actual entities, all the while being consigned to rigorous acts of "environmentally based, embodied, and embedded symbiosis" with singular bodies and objects (Braidotti 2013, 216–17). About VR specifically, Lucky admits that "telling stories in virtual reality is very different to telling stories through traditional films or even video games" and that "it's going to be a long time until virtual reality storytelling is nearly as refined as film.

Decades" (Dredge 2015). But with such technologies gradually being pushed farther into the consciousness of the transnational economic market (Castells 2009), it is never too early to start imagining what singular forms of a-signification will be necessary when VR becomes as ubiquitous as the companies producing it certainly seem to believe it will.

Deleuze's particular articulation of the concept of "the fold" has a lot to offer us at this moment of passage, whereby the pre-programmed performance of abstract machines evolves a capacity to double back on their linear sequence of enactment so as to produce something completely unexpected and beyond their tendency to recur in a determinate manner. It is exactly in this way that "the digital reaches beyond its flat plane to connect to the human world" (Evens 2010, 147), albeit in a manner considered impossible and, in a sense, excluded from the perspectives of binary logics alone. The products of this process are never purely the effects of digital technology per se, or really *effects* at all; rather, they are in fact *quasi-causes* between which effects of discrete material collisions affect each other and produce new lines of flight in ultimately indeterminable ways (Deleuze 1987, 1994). To be clear, this is not to suggest that future events are in any sense completely unrestricted by past material conditions in terms of how or when they might come to fruition but, rather, that the precise manner through which such procedures might unfold cannot be predicted solely on the basis of previous encounters with objects and events deemed similar in nature – in short, according to an already indexed memory of chance and structure (i.e., the scientific method). Therefore, the more technologically advanced that forms of VR become, the larger the number of rules for how it should be used. But, by the same token, there will also be an ever greater indeterminate virtual capacity for it to be used in ways that subvert these very same sets of rules.

According to Deleuze (2006, 151):

The actual object and the virtual image, the object become virtual, the image actual, are all figures dealt with in elementary optics. This distinction between the virtual and the actual corresponds to the most fundamental split in time, that is to say, the differentiation of its passage into two great jets: the passing of the present, and the preservation of the past … [T]he relationship between the actual and the virtual is not the same as that established between two actuals. Actuals imply already constituted

individuals, and are ordinarily determined, whereas the relationship of the actual and the "virtual" forms must be determined case by case.

Likewise, in *Matter and Memory*, Bergson (2004) describes memory of the past as being coextensive with contemporary conscious experience without its ever exerting a linear causal force over it. This implies two important points of relevance for the current discussion on VR: (1) psychological causes are regularly subsumed by motivations to act in the present, and (2) while the past has not ceased to exist entirely, it has in a certain sense already performed its function with regard to action in the present tense (O'Sullivan 2013, 165). For these thinkers, then, the concept of the virtual represents the largely unconscious capacity for memory to serve as "a resource of sorts in the production of a specifically different kind of subjectivity," particularly one that might break up the set of habitual affective reactions that "staples us to the present and stymies access to this realm of potentiality" (166).

In Deleuze's (1986, 20) analysis of cinema, particularly Hitchcock's *Birds*, he describes each scene as "trac[ing] a [different constellation of] movement which means the things between which [the scene] arises are continuously reuniting into a whole." On even the most mundane level, movement from one shot to the next is never quite seamless in its transition, nor could it ever be, given the physical procedures by which visual images are produced through a combination of matter and light. What remains necessary for a film to work as it should, however, is not an actual continuity between shots (which would be impossible) but that the gaps in between each perspective scene remain virtually undetectable by the human eye. Altogether, this process forms what Villani (2013) terms a "disjunctive whole," or Deleuze (1986) a "fragmentary whole." The continuity of each scene or perspective is virtually holistic in that it totalizes all of its components, despite the actual individuation and distinction of each discrete shot. Cinema, as a form of art, thus has a unique capacity to produce a purely immanent engagement with the virtual, in the affective sense described above, all with the support of proto-VR technological apparatuses constructed through transcendent capitalist relations dependent on economic circulation and stimulation.

One might ask: What could possibly bring something as immanently produced as an artistic act to an end? What defines the final product of a certain act as a piece of art, for example? In Bradbury's "The

Veldt," the precise sequence of events at the end of the story is never made explicit but can only be inferred – retroactively for that matter – by a series of partial objects: the lions' roar, the children's smile, the vultures descending on two faraway corpses. But most telling here is the parents' absence from the description of the final scene, despite their children's utter lack of remorse, leaving only the psychologist in the room with them – completely horrified, as if he were looking directly at a spectral image of himself (or perhaps the dark underbelly of the Oedipal family structure become actualized before his very eyes). On one hand, the virtual reality nursery itself was not the site of this event – unless, of course, the nursery is understood solely in terms of how local quanta of electrical energy are dictated by alternating computer codes to transfer. While the death of the parents in this final scene certainly has its distinctive symbolic elements, there is no clear sense in which the act was a particularly emotionally meaningful one for the children. In fact, they are described as appearing quite unaffected by the events that ostensibly preceded it. It was, on the other hand, as though their parents' death was a purely indeterminate effect of the encounter between certain social-economic conditions and virtual desire, with the VR nursery operating in a realm of movements and actions entirely beyond those that it was programmed to produce.

The already actualized sets of rules and digital technical commands typically described as accompanying VR-like technologies could be said to have been there in the narrative the entire time, theoretically underlying the production of the scenes as such for the readers of the text. The end of the story, in this sense, isn't brought about by any sort of mechanistic action, or even by Ray Bradbury's own power; rather, it is something that must be inserted into the narrative scene by how it is taken up and read. Only by interpreting the parents as dead, for instance, or the children as *evil* or *liberated* (depending, of course, on the particular reading afforded it), does the story finally come to a close. In other words, the final outcome of the narrative is not written in by its author but occurs only in so far as the expression he laid bare can be forced into a representational framework whereby some sense of morality can be regained. While there can certainly be multiple readings of a narrative such as "The Veldt," the junction between the cultural-scientific innovation that was the VR nursery and the set of relations maintained by the family members in the story is clearly meant to indicate an event, in its purest sense. While there

is no need to infer a moral from an analysis of the story, one could certainly be one found if one wished to make a final determination on what *actually* occurred.

With respect to VR technology specifically, then, the relationship between actual object and virtual image and how the two reciprocally affect each other, especially in the way described above by Deleuze, takes on special significance and can be analyzed on multiple levels of mechanization. Exploring the temporal constitution of computer-generated objects from an intensive perspective – in addition to its extensive, digital composition – begins to highlight just how many such levels are possible; and perhaps, as Deleuze suggests above, they should only be taken up case by case. In any event, what we have with VR technologies are a set of platforms that can radically reconfigure the intensity of affect, motivation, and desire through an encounter with a predefined series of alternating digital expressions. Any given elements of a particular single image function in unison only so as to "give rise to something new, in short, to endure" (Deleuze 1986, 9). Movement in the actual instance of the image is the only constant. Any parts perceived as immobile are merely illusions of duration, regardless of their persistence in perception. But such illusions are doubtless necessary components of the object itself and can in no way be reduced to something akin to an insular moment in a diachronically ordered narrative, human or otherwise. This is because the processes whereby such virtual illusions become actualized instantaneously double back on those already actualized objects in the environment so as to construct duration in sequence with the whole of the entirely open ambiance within which they are perceived. Like nodes in an energetic field, virtual elements extend over and throughout their actual counterparts in order to communicate with each other in such a way so as to subtend their specific natures in relation to each other (Deleuze 2006).

In this sense, consciousness does not exist as a byproduct of the brain alone, in turn able to be localized somewhere within the human body; rather, it subsists in any objects experienced and in their unique configuration at any given moment in time. Even a particular brain is itself never enacted in the same state twice. Similar to the two functions of VR discussed above, through art, the brain becomes something other than it is commonly conceived according to scientific opinion or fact. No longer part of a *mechanistic* framework that carries out already formulated functions, art produces neuronal connections in

a more *machinist* manner by providing opportunities to escape molar forms of psychological capture (Deleuze and Guattari 1987). As opposed to being merely an isolated organ, or even the central processor of the nervous system, the brain here, similar to what is discussed regarding VR above, becomes a critical hinge within a network of flows of affective intensity whereby a given subject can become connected to an outside beyond the limits of any perceptual and cognitive capacities that have been utilized up until that point (Deleuze and Guattari 1994). What results at such a juncture is not a virtual reality over and against an actual one (a sort of artificial surplus) but, rather, a blurring of the line between virtual and actual dimensions, whereby a given area can be calibrated for a becoming-actualized of the virtual without prioritizing the already actualized bodies themselves. It is in this sense that the process of actualization, and not necessarily the causes or products thereof, makes possible a properly nomadic procedure of auto-poetic subjective reorganization. As suggested throughout this chapter, VR offers an especially stimulating example of thinking through such processes in relation to popularly narrated cultural conditions; on the other hand, VR is still in the beginning stages of just such a process itself and, as such, should be considered a mere placeholder for a set of technologies and generation of users yet to come.

REFERENCES

Artaud, Antonin. 1958. *The Theater and Its Double*. Trans. Mary Caroline Richards. New York: Grove.

Baudrillard, Jean. 1994. *Simulacra and Simulation*. Trans. Sheila Faria Glaser. Ann Arbor: University of Michigan Press.

Bergson, Henri. 2004. *Matter and Memory*. Mineola, NY: Courier Dover Publications.

Bradbury, Ray. 1950. *The Illustrated Man*. New York: Harper Collins.

– 2013. *Fahrenheit 451: A Novel*. New York: Simon and Schuster.

Braidotti, Rosi. 2010. "Elemental Complexity and Relational Vitality: The Relevance of Nomadic Thought for Contemporary Science." In *The Force of the Virtual: Deleuze, Science, and Philosophy*, ed. P. Gaffney, 211–28. Minneapolis: University of Minnesota Press.

Castells, Manuel. 2009. *The Information Age: Economy, Society, and Culture*. Vol. 1: *The Rise of the Network Society*. 2nd ed., new preface. Chichester, West Sussex: Wiley-Blackwell.

Cline, Mychilo Stephenson. 2005. *Power, Madness, and Immortality: The Future of Virtual Reality*. San Jose, CA: Mychilo Cline, 2005.

Cogburn, John, and Mark Silcox. 2013. "Against Brain-in-a-Vatism: On the Value of Virtual Reality." *Philosophy and Technology* 27 (4): 561–79.

Deleuze, Gilles. 1986. *Cinema 1: The Movement-Image*. 1st ed. Minneapolis: University Of Minnesota Press.

– 1990. *The Logic of Sense*. Ed. C.V. Boundas. Trans. M. Lester and C. Stivale. New York: Columbia University Press.

– 1994. *Difference and Repetition*. New York: Columbia University Press.

– 1997. *Negotiations 1972–1990*. Trans. M. Joughin. New York: Columbia University Press.

– 2005. *Pure Immanence: Essays on a Life*. 2nd ed. Cambridge, MA.: Zone Books.

– 2006. "The Actual and the Virtual." In *Dialogues II*, ed. C. Parnet and G. Deleuze, 148–59. London: Bloomsbury Academic.

Deleuze, Gilles, and Félix Guattari. 1987. *A Thousand Plateaus: Capitalism and Schizophrenia*. Trans. B. Massumi, 1st ed. Minneapolis: University of Minnesota Press.

– 1994. *What Is Philosophy?* Trans. H. Tomlinson and G. Burchell. New York: Columbia University Press.

– 2009. *Anti-Oedipus: Capitalism and Schizophrenia*. Trans. R. Hurley, M. Seem, and H. Lane. (6th printing). New York: Penguin Classics.

Dick, Phillip K. 2011. *VALIS*. Boston: Mariner Books.

Dredge, Stuart. 2015. "Oculus VR: 'Classrooms Are Broken. Kids Don't Learn Best by Reading Books.'" *Guardian*. http://www.theguardian.com/technology/2015/nov/03/oculus-vr-founder-classrooms-are-broken.

Evans, Aden. 2010. "Digital Ontology and Example." In *The Force of the Virtual: Deleuze, Science, Philosophy*, ed. P. Gaffney, 147–68. Minneapolis: Minnesota University Press.

Guattari, Félix. 2008. *The Three Ecologies*. Trans. I. Pindar and P. Sutton. London: Bloomsbury Academic.

Hayles, N. Katherine. 1990. *Chaos Bound: Orderly Disorder in Contemporary Literature and Science*. Ithaca, NY: Cornell University Press.

Hroch, Petra. 2014. "Deleuze, Guattari, and Environmental Pedagogy and Politics." In *Deleuze and Guattari, Politics and Education: For a People-Yet-to-Come*, ed. M. Carlin and J. Wallin, 51–73. New York: Bloomsbury Publishing USA.

Lewontin, Richard C. 2001. *It Ain't Necessarily So: The Dream of the Human Genome and Other Illusions*. New York: New York Review Books.

Merleau-Ponty, Maurice. 1945. *Phenomenology of Perception*. Trans. Colin Smith. London: Routledge.

Moreau, Gillaume, and Phillipe Fuchs. 2011. *Virtual Reality: Concepts and Technologies*. Boca Raton, FL: CRC Press.

Murphie, Andrew. 2005. "Putting the Virtual back into VR." In *A Shock to Thought: Expression after Deleuze and Guattari*, ed. B. Massumi, 188–214. New York: Routledge.

Negri, Antonio. 1996. "Twenty Theses on Marx." In *Marxism beyond Marxism*, ed. C. Casarino, R. Karl, and S. Makdisi, 149–80. London: Routledge.

O'Sullivan, Simon. 2013. "A Diagram of the Finite-Infinite Relation." In *Bergson and the Art of Immanence*, ed. J. Mullarkey, 165–82. Edinburgh: Edinburgh University Press.

Skott-Myhre, Hans A. 2015. "Marx, Ideology and the Unconscious." *Annual Review of Critical Psychology* 12. http://www.discourseunit.com/arcp12/08Skott.pdf.

Sparrow, Tom. 2014. *Plastic Bodies: Rebuilding Sensation after Phenomenology*. Foreword by Catherine Malabou. London: Open Humanities Press.

Spinoza, Baruch. 2000. *Ethics*. Trans. G.H.R. Parkinson. Oxford: Oxford University Press.

Villani, Arnaud. 2013. "The Insistence of the Virtual in Science and the History of Philosophy." In *The Force of the Virtual: Deleuze, Science, and Philosophy*, ed. P. Gaffney, 69–86. Minneapolis: University of Minnesota Press.

2

Playing with Fire: A Quasi-Causal Machine in Multiple (Mostly Russian) Februaries

Douglas Ord

> Pussy Riot becomes a meteorite.
> Rosi Braidotti

In a public talk of 12 May 2014 in Oslo, Norway, called "Punk Women and Riot Grrls," Professor Rosi Braidotti of Utrecht University introduced this statement: "Pussy Riot becomes a meteorite." The talk's context is described on Braidotti's website:

> On Monday May the 12th Professor Rosi Braidotti, together with American scholar Judith Butler, met the members of the punk protest band Pussy Riot in Oslo during the First Supper Symposium. The symposium, which gathered enormous attention from the press, addressed questions such as feminist performance art, the politics of protests and prisoners' rights. Other speakers were curators Viktor Misiano and Ekaterina Sharova. Pussy Riot was represented by Nadezhda Tolokonnikova and Maria Alyokhina who reflected on the context of their Punk Prayer performance ([Pussy Riot] 2012) and subsequent imprisonment. (Braidotti website)

The embedding sentences for the statement "Pussy Riot becomes a meteorite" are in the twenty-seventh minute of Braidotti's thirty-eight-minute talk.[1] A transcription reads:

In the case of Vladimir Putin, his visual illiteracy made him underestimate the extent to which the exposed faces of the previously nameless Pussy Riot protesters would turn Nadia and Maria into global icons and mega-stars. Pussy Riot becomes a meteorite. And I don't think there's anybody in the world today who does not wish to be them, to be like them. My students all ordered me to bring back 500 photos, please, or they will never finish my course. (Braidotti 2014, 28:00)

The five-word statement "Pussy Riot becomes a meteorite" was enclosed in speech – that is, by sentences that emphasized the global prevalence, in different ways, of a culture of face- and image-based celebrity: "exposed faces ... global icons and mega-stars ..." / "Pussy Riot becomes a meteorite" / "... 500 photos, please." But the statement deserves, perhaps, to escape these brackets. What is explored here is a syntax of association, via a tapestry of events and via concepts bequeathed primarily by Gilles Deleuze, writing on his own and with Félix Guattari, and in "intercession" with Claire Parnet. Braidotti has herself interpreted Deleuxe's œuvre in multiple books, towards her own "vitalist brand of materialism" (Braidotti 2013, 138). But the focus here is on a five-word statement, and on what its three terms – "Pussy Riot / becomes / a meteorite" – draw to them and put into motion when the nouns open into relation with spatio-temporal events and the verb into a concept of "becoming" as developed by Deleuze and Deleuze/Guattari.

This focus is towards venturing a more general sense of how *events* might coalesce in virtuality to make for "quasi-causal machines," with the term "quasi-cause" as introduced by Deleuze in *Logique du sens* (1969) and the term "machines" as per its profligate usage in Deleuze and Félix Guattari's *L'Anti-Œdipe* (1972). Deleuze of 1969, provides the phrase "expressive relations of events among themselves" and asserts that these need not be "relations of cause and effect" but, rather, can be approached as "an ensemble of non-causal correspondences, forming a system of echoes, of reprises, and of resonances, a system of signs, in short, an expressive quasi-causality, and not at all a necessitating causality (Deleuze 1969, 198–9). Three years later, Deleuze and Guattari (1972, 8) would begin *L'Anti-Œdipe* with some thirty-three instances of the word "machine" in the book's first three pages, culminating with the following:

All makes machine. [Tout fait machine.] Celestial machines, the stars or the rainbow, alpine machines that couple themselves/are coupled [se couplent] with those of his body. Non-stop sound [bruit ininterrompu] of machines. "He thought that it must be a sentiment of infinite beatitude to be touched by the profound life of every form, to have a soul [âme] for stones, metals, water, to gather into himself all the objects of nature, as in a dream, as the flowers absorb the air with the waxing and the waning of the moon."[2]

The quoted passage is from George Büchner's 1836 novella *Lenz*, whose translation from German into French is attributed by Deleuze and Guattari to Éditions Fontaine. As selected by them to introduce their concept of "machine," it, in its eloquence, bears keeping in mind alongside their possibly better-known relation of this concept to "libido" as "energy of production" (23).

To bring these two terms, "quasi-cause" and "machine," together to form the hybrid concept "quasi-causal machines" is to suggest a device that moves towards exploring "expressive relations of events among themselves" in their "resonances and reprises" *and* in their "energy of production," incorporating considerations not only of "libido" but also of "the profound life of every form." Here the device is brought to specifics, beginning with the events referred to most obviously in Braidotti's choice of words for her three-term statement of 12 May 2014. This mapping will then also open towards a radical interpretation of her further statement, in the same talk, to do with the commodity culture of celebrity: that "the political economy of faces actually organizes power, distributes it," with "the commodified face as a landscape of power" (Braidotti 2014). Crucial to this reread-ing will be the distinction, in French and as recognized by Deleuze and Deleuze/Guattari, between "puissance" and "pouvoir" as kinds of power.

1

By 12 May 2014, the date of Professor Braidotti's talk and of their encounter with her and Judith Butler in Oslo, Nadezhda Tolokonnikova, then twenty-four years of age, and Maria Alyokhina, then twenty-five, had been out of the Russian prison system for less than five months.

They had been released on 23 December 2013, sixteen months into two-year sentences imposed by a Moscow court in August 2012 for "hooliganism motivated by religious hatred" (Tayler 2012, 1). Their convictions derived from their having been involved in brief surprise masked musical protest performances, under the name Pussy Riot, on 19 and 21 February 2012. Each of these events involved a group of women – six in the first, and five in the second – clad in brightly coloured simple dresses and tights, and coloured balaclavas that, apart from holes cut for eyes and mouth, hid their faces. The events took place, respectively, at the Cathedral of the Epiphany at Yelokhovo in northeast Moscow on 19 February and at the Cathedral of Christ the Saviour in central Moscow on 21 February. The performances, which consisted of dancing, gesticulating, and singing/shouting lyrics, were recorded. And, central to the trial and conviction of Tolokonnikova and Alyokhina, was the group's having also spliced footage of both performances into a two-minute video that was overdubbed with a previously recorded song and uploaded to Youtube on the evening of 21 February. The song was called "Punk Prayer – Virgin Mary, Mother of God, Chase Putin Out" (Gessen 2014, 117), or, in another translation, "Virgin Birth-Giver of God, Drive Away Putin" (Tayler 2012, 1).

Details of how these performances evolved, unfolded, were recorded and disseminated, and made for consequences in the Russia of Vladimir Putin, can be found most accessibly in Masha Gessen's 2014 group-biography *Words Will Break Cement: The Passion of Pussy Riot*. Gessen's translation of the song, however, competes with multiple other versions available on the internet. Perhaps the most credibly sourced is that by Jeffrey Tayler, which appeared in *Atlantic Monthly* in November 2012. Tayler gives for the chorus translated by Gessen as "Shit, shit, holy shit!" the phrasing "Shit, shit, the Lord's shit!" (Gessen 2014, 117; Tayler 2012, 1). The latter translation seems more loyal to the percussive cadences of the sung Russian and is also less softened by the possibility of an ironic reading, given the ease with which the English term "holy shit" is used in the vernacular. But the very existence of so potential a difference in readability, according to the usual terms of sacrilege, suggests the differences of worlds that came into conflict with one another in the wake of these performances and video release via the trial of the three women who were identified and arrested: Alyokhina, Tolokonnikova, and Yekaterina Samutsevich (the latter of whom turned thirty in the course of the trial in the summer of 2012).

In the course of this trial, all three women were not only unmasked, exposing their faces, but were held in custody and obliged to sit together, week after week, in a barred cage or glass box in a Moscow courtroom while the court heard from Russians who, amid the post-communist revival of Christian Orthodoxy, took "the name of the Lord" with utmost gravity. With this resuscitation and mutation of 1930s show trial atmospherics, global media as they existed in 2012 were provided with the ongoing spectacle of three young women presented in this way, while political activists were provided with the ongoing affront of their being treated in this way. Nor can it be ignored that of the unmasked three, one of them – Tolokonnikova – proved to be, in the terms usually associated with the word as applied to women, exceptionally beautiful. When the German magazine *Der Spiegel* (2012), for example, did a cover story on the trial under the title "Putin's Russland" in the issue of 13 August 2012, the colour image that occupied most of the cover showed not the three women together but only Tolokonnikova, clad in a blue T-shirt and looking plaintively skyward from behind prison bars and with an out-of-focus pair of handcuffs in the foreground.

Notwithstanding the global attention drawn by the trial, on 17 August 2012, all three women were convicted of "hooliganism motivated by religious hatred" (Tayler 2012, 1) and given two-year prison terms. Samutsevich was then released on appeal, after a replacement lawyer successfully argued that she had been physically restrained from putting on her guitar and entering the sanctuary of Christ the Saviour Cathedral and so had not been part of the performance. Alyokhina and Tolokonnikova could mount no such defence, and, with the failure of their own appeals, were, in October 2012, sent by train to separate penal colonies hundreds of kilometres from Moscow, even though each was the mother of a young child. Alyokhina was conveyed 1,600 kilometres northeast to Berezniki in Perm Oblast on the west side of the Ural Mountains, and Tolokonnikova 500 kilometres southeast to Yavas in the Republic of Mordovia – a name that, for any *Lord of the Rings* fan, could only be remindful of Mordor. A degree of media attention followed them, and while in prison both women, with memorable courage and eloquence, challenged the casual brutalities of the Russian prison system, advocated on behalf of fellow prisoners, and engaged in hunger strikes (Harding and Verzilov 2015, 1).

Nominally, the 23 December 2013 release of both women was part of a wider amnesty declared by Putin, who, notwithstanding their

cathedral protests, had been re-elected to the Russian presidency for a third term on 6 March 2012, after a one-term cosmetic inter-regnum by Dmitri Medvedev to satisfy constitutional term limits, with Putin as prime minister. Speculation was rife in the media, however, that the early release of Russia's most famous and decidedly most photogenic prisoners was to improve his own international image as president of the host nation for the twenty-second Olympic Winter Games, scheduled to begin in Sochi on the Black Sea coast on 7 February 2014. If this was the stratagem, it can be said to have been conspicuously flawed. For between 23 December 2013, when Alyokhina and Tolokonnikova emerged from prison camps in, respectively, Perm and Mordovia, and 12 May 2014, when they appeared in Oslo, they can indeed be said to have become, as Braidotti put it, "global icons and mega-stars" in the sense that these terms have evolved in relation to media, which is to say to include faces with a high degree of recognizability and a culture of celebrity (Harding and Verilov 2015, 1; Pussy Riot 2014b, 2014c).

From shortly after their release, through January 2014, Alyokhina and Tolokonnikova appeared without disguise on TV talk shows in Russia and Western Europe and, after this, in the first week of February, on the Stephen Colbert Show (4 February) and with the singer Madonna at a benefit for Amnesty International (5 February), both in New York City (Pussy Riot 2014a). Then, shortly afterward, they returned to Moscow and, with several other women and men, travelled to Sochi, on the Black Sea, where the Winter Olympics were under way. Once there, they were initially observed by police and then detained, reportedly on suspicion of their having stolen a purse. This surprise development itself drew the attention of media who were in Sochi for the Olympics, and they were quickly released. The cascading momentum of events then accelerated when, within hours, on 18 February 2014, two years almost to the day after their first cathedral performance in Moscow, they again donned coloured balaclavas, this time along with two other women and a male guitarist. (The women were not the missing two from the cathedral performances, who were never arrested or publicly identified.) They then appeared again as Pussy Riot in Sochi, in front of a big blue display wall for the Winter Olympics against which scheduled performances, proceeding by fixed sets of rules, were taking place around them. Their performance entailed an attempt to video-record

a song called, in English, "Putin Will Teach You How to Love the Motherland," for later editing and overdubbing into a video for public distribution. This was, to an extent, a repetition of the model established in the Cathedrals of the Annunciation and Christ the Saviour on 19 and 21 February 2012, two years earlier (Ostrovsky 2014; Pussy Riot 2014d).

The confrontation that ensued and was recorded, however, did not make for favourable publicity for Putin's Russia. All of the performers, but Tolokonnikova in particular, were literally horse-whipped by a black-uniformed Cossack who rushed into the recording frame, furiously striking at everyone involved. Multiple videos exist, including Pussy Riot's own version, called "Putin Will Teach You How to Love the Motherland," released two days later on 20 February 2014 and recorded in two locations, as were the cathedral videos (Pussy Riot 2014d). In this case, continuity of background was provided by the Olympic Rings via a second, night-time location, in which they were displayed; this joined the location in front of the big blue Sochi Olympics sign that hosted the intrusion of actual violence and physical danger in an attempted Pussy Riot performance in Russia. Perhaps the most widely disseminated still image, which, for example, introduced the Vice.com report of the event, shows an unmasked Tolokonnkova, in a lavender dress, yellow tights, and work boots, lying on the pavement, grimacing in pain, with behind her the legs and boots of black-uniformed men and beside her the legs and boots, in blue tights and white skirt, of Alyokhina – also by then unmasked – who had come to help her (Ostrovsky 2014).

The Sochi performance of 18 February 2014, and the video release that closely followed it on 20 February 2014, also preceded, in this case by nearly three months, Alyokhina and Tolokonnikova's meeting with Rosi Braidotti and Judith Butler in Oslo on 12 May 2014. But there are grounds to pause over the dates of these two February 2014 events, which, in their timing, also made for a recognizable relation: that of "the anniversary," but set slightly askew. That is to say, if, rather than a specific February – that of 2012 or 2014 – these events are considered in terms of *a* February, the Sochi Pussy Riot performance date of 18 February 2014 and video release date of 20 February 2014 overlap in displaced symmetry and alternate sequence with the dates of the first Pussy Riot cathedral performance (at Yelokhovo) on 19 February 2012 and the second such performance (at Christ the

Saviour Cathedral) on 21 February 2012. The sequence of dates in *a* February looks like this:

18 February	19 February	20 February	21 February

But, in so far as a history of Pussy Riot is concerned, this sequence of dates can be linked with specific eruptive events not just in one specific year but in two, as per this table of alternating and displaced sequentiality:

18 February	19 February	20 February	21 February
2014	2012	2014	2012
Recorded performance in Sochi, disrupted by Cossacks, in conjunction with the Winter Olympics	Recorded performance in the Cathedral of the Epiphany, Yelokhovo (Moscow)	Release of the video "Putin Will Teach You (How) to Love the Motherland"	Recorded performance in the Cathedral of Christ the Saviour, Moscow, and release of the video "Mother Mary, Chase Putin Out"

This displaced but symmetrical sequentiality and contiguity in terms of *a* February may have been coincidental. That it was not, however, is suggested in the collectively written open letter that was signed "the Anonymous members of *Pussy Riot* Garadja, Fara, Shaiba, Cat, Seraphima and Schumacher" and that appeared on both the Pussy Riot blog and in the *Guardian* on 6 February 2014. This was the day after Alyokhina and Tolokonnikova appeared with the American pop star Madonna at the Amnesty International benefit concert in New York. The open letter disavowed continued association of the name "Pussy Riot" with the unmasked Alyokhina and Tolokonnikova, declaring them, on the basis of their challenges to authority while in prison, "brave human rights defenders" but identifying them with an "institutionalized advocacy" no longer "compatible with radical political statements and provocative works of art." The open letter also foregrounded an anniversary:

We demand real justice: that is, the complete abolition of the verdict and the recognition that the entire criminal case against Pussy Riot was illegitimate. We hope that justice will

be restored on 21 February, the anniversary of our teasing performance in Christ the Saviour Cathedral with the song "Mother of God, Put Putin Away." (Anonymous Members of Pussy Riot 2014)

It was after the appearance of this open letter, and just before the second anniversary of the "teasing performance" of 21 February, that Alyokhina and Tolokonnikova again appeared in balaclavas on 18 February 2014 with three other women and a male guitarist, precisely *as* Pussy Riot in Sochi, much to the chagrin of Cossacks reportedly charged with keeping public order. After having her balaclava torn off, and being horsewhipped by one of them, Tolokonnikova, while recovering in a café, declared to Simon Ostrovsky of VICE news: "Anyone can become a member of Pussy Riot, including any one of you. The only thing you have to do is be passionate about politics, make up a song, record that song, find a place, put on a mask, and perform. Anybody can be Pussy Riot" (Ostrovsky 2014 7:59). With this statement, Tolokonnikova directly contradicted "the Anonymous members of *Pussy Riot*" responsible for the letter of 6 February, whose admonishments included mention of a balaclava-clad male guitarist in publicity for the Amnesty International benefit in New York: "we are an all-female separatist collective – no man can represent us either on a poster or in reality" (Anonymous Members of Pussy Riot 2014, 1). In doing so, she also provided, in succinct terms, a "Pussy Riot" *concept*, in the sense of the word given by Deleuze and Guattari (1994, 161) in *Qu'est-ce que la philosophie?* (1991): "The concept … refers not to series of numbers but to strings of ideas that are reconnected over a lacuna (rather than linked together by continuation)." There is a lacuna between each of the ideas of condition strung together by Tolokonnikova in that there is no causal or even customarily associational connection among: being passionate about politics, making up and recording a song," "finding a place," "putting on a mask," and "performing." Tolokonnikova's concept is also striking in how it incorporates Deleuze's prioritization of the indefinite article in the 1993 essay "Ce que les enfants disent":

That which concerns the libido, that which the libido invests presents itself with (se présente avec) an indefinite article, or rather is presented by (est présenté par) the indefinite article: *an* animal as qualification of a becoming or specification of a trajectory (*a* horse, *a* chicken). (Deleuze 1993, 86)

It bears emphasizing here that "the libido," as described by Deleuze in this passage, is not to be identified with a personal unconscious bound, in Freudian terms, to childhood experience and the Oedipal triangle "daddy-mommy-me," as Deleuze and Guattari introduce the phrase in *L'AntiŒdipe* (Deleuze and Guattari 1972, 30). In keeping with the notion of a dynamic, impersonal, and autoproductive unconscious developed there, Deleuze (1993, 82), in "Ce que les enfants disent," asserts that "the mother and the father are not the coordinates of all that the unconscious invests." Rather: "It is the peculiarity of the libido to haunt history and geography, to organize formations of worlds and of constellations of the universe, to derive the continents, to people them with races, tribes, and nations … The libido has not metamorphoses but world-historical trajectories" (ibid.). Concern here is with just such trajectories. And, to highlight the prominence in Tolokonnikova's concept not only of the indefinite article "a" but also of the indefinite pronoun "any": "*Any*one can become a member of Pussy Riot, including *any* one of you. The only thing you have to do is be passionate about politics, make up *a* song, record that song, find *a* place, put on *a* mask, and perform. *Any*body can be Pussy Riot."

Yet this concept of Pussy Riot, as a stringing together of *these* ideas, says nothing about the *kind* of politics about which to be "passionate." Anyone with any knowledge of Tolokonnikova's own politics could have little doubt that they inclined towards the radical – specifically the anarchistically performative and feminist left. By way of just one example among many, in the course of the 2012 trial she described Pussy Riot as "a feminist punk group" (Lerner and Pozdorovkin 2013). However, in the extreme but widely publicized circumstances of this interview, the concept was more ambiguous, more open-ended: "the only thing you have to do is be passionate about politics."

According to Deleuze and Guattari "a concept also has a *becoming*," and "concepts are centres of vibrations" (Deleuze and Guattari 1994, 18 and 23, emphasis in original). What sort of "becoming" is implied for the concept of "Pussy Riot" in the phrase "Pussy Riot becomes a meteorite"? What sort of – dare it be asked – "vibrations"?

It was the "Anonymous members of Pussy Riot," challenging Tolokonnikova's and Alyokhina's appearance with Madonna, who brought up the matter of an anniversary: "We hope that justice will be restored on 21 February, the anniversary of our teasing performance in Christ the Saviour Cathedral with the song 'Mother of God, put

Putin away.'" And it is they who provide a reminder, precisely with this association of "hope" with *an* anniversary, that anniversaries, as cyclical repetitions of the same, but with each year different, are widely considered to have *sense* of some kind.

2

With this in mind, we now travel incorporeally to on or about 20 October 2012 when, after confirmation by a Moscow appeals court of their 17 August two-year sentence, Maria Alyokhina and Nadezhda Tolokonnikova were "transported" to separate penal colonies to the east of Moscow. Alyokhina went to a penal colony near Berezniki, known for gypsum mines and giant sinkholes, in the Oblast of Perm some sixteen hundred kilometres east northeast of Moscow, on the western edge of the Ural Mountains. Tolokonnikova went to Yavas, Republic of Mordovia, some five hundred kilometressoutheast of Moscow. With these voyages, they entered the time and space of the Russian penal system. They did so as Pussy Riot. They had become the faces of Pussy Riot. They were suffering, as Pussy Riot, for having been and continuing to be Pussy Riot.

According to Google Maps, these trans-shipments put them, by road, 1,545 kilometres from one another in a Russian state. Neither president Vladimiar Putin nor Patriarch Kirill of the Russian Orthodox Church had been affected by the protest of Pussy Riot's song.

From what we might call our own quasi-causal machine, we can view a spatial relation across a surface (with Google Maps screen captures reproduced for non-profit study). A satellite map shows Moscow (the pink A), Yavas in Mordovia (Tolokonnikova, the green A), and Berezniki in Perm Oblast (Alyokhina, the green B), across an expanse of Russian territory that neither Napoleon in 1812 nor the German armies of Adolf Hitler in 1941 ever reached (see figure 1).

Four months after the transfer of Alyokhina and Tolokonnikova to these locations, on the morning of 15 February 2013, an entirely unpredicted and unrepeatable event took place in this same hinterland, above the Russian city of Chelyabinsk, on the east side of the Ural Mountains and north of the border with Kazakhstan.

An asteroidal meteor, also referred to in surprised global media as a meteorite, and among astronomers as a super-bolide, exploded in the sky twenty kilometres above the city with a blinding fireball and

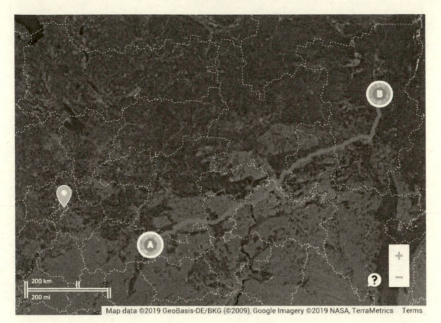

Figure 1 Satellite image of the route between Yavas in Mordovia, where Nadezhda Tolokonnikova was held ("A"), and Berezniki in Perm, where Maria Alyokhina was held ("B"), with the location of Moscow (at left) for reference.

a shock wave. References to this event are legion on the internet. Russian English-language press continues to describe it in terms of a "meteorite," as in this 3 November 2014 article at R T *Question More*: "When a *meteorite exploded* in the skies above the Russian city of Chelyabinsk in February 2013, the energy of the explosion was estimated to be equivalent to 300–500 kilotons of T N T" (R T 2014, emphasis added). Strictly speaking, it would seem that "a meteorite" is the physicality – the body or corporeal dimension – of the event of a meteoritic fireball.

This event was widely recorded via the dashboard cameras then popular in Russia. Perhaps the most widely distributed image from among these recordings was a capture from a video made by Aleksandr Ivanov and later made available to Wikipedia. Slow-motion viewing of the video indicates that, in fact, the screen capture most widely circulated did not record the instant of maximum light burst of "the meteorite" within the second of 09:20:30 local time (according to Ivanov's dash-cam), as shown below. The windscreen opened towards the south near the Central Square of the city of Kamensk-Uralski,

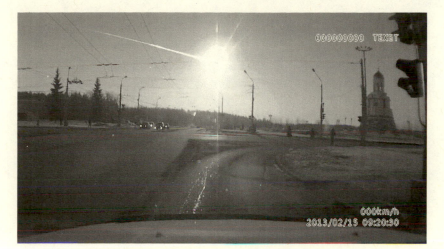

Figure 2 The Chelyabinsk meteor at maximum illumination, 15 February 2013, as photographed from Kamensk-Uralski.

approximately two hundred kilometres north of Chelyabinsk, above which the "asteroidal meteor" exploded (see figure 2). The building illuminated instantaneously at right, in the Central Square of Kamensk-Uralski, is the Russian Orthodox Alexander Nevsky Chapel, consecrated in 2001.

Chelyabinsk was described in media as "about 1500 kilometers (930 miles) east of Moscow." Google gives the driving distance between Moscow and Chelyabinsk as 1,771 kilometres. The website of the Governor and Government of the Chelyabinsk Region informs a curious reader that, "after the Trans-Siberian Railway construction (1891–1916), Chelyabinsk region became the largest transportation centre linking central Russia, the Urals and Siberia into an integral whole." It produced tanks for the Soviet Army in the Second World War, becoming known as "Tankograd" (Chelyabinsk).

The Russian Orthodox church in Kamensk-Uralski, as shown in the Ivanov image, was clearly not damaged physically by the meteoritic fireball of 15 February 2013. It was, however, intensely illuminated, for an instant, from a physical outside, in such a way that this singular instant in time – this Aiôn, to use the Stoic term that Deleuze (1969, 193) uses to refer to an activated surface of incorporeal events and sense – could be recorded.

Much the same can be said, with some degree of difference, of two other Russian Orthodox churches almost exactly one year earlier, on

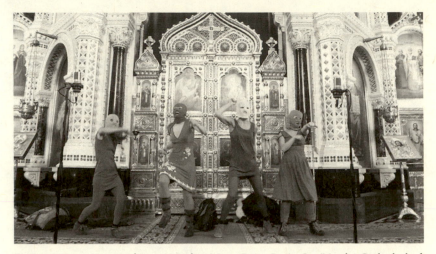

Figure 3 Pussy Riot performs "Mother Mary, Drive Putin Out" in the Cathedral of Christ the Saviour in Moscow, 21 February 2012.

19 and 21 February 2012, when Pussy Riot, then anonymous, performed very briefly in the Cathedrals of the Epiphany in Yelokhovo (on the nineteenth) and the Cathedral of Christ the Saviour in central Moscow (on the twenty-first). Both churches, in the intercut fragments that provide the visual complement to "A Punk Prayer," are physically illuminated from inside via flashlit cameras present for each performance. But, rather than showing a Russian Orthodox church from outside (as in the Ivanov meteorite video), the fragments that comprised the Pussy Riot video showed *an* outside – an extreme outside – that had made its way inside, in such a way that (as with the Ivanov video of a year later) a recorded instant can be extracted from a recorded continuity. But, unlike the Ivanov image above, which shows the instant of the meteorite's maximum explosion, the still from "Mother Mary, Drive Putin Out" is simply extracted from a continuity that shows two locations, each with gilded iconography, whose gilding reflects intensely gold, in the light of an electronic flash (see figure 3).

The Cathedral of Christ the Saviour in Moscow was no more physically damaged in the course of the event and illumination that made for the image in figure 3 than would be the Chapel of Alexander Nevsky by the event and illumination that would make for the Ivanov image a year later (see figures 4 and 5).

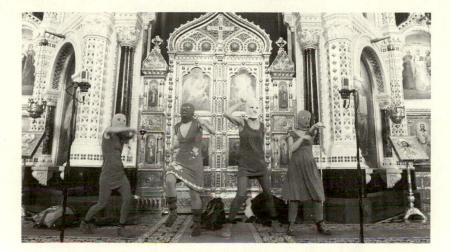

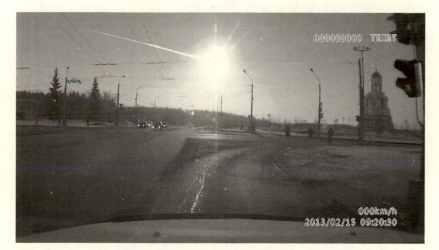

Figure 4 and 5 The images juxtaposed.

In *Logique du sens*, Deleuze (1969, 126) writes: "the surface is the zone (le lieu) of sense: signs remain deprived of sense insofar as they do not enter into the organization of surface that assures the resonance between two series (two image-signs, two photos, two trails, etc.)." Clearly there is a *sense* in which Pussy Riot does indeed *become* a meteorite, precisely in this "organization of surface that assures the resonance between … [*these*] two image-signs" as they are joined, in

the associational series specific to each, by what Deleuze calls "a paradoxical element or quasi-cause" (196). Here this might be described in terms of a repetition with difference across two successive (Russian) mid-Februaries, spinning an associational network of contiguities and resemblances (though without causality). The earth appears to shake between the two images, of 21 February 2012 above, and 15 February 2013 below. Orthodox Christian iconography and sacralization of space are in both cases illuminated: from an architectural inside in the image above and from an architectural outside in the image below. There are also two prominent parts to each image, and, in each case, one of these parts shows this Christian sacralization of space. The "other part" consists, in the image above, of Pussy Riot as anonymous: as prior to the unmasking of two of them, and the beginning of the very public drama of Nadya and Masha, and as prior also to the concept of Pussy Riot that would be voiced by Tolokonnikova on 18 February 2014. The "other part" consists, in the image below, of a meteorite: exploding in the earth's atmosphere at the instant of its maximum luminescence.

These relations of resonance across a narrow time frame within *a* February, as extended over three specific Februaries – from the 15th as the date of the Chelyabinsk meteorite in 2013 to the 21st as the date of the second Pussy Riot Moscow cathedral performance of 2012, with between them the dates not only of the first cathedral performance in 2012 but also the dates of both performances at the Sochi Olympics in 2014 – provide the constituting terms of a quasi-causal machine. But, given Deleuze and Guattari's statement in *L'Anti-Œdipe*, "Tout fait machine," it might just as easily be suggested that these relations are viewed here precisely from within a quasi-causal machine.

3

In the Oslo talk of 12 May 2014 in which the statement "Pussy Riot becomes a meteorite" appears, Braidotti also says of the commodity culture of celebrity that "the political economy of faces actually organizes power, distributes it," with "the commodified face as a landscape of power." This talk was given in English, so there was not the latitude, as there would have been in French, for her to distinguish, as Deleuze alone and with Guattari and Claire Parnet do in their texts, between

the kinds of power that, in French, can be distinguished by the words "pouvoir" and "puissance." Thus, Deleuze could write of power as "pouvoir" *in relation to thought* in the 1977 *Dialogues* with Parnet:

> The history of philosophy has always been the agent of power (pouvoir) within philosophy, and likewise in thought. It has played the role of repressor: how can you wish to think without having read Plato, Descartes, Kant, and Heidegger, and the book by so and so about them? ... An image of thought, called philosophy, is constituted historically, which perfectly prevents people from thinking. (Deleuze and Parnet 1996, 19, with the word "image" uncapitalized in the French; see Deleuze 1977, 13 for the translation)

Deleuze (1968, 172) has already, in *Différence et répétition*, conjoined such an "image of thought" with the words "dogmatic, orthodox, moral." In her own text in response to Deleuze's, in which he names the history of philosophy as "an agent of power (pouvoir)," Parnet explicitly describes as a "theme" in Deleuze's œuvre "an image of thought which prevents thought, which prevents the exercise of thought." This she presents, with no objection from Deleuze, in terms of "an organization that effectively trains thought to operate according to the norms of an established order or power, and moreover, installs in it an apparatus of power, sets it up as an apparatus of power itself" (Deleuze and Parnet 1996, 31). Each appearance of the word "power" in French in this passage is given as "pouvoir." Daniela Voss has memorably described this dogmatic image of thought in terms of "a specific machinery *coding* thoughts in accordance with some normative form" (Voss 2013b, 13, emphasis in original; see also Voss 2013a, 19).

Of his own preferences, Deleuze writes in the same exchange with Parnet:

> But I liked writers (auteurs) who seemed to be a part of the history of philosophy, but who escaped from it in one way or altogether: Lucretius, Spinoza, Hume, Nietzsche, Bergson. Of course every history of philosophy has its chapter on empiricism: Locke and Berkeley have their place there, but in Hume there is something very strange (très bizarre) which completely displaces

empiricism, giving it a new power (*une puissance nouvelle*), a theory and practice of relations, of the AND ... which remains underground or marginal in relation to the great classifications. (Deleuze and Parnet 1996, 14–15)

Deleuze here connects "a displaced empiricism" with "a new power," where the French for "power" is "puissance." The distinction is lost in the dual-service English word "power," with which both "pouvoir" and "puissance" tend to be translated (including in the standard translation of *Dialogues* by Hugh Tomlinson and Barbara Habberjam). It is thus understandable that an English-language reader could get confused. Deleuze also links this "new power/puissance nouvelle" with "a theory and practice of relations, of the AND" (Deleuze and Parnet 1996, 16).

Worth noting here, too, is that Deleuze introduces this formulation – "puissance nouvelle" / "theory and practice of relations, of the AND" – in the context of his foregrounding Hume: "il y a chez Hume quelque chose de très bizarre" (Deleuze and Parnet 1996, 21). It is Hume of the 1739 *Treatise of Human Nature* who names three "principles of association of ideas": not only "cause and effect" but also "resemblance" and "contiguity of time or place" (Hume 1969 58). And it is Deleuze of 1953 who reminds us, in *Empirisme et subjectivité* (his own early book on Hume) that "associations are vague, but in this sense that they are particular and vary with the circumstances. The imagination reveals itself (*se révèle*) as a veritable production of extremely diverse models ... This does not signify that the imagination in its essence is active, but only that it rings, that it resonates" (Deleuze 1953, 39).

Given the context in which the references to "power" appear in Braidotti's statement that "the political economy of faces actually organizes power, distributes it," and in her equation of "the commodified face" with "a landscape of power," it seems likely that, had she been giving the talk in French, she would have used "pouvoir." For she was speaking of the circulation of iconic faces via screens in commodity capitalist societies, where inequities not only in celebrity but also in material wealth, political influence, and control over surveillance form a wide gulf. Thus she also says: "The political function of faces enters a new phase of intensity when these faces become hyper-mediated. Visualization today is the ultimate form of success, control, and commodification." With this she could add an edge of

ambiguity to the statement that directly precedes the assertion "Pussy Riot becomes a meteorite": "the exposed faces of the previously nameless Pussy Riot protesters would turn Nadia and Maria into global icons and mega-stars." She might have emphasized that "Nadia and Maria" had also previously, in the video released on 21 February 2012, been faceless as well as nameless: they had been impersonal, *an* outside, indefinite.

In "Ce que les enfants disent" / "What Children Say" (1993), Deleuze affirms direct linkage among "the indefinite," "an impersonal," "puissance," and "becoming": "the indefinite lacks nothing, least of all determination. It is the determination of becoming, its own power (sa puissance propre), the power of an impersonal that is not a generality, but a singularity at highest point" (Deleuze 1993, 86). The performances that produced the video "A Punk Prayer – Mother Mary Chase Putin Out" made also for "an impersonal that [was] not a generality, but a singularity at highest point": hence the viability of a single excerpted "image-sign" from the video as expressing *a sense* of the entire series. This same phrase can be applied to the Chelyabinsk meteorite of 15 February 2013 in relation to its series, which includes all reportage on it, and all images of it, as they circulate in virtuality.

There was no demonstrable causal relation between the two series "Pussy Riot" and "a meteorite" as also *events*. Braidotti, however, made the announcement in Oslo on 12 May 2014 that she *in some sense recognized a relation* – resemblance? contiguity? – precisely via the statement: "Pussy Riot becomes a meteorite." In doing so she herself provided – the suggestion can be made – a "paradoxical element or quasi-cause" that cuts across or traverses (parcourt) two series, intervening as non-sense – "Pussy Riot becomes a meteorite" – and sets them resonating (Deleuze 1969 83, 116, 196). "We do not seek in Freud," Deleuze writes in *Logique du sens*, "an explorer of human depth and of original sense, but the prodigious discoverer of the machinery of the unconscious, through which sense is produced, always produced, as a function of nonsense[4]"(90). The footnote "4" in this case appears in Deleuze's text, and it refers to a conceptual comment to be found in one of his occasionally obscure (or "minor") sources: in this case J.-P. Osier's Preface to Feuerbach's *Essence of Christianity* as published in French in 1968. Deleuze attributes to Osier a peculiarly elegant distinction, which a reader of the English translation is likely to miss because the footnote does not appear in smaller print at the bottom of the same page, as in French, but in

distant endnotes. "Osier estimates," Deleuze tells his reader in small print, "that the problem of interpretation does not consist at all in passing from the 'derived' to the 'original,' but in understanding mechanisms of production of sense (les mécanismes de production du sens) in two series: sense is always 'effect'" (Deleuze 1968, 90; 1990, 341).

We have here "two series": "not relations of cause and effect, but an ensemble of non-causal correspondences, forming a system of echoes, of reprises, and of resonances, a system of signs, in short, an expressive quasi-causality, and not at all a necessitating causality" (Deleuze 1969, 199). What "effect," as "the zone (lieu) of a quasi-cause," do they have, recalling also that, according to Deleuze of *Logique du sens*, "signs remain deprived of sense insofar as they do not enter into the organization of surface that assures the resonance between two series (two image-signs, two photos, two trails, etc)" (150, 126)? We are reminded here also of Deleuze's insistence that "sense" is, in French "une doubleur": a word of multiple meanings that can translate as "understudy" but that is given in the Mark Lester/ Charles Stivale translation as "a doubling up" (Deleuze 1969, 151; 1991, 125). "Sense," Deleuze tells us, "presents itself/is presented [we note the ambiguity of the French reflexive pronoun "se présente"] at once as that which happens to bodies and that which insists in propositions" (Deleuze 1969, 151).

4

To begin to play, then, with this "ensemble of non-causal correspondences" in two series, in its generative non-sense and insistence: the asteroidal meteor that exploded above Chelyabinsk at 09:20:30 local time on 15 February 2013 was, because of its trail in relation to the sunrise, initially deemed to have had a north-south trajectory. Multiple trajectory models of the descent path, put together by Stefan Geens (2013), can be seen at ogleearth.com. These suggest that, broadly speaking, the trajectory appears to have been more from east to west. But whether from north to south or east to west, this very ambiguity plays towards another north-south, east-west relation in the same vicinity that suggests a different reading of the ambiguity in Professor Braidotti's use of the word "power," in a statement and an equation, in the talk given on 12 May 2014. The statement is: "the political economy of faces actually organizes power, distributes it." The

equation is: "the commodified face as a landscape of power." The shift in reading of the word "power" is from "pouvoir" to "puissance."

In "Ce que les enfants disent," published in 1993 two years before his corporeal dissolution, textual Deleuze considers maps in relation to two famous cases in psychoanalysis: Sigmund Freud's "Little Hans" and Melanie Klein's "Little Richard." Both little boys liked to draw maps, and Deleuze disputes the psychoanalytic tendency to see these in terms of a child's relationship with his or her parents. He extrapolates to assert that "a cartographic conception is very distinct from the archaeological conceptions of psychoanalysis" and that "maps must not be understood only in extension, by relation to a space constituted of trajectories. There are also maps of intensity" (Deleuze 1993, 83–4). Let us consider the adaptations of the map in Section 3 above in these terms, re-entering, as we do, our quasi-causal machine and focusing the map in time as well as in space (see figure 6).

This provides a reminder that, also residing in approximate north-south relation to the site of the explosion of the meteorite above Chelyabinsk on 15 February 2013, was one of the members of Pussy Riot who had been unmasked and punished and had become a name and face for global media. The green "A" gives the location of Berezniki in Perm Oblast on the west side of the Ural Mountains, where Maria Alyokhina was then in a penal colony set among potash mines and giant sinkholes. The image of her face, which by then had been seen around the world from many angles, shows her on 16 January 2013, a month before the meteorite, at a hearing in Berezniki, when she learned that her appeal for postponed imprisonment (so she could be with her small son) had been rejected. Shown at the other antipode of the particular zig-zag on the surface map above, at "B," is the site of Chelyabinsk, on the east side of the Urals, with a reminder of the intensity and singularity of the meteorite "at highest point": its maximum illumination. The distance by road from Berezniki to Chelyabinsk is given as 722 kilometres.

In *L'Abécédaire de Gilles Deleuze*, the eight-hour series of video "intercessions" that Claire Parnet made with Deleuze in 1988–89 and that is built thematically around letters of the alphabet, the concluding episode is titled "Z pour zig-zag." Deleuze was by then showing the symptoms of incurable emphysema. In image he is very thin, and his voice is strained and rasping: this has been hard work. Yet he smiles, providing a reminder, as throughout, that an upper right tooth

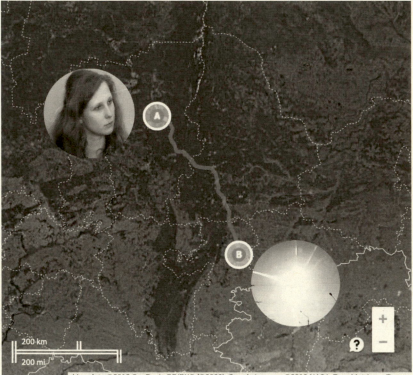

Figure 6 Satellite image of the route between Berezniki ("A") and Chelyabinsk
("B"), with Maria Alyokhina as photographed on 16 January 2013, and the
Chelyabinsk meteor as photographed at maximum illumination.

is missing. He accepts Parnet's invitation to elaborate, looks into the
camera with obvious enthusiasm, and says (in literal translation):

> Zed, but yes, it is a great letter, since it helps us rejoin "A," the fly,
> the zed of the fly, the zed-zed, the zig-zag of the fly, the zig-zag,
> the Zed, it's the last word. There is no word after the zig-zag. It is
> good to end on this word. (Deleuze and Parnet 1988 III 2:22:32)

It is in these terms that he describes "le zig-zag": as "the zig-zag of
the fly." Which is to say: a random and unpredictable movement event
that nevertheless presents a pattern – with the paradox that this pat-
tern is unrepeatable in its exactitude, repeating each time with differ-
ence. He then muses: "Alors, qu'est-ce qui se passe, en fait, en Zed?

Zen c'est l'invers du Nez, qui est aussi un zig-zag [So, what happens, in fact, in Zed? Zen is the reverse of Nez (nose), that is also a zig-zag]"). While speaking these words, he makes a gesture with his index finger that resembles both a "Z" (from his perspective) and a nose, recapitulating, as he does, the efficacy of resemblance as a "principle of association of ideas." He muses again, repeating the gesture more slowly four seconds later as he asks: "Qu'est-ce que c'est, que ça [What is that about]?" He then replies to his own question, first covering his eyes, and then uncovering them with a look of astonishment: "C'est peut-être le mouvement élémentaire, c'est peut-être le mouvement qui a présidé à la création du monde [It is perhaps the elementary movement, perhaps the movement that presided at the creation of the world]."

Also residing in relation to Chelyabinsk itself at the time of the fireball, but in east-west trajectory rather than north-south, was the other unmasked and imprisoned member of Pussy Riot, Nadezhda Tolokonnikova, at Yavas in Mordovia southeast of Moscow (see figure 7). On the map she is shown in the Yavas penal colony, via a photograph made over the winter of 2012–13. The meteorite is shown again in its instant of highest intensity. "A" indicates Chelyabinsk, and "B" the location of Yavas in Mordovia. AB, along a more curvilinear (incorporeal) zig-zag, is 1,438 kilometres by road.

Eight days after the meteoritic fireball, on 23 February 2013, Nadezhda Tolokonnikova sent a letter of reply from prison to the Slovenian philosopher, and sometime commentator on Deleuze, Slavoj Žižek, who had written to her on 2 January. Her letter, as published in the *Guardian*, reads in part:

Borrowing Nietzsche's definition, we are the children of
Dionysus, sailing in a barrel and not recognising any authority.
We are a part of this force that has no final answers or absolute
truths, for our mission is to question. There are architects of
apollonian statics and there are (punk) singers of dynamics
and transformation. One is not better than the other. But it is
only together that we can ensure the world functions in the way
Heraclitus defined it: "This world has been and will eternally
be living on the rhythm of fire, inflaming according to the
measure, and dying away according to the measure. This is the
functioning of the eternal world breath." (Tolokonnikova and
Žižek 2013)

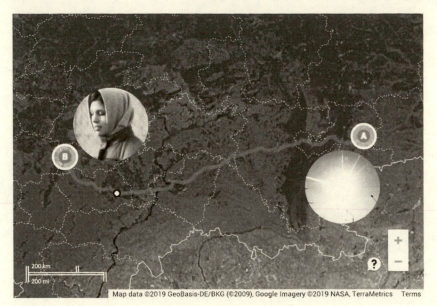

Figure 7 Satellite image of the route between Yavas ("B") and Chelyabinsk ("A"), with Nadezhda Tolokonnikova as photographed during the winter of 2012–13, and the Chelyabinsk meteor as photographed at maximum illumination.

Presumably, by 23 February 2013, as this letter's date, she had heard about the fireball above Chelyabinsk eight days before. Did this inform her choice of imagery in the letter to Žižek?

"This world has been and will eternally be living on the rhythm of fire … [see figure 8]

… inflaming according to the measure … [see figure 9]

… and dying away according to the measure. [see figure 10]

This is the functioning of the eternal world breath." [see figure 11]

Tolokonnikova's invocation, in two short paragraphs, of Nietzsche, "the children of Dionysus," and Heraclitus directly recalls, as though

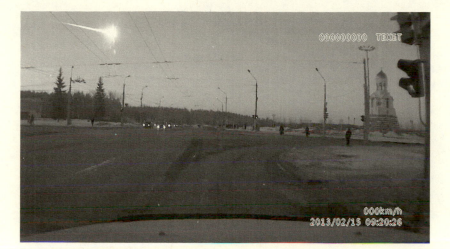

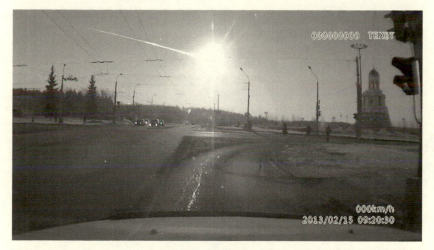

Figures 8, 9 (*above*), 10, 11 (*over*) The Chelyabinsk meteor, seen from Kamensk-Uralski, in phases of its brightening and fading.

interwoven with them, two passages from Deleuze's *Nietzsche et la philosophie* (1962) that deserve to be quoted. First on "becoming" and affirmation:

To affirm becoming, to affirm the being of becoming, are the two moments of a game, which composes itself [qui se compose] with a third term, the player, the artist, or the child. The player-artist-child, Zeus-child: Dionysos, whom myth presents to us surrounded by his divine toys ... In this game of becoming, it is

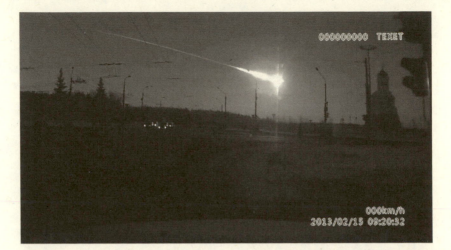

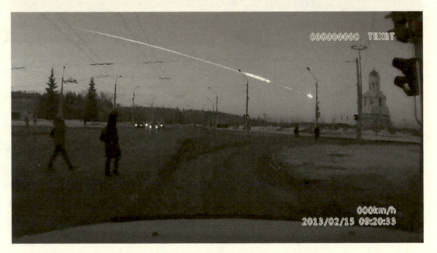

just as well the being of becoming that plays the game with itself:
time [Aiôn] says Heraclitus, is a child who plays, who plays at
draughts [qui joue au palet]. (Deleuze 2014, 38)

And:

This game of images chaos-fire-constellation resembles all the
elements of the myth of Dionysos. Or rather these images form
the game that is exactly Dionysian … The machine to affirm
chance, to make chance cook, to compose the number that brings
back the dice throw, the machine to activate (*à déclencher*) the

immense forces beneath multiple little promptings, the machine
to play with the stars, in short, the Heraclitean fire machine.
(Deleuze 2014, 48)

Deleuze, on the same page of *Nietzsche et la philosophie,* also gives
the following as among the reasons Nietzsche chose the personage
of Zarathustra for his poem *Also spache Zarathustra*: "The third
reason, retrospective but alone sufficient, is the beautiful reason of
chance: 'Today I learned by chance what Zarathustra signifies, namely
star of gold. This chance [ce hasard] enchants me" (Letter to Gast,
20 May 1883).

What "beautiful reason of chance" might be in play here, in rela-
tion to the particular "star of gold" that exploded over Chelyabinsk
on 15 February 2014? What scale of "game of images chaos-fire-
constellation"? What "machine to unlock the immense forces beneath
multiple little promptings"?

The map of zig-zag incorporeal trajectories and singularity-
intensities below, as viewed from within our quasi-causal machine,
can introduce an "abécédaire" of post-anonymous Pussy Riot: Masha
and Nadya *and* "a meteorite" (see figure 12). In presenting this map,
we keep in mind Braidotti's statement "the political economy of faces
actually organizes power, distributes it," and her equation "the com-
modified face as a landscape of power." But we do so thinking "power"
as an immanence of "puissance" rather than as "pouvoir." We do so
recalling Deleuze's phrase in *Nietzsche et la philosophie*: "This game
of images chaos-fire-constellation."

The points A-B-C invite contemplation and, in being contemplated,
also invite an experiment. They can be joined, across this surface of
a satellite map, by cartographic straight lines that reside in virtuality:
real but not actual, as Deleuze of 1968 introduces this vocabulary in
Différence et répétition (Deleuze 1968, 269). When actualized across
this surface, they look like (see figure 13).

What we discover, with the point-to-point lines forming *a constel-
lation* in this way, is that the spatial relation Berezniki (A) – Chelyabinsk
(B) – Yavas (C) makes for the appearance, on this same surface, of
not just any triangle, such as resides implicitly in any three points
not on a straight line. Rather, it makes for an especially harmonious
geometrical form: a right-angle, or Pythagorean, triangle, with its
ninety-degree vertex at Berezniki, as the site of Maria Alyokhina's
imprisonment and 16 January 2013 hearing, as pictured. A Pythagorean
triangle is also plausibly the most generative form in mathematics,

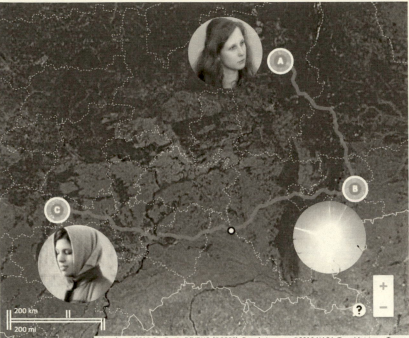

Figure 12 The routes joined at Chelyabinsk.

serving as the basis for trigonometry and for trigonometric functions
– sine / cosine / tangent ; secant / cosecant / cotangent – and all the
applications that follow from these, including in differential and
integral calculus. To recall Deleuze's phrasing in *Nietzsche et la phi-
losophie*: if there exists a mathematical "machine to activate (*à
déclencher*) the immense forces beneath multiple little promptings,"
this might well be said to be the Pythagorean triangle in its relation
to differential calculus. Such right-angle triangles were considered by
Plato, in the late dialogue *Timaeus*, "to be the original elements of
fire and the other bodies" (Plato 1961, 1180, *Timaeus* 54d).

Such is the surprise elegant harmony of this relation: this "and …
and … and," that inhabited – as Deleuze (1993, 83) quotes Barbara
Glowczewski's *Du rêve à la loi chez les Aborigènes* in "Ce que les
enfants disent" – "an immense cut of space and of time that it is
necessary to read as a map."

Pussy Riot, in this sense, also *becomes* a meteorite. A meteorite
becomes Pussy Riot. They *become* one another – what Deleuze calls
"a double capture" (Deleuze and Parnet 1996, 8) – in this case also

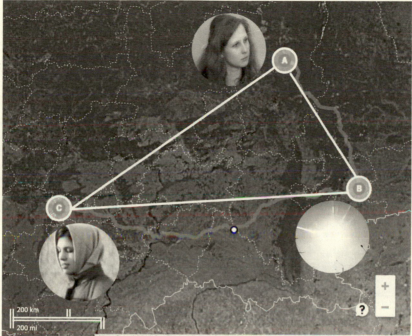

Figure 13 The points joined by cartographic straight lines.

carrying one another into imaginative relation with the entire range of applicable mathematics.

What is to be made of this icono-geometric running of lines across time and space, this circulatory system, this constellation, this structure of resonance, this "sense out of non-sense," and zig-zag on the statements "Pussy Riot becomes a meteorite" and "the political economy of faces actually organizes power, distributes it," with "power" read not as as "pouvoir" but as "puissance"? An attempt to draw "meaning" from this relation would be presumptuous. But it can be asked: Did Gilles Deleuze ever commit to text a more eloquently simple yet resonant a paradox than "la belle raison du hasard" / "the beautiful reason of chance"?

5

Thus we have, in terms of *a* February, a series of dates that stand out in the Pussy Riot / meteorite relations as distributed over three Februaries. That is:

15	16	17	18	19	20	21
2013			2014	2012	2014	2012

To recapitulate: 19 and 21 February 2012 were the dates of the Cathedral performances in Moscow, with the 21st also the date of video distribution of "A Punk Prayer – Mother Mary Chase Putin Out"; 15 February 2013 was the date of the Chelyabinsk meteorite; and 18 and 20 February 2014 were, respectively, the dates of the Pussy Riot performance at Sochi and the release of the video "Putin Will Teach You to Love the Motherland."

But there is also a necessary addition.

Indeed, several additions could be made in relation to all of the above: shadow series that run in resonance with the five events, and three groupings of events (cited above) and in the same Februaries. These include as primary:

- on 10 and 11 February 2012, at Olimpiyskiy Stadium in northern Moscow within kilometres of the two cathedrals where Pussy Riot would perform just over a week later, two scheduled and highly ritualized performances by the German Neue Deutsche Härte band Rammstein, each of which deployed pyrotechnics (fire) in copious amounts, and ended with songs titled, in succession, "Pussy" and "Moscow";[3]
- on 15 February 2013, the same date as the unpredicted explosion of "the Chelyabinsk meteorite," the passage at record proximity to the earth of a much larger asteroid whose path had been predicted and anticipated, and that was given the provisional name 2012 DA14, later changed officially to 367943 Duende: remindful of a lecture given in Buenos Aires in 1933 called "Theory and Play of the Duende" by the Spanish playwright Gabriel Garcia Lorca; and
- on 18 and 20 February 2014, the dates of the Pussy Riot performance and video release in Sochi, the escalation into murderous but decisive violence of the Maidan pro-democracy protests in Kiev, Ukraine.

These relations can only be alluded to here. But at this point in February 2014, new February dates pushed forward into global media prominence. On 22 February, after a brief truce in Kiev, the

Russian-backed president of Ukraine, Victor Yanukovich, fled the city, and "the Maidan Revolution" was proclaimed triumphant, after some eighty people were killed just two days earlier. The following day, 23 February, the Sochi Olympics, so avidly sponsored by Vladimir Putin as a showcase to the world, came to an end. That same day, Victor Yanukovich was reported to be in the city of Balaclava on the Crimean Peninsula. He then vanished.

Three days later, on 27 February 2014, a previously unseen phenomenon began to manifest in this same Crimea, then a part of Ukraine. Green-uniformed soldiers, helmeted, bearing sophisticated weapons, but with no insignia and with their faces hidden by balaclavas in one colour – black – began appearing at key sites around the peninsula, including Ukrainian military installations. "The little green men," as they were widely called, proved to be Russian Special Forces (Spetsnaz), and their presence was the first stage of a piecemeal Russian invasion that would finesse a Russian military takeover of the peninsula with almost no bloodshed when Ukraine withdrew. This was followed by a referendum overseen by the Russian government less than a month later on 16 March 2014 and the annexation of Crimea by the Russia of Vladimir Putin (BBC News 2015).

The appearance of "the little green men" in black balaclavas on 27 February 2014 established a symmetry in the series of events in *a* February as shown below, with (1) 15 February as the date in 2013 of both the unpredicted Chelyabinsk meteorite and the predicted asteroidal meteor Duende; (2) 21 February as the date in 2012 when Pussy Riot most prominently and controversially donned identity-obscuring balaclavas for their performance in the Cathedral of Christ the Saviour in Moscow; and (3) 27 February as the date in 2014 when, under the ultimate authority and direction of Vladimir Putin, balaclava-clad Russian troops without insignia began to occupy Crimea.

15	16	17	18	19	20	21	22	23	24	25	26	27

It will be recalled that Professor Braidotti, in her talk of 12 May 2014, introduced the following sentence directly prior to the statement "Pussy Riot becomes a meteorite" with reference to Vladimir Putin: "In the case of Vladimir Putin, his visual illiteracy made him underestimate the extent to which the exposed faces of the previously nameless Pussy Riot protesters would turn Nadia and Maria into

global icons and mega-stars. Pussy Riot becomes a meteorite." We also recall Nadeszhda Tolokonnikova's succinct and eminently neutral conceptualization of the term "Pussy Riot" after she and her colleagues had been attacked by Cossacks on 18 February 2014 in Sochi: "Anyone can become a member of Pussy Riot, including any one of you. The only thing you have to do is be passionate about politics, make up a song, record that song, find a place, put on a mask, and perform. Anybody can be Pussy Riot" (Ostrovsky 2014, 7:59–8:13).

The invasion of Crimea was initiated and secured by balaclava-clad "little green men" whose individualities and unit affiliations were hidden; who were nameless and faceless; who were impersonal; and who invaded a place whose boundaries were considered by some to be sacrosanct. Whatever else this tactic suggests in so proximate a temporal relation to the actions and prominence of Pussy Riot – whose individualities were hidden; who were nameless and faceless; who were impersonal; and who invaded a place whose boundaries were considered by some to be sacrosanct – it does not suggest "visual illiteracy" on the part of its originator or originators. The invasion of Crimea in late February 2014 as a geopolitical fait accompli was stunningly successful and suggests, at the very least, a partial appropriation and *détournement* of the Pussy Riot concept as articulated in neutral terms by Tolokonnikova on 18 February 2014. Pussy Riot (as concept) also includes on its plane of consistency, and becomes, "little green men," who were highly political in the implications of their acts; whose "song" proved to be the Russian national anthem; whose found "place" proved to be Crimea; and whose "performance" was the incremental takeover of the peninsula.

"It is the peculiarity of the libido," as Deleuze (1993, 82) describes it in "Ce que les enfants disent," "to haunt history and geography, to organize formations of worlds and of constellations of the universe, to derive the continents, to people them with races, tribes, and nations … The libido has not metamorphoses but world-historical trajectories." This indeed suggests *neutrality*, akin to the "neutrality of sense" asserted by Deleuze in *Logique du sens* (Deleuze 1969, 151). However, in 1972, three years after *Logique du sens*, in *L'Anti-Œdipe*, Deleuze and Guattari (1977, 16, 30) would write of "the libido as energy of production": "In group fantasy the libido may invest all of an existing social field, including the latter's most repressive forms; or on the contrary, it may launch a counterinvestment whereby revolutionary

desire is plugged into the existing social field as a source of energy." "Without doubt," they tell us,

> there are astonishing oscillations of the unconscious from one to the other of the poles of delirium: the way in which an unexpected revolutionary power frees itself (la manière dont se dégage une puissance révolutionnaire inattendue), sometimes even from the womb (le sein) of the worst archaisms; inversely, the way in which it turns or encloses itself fascist, in which it falls back into archaism. (Deleuze and Guattari, 1972 330)[4]

This characterization of libido as "haunting history" invites cross-reference not only with the term "machine" as also related to libido in *L'Anti-Œdipe* but also with Deleuze's earlier description, in *Logique du sens*, of "relations of quasi-causality" in terms of an "unreal and ghostly causality that does not cease to return in the two senses" (i.e., "that which happens to bodies and that which insists in propositions") (Deleuze 1969, 46, 151). The verb "haunt" and the adjective "ghostly" are sufficiently distinctive to draw these passages together and to suggest a relation between the substantives in terms of which they are introduced: "libido" that "haunts" and "relations of quasi-causality" as a "ghostly causality" that is also a kind of "machine." It bears noting here, too, that in the last work credited to Deleuze and Guattari, *Qu'est-ce que la philosophie?* (1991), there is a pertinent reminder of Deleuze's early engagement with Hume's three "principles of association of ideas." "We ask only that our ideas link together according to a minimum of constant rules," states the book's conclusion,

> and the association of ideas has never had any other sense, than to furnish us with these protective rules, resemblance, contiguity, causality, that permit us to put a little order in ideas, to pass from one to another following an order of space and time, preventing our "fantasy" (the delirium, the madness) from traversing the universe in an instant to beget there winged horses and dragons of fire. (Deleuze and Guattari 1991, 189)[5]

Remarkably, in this passage, the standard English translation of *Qu'est-ce que la philosophie?* (by Hugh Tomlinson and Graham Burchell) *simply leaves out* the phrase "to pass from one to another

following an order of space and time," which, in the original French, is clearly present as "de passer de l'une à l'autre suivant un ordre de l'espace et du temps."[6] This is not inconsequential, and not only because English-language readers have been left unaware of this phrase within the passage since the translation's appearance in 1994. For precisely what is being "followed" here is "*an* order of space and time" to do with resemblance and contiguity, that also respects – as does this phrasing – Deleuze's emphasis, in "Ce que les enfants disent," on the importance of the indefinite article in "that which concerns the libido, that which the libido invests." Such "an order" makes no claim to being "the order." But neither does it invest in "winged horses and dragons of fire."

Rather, if relations of strict causality, as described by Hume in terms of "constant conjunction," are covered by one of the three "rules," there seems to exist a possibility, and even an imperative, to draw out of Deleuze a suggestion that "the libido haunts history" precisely through "relations of quasi-causality" as an "unreal and ghostly causality": that is, through "resemblance and contiguity" as the "protective rules" / "principles of association of ideas" that are not, among the three, identifiable with "cause and effect" and that have to do not with inference (as do cause and effect) but with "resonance." This possibility invites and deserves further exploration. What we have sought to do here, via terms bequeathed primarily by Deleuze, including with Parnet and Guattari, is to dare a version of what, in a 1986 typescript that became the Preface to the English translation of *Différence et répétition*, Deleuze (1994, xvi–xvii) calls "a new image of thought – or rather, a liberation of thought from those images that imprison it." This is in response to "problems which point beyond the propositional mode, … involving encounters which escape all recognition … forc[ing] us to think."

NOTES

This chapter was initially presented as a paper, coordinated with large-screen images, on 6 February 2015 at the conference "Thinking through Deleuze," held at Brock University, St Catharines, Ontario. The text has undergone revision, including in the number of images.

1 Rosi Braidotti's talk "Punk Women and Riot Grrls," given in Oslo on 12 May 2014, is available on youtube (https://www.youtube.com/watch?v=BXbx_P7UVtE), as is Judith Butler's talk "Performing the

Political" (https://www.youtube.com/watch?v=QeHPfXUmY3g), which
was given on the same occasion.

2 Unless otherwise noted, translations from French texts are by Douglas
Ord.

3 As of January 2017 the Rammstein Moscow concerts of 10 and 11 Febru-
ary 2012 are at https://www.youtube.com/watch?v=gjdVwXX7Dig,
courtesy of "Leshik," in multicam composite over both nights. The recom-
mended multicam video is that of the 10 February concert directed by
"DihlofozzZ," which was at youtube for several years but, at the time of
this writing, is not. Another simple pairing of "image-signs," however, will
convey at least the beginning of a sense of how the Rammstein Moscow
concerts of 10 and 11 February 2012 resonated with the Pussy Riot
Moscow cathedral performances of 19 and 21 February 2012 (see figures
14 and 15). The image on the left shows Rammstein's lead singer, Till
Lindemann, performing his "hammer dance" in a sleeveless vest during
the song "Du Hast" on 11 February 2012. The image on the right shows
two of the anonymous members of Pussy Riot, who would later be identi-
fied as Nadezhda Tolokonnikova and Maria Alyokhina, in sleeveless
dresses, performing a move that looks remarkably similar, in the sanctuary
of the Cathedral of Christ the Saviour in Moscow on 21 February 2012 –
at most eleven days later.

4 An especially misleading error in the standard translation of this passage
cannot go unnoted. For the French "la manière dont se dégage une puis-
sance révolutionnaire inattendue," Robert Hurley, Mark Seem, and Helen
R. Lane give "the way in which an expected revolutionary force (*puis-
sance*) breaks free" (Deleuze and Guattari 1977, 277). The *Collins Robert
French~English / English~French Dictionary* (Atkins 1978, 364, emphasis
added) gives for the adjective "inattendu, e" the English words "<u>un</u>ex-
pected, <u>un</u>foreseen" (*Collins Robert* 364, emphases added). The distinction
is considerable.

5 The word "ideas" (idées) as given by Deleuze and Guattari in *Qu'est-ce
que la philosophie?* is uncapitalized. What this suggests is a usage less
constrained than that in Deleuze's earlier analysis of the capitalized term
"Ideas" (Idées) in its Platonic, Leibnizian, and Kantian associations, espe-
cially in chapter 4 of *Différence et répétition*, "Synthèse idéelle de la
différence" (Deleuze 1968, 218–85). This text conceptually follows a dif-
ferent thread, as implied by the facts that (1) Hume (1969) in *A Treatise
of Human Nature* uses "ideas" as uncapitalized; and (2) so does Deleuze
in his two books on Hume (Deleuze 1953; Deleuze and Cresson 1952),
which were also his first two books.

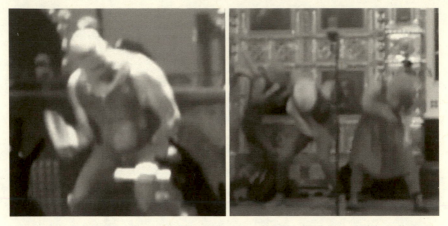

Figure 14, *left* Till Lindemann of Rammstein performing his hammer dance during
the song "Du Hast" at Olimpiyskiy Stadium, Moscow, on 11 February 2012.
Figure 15, *right* Nadezhda Tolokonnikova and Maria Alyokhina, masked as Pussy
Riot, performing "Mother Mary, Drive Putin Out," in the Cathedral of Christ the
Saviour, Moscow, on 21 February 2012.

6 Translation is hard work, and English-language translators of Deleuze and
 Deleuze-Guattari deserve credit. There are anomalies, however, and some-
 times these are important. In this case, the French for the quoted passage
 reads, on page 189 of the 2005 Minuit edition of *Qu'est-ce que la
 philosophie?*:

 > Nous demandons seulement que nos idées s'enchaînent suivant un
 > minimum de règles constantes, et l'association des idées n'a jamais eu
 > d'autre sens, nous fournir ces règles protectrices, ressemblance, conti-
 > guité, causalité, qui nous permettent de mettre un peu d'ordre dans
 > les idées, *de passer d'l'une à l'autre suivant un ordre de l'espace et
 > du temps*, empêchant notre "fantaisie" (le délire, la folie) de parcourir
 > l'univers dans l'instant pour y engendrer des chevaux ailés et des dra-
 > gons de feu.

 The phrase missing from the Tomlinson/Burchell translation is italicized.
 The passage in French deserves closer analysis than is possible here, as does
 Deleuze's treatment of Hume – which is not exactly Hume, but not exactly
 "winged horses and dragons breathing fire" either.

REFERENCES

Anonymous members of Pussy Riot: Garadja, Fara, Shaiba, Cat,
 Seraphima and Schumacher. 2014. *Guardian.* "We Wish Nadia and
 Masha Well – But They're No Longer Part of Pussy Riot." https://www.

theguardian.com/commentisfree/2014/feb/06/nadia-masha-pussy-riot-collective-no-longer.

Atkins, B., A. Duval, and R. Milne. 1978. *Collins Robert French~English / English~French Dictionary*. New York: Harpercollins.

BBC News. 2015. "Putin Reveals Secrets of Russia's Crimea Takeover Plot." 9 March 2015. https://www.bbc.com/news/world-europe-31796226.

Braidotti, Rosi. 2013. "Nomadic Feminist Theory in a Global Era." *labrys, études féministes. June.*

– 2014. "Punk Women and Riot Grrls." *First Supper Symposium*. Oslo. 12 May. http://cfh-lectures.hum.uu.nl/punk-women-and-riot-grrls/.

Deleuze, Gilles. 1953. *Empirisme et subjectivité, Essai sur la nature humaine selon Hume*. Paris: Presses Universitaires de France.

– 1968. *Différence et répétition*. Paris: Presses Universitaires de France.

– 1969. *Logique du sens*. Paris: Éditions de Minuit.

– 1977. *Dialogues*. Paris: Flammarion.

– 1990. *The Logic of Sense*. Trans. Mark Lester and Charles Stivale, ed. Constantin Boundas. New York: Columbia University Press.

– 1993. *Critique et clinique*. Paris: Éditions de Minuit.

– 2014. *Nietzsche et la philosophie*. Paris: Presses Universitaires de France.

Deleuze, Gilles, and André Cresson. 1952. *David Hume, Sa vie Son œuvre Sa philosophie*. Paris: Presses Universitaires de France.

Deleuze, Gilles, and Félix Guattari. 1972. *L'Anti-Œdipe: Capitalisme et schizophrénie*. Paris: Éditions de Minuit.

– 1977. *Anti-Oedipus: Capitalism and Schizophrenia*. Trans. Robert Hurley, Helen Lane, Mark Seem. Minneapolis: University of Minnesota Press.

– 1994. *What Is Philosophy?* Trans. Hugh Tomlinson and Graham Burchell. New York: Columbia University Press.

– 2005. *Qu'est-ce que la philosophie?* Paris: Éditions de Minuit.

Deleuze, Gilles, and Claire Parnet. 1996. *Dialogues*. Paris: Flammarion.

– 1988. *L'Abécédaire de Gilles Deleuze*. Dir. Pierre-André Boutang. 1988. Subtitles Charles Stivale. Los Angeles: Semiotext(e) Video.

Geens, Stefan. 2013. "Reconstructing the Chelyabinsk Meteor's Path." *Ogle Earth* (ogleearth.com). 13 February–5 April. https://ogleearth.com/2013/03/three-trajectory-models-of-the-chelyabinsk-meteoroid-compared/.

Gessen, Masha. 2014. *Words Will Break Cement: The Passion of Pussy Riot*. New York: Riverhead.

Harding, Luke, and Peter Verzilov. 2015. "Pussy Riot: Q&A with Nadya Tolokonnikova and Masha Alyokhina." *Guardian*. 18 February. https://www.theguardian.com/world/2015/feb/18/pussy-riot-i-cant-breathe-nadya-tolokonnikova-masha-alyokhina.

Hume, David. 1999. *An Enquiry Concerning Human Understanding*. Ed.
 Tom Beauchamp. Oxford: Oxford University Press.
– 1969. *A Treatise of Human Nature*. London: Penguin.
Lerner, Mike, and Maxim Pozdorovkin. 2013. *Pussy Riot: A Punk Prayer*.
 (Documentary film.) London: HBO-Goldcrest.
Ostrovsky, Simon. 2014. "Pussy Riot Gets Whipped in Sochi." *Vice News*.
 20 February. https://news.vice.com/en_us/article/3kwgzj/
 pussy-riot-gets-whipped-in-sochi.
Plato. 1961. *Plato: The Collected Dialogues*. Ed. Edith Hamilton and
 Huntington Cairns. Princeton: Princeton University Press (*Timaeus*
 trans. Benjamin Jowett).
Pussy Riot. 2012. "Punk Prayer: Virgin Mary, Put Putin Away." https://
 www.youtube.com/watch?v= lPDkJbTQRCY (Two-minute video).
– 2014a. "Madonna and Pussy Riot Respond to Putin at Amnesty
 International Concert: Their Complete Speeches." Video. https://www.
 youtube.com/watch?v=lpgWrz-2R9A.
– 2014b. "Pussy Riot on Prison, Putin, the Ukraine Crisis and Activism."
 BBC *Channel 4 News*. 14 November. Video. https://www.youtube.com/
 watch?v=ruMclx5Gy7M.
– 2014c. "Pussy Riot: Sex, Art and Vladimir Putin." *Guardian Live*.
 Video. https://www.youtube.com/watch?v=3mU2Di2I8Zw.
– 2014d. "Putin Will Teach You How to Love the Motherland." Video
 https://www.youtube.com/ watch?v=gjIoKYl9gWs.
Russia Today. 2013. "1,000 Times Stronger than Chelyabinsk Meteorite:
 New Asteroid May Threaten Earth." 3 November. https://www.rt.com/
 news/201827-dangerous-asteroid-discovered-ur116/.
Der Spiegel. 2012. "Putins Russland: Auf dem Weg in die lupenreine
 Diktatur." No. 33. 13 September. http://www.spiegel.de/forum/politik/
 ist-russland-auf-dem-weg-eine-diktatur-thread-68074-1.html.
Tayler, Jeffrey. 2012. "What Pussy Riot's 'Punk Prayer' Really Said."
 Atlantic. 8 November. https://www.theatlantic.com/international/
 archive/2012/11/what-pussy-riots-punk-prayer-really-said/264562/.
Tolokonnikova, Nadezhda, and Slavoj Žižek. 2013. "Nadezhda
 Tolokonnikova of Pussy Riot's Prison Letters to Slavoj Žižek."
 Guardian. 15 November. https://www.theguardian.com/music/2013/
 nov/15/pussy-riot-nadezhda-tolokonnikova-slavoj-zizek.
Voss, Daniela. 2013a. *Conditions of Thought: Deleuze and Transcendental
 Ideas*. Edinburgh: Edinburgh University Press.
– 2013b. "Deleuze's Rethinking of the Notion of Sense." *Deleuze Studies*
 7 (1): 1–25.

3

Creepers, Pixels, and the Nether: Performing Minecraft Worlds

Nicole Land, Veronica Pacini-Ketchabaw,
and Eric Lochhead

We imagine this chapter to be made entirely of momentary, divergent Minecraft performances, where Steve, Obsidian, Eric, Dog, Veronica, Creepers, Nicole, Theory, and Pixels matter with/in Minecraft to imagine the possibilities that might emerge from the troubling spaces of Minecraft. Eric is a Minecraft enthusiast. Nicole wonders about Minecraft bodies. Veronica, who lives with a Minecraft gamer, has become a Minecraft ethnographer (Pacini-Ketchabaw 2014).

Pixelated Block Worlds

You might have heard of me. My name is Steve. And, like my friends so pointedly tell me, my head is a cube. I live in a world filled with blocks of vibrant colours, with animals I can tame.

Alright. Before I delve into a story filled with adventure and corny jokes, I'll tell you a little about myself. My favourite animals are wolves. I don't like Creepers. And I can't sleep without my teddy bear.

One day I was walking in the forest with my favourite dog, Dog. We were heading to the plains, where my house is, when suddenly we heard a strangled grunt from a cave, so we went to investigate. Standing there was a snot-green, rotting beast with night-black eyes, wearing the tattered remains of a green shirt and blue pants. It was a zombie.

I had never seen a zombie before, only read about them in books. The books said zombies were aggressive, but as soon as I saw that zombie I stopped believing it. The zombie was a calm, dignified

creature. As I looked into its eyes, I could feel a connection
between us, as if it were saying "I'm not going to hurt you."
Dog and I marched on. This zombie was okay. What a nice guy!
And then it stepped forward and killed Dog.

LIVING WITH(IN) MINECRAFT PERFORMANCES

Compact, fractured, and entangled Minecraft performances that stem
from our embeddedness in these assemblages populate this chapter.
Minecraft performances draw attention to the historical continuities
and dispersals of natural resources, geological subjectifications, mul-
tispecies politics of refuse, and porous, technologically tendinous
bodies across Minecraft sites. We grapple with the ethical and political
eruptions that flow from both these Minecraft worlds and the hybrid,
entangled social terrain of the Anthropocene upon which they are
engaged. Nourished by more-than-human theoretical perspectives
(Pacini-Ketchabaw 2014), this chapter offers an alternative to the
developmentalist, humanist, and consumerist framings that shape
youth-technology analyses in contemporary Euro-Western worlds
(Bebbington and Vellino 2015; Bos et al. 2015; Wernholm and Vigmo
2015). Entertained by Latour (2005, 248), we take Minecraft perfor-
mances seriously as "phenomena we have to find puzzling again if
we want to understand the types of entities the collectives may be
composed of in the future."

The chapter labours to resituate youth-Minecraft assemblages in
the ethical domain by focusing on complex, entangled, mutually
affecting, and co-shaping relations. We propose thinking with
Minecraft performances as an experimental, hybrid, and risky endeav-
our, where human and more-than-human actants populate these
performances and interject to tug our engagements away from objec-
tive Truth or sociological analyses and instead demand an ethical
engagement with "the very special fact that faced with a challenging
situation, nobody can speak in the name of this situation" (Stengers
2003, 193). This chapter is neither a literal commentary about the
entanglement of humans and technology nor a romantic take on
Minecraft, the bestselling computer game of all time (Mac, Ewalt,
and Jedeur-Palmgren 2015). Minecraft performances interject in our
worlds as Minecraft *figures*, taking form around our colleague Emily
Ashton's (2015, 21) interpretation of Povinelli's figures:

Povinelli's guiding question is "What are the figures that organize formations of power in the present?" (2013c). Figures of analytical worth for Povinelli are those that figure-forth contemporary problems of governance, and through which we can think through the differently situated consequences of "climate change, the emergence of the security state, and the shaking of neoliberalism" (2014c). Figures indicate "a possible world beyond themselves" and we can "understand them as a stand-in for something else," but, most importantly for me, we are also obligated to them in ways that exceed their instrumentalization. Reflecting on Povinelli's work, I propose five qualities of Povinelli-recommended figures: (1) figures are contemporary, (2) figures are symptomatic, (3) figures are relational, (4) figures are disruptive, (5) figures are a new-normative.

When we inhabit Minecraft performances as precarious, consequential, and timely figures, Minecraft is kin to Haraway's (1997) OncoMouse, the cyborg (Haraway 1991), and SF (Haraway 2013): Minecraft performances have real implications for the worlds we inherit, invent, and inhabit together.

Mining and Worlding

Fast forward 10 Minecraft days (20 minutes each). I moved into a town with nice villager neighbours who give me bread baskets. Now my only worry is boredom.

And that is why I decided to build a zoo. You should really see the place – it's coming along nicely. I used bricks for the wall, and I am in the middle of planning the layout.

The exhibits at the front will be Creepers and Ghasts, because they are some of the most exciting mobs in Minecraft. Ghasts are giant white ghosts that shoot fireballs, and Creepers are green humanoids with a tendency to explode.

To build the Creeper cage, I'll need leaves, wood, dirt, and iron bars. First up – iron bars. I'll need to mine to get iron, so that takes a couple of steps. First, I chop down some trees with my fists. Later, I can make an axe out of basic material, but for now I need to suffer through the pain.

After I have cut down a tree, I use the wood to make a pickaxe. When I get stone, I can upgrade it. Now it is time to find a cave.

I walk around a little, but when I don't see any caves, I decide to dig a strip mine.

In Minecraft, strip mines are easy to construct – you dig a stair-case downwards, and then you dig straight until you find a cave. It takes me a while to find a cave and I come out at ground level. Just remember the basic rule: Don't dig straight down, otherwise you might fall into lava.

Alright. Now to explore. I make torches with my extra wood and the coal I found during my dig.

MINECRAFT FIGURING IN THE ANTHROPOCENE

Might Minecraft worlds "enrich our understandings of capitalist world making"? Might they assist us somehow in ethically responding to the challenges of the Anthropocene (van Dooren 2015)? "The Anthropocene" is a term popularized by chemist Paul Crutzen and is increasingly used to describe the effects of human activity on a geological planetary scale. Environmental humanities scholars see the Anthropocene as a potentially transformational moment. Gibson, Rose, and Fincher (2015), for example, suggest that we can no longer deny that humans, by our short-sighted humancentric actions, have fundamentally altered the planet that sustains us, nor can we any longer deny that human and nonhuman histories and futures are inextricably entwined. The Anthropocene, or, as Haraway (2015) prefers to call it, the Capitalocene, is also a reminder of the profound challenges to the future of life on earth as we know it. These scholars propose that the Anthropocene may be an opportunity for humans to accept the impossibility of maintaining colonialist separations between humans and the rest of the world.

Like Haraway's (1991) cyborg, might Minecraft be one of those "disorderly" (i.e., extremely risky and strangely compelling [van Dooren 2015]) figures that prompt us to confront the paradoxes of the Anthropocene – first, that, as a species, humans are both responsible for, and mortally vulnerable to, the geo-biospheric changes we have caused; and second, that our own delusional, self-centred, and self-aggrandizing thinking has created this predicament? Take, for instance, the infinite world of Minecraft. In the 4 billion square kilometres of Minecraft world (Fallon 2015) there is only regeneration, no end to life or the world. Indeed, as Deleuze and Guattari (1987) say, there is only the creative force of life. This is not to say

there is no destruction. However, every mutilation brings a mutation (van Dooren 2015), and new possibilities in Minecraft worlds constantly emerge above and beyond the mortality of humanity. We are reminded of what Yusoff (2013, 782) proposes: "that the actual extinction that is presupposed in the Anthropocene is not the totality of life, but rather the end of the subject of late capitalism." If the figure of Minecraft provides a glimpse into life in advanced capitalism, might Minecraft challenge us to respond to the Anthropocene through a paradigm shift in the ways in which we think about what it means to be human and about our place in the world, as a species?

THICKLY ENTANGLED YOUTH-MINECRAFT COMMON WORLDS

Latour (2004) speaks about common worlds as ethical worlds that attend to the common good. For Latour, a common world ethics means remaining radically open to composing these worlds. Rather than shutting down ideas of what might constitute a common world, Latour urges a more generative understanding of common worlds as always in the process of composition (Taylor 2013). Central to his way of thinking is the recognition that humans are not the sole composers or caretakers of the youth-Minecraft commons. Thus youth-Minecraft common worlds are thick entanglements of youth-technology that are constantly in the making and inseparable at the time of the Capitalocene. Already a knot, these entanglements result in a surprising conglomerate (Latour 2005).

This idea is similar to Donna Haraway's (2008, 19) notion of making worlds, or worlding, in which "species interdependence is the name of the worlding game on earth, and that game must be one of response and respect." This game of response and respect is not about finding an innocent location on which to stand in the Nether, playing a transparent game, nor about transcending the fear of monsters. It might be about "keen appreciation" for the monsters and zombies that make us feverish and nauseated, that cause rashes and indigestion (Haraway 1997, 39) as we inhabit the belly of Minecraft.

Active Worlds of Caves, Mobs, and Uncertainty

Up until now, the mining has been pretty simple, but this is the hard part. Caves are very dangerous, and inhabited by dangerous mobs. I have come for resources, but also to scope out if I can find some mobs for my zoo.

I dig in the wall, mining out stone. With the last of my wood, I make a stone pickaxe and sword to defend myself.

Certain materials require other materials to mine them. Iron requires stone, gold and diamonds need iron, and obsidian needs a diamond pickaxe.

Suddenly, a zombie rounds a bend in the cave! I draw my sword and stare it down.

"Your kind hurt my dog," I growl. "No one likes it when someone kills their dog."

As the zombie growls and advances, I raise my sword and slash downwards. The zombie falls to the ground.

I need to get out of here before more zombies show up, I think. I look around the cave and see a patch of beige streaks in the stone.

"Gotcha," I say. I walk over, and using my stone pickaxe, I mine the blocks of iron ore in the wall. All in all, there are 9 blocks of ore. I check the cave for more, and a quick sweep leaves me with 30 iron ore.

I head back to my house on the surface and use the stone I've mined to make a furnace. I use my extra coal as fuel to smelt my ore. After it is done, I make iron bars, saving some for tools. Next on my list are wood and leaves. Both of those materials come from trees. With some of my iron, I make an axe and shears.

When I arrive at the forest, I chop down a tree and shear its leaves. I sigh. This is going to take a while. I chop and shear for three Minecraft days. At the end I have 300 logs and 500 leaves. I head back to my house to store them. Last up is dirt. I use my last iron ingot to make a shovel. I go outside of town and dig up as much dirt as I can.

Later that night I put together the Creeper cage. It is tall and has a rim of leaves, but the rest of the cage is made of iron bars. I use dirt to cover the floor, and wood and the rest of my leaves to make tall trees. I think the Creepers will be happy here. It is brighter than their cave.

Slowly, over a course of 20 Minecraft days, I collect the resources to assemble the cages. It takes me 10 more to put them together.

DIGGING GEOLOGICAL SUBJECTIVITIES

Digging with Yusoff (2013, 2014), we become interested in how the Anthropocene, as a new geological epoch of human-driven planetary

change and with all its paradoxes and conflicting origins, might be a call to reimagine subjectivities by placing the individual within a geologic temporal frame: "*being as geological* effects the temporal and material imagination of the capacities of the human that move beyond a conceptualisation of social relations with fossil fuels into the contemplation of the social as composed through the geologic (and thus politically constituted by it in both political and radically apolitical ways)" (Yusoff 2014, 780, emphasis in original). Steve navigates more than the roads and buildings on the surface of Minecraft worlds. He does more than interact with other life forms: zombies, trees, animals, humans. As the "man of the Anthropocene," he goes beneath the surface and grapples with geologic life, with the geopolitical (Australian Government n.d.; British Broadcasting Corporation 2007; British Geological Survey 2014). He digs through the earth, not just "learning" the different strata of sedimentary rock of Minecraft worlds. Iron becomes wall. Metal ore becomes tool. Steve becomes iron to regenerate himself. Iron becomes Steve. Geologists work alongside computer scientists alongside chemists alongside educators ... (Condliffe 2015; Geological Survey of Sweden 2013; Petrov 2014; *Science Daily* 2015). Taking "seriously not just our biological (or biopolitical) life, but also our geological (or geo-political) life and its forms of differentiation," Minecraft becomes "a provocation to begin to understand ourselves as geologic subjects" in the Capitalocene (Yusoff 2014, 781).

Confronting Zoo Complexities

During the sunset of the last day, I gaze in wonder at my completed zoo. Yep, it looks amazing. Surrounding the place is a brick wall, with iron bars and cobblestones to top it off. The interior has nice stone paths and lush grass, with wooden benches made with stairs.

The first thing you see when you enter are the Creeper and Ghast cages. These are the biggest of the cages, and I made them to make a good impression on people who have never been to my zoo before.

In the centre of the zoo is the food court. It has apples, beef, pork, carrots, bread, and potatoes. I use those because, well, we can produce them ourselves (malicious grin).

I built twelve cages, for Creepers, Ghasts, Slimes, zombies, skele-tons, Blazes, spiders, Endermen, cows, pigs, chicken, and sheep.

I sigh. Getting the animals here is going to be a lot of work. First up, I'll do the cows, chicken, sheep, and pigs. These will be the

easiest, because I can use wheat to lure them here. For the chickens, I can use seeds.

"Here, chicken, chicken, come on, boy!" I am almost done. The cows, sheep, and pigs are in their respective cages, and I am halfway back to my zoo with a chicken flapping along behind me. The cows and sheep share a pen, and it is a lovely grey, highlighted with brown patches on the wall. The pigs have a bright pink cage, with richer red wool blocks running in patterns down the sides. The pigs have a smaller cage than the sheep and cows because they aren't as big and they don't share with anything else.

Slowly but surely, I make my way back to the zoo, my chicken friend in tow. I fit him into his cage along with the others. The chicken coop is a nice white, with yellow patches on the ground. I built the chickens a small house to lay their eggs in, although chickens tend to inconsiderately lay them all over the place. Ever stepped on an egg? Not fun.

The ground is made of podzol, because I like the way it contrasts with the white wool. Sunk in the brown block is a small pond for the chickens to float in.

This is my second chicken. When my zoo gets up and running, I'll use seeds and wheat to breed them.

Next up on my list are Creepers, spiders, zombies, and skeletons. While I find the spiders, I'll take a moment to talk face to face with you. How are you? Good, good, alright. How is the family? Do you have a family?

Jeez! Ten kids! How do you keep track of them all!? No, no, just joking, I know you don't have ten kids. Wait, you do? Never mind, let's move on.

It's weird being part of Minecraft. As you could probably guess, I am not really me. My real mind resides in the commander. It's kind of weird to think that I am controlled by someone with a brain! What does it feel like to have a brain? Do you have circles where you live? Circles are forbidden in Minecraft. It's against the rules to have or even make one!

Am I even human?

Wow, where did that come from? The commander must be a philosopher. I suppose that I am human. But then again, I'm not. I am an avatar, but I can think and walk and talk. Well, not so much talk. All I say is "ugh!" when I get hurt.

Are you human when you control me?

*My goodness, where are these questions coming from? I think
you are. I don't think you are the same human as you are normally,
but I think when the commander controls me, then he is me, if that
makes sense. And aren't I as human as anyone?*

*I see a pair of glowing red eyes in the shadows of the cave I am
checking. Oh well, discussion over. I stare at the spider. It works,
and the spider leaps at me. I run back to the zoo with it on my tail
(just a figure of speech, I don't really have a tail). When I arrive at
the zoo, I bait the spider into its cage, a midnight black colour
with dripping red wool, with the prospect of human flesh. I dance
around it and run out the door, slamming it on my way past.*

*I do this again with another spider, and bam! Spiders, check. I do
zombies and skeletons in the same cage, with dark green wool and
white wool for bone. The Creepers are easy to get, too, and I lead
them to the zoo with only a handful of trouble.*

*But that's where things go wrong. My favourite scientist,
Oinkstein, I think – you know, the guy with the theory of
Minecraft relativity (a block in motion will stay in motion until it is
stopped by the ground) – once wrote in his books that doing some-
thing requires trial and error, and the first time you try something it
always goes wrong. Well, this went wrong.*

WE HAVE NEVER BEEN HUMANS/INDIVIDUALS

The question of whether or not we are biological individuals is crucial
not only to studies of genetics, immunology, anatomy, physiology,
evolution, and development (Gilbert, Sapp, and Tauber 2012) but
also to Minecraft. As Steve meets with zoo complexities, as cages are
crafted for chickens and zombies, nature and creatures become more
than a foundational currency of this zoo and cannot be easily appro-
priated to twenty-first-century "human" projects of domination. In
a world where circles are banned and spiders can be baited by flesh,
what it is to be human is to take seriously Haraway's (Haraway and
Gane, 2006) claim that we have never been human. Steve, fleshed
with a pixelated brain, is more than a metaphor for entangled species
relations in our increasingly digital spaces: Steve is a problem, a figu-
ration, kin to the cyborg, kin to iron, kin to zoo inhabitants. Thus,
as Haraway (Haraway and Gane 2006, 139) reminds us, Steve is an
"obligatory worlding" in a world where humans have never been
bounded by the mythical concrete dictates required of "humanness."

When the pixels that make Steve possible are powered by our hydro-electric damming of the rivers that snake across the land we borrow (or, more accurately, that we stole) and the fingers that brush iPad screens to mine for podzol are sustained with microbes and hand sanitizer, any remnants of a true, pure, or modern "humanness" dissolves into the oxygen that performs OncoMouse, Minecraft, and our always-assemblage bodies. Minecraft is playing our game – queering the notions of humans (who have never been human), our modern world (which has never been modern [Latour 1993]), and our physiological and immunological individuality (which has never been individual [Gilbert et al. 2012]). Then what? What's next? No clear answer. Let's return instead to that troubling notion of responsibility, in which, "no longer able to sustain the fictions of being either subjects or objects, all the partners in the potent conversations that constitute nature must find a new ground for making meanings together" (Haraway 1992, 65). When Steve and the zoo meet (Haraway 2007, 65), perhaps they scream at us to craft worlds where we might "find another relationship to nature besides reification, possession, appropriation and nostalgia." Can we?

Inhabiting Block Bodies

My blocky foot hits an inconveniently placed block. I stumble, and turn to look at the treacherous cobblestone. All of you who play Minecraft are probably shaking your non-square heads at my mistake. Because as soon as I looked at where I was going, I turned my back on the Creepers. I was only turned around for a second, but a second is all it takes.

Hisssssssss.

BOOM!

The violent explosion pushes me back a block.

Hisssssssss.

BOOM!

The second Creeper explodes, blowing up the side of the spider cage. Spiders start to stream out of the hole in the cage. In total, five spiders, including three that spawned in the cage, confront me.

In my current state, weakened by the dual explosions and with no weapon, I hurry to escape. In between the zombie/skeleton and Blaze cages is a chest labelled "Emergency." Out of it I pull a golden apple and an iron sword. It always pays to be prepared. After I eat the golden apple, I gain health regeneration, which sets

*about healing back up to my usual ten hearts. It also gives me
absorption and resistance, which give me extra hearts and allow
me to be more resistant to attacks. I heft my sword and charge at
the approaching spiders. Three quick swings account for one spider.
The other four take heavy damage as I rain blows on them, slowly
backing up to avoid getting hit. Two of them fall to my blade and I
lead the other two back into their cage, sealing the hole in the wall
with extra blocks.*

*I sigh. I'm going to have to find more Creepers. Those first two
took me longer than I was expecting, and now I need more. It
takes me another day to find the Creepers and get them into their
cage. This time I manage to avoid the cobblestone, and the opera-
tion goes off without a hitch. Last up on my list are Ghasts, Slimes,
Blazes, and Endermen. These are the hardest mobs to acquire on
my list, because they are either dangerous or hard to find – or both.*

*Endermen are found in the End, a nasty floating island dimen-
sion with a ferocious Ender Dragon, ready to tear you limb from
limb. Blazes are found in the Nether, a fire dimension that has all
sorts of terrible monsters. The Nether also has Ghasts floating
above the rocky surface. Slimes are found in swamp biomes, the
same place that has deadly witches.*

BATTLING (WITH) TRANSCORPOREAL MINECRAFT BODIES

Stuck in the Nether, Steve bodies (Manning 2014); Endermen, Blazes,
and golden apples perform Steve's pixelated flesh as transcorporeal,
where it is "difficult to pose nature as a mere background for the
exploits of the human, since 'nature' is always as close as one's skin"
(Alaimo 2008, 238). Steve's ten hearts, connected through a lime-
green-covered iPad to Eric's four-chambered heart, beat as if with
the realization that we are "accountable to a material world that is
never merely an external place but always the very substance of our
selves and others" (Alaimo 2010, 158). This is performed in a place
of increasing chemical contagion, where ecological ethics and pipe-
line politics populate everyday relationships. Steve performs, and is
performed within, our common world of toxicity and intense con-
nection. Steve's skin, performed as tiny square pixels of Apple's finest
retina display, matters with Eric's skin made of connective tissue
and scars: both skins encounter the same politics, where environ-
mental traces transit through bodies until bodies matter as part of a

vast transcorporeal circus of fractured more-than-human actants. In this performance, we are rooted in a "swirling landscape of uncertainty where practices and actions that were once not even remotely ethical or political matters suddenly become so" (Alaimo 2012, 476). Creepers, iPads, iron swords, and power cords de/compose me, and Eric owes a deep debt to the explosions and apples that fuel his heart.

As Creepers and spiders march through transcorporeal Minecraft bodies, Minecraft demands "attention to the materiality of the human and to the immediacy and potency of all that the ostensibly bounded, human subject would like to disavow" (Alaimo 2010, 4). Here, Steve's hunt for mobs echoes his earlier question – "am I human?" If, as Alaimo (2012, 490) proposes, "trans-corporeality must be 'composed' [and] is not given but instead require[s] the composition of many discontinuous pieces," perhaps Steve is asking a question that becomes obsolete. If skin, pixels, and Dog are assembled as they are bodied (Manning 2014, 163) – that is, if "a philosophy of the body never begins with the body: it bodies" – these bodies are made in/of Minecraft performances marked by fractures, by coextensiveness, by Slimes, and by neuronal impulses that leap from Eric to Steve and back again. Ethics, the Nether, skin, and pixels are inseparable and refuse to be otherwise appropriated within the contemporary Euro-Western spaces they enact.

Encountering Violent Pixel Landscapes

First up, I am going to go for Blazes and Ghasts, because you find them both in the Nether. Normally, if you wanted to go to the Nether, you would have to find diamonds to make a pickaxe. Then, you would have to use that pickaxe to mine ten pieces of obsidian to make a portal. Next, you would light the portal with a flint and steel, and then you could step through. But I don't have that sort of time if I want to get my zoo up and running in seven days. Luckily, I know a guy who is willing to trade for obsidian.

Repear_Rudolff3 has been my friend ever since he sold me Dog. He owns the pet shop in spawn town. I don't get many excuses to visit him, so I welcome this one with open arms. As usual, he has a solution to my Nether problem.

"Aye, I gots some obsidian," he says when I ask him. "Some Ghast eggies as wells. All I be needin' is some tickets to yer zoo when it opens."

I smile at him. I was wondering how I was going to get the Ghasts through the portal, and Ghast eggs could spawn the mobs in the cage.

"Great! Here is your VIP annual pass."

I hand him a piece of paper I named in an anvil. Now it reads "Steve's Zoo – Annual VIP Pass" instead of "Paper."

"Good doin' the businesses wiz ya." Rudolff inclines his head thankfully.

After I make and light the portal, I travel through it to the fiery Nether. The Nether is a large place, and I need to explore to find a Nether Fortress. After at least ten minutes of searching, a Nether Fortress looms out of the crimson mist. The fortress is a big castle made entirely out of maroon bricks called Nether Brick. After a little searching, I find a Blaze spawner. I wait for a minute and then hightail it back to the Overworld to trap the two Blazes that are following me.

The Blaze cage is made of stone and Netherrack, the rock found in the Nether. I got it from Rudolff, who had been to the Nether before. I spawn the Ghasts in their cage, a tall white and red cage with glass to view the giant ghosts in all their glory. Time for the Slimes. I find two in a nearby swamp and bring them back for imprisonment. The Slime cage is a bright green, made from lime wool, with Slime blocks making platforms for the Slimes to jump on. The top is exposed to the sky so that the Slimes can sunbathe.

Now it is time for the ultimate challenge. To get to the End, I need to go through the End Portal in the Stronghold. There is only one Stronghold in the world, and luckily I know the guy who has it in his basement.

This friend of mine is a little strange. He has a tendency to go on and on and it gets really annoying. If you start to get a headache from his compulsive talking, get it checked out. It is probably fatal. Alright, then, just remember – you have been warned!

"OhSteveIt'ssogoodtoseeyouImissedyousomuchohlookasheepwhy areyouheredoyouwanttoshareapotatoIhearthereisgoodweatherin junglebiomesthistimeofyearohIheardaboutyourdogsdeathwhatwas hisnameagainohDogdoyouwanttogototheEndandslaytheEnder DragonIhavearmorandweaponsandthingswhatdoyouthinkIshould dooverth eweekend?"

As you can probably tell, BennyBenny_Benben-LIME is a little strange.

"Wecouldgofishingorsleddingorsightseeingorshoppingwhatisyour favouritekindofflower."

Okay, a lot strange.

"Benny," I manage to cut in. "Can I use your End Portal?

Benny's face brightened further, which I didn't think was possible.

"MyEndPortalsureitwouldbemypleasureIwouldlovetohaveyougo totheEndtheportalisinthebasement..."

"Great," I say, moving for the basement.

"I'llseeyouonopeningdayohmanI'msoexcited..." I don't hear the rest as I plunge into the basement. Right in front of me is the end portal, a swirling vortex of darkness. I hop into the shadow, and a loading screen greets me:

Generating Terrain . . .

GENERATING COMMON WORLD(ING)S

Steve, BennyBenny_Benben-LIME, and obsidian initially brush this moment of mediated terrain invention aside as a mundane routine, but what if questions of how we might generate terrain together are much more than an inconvenient pause to allow the Wifi to awaken Minecraft algorithms and make tundra out of binary code? What if to pause is to generate terrain, where crafting worlds is a project that "requires no other verification than the way in which it is able to 'slow down' reasoning and create an opportunity to arouse a slightly different awareness of the problems and situations mobilizing us" (Stengers 2005, 994)? What if generating terrain is to orient bodies, subjectivities, and performance to the potentialities of living in, inheriting, destroying, or reinventing contested common worlds? Perhaps as we perform pauses and generate terrain, Latour's (2005) proposal for reassembled common worlds interjects and scatters the pixels of modernity to reformulate what it is to live together.

As we dive into, or trudge towards, the end portal, we encounter Latour's (2005, 247) generative predictions that animate common worlding: first, "the question of the social emerges when the ties in which one is entangled begin to unravel" as Steve connects with shadowy space and Minecraft slinks along the bottom of an ocean populated by cabled life and marine life to give Steve life; then, as BennyBenny_Benben-LIME augments their relationship with Steve, and Steve encounters resource extraction, zoology, transcorporeality, and subjectivity, "the social is further detected through the surprising

movements from one association to the next" (ibid.); finally, we perform a collective rooted in iterative Minecraft performances, where what is common is more than a game interface: it is an assemblage of relations, pauses, and performances.

As we take seriously the concept of common worlds while also jamming our own feet into Steve's square shoes, we are reminded that such an assemblage is also populated by the pause, by the disjunctures in generating terrain in common worlds. Here, Minecraft performances and practices are profoundly momentary, and my own participation in Minecraft performativities takes seriously Stengers's (2003, 198) proposal that "misunderstanding is something an ecology of practice has to affirm without nostalgia for what would be faithful communication." This is an ethic and ethos upon which we inaugurated our encounter with Minecraft performances: Minecraft performativities might be made with/in our Euro-Western worlds, but if we want to take seriously the possibility for inhabiting with the political, ecological, and pedagogical disjunctions of Minecraft performances, as well as the possible worlds we might generate together, Minecraft performativities "make us think and not recognize" (Stengers 2003, 185). Dog, Ghasts, the Nether, chickens, Steve, and swords perform an invitation, not a lesson.

Late-Stage Performances

The portal finally places me in the End, a creepy beige island in the middle of space. I draw in a breath. The only way to escape the End is to kill the Ender Dragon, the evil guardian of the End.

I draw my sword. It is the best weapon I have: a diamond sword enchanted with Sharpness III, Fire Aspect II, and Knockback I. My armour is also diamond, with Protection IV and Thorns II. My bow is my principal line of defence, with Power V and Punch II.

I hear a resounding roar from up above me. Time to fight. I aim my bow and destroy the crystal on top of one of the numerous obsidian towers that dominate the island. The Dragon shrieks in pain.

The only way to defeat the Ender Dragon is to destroy all the crystals that give it health regeneration. I shoot with outstanding accuracy, destroying all of his crystals. Now I need to kill the Dragon. I shoot it as it flies overhead, settling on its perch and breathing purple fire. I shoot it again and again until it is at low health. The Dragon takes off and I fire off the killing shot. The

Dragon explodes in a shower of XP. I collect it, gaining seventy-six levels in all.

The portal to the Overworld opens. I stare at an Enderman until it charges me, and then I drop into the portal. The Enderman follows, and I lead it into its cage. Finally. The last addition to my zoo. The Enderman cage is obsidian black, with an End Stone floor that would make them feel at home. The entire cage is surrounded by water, so the Endermen can't teleport to escape.

I lie down in the cabin I built for myself. Tomorrow is a big day, when everyone will come to my zoo. I close my eyes and drift off to sleep.

This is Steve, signing out. Goodbye.

REFERENCES

Alaimo, Stacy. 2008. "Trans-Corporeal Feminisms and the Ethical Space of Nature." In *Material Feminisms*, ed. S. Alaimo and S. Hekman, 237–64. Bloomington, IN: Indiana University Press.

– 2010. *Bodily Natures: Science, Environment, and the Material Self.* Bloomington, IN: Indiana University Press.

– 2012. "States of Suspension: Trans-Corporeality at Sea." *Interdisciplinary Studies in Literature and Environment* 19 (3): 476–93.

Ashton, E. 2105. "Worldly Figures, or, a Monstrous Methodology." Working paper.

Australian Government. n.d. *Geology of Minecraft.* http://www.ga.gov.au/corporate_data/79560/79560.pdf

Bebbington, Sandra, and Andre Vellino. 2015. "Can Playing Minecraft Improve Teenagers' Information Literacy?" *Journal of Information Literacy* 9 (2): 6–26.

Bos, Beth, Lucy Wilder, Marcelina Cook, and Ryan O'Donnell. 2014. "Learning Mathematics through Minecraft." *Teaching Children Mathematics* 21 (1): 56–9.

British Broadcasting Corporation. 2007. *Bardarbunga volcano; Geology in Minecraft; Synthesising Opioids; Ammonia* [podcast]. https://player.fm/series/bbc-inside-science/bardarbunga-volcano-geology-in-minecraft-synthesising-opioids-ammonia.

British Geological Survey. 2014. *GB Geology with Minecraft.* http://www.bgs.ac.uk/discoveringGeology/geologyOfBritain/minecraft/home.html#/-219939/64/230363/-9/0/0

Condliffe, Jamie. 2015. "Scientists Built This Molecular Playground in Minecraft to Teach Kids Chemistry." *Gizmodo*. http://gizmodo.com/scientists-built-this-molecular-playground-in-minecraft-1740240211.

Deleuze, Gille, and Félix Guattari. 1987. *A Thousand Plateaus: Capitalism and Schizophrenia*. Minneapolis, MN: University of Minnesota Press.

Fallon, Sarah. 2015. "How Big Is Minecraft? Really, Really, Really Big." *Wired*. http://www.wired.com/2015/05/data-effect-minecraft/

Geological Survey of Sweden. 2013. *Bettergeo*. http://www.sgu.se/Global/Om%20geologi/BetterGeo/Lathund-juli-2015-ENG-v2.pdf.

Gibson, Katherine, Deborah Bird Rose, Ruth Fincher, J.K. Gibson-Graham, Ethan Miller, Jessica K. Weir, Kurt Iveson. 2015. *Manifesto for Living in the Anthropocene*. Brooklyn, NY: Punctum.

Gilbert, Scott F., Jan Sapp, and Alfred I. Tauber. 2012. "A Symbiotic View of Life: We Have Never Been Individuals." *Quarterly Review of Biology* 87(4): 325–41. http://blogs.bu.edu/ait/files/2012/12/SymbioticViewQRB.pdf.

Haraway, Donna. 1991. "A Cyborg Manifesto: Science, Technology, and Socialist-Feminism in the Late Twentieth Century." In *Simians, Cyborgs, and Women: The Reinvention of Nature*, 149–81. New York, NY: Routledge.

– 1992. "Otherworldly Conversations; Terran Topics; Local Terms." *Science as Culture* 3 (1): 64–98.

– 1997. *Modest_witness@second_millennium.femaleman_meets_OncoMouse: Feminism and Technoscience*. New York, NY: Routledge.

– 2007. *When Species Meet*. Minneapolis, MN: University of Minnesota Press.

– 2013. "SF: Science Fiction, Speculative Fabulation, String Figures, So Far." *Ada: A Journal of Gender, New Media, and Technology* 3: 1–18.

Haraway, Donna, and Nicholas Gane. 2006. "When We Have Never Been Human, What Is to Be Done?" Interview with Donna Haraway. *Theory, Culture, and Society* 23(7 and 8): 135–58.

Latour, Bruno. 1993. *We Have Never Been Modern*. Trans. C. Porter. Cambridge, MA: Harvard University Press.

– 2005. *Reassembling the Social: An Introduction to Actor-Network-Theory*. Oxford, UK: Oxford University Press.

Mac, Ryan, David M. Ewalt, and Max Jedeur-Palmgren. 2015. "Inside the Post-Minecraft Life of Billionaire Gamer God Markus Persson." *Forbes*. http://www.forbes.com/sites/ryanmac/2015/03/03/minecraft-markus-persson-life-after-microsoft-sale/.

Manning, E. 2014. "Wondering the World Directly – or, How Movement Outruns the Subject." *Body and Society* 20 (3 and 4): 162–88.

Pacini-Ketchabaw, Veronica. 2014. "Crafting and Uncrafting Relationships in Child and Youth Care: Human – More-Than-Human Encounters." In *With Children and Youth: Emerging Theories and Practices in Child and Youth Care,* ed. K. Gharabaghi, H.A. Skott-Myhre, and M. Krueger, 101–20. Waterloo, ON: Wilfrid Laurier University Press.

Petrov, Anton. 2014. "Using Minecraft in Education: A Qualitative Study on Benefits and Challenges of Game-Based Education." MA thesis, Ontario Institute of Studies in Education, University of Toronto. https://tspace.library.utoronto.ca/bitstream/1807/67048/1/Petrov_Anton_201406_MT_MTRP.pdf.

Science Daily. 2015. "Using Minecraft to Unboggle the Robot Mind." http://www.sciencedaily.com/releases/2015/06/150608120222.htm.

Stengers, Isabelle. 2003. "Introductory Notes on an Ecology of Practices." Symposium presentation at Australian National University Humanities Research Centre, Canberra, Australia, August.

– 2005. "The Cosmopolitical Proposal." In *Making Things Public: Atmospheres of Democracy*, ed. B. Latour and P. Weibel, 994–1004. Cambridge, MA: MIT Press.

Taylor, Affrica. 2013. *Reconfiguring the Natures of Childhood*. New York, NY: Routledge.

van Dooren, Thom. 2015. *On ferals*. http://thomvandooren.org/2015/12/05/on-ferals/.

Wernholm, Marina, and Sylvi Vigmo. 2015. "Capturing Children's Knowledge-Making Dialogues in Minecraft." *International Journal of Research and Method in Education* 38 (3): 230–46.

Yusoff, Kathryn. 2013. "Geologic Life: Prehistory, Climate, Futures in the Anthropocene." *Environment and Planning D: Society and Space* 31 (5): 779–95.

– 2014. "Geologic Subjects: Nonhuman Origins, Geomorphic Aesthetics, and the Art of Becoming Inhuman." *Cultural Geographies* 22 (3): 383–407.

4

Decolonizing Science Fiction, Performing Postcolonial Lines of Flight

Malisa Kurtz

> We lack creation. *We lack resistance to the present.* The creation of concepts in itself calls for a future form, for a new earth and people that do not yet exist.
> Deleuze and Guattari, *What Is Philosophy?*

In this chapter, I examine the ways in which science fiction (sf), perhaps more than any other popular genre, is a particularly useful medium for exploring what postcolonial resistances might mean in the era of multinational capitalism. This is so because sf emerges at the height of the imperial project, and many of its central tropes are deeply invested in colonial ideologies. Contemporary sf reveals the ways in which these colonial frameworks continue to affect today's neoliberal agendas. As authors, scholars, and fans alike are increasingly attuned to the dynamics of race, colonialism, and non-Western sf, the idea of "postcolonial science fiction" developed as a label for those texts emerging in the twentieth and twenty-first centuries that explicitly challenged the genre's imperial drive. Early theorizations of postcolonial sf therefore focused on deconstructing sf's relationship to colonialism, and scholars typically defined the subgenre as "science fiction texts that draw such explicit and critical attention to how imperialist history is constructed and maintained" (Hoagland and Sarwal 2011, 10). Recently, however, scholars have turned their attention to what exactly "postcolonial" means in the phrase "postcolonial sf," revealing the ways the subgenre is faced with many of the same problems

experienced by postcolonial studies – that is, does postcolonialism suggest that colonialism has already ended? Or does identifying a "postcolonial" sf replicate centre/periphery binaries that also risk the ghettoization of international sf? Furthermore, does setting up this centre/periphery binary (whether colonial/postcolonial or Global North/Global South) mask the potential of works that engage with the complexities of empire beyond the "talking back" paradigm of postcolonial theory?

In order to address these questions, I consider the ways postcolonial science fiction is not only a genre but also a process, strategy, or mode of relation between people committed to imagining less exploitative futures. I argue that postcolonial sf, in fact, transforms the genre's world building into a *strategy of postcolonial experimentation* that strives to understand the complexity of problems facing diverse global communities. Postcolonial sf therefore performs the important task of *deconstructing* the exploitative logic of colonialism and capitalism while simultaneously *constructing* alternative spaces of resistance by privileging a non-imperial ethics of relationality. This process of deconstruction and reconstruction in the genre thereby also reveals the ways "postcoloniality" (which connotes a historical time period or the end of formal colonialism) might best be conceptualized as an attitude or ethical view rather than as a historical time period or oppositional stance that reiterates centre/periphery binaries. In this chapter, I briefly examine how the way that sf is produced from diverse national contexts is in fact the expression of a transnational desire to understand such questions as: What do we need to do so that tomorrow is not characterized by the violence against others that we exhibit today? Or, more specifically, how can we create new visions of "postcolonialism" that will materialize into more ethical practice? Such questions are the expression of "careful forms of sociability" (Bignall 2010a, 220) that define postcolonial sf and thus are also representative of the ethical drive that characterizes this emerging subgenre.

I begin with a historical analysis of the emergence of science fiction in order to highlight the ways in which colonial ideologies are foundational to the genre's images and tropes. Examining the semantic/syntactic structures of sf as they relate to colonialism reveals that, while many of the semantic images of sf appear to change, the syntactic structures of the colonial gaze and "ideologies of progress" persist in contemporary articulations of the genre.[1] Thus, while, in the late twentieth century, sf increasingly focuses on the socio-economic

conditions of late capitalism (as most evident in the proliferation of cyberpunk, for instance,), postcolonial sf explicitly links the genre's colonial gaze to the logic of advanced capitalism. The first half of the chapter therefore focuses on the ways in which postcolonial sf decolonizes the genre in order to highlight persisting imperial structures in both science fiction and contemporary neoliberal contexts. The second half examines the ways in which postcolonial sf not only deconstructs sf's investment in colonial frameworks but also *reconstructs* science fictional tropes in order to perform more "careful forms of sociability" within texts as well within their reading communities. Using Gilles Deleuze and Félix Guattari's (1987) work on positive ontology as well as Simone Bignall's (2010b) work on non-imperial political agency, I outline the ways postcolonial sf articulates an alternative model of agency and social transformation. By asking what "postcolonial" futures might look like in worlds (both textual and actual) still defined by imperialistic relations, postcolonial sf forms a space of affinity between diverse social groups brought together by their mutual desire for alternative social relations. Postcolonial sf thus constructs a nomadic line of flight driven by shared ethical commitments to creating new futures.

DECOLONIZING SCIENCE FICTION

Science fiction is a particularly useful medium for exploring the relationship between colonialism and what Frederic Jameson (1991) defines as late capitalism, or the era of multinational capitalism. This is because science fiction consolidates as a genre in the late nineteenth/ early twentieth centuries in the wake of the European imperial project, and many of its central tropes inevitably reflect and contribute to colonial ideologies. As John Rieder (2008, 26) notes in his work on the emergence of sf, "colonialism" here refers to a fairly complex process, but "one of the most comprehensive and inclusive ways to think about colonialism is by way of its role in the construction of a world-wide, unified capitalist economy." The construction of a global economy is therefore a historical and epistemological project as genres such as science fiction reveal how colonialism "provides the impetus behind cognitive revolutions in the biological and human sciences that reshaped European notions of its own history and society" (Rieder 2008, 4). Using Larissa Lai's *Salt Fish Girl* (2002) and Lauren Beukes's *Moxyland* (2008), I examine the ways contemporary sf interrogates

and deconstructs sf's colonial frameworks. Furthermore, both novels link a critique of the sf's colonial gaze to the exploitative logic of advanced capitalism, revealing the ways in which, despite the supposed "end" of formal colonialism, many of colonialism's exploitative structures continue under a contemporary technoscientific empire. Postcolonial sf performs a historical analysis of specific generic tropes by outlining the transition from colonial power to the era of multinational capitalism in sf's genealogy.

Two generic frameworks in particular exemplify sf's close relationship to colonialism: its "colonial gaze" and its ideology of progress. Importantly, these two frameworks are central to both the genre's internal logic and the exploitative structures of empire. Sf's colonial gaze is one of the genre's most recognizable conventions, and it manifests narratively as a fascination with the exotic that is frequently constructed through the binary division between technologically superior observers/scientists and "native" or alien inhabitants. Where the colonial gaze in Victorian adventure fiction manifests as the gaze of the traveller upon "exotic" natives (e.g., Marlowe in *Heart of Darkness*), the colonial gaze in sf translates to the binary division between human/non-human (alien or posthuman) others. This is most evident in early sf focused on scientific travellers such as H.G. Wells's *The Time Machine* (1895) or Arthur Conan Doyle's *The Lost World* (1912). By constructing this dichotomy, narrative voice and power is given to the (white, male) observer while those positioned as alien "others" are often denied the same voice or complexity. As Rieder (2008, 7) says, the cognitive framework of the colonial gaze in sf "distributes knowledge and power to the subject who looks, while denying or minimizing access to power for its object, the one looked at." Jessica (2011, 3) expands on Rieder's work and argues that the dual poles of the colonial gaze – or what she calls the use of the "Stranger" and the "Strange Land" – are central signifiers for sf as well as "the very same twin myths of colonialism." This binary is also symptomatic of the Manichean relations that define colonial contexts, whereby a number of other ideological divisions emerge between conceptualizations of civilization and savagery, modernity and its past, and biological determination and cultural construction.

The ideology of progress is the second framework that structures both science fiction and colonialism. For Rieder (2008, 30), this second framework is the most defining feature of the relationship between sf and colonialism as "science fiction addresses itself to the ideological

basis of colonial practice itself, by engaging various aspects of the ideology of progress." Following Jameson's work, Rieder sees progress as a form of social memory required by capitalism and expressed through narratives about social development, growth, and expansion (29). In sf, the notion of technological development can often eschew political charges by appealing to the idea of "scientific progress" and global development. However, as Rieder points out, early sf reveals the ways scientific projects are also driven by a colonial ideology of progress as underpinning even "the most legitimate scientific endeavor" is the "common assumption that the relation of the colonizing societies [seen as more technologically advanced] to the colonized ones is that of the developed, modern present to its own undeveloped, primitive past" (30). Sf's focus on an evolved future exemplifies the same logic as the imperial expansionist project in its vision of "growth," expansion, and the building of new worlds. As I explore in more detail later, this future orientation is a means for creating imperialist relations (e.g., through the continued exploitation of the Global South for the development of the North), but it can also function as a site of resistance to imagining alternative futures. How sf narratives engage with the ideology of progress is thus important to considering the extent to which sf engages with the principles of colonialism.

While late twentieth-century science fiction may not depict the explicitly racist frameworks of yellow peril sf or the colour-blind futures of colonial adventure narratives, contemporary sf still continues to reiterate colonial ideologies in the new context of what Deleuze (1992) calls "societies of control." According to Deleuze, societies of control operate with computers, a technological evolution that has meant that means of production are no longer distinct spaces, privately or state owned. Instead, the multinational corporation replaces the factory. Thus, the "coded figures" of stockholders and banks signal that "the operation of markets is now the instrument of social control and forms the impudent breed of our masters" (Deleuze 1992, 6). Sf not only reflects this shift towards societies of control but also, in many ways, anticipates and contributes to its technological discourses. "The operation of markets" and "coded figures" of modernity are most clearly foregrounded in subgenres such as cyberpunk. Reflecting the space race in the 1960s and vast progress in computing technologies through the 1970s and 1980s, cyberpunk such as Gibson's foundational *Neuromancer* (1984) and Bruce Sterling's *Islands in the Net* (1988) depicts cyberspace as the

battleground of humanity's future. As Deleuze notes, such "invisible" mechanisms of control are not necessarily ones relating only to sf, and the shift to a corporate system marks new forms of domination. Thus, beginning with the emergence of cyberpunk in the 1970s and extending to the current explosion of films fascinated with artificial intelligence – such as Spike Jonze's *Her* (2014), Wally Pfister's *Transcendence* (2014), and Alex Garland's *Ex Machina* (2015) – the genre's increasing focus on information communication technologies is part of a larger cultural shift towards "capitalism of higher-order production" (Deleuze 1992, 6).

Despite the supposed end of formal colonialism (Indigenous communities in settler colonies such as Canada, the United States, and Australia might disagree), many of colonialism's exploitative structures therefore continue under the emergence of a "technoscientific empire." In the age of multinational capitalism, Istvan Csicsery-Ronay (2008, 244) argues that "an invisible imaginary imperial regime takes shape, one for which national borders are secondary obstacles. It is an Enlightened empire of shared commitments to instrumentality, justified by its promise of an ever-greater rationality and material abundance in the future." Csicsery-Ronay (2003, 236) notes that this global regime is maintained by the colonial impulse of material expansion and technoculture and that sf performs a critical role in mediating the transition from "colonial expansion to global imperial power predicated on technological hegemony" (Csicsery-Ronay 2008, 218). Such technological hegemony is therefore driven by the same ideology of progress (in this case in the name of "technological growth") as early colonial narratives. Similarly, the expansion of information communication networks appears independent of overt political ideology despite affecting all of social life. In many ways Csicsery-Ronay's work consolidates the work of other theorists concerned with late capitalism and the development of information communication technologies, including, for instance, Donna Haraway's (1991, 160) work on the "informatics of domination" and Manuel Castells's (1998) articulation of a network society that results in the rise of a "Fourth World" excluded from access to technological resources – essentially, the have-nots of the information age. Several postcolonial sf texts (including *Moxyland*, which I explore below) foreground the ways that the binary thinking of colonial ideology is translated into new forms of neocolonial rule between developed/developing countries, the First/Third World, and the Global North/South. In sf this

ideological division reveals the troubling conclusion that those who are unable to afford the latest technological tools will be left behind.

The consolidation of a technoscientific empire reveals that the colonial gaze and ideology of progress expressed in early sf also applies to contemporary sf even if current genre texts appear less imperialistic. Where early science fiction presented clearly demarcated boundaries between its (white) scientists and (non-white) aliens, late twentieth-century sf depicted a different array of alien "others" in the form of posthuman or technological others. In contemporary sf the changing semantic structures, or tropes, of sf do not necessarily signify the end of colonial regimes; rather, the binary logic of the colonial gaze is translated into new divisions between, for instance, the have/have-nots of informational capitalism, or the virtual/actual divide manifest in cyberpunk fictions. If early sf erased the complex history of race relations by depicting solely white societies and colour-blind futures, the inclusion of Japanese and East Asian characters in cyberpunk of the 1970s and 1980s does not necessarily signify a departure from the genre's colonial gaze. In fact, the frequent association of "Asian" identity and settings with high technology (in Gibson's *Neuromancer* or Ridley Scott's *Blade Runner*, for instance) points to a form of "techno-orientalism" in contemporary sf and technoscientific discourse. David Morley and Kevin Robins (1995) argue that racist assumptions have not disappeared with advancements in technoscience but, rather, are integrated into the technology itself. Depictions of Japanese technological dominance in cyberpunk, for instance, frequently reiterate Orientalist fears:

> Within the political and cultural unconscious of the West, Japan has come to exist as the figure of empty and dehumanised technological power. It represents the alienated and dystopian image of capitalist progress. This provokes both resentment and envy. The Japanese are unfeeling aliens; they are cyborgs and replicants. (Morley and Robins 1995, 170)

Even though cyberpunk might depict racially diverse futures, "the desire to conceptualize the East through a technocratic framework within cultural production leads to a re-articulation and re-emergence of the yellow peril" (Sohn 2008, 10) as Asian characters are often represented through racial frames that present them as cold, calculated, and emotionless "robots." Asian characters and settings in

contemporary sf therefore continue to reflect anxieties about the potential dominance of the "East."

Larissa Lai's (2002) *Salt Fish Girl* counters such yellow-peril and techno-orientalism in sf by depicting posthuman "Asian" characters who express more humanity and care towards others than do their corporate (human) designers. *Salt Fish Girl* is set in the near future along the west coast of Canada, and one of its primary narrative arches concerns the relationship between Miranda and Evie, who are both represented as characters of Asian descent even though Evie's genes have been spliced with those of freshwater carp in order to render her "nonhuman." Developments in genomics means that human genetics can be cloned and altered. Though it is considered illegal in the novel, multinational corporations are revealed to be creating genetically altered humans for work in their factories. Nextcorp, for instance, produces material goods such as shoes while also "producing" biogenetic material to create workers (called Sonias) for the company's shoe factories. Significantly, all factory clones/workers for Nextcorp have "brown eyes and black hair, every single one" (190). Evie, an escaped clone/worker, explains that this is because the genetic material from which she is made was acquired through the "Diverse Genome Project," which "focused on the people of the so-called Third World, Aboriginal peoples, and peoples in danger of extinction" (ibid.). Evie's posthuman othering is thus directly related to processes of racialization.

Salt Fish Girl's focus on posthuman figurations who are specifically racialized in these futures draws attention to the ways in which contemporary applications of genetic technology might continue to link processes of racialization with supposedly internal, inherent qualities. For example, posthumans who have "gone too far" in their genetic modifications are racialized because their lack of (white, healthy, "pure") recognizable bodies positions them as nonhuman. Asserting difference at the genetic level in this manner functions as a tool of subjugation in which race *is* technology, not only because it is purposely and culturally engineered but also because it is established through the supposedly neutral scientific fields of genetic engineering and the discourse of genomics. In fact, by using sf tropes in particular, Lai's novel points to the ways in which the language we associate with technology can also contribute to creating narratives regarding racial difference. In *Salt Fish Girl*, for instance, Evie is specifically "not human" because her "genes are point zero three per cent *Cyprinus carpio* – freshwater carp" (Lai 2002, 158). However, Evie "looks"

human, and Miranda does not suspect anything is different about Evie until this moment. Once Miranda learns about Evie's background, she notes: "She creeped me out. I may not be the most natural creature that ever walked the face of the earth, but there was something sordid about her origins" (158). Miranda's use of the word "natural" in opposition to Evie's "sordid … origins" positions Evie as a figure whose difference is established through her different roots. These roots are technological, the consequence of genetic manipulation of "human biomaterial" (158), though Miranda would never have known this had Evie not told her.

At the level of representation Evie's origin story functions as a means of establishing racial difference. On the one hand, this may appear to reiterate techno-Orientalist narratives because "high-tech Orientalism seeks to orient the reader to a technology-overloaded present/future … through the promise of readable difference" (Chun 2006, 177); hence, narratives often use racial others as signifiers of an unknown and uncertain future. However, Lai's novel undermines the equation of high technology with readable/racial difference by creating posthuman characters who are intentionally racialized for their *labour* rather than only for their exoticism. Lai's novel therefore performs the more complex task of linking colonial ideologies to the exploitative logic of advanced capitalism. Like the ideology that underpins colonialism's divide between civilization and savagery, colonizer and colonized, science fiction's alien and posthuman others are products of a racialized colonial gaze. This ideological division between civilization/savagery or human/nonhuman is central both to colonialism and to the structures of racialized capitalism, where the exploitation of people of colour is still a reality. Just as the colonial gaze is premised upon the binary between the one who looks and the one who is looked at, Rieder (2008, 110) points out that "the apologetic function of the concept of race does not depend on precise categorization, however, but simply on division itself." By reinforcing ideological barriers between human and "nonhuman" Sonias, Nextcorp can continue to use cheap labour and to exploit its workers with little regard for their well-being.

Like Lai's novel, Lauren Beukes's *Moxyland* (2008) critically examines the transition from colonialism to the consolidation of new technological empires and the continued exploitation of the Global South. It does this primarily by examining the ways in which access to corporate resources (mostly technological resources) are

determining factors for the ability of the novel's characters to survive a ruthless neoliberal state. Set in a near-future Cape Town, *Moxyland* is a post-cyberpunk text that follows four characters (Kendra, Lerato, Tendeka, Toby) from different socio-economic backgrounds. All four characters exemplify the ways in which human relations are supposedly improved by access to technoscientific resources when, in reality, such developments "facilitate unfettered capitalism's inherently destructive and mutagenic dynamism, which turns every sphere of experience, from fashion to labour, into commodities" (Csicery-Ronay 2003, 245). Kendra, for instance, demonstrates the biopolitical power of this near-future – as a "sponsor baby" (Beukes 2008, 7), she is a brand ambassador for a drink called "Ghost." Part of her job entails being injected with nanotechnology that brands her skin, marking her body with the corporation's logo and effectively rendering her a "product" of Ghost. A side effect of the nanotechnology is the development of her addiction to the drink, establishing her as both the perfect consumer and the perfect marketer. Using the vocabulary of science fiction, *Moxyland* makes literal the ways in which corporate power, as Hardt and Negri (2000) argue, "not only regulates human interactions but also seeks directly to rule over human nature" through the ways in which Kendra is marked and controlled by Ghost. At the end of the novel, when Kendra suggests she would like to end her contract with Ghost, she is killed by the company and thus treated as a disposable commodity.

Lerato also exemplifies the ways in which all forms of social life are turned into commodities under a neoliberal state – indeed, Lerato's ethical choices are defined by how they will strengthen her personal "brand" and enable her to move up the corporate ladder. Lerato is a computer programmer for Communique, a powerful multinational company. She is initially from the Rural (a place described as resembling the black townships outside Cape Town that have little access to technological resources), but Lerato's ability to ruthlessly navigate the corporate world and her programming work for Communique enable her to obtain privileges unavailable to other characters. As part of her desire for upward mobility, Lerato develops a personal brand (arguably much like Kendra's physical branding), immersing herself in creating an image as a corporate hacker. For example, Lerato performs sideline work with rebels against corporate control, but she does so only as a means to establish backdoor monitoring sites in order to strengthen her market value to future employers wanting to

learn more about Communique and its enemies – "Call it market research," she says (Beukes 2008, 111). Lerato also rejects forming personal attachments to people as they might hinder her progress up the corporate ladder, and she "can't afford to be coupled with someone who might hold [her] back" (144).

Moxyland therefore reveals how the exploitative logic of South African apartheid is translated into new binary divisions between the technological "haves" and "have nots" of a competitive, neoliberal world. Kendra's and Lerato's adoption of principles of instrumentality in a technoscientific regime exemplifies how the adoption of neoliberal principles regards human bodies and relationships as resources available for exploitation. Kendra's body and identity as an innovative artist is used by Ghost to promote their "fashionable" brand, while Lerato shapes her personal identity according to the needs of Communique's corporate goals. In order to escape poverty and the conditions of the Rural, both characters deem this commitment to technological change as necessary to their survival. Arguably, the exploitation of human bodies in this manner is an extension of colonial logic itself – apartheid's racial policies were deeply rooted in the struggle over South Africa's resources. Thus, by the time of deracialization in the 1990s, the country was already deeply divided by class structure. Adoption of neoliberal policies post-apartheid therefore only exacerbated existing class structures.

As briefly explored here, *Salt Fish Girl* and *Moxyland* deconstruct both sf's colonial gaze and the ideology of progress central to the genre's imperial drive. *Salt Fish Girl* and *Moxyland* can therefore be seen as exemplary of the ways in which postcolonial sf link a colonial gaze (manifest in both these texts as the alien/raced body) to contemporary socio-economic conditions (or the consolidation of global capitalism and increased divisiveness). In fact, as many postcolonial theorists have argued, through its very form postcolonial sf reveals the need to pay closer attention to "the discourses that underwrote the colonial project and that continue to inform neoliberal imaginings of a unified world (market), including 'civilization' and 'progress'" (Jefferess, McGonegal, and Milz 2006, 1). Though Hardt and Negri (2000) argue that today's empire does not resemble its imperial precursor, much contemporary sf reveals the ways in which colonial ideologies carry over and are reappropriated as neocolonial forms of subjugation through technoscientific means. Uneven access to information communication technologies, power over financial markets,

and the promotion of scientific rationalization contributes to the emergence of a technoscientific empire.

CONSTRUCTING A "POSTCOLONIAL" SCIENCE FICTION

In thinking about what unites postcolonial sf as a genre, scholars have been torn between two main approaches: one approach concentrates primarily on the ways in which the genre deconstructs colonial discourse, while the other emphasizes the ways in which postcolonial sf points to the very real economic and political process of decolonization in the Global South. For instance, *Moxyland* and *Salt Fish Girl* not only critique sf's colonial framework but are also attuned to the historical realities of the specific geographic regions of South Africa and of Canada's west coast, respectively. As scholars such as Jessica Langer (2011) and Eric D. Smith (2012) have acknowledged, a discursive/materialist divide characterizes both the challenges of defining a postcolonial sf and the challenges faced by postcolonial studies in general. Where a discursive approach to postcolonialism privileges questions of identity and epistemology, a materialist approach emphasizes the need to remain cognizant of local and material anti-imperial resistances. As scholars attempt to define postcolonial sf, many of the questions that have plagued postcolonial theory arise: does constructing the idea of a "postcolonial" genre revert to idealistic/exploitative identity politics, or, as Graham Huggans might say, does postcolonial sf market the margins?[2] Furthermore, can connections and a space of affinity be forged between different global visions of sf? Or does the subgenre necessarily revert to a form of cultural relativism? The bifurcation between discursive/material approaches is therefore problematic not only because it complicates how we understand postcolonial sf but also because it highlights what is at stake in definitions of postcolonialism that must choose between affirming difference through identity-focused approaches and maintaining a collective sense of agency against imperial violence in diverse geopolitical contexts.

I see two main reasons that scholars have struggled to define postcolonial sf and that discussions of the genre have replicated the discursive/material divide of postcolonial theory. First, there has been more emphasis on *deconstruction* in scholarly work on postcolonial sf and thus more focus on the genre's critiques of colonialism. This is a necessary and important project; however, it also elides the ways in which the subgenre emerges from the material practice of a

community of scholars, fans, and authors who are actively engaged in *constructing* futures (science fictional and otherwise) that are premised upon non-imperial, more equitable forms of relation. Furthermore, the emphasis on deconstruction is also symptomatic of a second, and perhaps primary, reason theorizations of postcolonial sf are often problematic: because they privilege dialectical philosophies of transformation grounded in the negativity of difference, attempts to theorize the genre remain complicit with colonial epistemological frameworks. Under dialectical frameworks, difference is seen as "lack" or negation and must, therefore, be suppressed or eliminated in enacting the desire towards unification. Simone Bignall argues this point most eloquently, explaining that dialectical philosophies of transformation in Western philosophical traditions replicate the very binary structures that postcolonial theory attempts to rethink. Bignall (2010a, 100) notes that "the model of dialectical process is problematic from a postcolonial perspective, since the trajectory is driven simultaneously by difference conceptualised negatively as lack or opposition, and by the desire to negate this difference in the movement towards unity and recognized presence." Thus, constructing postcolonial thought on the traditions of Western epistemology – which are founded upon necessarily antagonist relations between self and other – only continue to perpetuate imperialistic tendencies. For postcolonial sf this means the genre is caught between the problematic space of affirming the cultural and social difference of the genre while attempting to elide replicating a colonial gaze and marginalizing this "other" form of science fiction.

Gilles Deleuze and Félix Guattari's work offers a way of reorienting current discussions of postcolonial sf. Specifically, Deleuze and Guattari (1987) are key to reconceptualizing two main aspects of postcolonialism: first, their conceptualization of ontological difference can help redefine "difference" as a positive, creative force rather than as something negative, as a lack that must be overcome; and, second, their emphasis in *Anti-Oedipus* (1983) on desire as a produced, social mechanism helps position postcolonialism as an ongoing process and ethic. To begin with the first of these points, Deleuze and Guattari (1987) conceptualize ontology (bodies both human and nonhuman) as composed of varying internal and external relations. By doing so, they redress dialectical philosophies of transformation that consider the relationship between self and other as necessarily antagonistic or possessive (as evidenced, for example, in the work of

Hegel, Lacan, and even Fanon's postcolonial work). Specifically, they view ontology as a "double articulation" characterized by virtual and actual relations (Deleuze and Guattari 1987, 45). In this context, the virtual is conceived of positively as a chaotic force, "a pure plane of immanence, univocality, composition, upon which everything is given, upon which unformed elements and materials dance that are distinguished from one another only by their speed and that enter into this or that individuated assemblage depending on their connection, their relations of movement" (255). Virtual unity is "not the unity of substance but the infinity of the modifications that are part of one another on this unique plane of life" (254). Accordingly, virtual becoming is expressed in differentiated actuality, and thus actual being arises from bodies that develop, or become actual, along divergent paths on this plane of immanence. Importantly, incorporeal virtuality and the material act in concert as a "double articulation" (45), and this relationship is conceived of as productive of complex being and thus positively, rather than negatively, as a lack or absence that must be overcome.[3]

Furthermore, Deleuze and Guattari (1983) see desire as a produced, social mechanism, or as a social force between two or more bodies. As they note, "the truth of the matter is that social production is purely and simply desiring-production itself under determinate conditions" (29). For Deleuze and Guattari, desire is the product of encounters that increase the power of bodies to act, and their articulation of internal and external differences demonstrates the ways in which desire is constructed between bodies through the connections and affiliations they form. As Bignall (2010a, 146) points out, seeing desire as a social mechanism is important for postcolonial thought as it begins to outline how, "firstly, the material disunity or disadvantage in post-colonial society is itself the creation of desire; and secondly, postcolonial reconciliation must therefore involve a transformation of material reality, at the level of desiring-production." In an insightful move, Bignall (2010b, 100) uses Deleuze's theory of embodiment to construct a notion of postcolonial agency that "incorporates a positive and creative role for ontological difference and gives rise to an ethic of joyful sociability based on material practices of self-awareness, listening respect and attentiveness to the other." For Bignall, through the conscious practices of "self-awareness, listening respect and attentiveness to the other" there emerges a common commitment, or attitude, towards fostering mutual understanding and non-imperial

interpersonal ethics conducive to creating the postcolonial ethos necessary for less violent, more equitable futures.

Seeing postcolonialism as premised upon a shared ethical commitment is central to reimagining the truly productive potential of postcolonial sf. Rather than seeing the genre as yet one more way capitalism appropriates and resells difference by marketing the margins, postcolonial sf can be seen as the manifestation of a collective ethos, or desire, to imagine lines of flight from the colonial logic that binds us. For example, while genre scholars generally acknowledge that "genres are not inert categories shared by all ... but discursive claims made by real speakers for particular purposes in specific situations" (Altman, 1984 101), discussions of postcolonial sf also need to consider the risks of attempting to define postcolonial sf as specifically "non-Western" science fiction, thereby erasing the socio-political complexity of texts such as Alex Rivera's (2008) film *Sleep Dealer*. *Sleep Dealer* takes place at the San Diego/Tijuana border in a near-future where *maquiladoras* host Mexican workers who remotely control robots working in the United States. Foreign labour is therefore used without the need to "see" or interact with actual workers. While *Sleep Dealer* is critical of Mexico/US border relations and the exploitation of immaterial labour from Mexican cyber-workers, *Sleep Dealer* also articulates the biopolitical nature of global capitalism. The film's critique of migration and labour is certainly specific to the context of the Mexico and NAFTA, but it also expresses affinities with migrant workers in the Global South generally whose raced/gendered social positions render them particularly vulnerable to the exploitative frameworks of neoliberal capitalist regimes and anti-immigration racism.

Furthermore, postcolonial sf such as *Sleep Dealer* exposes the immanent potential for utilizing the very tropes of sf to construct lines of flight from the genre's imperial logic. Hence, *Sleep Dealer* draws on the science fictional trope of robots used as labour in order to reveal how the same virtual networks, which permit this exploitation, also enable two characters to form an affective connection across cultural differences. Memo is a Mexican worker whose father is killed by a US drone supposedly "protecting" the privatized water resources of Santa Ana Del Rio. The US drone operator who kills Memo's father, Ramirez, is haunted by his role in the attack. Drawn to the Mexican border, Ramirez attempts to find Memo, and through a series of videos about Memo that have been posted online by his friend Luz, he is eventually able to find and connect with him. To briefly summarize

a rich and complex story, Ramirez eventually helps Memo break the Del Rio Water dam, which has privatized water and led to drought in the Mexican villages below it. Upon damaging the dam's barrier, the river is able once more to flow to the drought-stricken areas of Memo's village. The film, while clearly a critique of migrant labour and the exploitative conditions of late capitalism, also permits a counter-narrative in which Memo and Ramirez are able to connect through the very resources (information communication technologies) that constrain them. Importantly, however, Memo and Ramirez must work together to achieve this – in order to find mutual ground, Ramirez has to first recognize that he wants to rectify his mistakes and listen to Memo, and Memo must be willing to use the tools of modernity (the network) to suit his own purposes. Working through the boundaries the separate them, Memo and Ramirez work against capitalism's tendency towards increased divisiveness and competition.

Memo and Ramirez therefore exemplify the ethical project that Bignall (2010b, 206) points out is crucial to a postcolonialism not founded upon imperial frameworks: they partake in the "the practice of an attitude of listening respect," where desire manifests as a social interaction between two bodies that realize their power to create more joyful, productive encounters. Both Memo and Ramirez recognize their situated differences as people from different sides of the US/ Mexico border, but through attentiveness to their material differences as well as willingness to listen to other perspectives, Memo and Ramirez create common notions that result in their ability to act against Del Rio Water and to support Memo's local community. Their act, in fact, represents the ways in which social production is "desiring-production itself under determinate conditions" (Deleuze and Guattari 1983, 29). Bignall (2010b, 207) argues that recognizing individual and collective desire as inseparable is critical as "this means that widely practised individual performances of a postcolonial ethos become actualised as the collective phenomenon of postcolonial society: the institutions, structures and modes of discourse and thought that make possible the public performance of a postcolonial ethos and, in turn, provide the context for the ongoing constitution of postcolonial subjectivity." By constructing critical alternatives to the epistemologies of empire and by collectively building common practices towards alternate futures, Memo and Ramirez create a postcolonial mode of relation. "Postcolonialism" in *Sleep Dealer* is therefore defined by the ways difference itself is seen as an *affirmative*

relationship, created through the ability of disparate bodies to construct common notions towards more joyful, non-imperial practices of relationality. If postcolonialism is therefore the construction of an attitude, rather than simply a critique, then "it is an attitude of friendly relation or sociability, which becomes sensible only in terms of collective participation" (Bignall 2010b, 206).

The emphasis on creation, constructing common notions, and collectivity is significant for understanding not only postcolonialism as process but also for considering the ways postcolonial science fiction is a strategy of postcolonial experimentation. Authors, fans, and scholars alike use the conventions of the genre to actively *create* the conditions of postcoloniality. Thus, scholars of postcolonial sf must themselves be attuned to the dangers of reiterating a colonial gaze in their analysis of the genre. Specifically, by conceiving of desire as the actualization of concrete relations, one sees that perhaps a concrete definition of postcolonial sf is not only impossible but also undesirable. In other words, thinking of the subgenre as an assemblage recognizes both the genre's actually existing texts and the possibilities inherent in using these texts in new and creative ways. Confining the body of postcolonial sf to a set of textual qualities prevents the creative potential of the genre from developing new ways of understanding postcolonialism beyond its material/discursive and global/local divides. Accordingly, one of the reasons postcolonial sf might be particularly useful has to do with its ability to produce new ways of understanding postcolonialism, reorienting old frameworks that have confined the possibilities for merging postcolonial theory with democratic practice. It is not only about what postcolonial sf texts might "stand for" but also about what thought/action they could foster and promote, or what postcolonial sf might be able to *do*. So far, the genre has brought together authors, fans, and scholars from such diverse contexts as South Africa, Canada, the United States, India, and Japan to name but a few places in which communities have engaged with the idea of postcolonial sf. Explorations of globalization, then, might benefit from thinking/looking through the lens of science-fictionality, where creative projects function as ethical experiments towards mapping out the possibilities of transnational affiliation.

Several sf authors are already, knowingly or not, part of this communal project moving towards exploring the potential shared definitions and workings of a "postcolonial" world. Ian McDonald, for instance, is an sf writer from Northern Ireland whose work exemplifies

a nomadic politics of location. His novels frequently take place in the Global South, ranging from Kenya in *Evolution's Shore* (1995), India in *River of Gods* (2004), to Turkey in *The Dervish House* (2010). When asked in an interview about his use of so-called "Third World" settings, McDonald responds:

> I'd use the expression "Third World" only in the sense that I include Northern Ireland as a Third World country: a society of two significant social groups that have been set against each other by historical engineering; a skewed economic infrastructure based on the public sector, with a highly economically significant samurai elite (the RUC) ... a post-colonial process of disengagement that failed half-way through; physical marginalisation ... the sense of cultural inferiority that forces both social groups into re-engineering of their cultural tropes ... My point is, there's more dynamic for change in "Third World" societies than in the West. (Gevers 2001)

His use of non-Western settings is not cultural appropriation (for which he is sometimes criticized) but, rather, insightful critiques of the complex dynamic and force between the Global North and the Global South.

Like Rivera, McDonald frequently uses the megatext of sf, reworking sf icons, tropes, and themes in order to simultaneously deconstruct sf's colonial gaze while creating visions of alternative, non-imperial futures. *Evolution's Shore* (1995), for instance, follows in a tradition of alien invasion narratives. In a near-future setting, Kenya is invaded by an alien life form known as the Chaga. *Evolution's Shore* reveals persisting imperial and patriarchal structures through global responses to this "disaster," and it becomes a scathing critique of UN policy and US military dominance. However, McDonald's text does more than simply invert prevailing hierarchies between the Global North and the Global South. By presenting a benevolent alien and an exploitative UN funded by biotech corporations, *Evolution's Shore* destabilizes the epistemological foundation of the colonial gaze, challenging the binary logic of Western epistemology and practice. As part of this critique it presents an alternative to capitalist ways of living by constructing new communities inside the alien, which has the unique ability of adapting to the needs of its inhabitants by creating new, free food sources based on an

individual's needs. As the novel's protagonist, Gaby, notes, she "did not wonder the Western industrials wanted it ring-fenced. The Chaga's Grace Abounding was the denial of consumer capitalism," an "insidious Eden where everything may be had by reaching out to take" (Macdonald 1995, 212). Money has no use in such environments. Furthermore, the Chaga's constant metamorphosis means that the communities that develop within the Chaga must also learn to constantly rethink and restructure their social knowledge – eventually, they must even come to accept the emergence of "Changed" humans who have become physiologically changed by the alien. *Evolution's Shore* presents an alternative to capitalist ways of living and moves towards a more ethical and empowering account of the other by transforming the figure of the alien. As his novel exemplifies, McDonald is committed to a nomadic politics that challenges exclusionary and exploitative visions of difference.

Similarly, Geoff Ryman's development of "mundane" sf is a project that attempts to imagine new ways of living in the world and thus, also, new ways of engaging with sf's imperial past. Ryman's mundane/postcolonial fusions, in fact, provide a line of flight from the fantasies of disembodiment that plague cyberpunk (and thus emphasize the importance of materialist, postcolonial critiques). The mundane movement differs from traditional notions of sf in the "dream" that it strives towards. Ryman (2007) identifies the "mass market SF" dream as one of escape, of leaving earth, the body, and death behind. The mundane movement, however, does not buy into this dream. Instead of partaking in typical sf tropes, mundane sf includes "no FTL [faster than light], no FTL communications, no time travel, no aliens in the flesh, no immortality, no telepathy, no parallel universe, no magic wands." It is a movement "not just about a near future, but also a far future, one in which there are new wonders to take the place of the old ones … a future in which things really change … These new humans won't be us … They will not be us because they value different things, speak differently, think differently, and respond differently in emergencies." Mundane sf is specifically grounded on earth, focusing on the social, cultural, and ontological changes that may occur in an increasingly technological and information-based world. Ryman's (2004) novel *Air: Or Have Not Have*, for instance, explores the struggles of Chung Mae, a young woman whose village (located somewhere in Central Asia) is one of the last places to go online. Mae must fight against the patriarchal oppression of her own government

and the global hegemony of corporate technologies as she attempts to use the internet to provide for her struggling community. Bould and Vint (2011, 197) explain that *Air* "explores issues of cultural specificity and hegemony," addressing "the transformative effects of information technologies and economic globalisation on human social existence, but it significantly decentres the perspective of Western, technological elites." Ryman's mundane sf reflects his belief that technology is a constantly changing force of human relations and that technoscientific development will contribute to the continuation of a "Fourth World" if we do not recognize the colonial frameworks implicit in our ideologies of progress.

McDonald and Ryman have very different perspectives on the type of sf they write. Their projects, however, share the same desire to imagine the world differently and to find a space in an increasingly technoscientific empire in which to engage positively and ethically with different subjectivities. The space of constructivism is found primarily in their image of the "future" human, thereby also simultaneously reorienting how sf constructs the image of the posthuman "other." Specifically, McDonald's text ends with the vision of an "alien"-infested future, and Ryman's novel ends with the birth of a "monstrous" child of the future who is born blind and physically changed. These future beings are different ontologically and epistemologically because they emerge out of the creation of new common notions between different communities, whether these communities comprise culturally different or ontologically different aliens. No matter the kind of "body" presented in the McDonald and Ryman's texts, all characters are required to exhibit the kind of listening respect essential to non-imperial relations – survival in these futures is determined by the ability of communities to construct these relations. Furthermore, by creating characters attuned to the discursive, material, and historical exploitation of "difference," McDonald and Ryman redress sf's colonial framework while calling for the need to address the genre's complicity in focusing on authors and scholars from the Global North. Thus, McDonald's and Ryman's work actively seeks to construct an understanding of the postcolonial "which then opens onto the concrete task of performing non-imperial interpersonal ethics as well as the strategic material transformation necessary for the expression of postcolonialism as a collective social ethos" (Bignall 2010a, 207). A postcolonial sf will therefore be attuned to both the

genre's internal tropes and the ways in which authors, scholars, and fans are accountable for creating a collective, postcolonial ethics.

CONCLUSION

What distinguishes contemporary postcolonial sf from texts previously engaged with questions of cosmopolitanism is its ability to oscillate between the historical realities of specific geographic regions (as Beukes does in South Africa or Rivera in Mexico) while imagining their possible futures. These futures are hardly ever perfect, but they reveal transformation as immanent and commitment as necessary with regard to shaping more ethical futures. For instance, in the recent endeavour to define postcolonial sf a wide variety of authors have been put forward as examples of the subgenre, including Ursula K. Le Guin and Robert Heinlein. While Le Guin may certainly exhibit a cosmopolitan ethics in her work, particularly in the Hainish Cycle, she does not explicitly draw on specific historical settings in the ways that authors such as Ian McDonald (in the context of Kenya or Turkey), Lauren Beukes (in South Africa), or Vandana Singh (in the context of India) do. Postcolonial sf film is also a growing field, with films such as Wanuri Kahiu's short *Pumzi* (2009), Neill Blomkamp's *District 9* (2009), and Gareth Edwards's *Monsters* (2010). These authors and filmmakers exemplify a movement that uses the discourse of science fiction to engage with the local singularity in which texts are produced while simultaneously recognizing the commonality of "our plural collective planetary condition" (Hardt and Negri 2005, 126). By reassembling the genre's conventions, postcolonial sf challenges sf's complicity with colonial ideologies and their troubling reiterations in the contemporary contexts of empire.

Accordingly, if postcolonial sf is a body of texts composed of complex, rhizomatic parts functioning in concert as a strategy of resistance, then it has much in common with Hardt and Negri's "multitude." Hardt and Negri (2005, 100) define the multitude as "internally different, multiple social subject[s] whose constitution and action is based not on identity or unity (or, much less, indifference) but on what [they have] in common." The project of the multitude is premised upon the openness and willingness of diverse communities to communicate, collaborate, and commit towards a common political process (106). Simone Bignall (2010a, 207) notes that, while Hardt and

Negri's definition of what the multitude might look like is fairly vague, evidence of the emergence of the "common" might actually be seen in the political standpoint of postcolonialism, and she attempts to outline this collective social practice. I see postcolonial sf as the physical manifestation of this project in which a subgenre has emerged out of the ethical commitment among a diverse group of writers, scholars, and fans alike. Positioning itself between the boundaries of the real and the speculative, the present and the future, postcolonial sf dismantles the regulatory fictions of colonial practice while creating space for dialogue about what postcolonial relations might look like. For several of the authors explored here, this means not only critiquing the continuation of colonial frameworks but also engaging in "a common commitment to creating the mutual understandings and the social conditions that reflect, develop, reinforce and support the idea and the attitude of postcoloniality" (Bignall 2010a, 207). The importance of exploring a notion of postcolonial sf therefore lies not simply in diversifying the genre; rather, the importance of the genre lies in its ability to realize the emergence of communities actively engaged in giving meaning to "postcolonialism" and, thus, actively engaged in constructing the conditions for more ethical relations and material practice in our collective, global future.

NOTES

1 I draw here on Rick Altman's (1999, 10) semantic/syntactic approach to film genre, where "traits, attitudes, characters, shots, locations, sets, and the like … [stress] the semantic elements which make up the genre," while the "constitutive relationships between undesignated and variable place-holders … might be called the genre's fundamental syntax." In other words, "The semantic approach thus stresses the genre's building blocks, while the syntactic view privileges the structures into which they are arranged" (ibid.). For an expanded discussion see Altman's *Film/Genre* (1999).

2 See for instance *The Postcolonial Exotic: Marketing at the Margins*, in which Graham Huggan (2001, 6) identifies the tensions between what he calls "postcolonialism" as "loosely enabled oppositional practices" and "postcoloniality" as the commodification of postcolonial discourses and its "regime of cultural value" in advanced capitalism.

3 I do not have the space here to explore the relationship between the virtual and the actual in detail, but establishing ontology as a "double

articulation" is crucial to understanding the possibility of immanent change manifest in the actual and, consequently, the transformative potential of Deleuze and Guattari's thought. For more, see in particular Deleuze and Guattari (1987, chap. 10) or Deleuze (2001).

REFERENCES

Altman, Rick. 1984. "A Semantic/Syntactic Approach to Film Genre." *Cinema Journal* 23 (3): 6–18.

– 1999. *Film/Genre*. London: BFI.

Beukes, Lauren. 2008. *Moxyland*. Nottingham: Angry Robot.

Bignall, Simone. 2010a. *Postcolonial Agency: Critique and Constructivism*. Edinburgh: Edinburgh University Press.

– 2010b. "Affective Assemblages: Ethics beyond Enjoyment." In *Deleuze and the Postcolonial*, ed. Simone Bignall and Paul Patton, 78–102. Edinburgh: Edinburgh University Press.

Bould, Mark, and Sherryl Vint. 2011. *The Routledge Concise History of Science Fiction*. New York: Routledge.

Castells, Manuel. 1998. *The Information Age: Economy, Society, and Culture*. Vol. 3: *End of Millennium*. Malden, MA: Blackwell.

Chun, Wendy Hui Kyong. 2006. *Control and Freedom: Power and Paranoia in the Age of Fiber Optics*. Cambridge: MIT Press.

Csicsery-Ronay, Istvan Jr. 2003. "Science Fiction and Empire." *Science Fiction Studies* 30 (2): 231–45.

– 2008. *Seven Beauties of Science Fiction*. Middletown, CT: Wesleyan University Press.

Deleuze, Gilles. 1992. "Postscript on the Societies of Control." *October* 59: 3–7.

– 2001. *Spinoza: Practical Philosophy*. Trans. Robert Hurley. San Francisco: City Light Publishers.

Deleuze, Gilles, and Félix Guattari. 1983. *Anti-Oedipus: Capitalism and Schizophrenia*. Trans. Robert Hurley, Mark Seem, and Helen R. Lane. Minneapolis: University of Minnesota Press.

– 1987. *A Thousand Plateaus: Capitalism and Schizophrenia*. Trans. Brian Massumi. Minneapolis: University of Minnesota Press.

Gevers, Nick. 2001. "Future Remix: An Interview with Ian McDonald." *Infinityplus.co.uk*.

Haraway, Donna. 1991. "A Cyborg Manifesto: Science, Technology, and Socialist-Feminism in the Late Twentieth Century." In *Simians, Cyborgs and Women: The Reinvention of Nature*. New York: Routledge, 1991.

Hardt, Michael, and Antonio Negri. 2000. *Empire*. Cambridge, MA: Harvard University Press.

– 2005. *Multitude*. New York, NY: Penguin Group, 2004.

Hoagland, Ericka, and Reema Sarwal. 2011. *Science Fiction, Imperialism and the Third World*. Jefferson, NC: McFarland.

Huggan, Graham. 2001. *The Postcolonial Exotic: Marketing at the Margins*. New York: Routledge.

Jameson, Fredric. 1991. *Postmodernism, or, the Cultural Logic of Late Capitalism*. Durham, NC: Duke University Press.

Jefferess, David, Julie McGonegal, and Sabine Milz. 2006. "Introduction: The Politics of Postcoloniality." *Postcolonial Text* 2 (1): 1–6.

Lai, Larissa. 2002. *Salt Fish Girl*. Toronto: Thomas Allen.

Langer, Jessica. 2011. *Postcolonialism and Science Fiction*. New York: Palgrave Macmillan.

McDonald, Ian. 1995. *Evolution's Shore*. New York: Bantam Books.

Morley, David, and Kevin Robins. 1995. *Spaces of Identity: Global Media, Electronic Landscapes and Cultural Boundaries*. London: Routledge.

Rieder, John. 2008. *Colonialism and the Emergence of Science Fiction*. Middletown: Wesleyan University Press.

Rivera, Alex, dir. 2008. *Sleep Dealer*. This Is That Productions and Likely Story.

Ryman, Geoff. 2004. *Air (Or, Have not Have)*.New York: St Martin's Press.

– 2007. "Take the Third Star on the Left and on til Morning!" Mundane-SF. http://mundane-sf.blogspot.com/2007/09/take-third-star-on-left-and-on-til.html.

Smith, Eric D. 2012. *Globalization, Utopia, and Postcolonial Science Fiction: New Maps of Hope*. New York: Palgrave Macmillan.

Sohn, Stephen H. 2008. "Introduction: Alien/Asian: Imagining the Racialized Future." *Melus* 33 (4): 5–22.

PART TWO

Aesthetics and Resistance

5

The Blues as Minoritarian Vernacular

Mark Bishop and Hans Skott-Myhre

In his text *Blues, Ideology and Afro-American-Literature* Houston A. Baker Jr (2013, 11) proposes a vernacular of expression rooted in what he calls "expressive geographies." Citing James Alan McPherson, he suggests that blues is a vernacular form that coalesces history, geography, aspiration, and struggle that is transformed as it engages flows of people and modes of production. He notes McPherson's example of the locomotive steam engine as a mode of new technology that evoked reactions from both emerging capitalists and, conversely, writers such as "Melville, Hawthorne and Thoreau" (ibid.). At another level, however, "To a third group of people, those not bound by the assumption of either business or classical traditions in art, the shrill whistle [of the steam locomotive] might have spoken of new possibilities" (ibid.).

McPherson argues that the American vernacular was comprised of this third group; a group of "backwoodsmen and Africans and recent immigrants" (Baker 2013, 11). Baker notes that African-Americans were at the bottom of what he terms "the vernacular ladder" (ibid.). For them the sound of the steam whistle opened possibilities of economic opportunity and the possibility of artistic expression through the introjection of this emerging technology into the vernacular form of a new kind of music. This music Baker tells us came from "the locomotive's drive and thrust, its promise of unrestrained mobility and unlimited freedom" (ibid.).

To set the context Baker notes that, at the historical moment of the locomotive steam engine, the blues musician was at a crossroads between modes of production in which their own bodies had been recently embedded as the very machinery upon which European and

American capitalism had founded itself. The early delta blues, with its erratic rhythmic style and idiosyncratic delivery, marked the force and creative geography of the slave economy, just as the emerging blues style would signal the advent of industrial production, the flows of populations north, and the engagement with urbanization. Baker (2013, 11) states: "The signal expressive achievement of blues, then, lay in their translation of technological innovativeness, unsettling demographic fluidity, and boundless frontier energy into expression."

In their final book, *What Is Philosophy*, Deleuze and Guattari (1996) also note a connection between geography and artistic creativity. Writing towards an explication of philosophy as the production of concepts on a plane of immanence, they draw a connection between the earth as a territorializing/deterritorializing force and the revolutionary force that has the capacity to bring forth a new earth and a new people. They suggest that it is upon the geography of the earth that territories are produced, peoples are constituted and dissolved, and complex intersections of technology and consciousness forged. Art, in this context, has the capacity to engage a particular form of revolt. Such a revolt is expressive and is premised upon sensation and an engagement with chaos. Deleuze and Guattari tell us that the artist must enter fully into chaos and emerge with a sensate composition comprised of the elements of a given historical moment in such a way as to produce the infinite.

In this, however, art is not bound by any form of historical materialism, although it draws from elements of production and dissolution derived from a particular moment. Instead, art expresses something that does not yet exist. Such a form is created through the contingent force of a particular geography, which is composed out of disparate flows and historic ruptures and is never still. Such a plane of composition constitutes a body without organs – that is to say, a virtual body. Art is that which can be distilled through an encounter with the strata of a becoming moment and the body without organs.

Art, then, as a form of revolt, takes on what Deleuze and Guattari call a resistance to the present. Such a resistance, though, is a gesture neither to the utopic nor to the nostalgic. Rather, it is an extensivity that cracks finite temporality through the infinitely becoming field of the sensate, which never remains in the present frame but is always extending into the next sensation that is already occurring as the past one fades. This dynamic overlapping of sensate being opens the organism to the virtuality of the infinite.

The pathway for the artist to art as revolt or resistance to the present passes through what Deleuze and Guattari (1996) term catastrophe. The catastrophe for the artist is the plunge into chaos from which there is never any assurance she or he will return. The opening to this pathway is to be found in the particular geography upon which the artist moves and that constitutes her/his work. It is discovered in what Deleuze and Guattrai (1996) refer to as the abominable sufferings of others. It is the resistance to such suffering that signals the advent of a new people, a new world. The artist, however, cannot bring forward a new people. What the artist can do is to summon and forewarn the creation of a people not yet formed.

Art as resistance summons forth the minoritarian vernacular (Deleuze and Guattari 1987). Such a vernacular is premised on the struggles and aspirations of those whose force consistently oversteps the majoritarian rule of command and control either through their constitutive inability to conform or their excess of living force. The Blues, we would argue, contains such a vernacular, composed, as Baker suggests, out of what Deleuze and Guattari (1987, 106) call "minority elements." Art becomes revolutionary by "connecting" and "conjugating" such elements and constituting "a specific, unforeseen, autonomous becoming" (ibid.). In this art propagates the "seeds" and "crystals" of minoritarian becoming, "whose value is to trigger uncontrollable movements and deterritoralizations of the mean or majority" (106).

Art, for Deleuze (Grosz 2008), is not a system of representation whereby a series of iconic events functions to give meaning through a process of semiosis. Rather, art acts as a generator of intensities, sensations, and affects that establishes a set of relations between the human body and the forces of nature. Art results in more than the mere instilling of a satisfactory experience, "[it] enables matter to become expressive, to not just satisfy but also to intensify – to resonate and become more than itself" (Grosz 2008, 4). An artwork is the organized structure of the materials in use, the creation of a particular mode of existence through which these materials produce and intensify sensation (ibid.).

BROKE DOWN ON THE BRAZOS

The relation between the Texas river called the Brazos and the blues might well constitute just such an artistic assemblage of geography and modes of existence as a "set of relations between the human

body and forces of nature." Of course, the Brazos River existed prior to colonial settlement, but, with the advent of colonization, we would argue that, over the span of the last two hundred years, the river takes on an emblematic role in its relation to colonial, industrial, and postmodern modes of production. We hope to show how the artistic expression of these transitions through the medium of musical form has centred the geography of the river as a site of human suffering, resistance, revolt, and flight up to and including our current historical moment.

Writing on the blues in 1952, Sterling Brown (1952) opens with the moment that the noted ethno-musicologist Alan Lomax first heard the blues. It was a woman singing on a levee along the Brazos River. This moment along the Brazos was to open the world of the blues to what was to become a complex and in many ways problematic relation with what would become ethnomusicology. The relation of the geography of the Brazos River to the musical expressions of those living and working on it figures prominently in any history of Texas blues for primarily two reasons: first, at one point every prison in Texas was along its banks; second, it was the site of cotton and sugar cane production – a particularly brutal mode of production that involved large numbers of convicts and African American labourers.

The Brazos River may be most famous in its relation to the blues for the song "Ain't No More Cane on the Brazos." In this song, also known as the "Texas Prisoners Cane Cutting Song," the lyrics reflect the harsh and desperate life of inmates along the river.[1] In one verse the singer calls to the boss not to do me like he did "poor shine." The boss bullied him till he went blind. The song goes on to say that in 1904 you could find a dead man in every row of cane. In 1910 they drove the women like they did the men. The song concludes with:

Wake up, dead man, an' help me drive my row,
Help me drive my row
Wake up, dead man, an' help me drive my row.
Oh, oh, oh, my row.
There's some in the building and some on the farm,
Some in the graveyard and some goin' home,
Wake up old lifetime, hold up your head,
Why, you may get your pardon, but you may drop dead.

Go down, Ol' Hannah, doncha rise no mo',
If you rise in the mornin' bring Judgment Day.

Consistent with the argument above that the blues is an expression
of struggle in a specific geography and is reflective of a particular
mode of production, we can see that "Ain't No More Cane on the
Brazos" contains all these elements. It is also an expression of what
Deleuze and Guattari refer to as the abominable sufferings of others
that presage the coming of a new people. The referencing here is
to the importance of having your old lifetime before prison giving
you the strength to hold up your head regardless of the judgment of
the dominant society that may give you a pardon or kill you. We can
see the contingency and the plunge into chaos in the verses that note
the dispersion of labour with some in the building and some on the
farm, some in the graveyard and some going home. In the final stanza
old Hannah refers to the sun going down, but the singer calls for it
not to rise until the morning brings judgment day. If we read this
through a Deleuzo-Guattarian lens we can see the summoning of a
new earth and a new people and the end of the earth, as we know it,
on the Brazos River.

The Brazos also figures in the Lyle Lovett (1987) song "Walking
through the Bottomland," a Texas waltz about an ill-fated murderous
love affair between an East Coast woman and a Texas cowboy. Here
again we can see the song as reflective of the issues, struggles, and
tensions of cultural dislocation and the struggles of encounters across
gender and social expectation. While the song is generally known as
a country song, the chorus, interestingly enough, cites the blues, again
in the context of the Brazos.

Sing me a melody
Sing me a blues
Walk through the bottomland without no shoes
The Brazos she's running scared
She heard the news
Walk through the bottomland without no shoes

The events of the song are opaque and riddled with anxious tension
and the probable murder of the cowboy by his lover. The chorus calls
on the Brazos as a space of desperation and fear. As the woman runs
across the bottom land of the Brazos after burying her lover in the

cold clay, the fact she has no shoes adds an element of contingent suffering and terror.

BLUES AND THE BRAZOS UNDER
POSTMODERN CAPITALISM

Gov't Mule (Haynes 2009) echoes the Brazos River as a space of anxiety, subjugation, suffering, and alienation in the song "Broke Down on the Brazos." As opposed to our previous examples, the musical form of this song is entirely contemporary (about which we will have more to say later). Gov't Mule is a southern rock jam band that originated as a side project to the Allman Brothers. Of course, the Allman Brothers were steeped in traditional blues forms as well as Southern Rock, and Gov't Mule has built on the improvisational form of the blues by adding elements of funk and blues rock. For this particular song the band brought in Billy Gibbons from the band zz Top because they said that they heard his boogie-style blues guitar as they wrote the song (Bosso 2010). One might assume that, since Gibbons is also from Texas, he is schooled in the blues of the Texas Delta, including the blues of the Brazos region. Certainly there are traces of all these forms in his Texas boogie style writing and playing in zz Top.

"Broke Down on the Brazos," we would argue, is another example of how the blues interjects the elements of geography and production in order to summon a form that is not yet. The lyrics evoke a sense of postmodern contingency, alienation, and psychic dislocation.

> Surrounded by strangers
> All my friends are gone
> I ain't had the blues yet today
> But I can feel them coming on
> Everywhere I go
> Trouble's all I find
> No matter what I do
> I feel like I'm losing my mind
> Broke down on the Brazos
> Broke down on the Brazos
> Broke down on the Brazos
> Living in a dream
> Chasing a sound

Told everybody I believe
I'm Texas bound
Here I am
Well, I guess it's no surprise
Up to my knees in water
Up to my ears in dragonflies
Broke down on the Brazos
Broke down on the Brazos
About to lose my mind
About to lose my mind

In *What Is Philosophy* Deleuze and Guattari (1996) cite the moment
of catastrophe as a crisis in the relation of the friend. They suggest
that, in the moment of catastrophe, the philosopher (and, one might
infer, the artist) becomes a stranger within his home geography. This
strangeness is compounded by the fact that it is the result of the
alienation of his own sense of belonging. One no longer belongs to
one's own people, one's own land. The catastrophe makes it impos-
sible to sustain any society of friends. We would argue that this is the
initial moment in "Broke Down on the Brazos," where we are imme-
diately thrown into a dystopic moment in which the singer is "sur-
rounded by strangers, all my friend are gone."

In the earlier examples of blues on the Brazos, we argue that it is
the modes of production that deeply influence both the musical
form and lyric content of the blues. In both "Ain't No More Cane"
and "Walking through the Bottom Land" the predominant modes of
production were slavery and prison labour operating at the historical
hinge between agriculture and industrial capitalism. We would propose
that, in the moment of catastrophe in "Broke Down on the Brazos,"
catastrophe is premised upon postmodern capitalism in a bringing
together of what Negri (2004) terms the two primary components of
capitalism – naked labour and pure wealth. This confluence of mate-
rial bodies and the abstract code of the money form is crucial to the
development of pure wealth as a representation of value associated
solely with money. As we transition from agricultural capitalism to
industrial capitalism in the nineteenth and twentieth centuries, the
blues reflected a significant shift in modes of production. Similarly,
as we transition into the mode of global postmodern capitalism and
other historical forms of wealth are gradually eroded and displaced,

we would suggest that the blues expresses the antagonisms and contradictions of this movement as well.

In transitioning from the relation of living bodies and industrial machinery to living bodies and virtual abstract global capitalism, naked labour is opened onto the field of human productivity structurally coupled with pure wealth. This cyborg melding of living form and abstract code begins to serve as absolute mediation between the material activities of living beings and the abstraction of the money form. Like Agamben's (1998) bare life, naked labour is without status or inherent value. Whatever immanent and autopoeitic force the activities of living beings may intrinsically hold is foreclosed into an ontological status of existing only in relation to pure wealth. This relation can take many forms, from direct servitude to the more opaque relation of the oligarch, but the relation of activity and money is overdetermined. Indeed, it is only through this relation that capitalism can expand itself across geographies and subjects.

Such a relation produces a subject that is constantly overdetermined by signifiers that have no constancy. In his "Postscript on the Society of Control," Deleuze (1995) tells us that current modes of control in late-stage capitalism operate through the production of anxiety based on infinite patterns of deferral. No one ever arrives at any form of social stability or security. In the song, the next stanza states that the singer didn't have the blues yesterday but that he can feel them coming on. From a Deleuzian perspective we can read this as the artist's premonition of catastrophe and the collapse of the old people, the old earth, or, in Marxist terms, the erosion of an old mode of production and the dislocation of the subject as he/she enters the new and indeterminate social sphere of the emerging form.

This high anxiety is reflected in the next stanza as well. "Everywhere I turn, trouble's all I find." Certainly this is a reasonable statement regarding the current economic, political, and social world. As Naomi Klein (2007) points out in her analysis of postmodern capitalism, crisis is a key element of rule and a generator of profit. It is an Orwellian world of both artificially and organically produced crisis constantly deployed as a new system of rule in which the signifiers of identity, morality, and justice are constantly shifting and morphing. Indeed, in the next stanza the song states, "No matter what I do, I feel like I'm losing my mind." Under the current mode of production subjective distress, anxiety, depression, and madness are reaching endemic proportions, and, of course, this distress is turned to profit by the

psychiatric collusion with multinational pharmaceutical companies who turn the entire earth into one large asylum without walls.

In the next verse we are told that the singer is "living in a dream." Of course this dream is a nightmare and signals the realm of simulacrum, in which the social becomes a copy of itself emptied of any function that would sustain the living. Instead, as we note above, the material reality of life is turned to the production of the abstract signifier of the money form. Foucault (1986) suggests to us that we should make a clear distinction between the actual and the present. The actual is always a dynamic force of creative becoming assembled out of the contingencies of chaos. The present is a dream that is premised on an abstraction. To live in the present of postmodern capitalism as a consuming subject is to live, as R.D. Laing (1990) would have it, asleep and dreaming rather than awake and living.

In the next stanza "chasing a sound" gives us our first opening into the artistic possibility of engaging the catastrophe and emerging from the chaos with a forewarning of a people to come. It will be in the chasing of a sound that the revolt will come into play. We say more about this when we discuss the sound of the music. "I told everybody I believe I'm Texas bound" can be read as an opaque reference to arriving on the Brazos. With its musical history of referencing the Brazos River as a site of despair and incarceration, but also as resistance and flight, this verse diagrams the contested space of the artist confronting the catastrophe of postmodern capitalism.

In the final verse we learn that the singer has arrived at the Brazos. "Well here I am, I guess its no surprise." In order to draw what Deleuze and Guattari (1996) refer to as the weapons to be obtained from the plunge into chaos, the artist must leave the dream and arrive into the actuality of the moment. Such an acknowledgment opens the artist to full deployment of the emerging capacities of a new earth, a new people. The artist must baldly, without illusion, face the catastrophe. In the song we find ourselves "up to my knees in water, up to my ears in dragonflies."

MUSICAL ASSEMBLAGE

The starting point for Deleuze and Guattari's (1987) consideration of music begins with the refrain, a type of rhythmic patterning that results in the establishment of a territory. It is a form of rhythmic motif that serves to establish, or define, the milieu or territory of a particular

organism. As Grosz (2008, 52) states, "[it] is a kind of rhythmic regularity that brings a minimum of livable order to a situation in which chaos beckons." It is thus a point of stability and order, functioning as a type of landmark within a surrounding field of chaos and providing a central locale for a newly delineated surrounding territory.

Milieux are blocks of space-time established by the repetition of their component parts. Through this vacillating trait they become coded, and, as a result, they are able to interact. Not only do they move in relation to each other but, indeed, milieux build upon and incorporate into each other creating structures with increasingly higher levels of complexity and interaction. A milieu is not a singularly identifiable discrete unit independently interacting with other milieux. Although milieux are not themselves territories, they do provide territories with the majority of their characteristic features (Grosz 2008). The established territory is not a fixed locale situated in time-space; rather, it is a pliant assemblage existing in a continual state of process with the ability to morph into something else. The territory thus "expresses an experiential concept that has no fixed subject or object" (Message 2005, 281). It does not signify or represent anything; rather, it is a manifestation of constantly changing elements and circumstances that meld for various reasons at a given time, resulting in a process of "reterritorialization." A number of musical characteristics contribute to this type of manifestation in "Broke Down," resulting in the formation of new territories and means of expression.

These territories have a direct affect on milieux and refrains through the process of territorialization. Individual milieu come into contact and connect with other milieux through a process of "entrainment." As mentioned above, milieux exist as a result of their vibratory, or oscillating, quality, and entrainment is the result of the tendency for an oscillating body to become synchronized with another oscillating body (Turetsky 2004). What is responsible for the development of this synchronization between milieu, and what results in the formation of a territory, is rhythm. However, Deleuze and Guattari stress that rhythm is not to be seen as metric or cadential. Indeed, for them, "there is nothing less rhythmic than a military march" (Deleuze and Guattari 1987, 313). Rhythm is that which exists between milieu acts as a means of generating the process of entrainment. As a result, independent elements come to be organized in a rhythmic assemblage. It is the coincidence of such elements, writes Turetsky (2004), and the resultant melded rhythmic

counterpoint that fuse the milieu together into a territorial assemblage. This type of contrapuntal intensity is evident in the arrangement of the song and the relationships that can be found between the given musical elements. It will be shown that the arrangement of "Broke Down on the Brazos," at a macro level, consists of two sections. The first is a presentation of the song in AAB style, with the A section identified as the verse and the subsequent B section as the chorus. The second half of the arrangement is an extended solo section in which the band's two guitarists improvise over a sustained C minor harmony. It is the intersection of these musical segments/components that allows for the generation of new territories and forms of expression.

When rhythm and milieu come into contact they form an internal set of relations that results in the delimitation of the milieu or "the compression and compaction of a number of different milieus" (Grosz 2008, 47). It is here, where territory emerges, "that the raw materials of art can erupt and the process of deterritorialization, which are the conditions of art, can begin" (48). Art can be seen as a response to chaos through the elaboration, intensification, and production of a series of elements extracted from chaos. Through a process of framing, sensations develop as the intensities inherent within nature are selected and organized in a way that allows for those given intensities to come into focus. Grosz (2008, 28) argues that the production of art should in no way be considered as a means of controlling chaos; rather, it is a way of containing some of its fragments within a defined time-space in order to "reduce [chaos] to some form that the living can utilize without being completely overwhelmed."

Deleuze and Guattari (1987) refer to Jakob von Uexküll's theory of "transcodings" whereby component elements of individual milieu engage in a form of counterpoint in order to produce new milieu. For von Uexküll this process results in the formation of a surplus value that contains the potential for the formation of new interactions and new territories. As these new territories develop, expression emerges as a result of the rhythmic interaction between milieu. Indeed, it is rhythm that is expressive. "Territorialization is an act of rhythm that has become expressive, or of milieu components that have become qualitative" (Deleuze and Guattari 1987, 315). In this way a particular territory takes on a quality of expressiveness that allows for communication with outside milieux and territories. With the development of this expressive quality the milieu components cease to be directional

and the rhythm itself becomes expressive. The territory thus becomes defined by the emergence of the expressive qualities.

Autonomy is realized both internally and externally. The qualities and shifting relations within a given territory interact in a way that expresses. The autonomous interaction of the various territorial components evinces the relationship of a given territory to its internal milieu of impulses constituting *territorial motifs*, which interact with internal impulses. This results in the emergence of expressive qualities that interact with each other, conjoining the component milieu to the given territory. Milieux, in this way, become territorializing and their expressivity becomes identifiable in the territory they draw (Deleuze and Guattari 1987, 317). This provides the territory with what Murphy and Smith (2001, 4) refer to as an "explosive potentiality," affording one the opportunity to consider music as "minor" in character.

"Broke Down" begins with a 12 measure introduction in which a low bass vamp establishes the home key of Eb major. In measures 1–4 a broken guitar scratch implies a direct reference to Bo Diddley's "Road Runner." With this musical reference we find the emergence of a minoritarian musical language that can be directly mapped onto the racism of the 1950s. Indeed, Diddley was an integral part of the emerging rock genre, but, at the same time, as Kiersh (2010) points out, he felt himself to be an outsider subject to the cruellest registers of racism.

Certainly, the contested landscape of race and music in the world of 1950s and 1960s blues and rock might well be seen as centred on African Americans as a minority. In this light it is pertinent to note that the Deleuzo-Guattarian (1987) use of the term "minor" does not refer to a language of lesser importance, rank, or stature but, rather, to a language that is constructed by a minority community within the confines of the language of a social and political majority. As such, the development of a minor literature results in the formation of a "kind of foreign language" within the language of the majority. The invention of new words and phrases not only results in the decomposition of the dominant language but also in the generation of a new language within the parameters of the old, and, as a result, power relations are challenged through the development of such a minor literature. The development of the minor "induces disequilibrium in its components, taking advantage of the potential for diverse and divergent discursive practices already present within the language" (Bogue 2005, 171). In this way the linguistic ordering of the dominant

language comes to be challenged, and, indeed, every aspect of the minor writing becomes political. The inclusion of the Diddley phrase in the opening of the song, we would argue, references and presages the development of just such a minoritarian vernacular.

The song's introduction continues in measures 5–12 with a guitar solo with electronic effects, the tone of which establishes the mournful, foreboding quality that resonates with what is found lyrically. The introduction ends with a melodic riff, establishing a musical foundation that is to reappear in various permutations throughout the form of the work.

The 8 measure A section begins with a continuation of the rhythmic drive established in the introduction yet contrasted texturally by the sparse vocal melodic line. Behind this melody, the guitars contribute to an increase of intensity through the presentation of harmonically abrasive figures, particularly in the second 8 measure A section. These figures are positioned so that an intensification of syncopation, whereby rhythmic placement begins to obscure a clearly identifiable "beat," begins to emerge. Within the opening 16 measures of the song form the listener is presented with a difference *in* repetition, the concept of which becomes more obvious within the following B section, or chorus.

The Western philosophical tradition, for Deleuze (1994), has failed to adequately address the concept of difference. The trend in traditional thought has been to relate difference, or, as Hulse (2010, 23) argues, to mediate difference to some type of identity, a form of identity that stands in direct opposition to difference. That which is different, when following this line of thought, acquires the characteristic of the negative and, as such, is subjectively isolated. The object in question is distinguished from everything that it is not. When taken as such, Deleuze (1994, 49) continues, "difference is negativity ... it extends or must extend to the point of contradiction once it is taken to the limit." Difference as identity does exist, but it exists only as a means for a demonstration of the identical (50). Rather, Deleuze believes that an authentic difference is not dependent on any form of identity but is produced by the set of prior relationships found between differentials. This demonstrates, as Hulse (2010, 23) suggests "a potential whose object is not its utility per se, but rather the range, quality and, novelty of thought in its fullest expressive potential." Thought should go beyond the set of fixed possibilities inherent in a traditional epistemology of identity as a means to afford a difference that is uniquely presented in each case.

At the start of the B section the harmonic centre shifts down a minor third to the key of C minor. This section is 6 measures in length and concludes with a restatement of the riff that is first heard in measure 8 of the introduction. A dotted sixteenth note dominant anticipation follows this figure leading to an immediate return to the home key and the A section of Verse 3. On the return to the A section we are presented with a full restatement of the form: AAB. However, the B section is extended from 6 to 8 measures, demonstrating an intensification of difference.

Difference is established by a dynamic repetition, as Deleuze (1994, 20) argues, a "repetition of an internal difference [that is integrated into each moment, and carried] from one distinctive point to another." This nullifies the requirement of any representative concept or pre-existing state. Deleuze makes the claim that multiplicities (assemblages, organizations, ensembles) exist everywhere, but their totality is secondary to an internal structure of difference: a multiplicity "must not designate a combination of the many and the one, but rather an organization belonging to the many as such, which has no need whatsoever of unity in order to form a system" (182). Deleuze strives for a contemplation of intensive assemblages and their constituent differences in order to advance the idea of unity and coherency (Hulse 2010, 24).

"Broke Down on the Brazos" continues, immediately following the second B section, with a repeating 4-measure transitional phrase. This phrase is presented four times with each successive repetition intensifying texturally by the inclusion of individual musical components. The transition begins with a syncopated guitar riff again associated with the contributions of Bo Diddley. By the fourth repetition, the level of musical intensity has dramatically increased and this motion, or drive, is furthered by the inclusion of one extra measure of ¾ time at the conclusion of the phrase, heightening the sense of chaos and catastrophe, the breaking down of rhythmic stability. This drive towards the virtual again intensifies as the transition continues.

Following the instrumental build-up, introductory material is restated in the home key of Eb, leading into the solo section of the piece. However, this restatement is accompanied by melodic material from the B section that is fused into the harmonic structure and stabilized with the familiar riff of the introduction and A sections. We thus have an intensification of sensation through revolt whereby the new expressive assemblage emerges as an extension of the previous frame.

The work concludes, as mentioned, with an extended solo section in C minor in which the band's two guitarists "trade off" solos over a span of seven 8-measure cycles. Of particular interest is the rhythmic displacement found in the last measure of each of these cycles. Here the introductory riff undergoes a process of transformation whereby the length of the riff is altered on each repetition, affectively bringing into question the precise anticipatory placement of the ensuing down-beat as the "plane of consistency" fractures and the cycles of rhythmic interaction emerge as an extension of chaos. It is here that Gov't Mule is able to musically generate a destabilizing "line of flight" by incorporating the "minor" into the temporal structure of the piece.

It must be kept in mind, however, that minor literature is not directly involved as a part of the political practice in that it is not involved in "molar" organizations; rather, it works as a means of connecting various aspects of human experience "so as to produce new lines of causality and new pathways of experimentation." (O'Sullivan 2006, 74). The minor, in art, is thus always political in that it is always in a process of opening up to alternative forms of assemblage and experimenting with different kinds of relative autonomy, as with "an association of individuals who have 'being against' the major in common." The generation of the new occurs within the parameters of the old, and it is this act of creation that results in "the invention and imagining of new subjectivities as well as [a] turning away from those already in place" (76). A minor literature is not just positioned against the dominance of the majority, as if occupying a position outside of the social and cultural structure. As O'Sullivan (2006, 76) argues, it functions from more of an oblique position, looking for alternative points of entry: "It is at once inside and outside the major, *in* the 'world' but not quite *of* it."

By obscuring the identity of a clearly definable "downbeat" Gov't Mule effectively breaks free from the restrictions inherent in the popular style and establishes a new plateau from which expression can emerge. With the development of this new expressive quality the milieu components cease to be directional (Deleuze and Guattari 1987, 315) and the new rhythmic configurations themselves becomes expressive. The qualities and shifting relations within the new territory interact and the territory itself becomes defined by the emergence of the new expressive qualities.

The central discursive figure of the song is the chorus. The chorus is composed of the repetition of the title "Broke Down on the Brazos."

Of course to break down is to cease to function within the specified parameters of a certain machinic configuration. But Deleuze and Guattari (1984, 8) tell us in *Anti-Oedipus* that "desiring machines only work when they break down, and by continually breaking down." It is only through breaking down that old systems are subverted and new systems emerge. It is only through breaking down that the artist can plunge into chaos to seek the weapons necessary to produce art that reintroduces the infinite. This is the process in *Anti-Oedipus*, where "desire constantly couples continuous flows and partial objects that are by nature fragmentary and fragmented. Desire causes the current to flow, itself flows in turn and breaks the flows" (5). Where does this breaking down occur that opens the flows of desire? At the confluence of prisons, slavery, resistance, death, anxiety, terror, and the emergence of a new people, a new earth: on the Brazos.

NOTES

1 There are many versions of this song. We are drawing from Mike Ballantyne's transcription of a 1933 recording of Ernest Williams and Others at Central Prison Farm, Texas (http://www.mikeballantyne.ca/tran-scriptions_cd/aintnomorecane.php) in combination with lyrics used by Lonnie Donegan (https://www.flashlyrics.com/lyrics/lonnie-donegan/aint-no-more-cane-on-the-brazos-95).

REFERENCES

Agamben, Giorgio 1998. *Homo Sacer*. Pre-Textos.
Baker, Houston A., Jr. 2013. *Blues, Ideology, and Afro-American Literature: A Vernacular Theory*. Chicago: University of Chicago Press.
Bogue, Ronald. 2005. "Minoritarian and Literature." In *The Deleuze Dictionary*, ed. A. Parr, 170–1. Edinburgh: Edinburgh University Press.
Bosso, Joe. 2010. Warren Haynes on Govt Mule and recording with Billy Gibbons. http://www.musicradar.com/news/guitars/warren-haynes-on-govt-mule-and-recording-with-billy-gibbons-236555.
Brown, Sterling A. 1952. "The Blues." *Phylon* 13 (Autumn): 318–27.
Deleuze, Gilles, 1994. *Difference and Repetition*. Trans. Paul Patton. New York: Columbia University Press.
– 1995. "Postscript on the Society of Control." In *Negotiations: 1972–1990*, 177–82. New York: Columbia University Press.
Deleuze, Gilles, and Félix Guattari. 1984. *Anti-Oedipus*. Trans. Robert Hurley, Mark Seem, and Helen R. Lane. Minneapolis: University of Minnesota Press.

– 1987. *A Thousand Plateaus: Capitalism and Schizophrenia*. Trans. Brian Massumi. Minneapolis: University of Minnesota Press.

– 1996. *What Is Philosophy?* New York: Columbia University Press.

Foucault, Michel. 1986. "Of Other Spaces." *diacritics* 1 (16): 22–7.

Grosz, Elizabeth. 2008. *Chaos, Territory, Art*. New York: Columbia University Press.

Hulse, Brian. 2010. "Thinking Musical Difference: Music Theory as Minor Science." In *Sounding the Virtual:Gilles Deleuze and the Theory and Philosophy of Music*, ed. B. Hulse and N. Nesbitt, 23–50. London: Ashgate.

Haynes, Warrren. 2009. "Broke Down on the Brazos." *By a thread*. Evil Teen Records.

Kiersh, Edward. 2010. *Where Are You Now, Bo Diddley?: The Stars Who Made Us Rock and Where They Are Now*. New York: Knopf Group E-Books.

Klein, Naomi. 2007. *The Shock Doctrine: The Rise of Disaster Capitalism*. London: Macmillan.

Laing, Ronald D. 1990. *The Politics of Experience and the Bird of Paradise*. London: Penguin UK.

Lovett, Lyle. 1987. "Walking through the Bottomland." *Pontiac*. MCA Records.

Message, Kylie. 2005. "Territory." In *The Deluze Dictionary*, ed. Adrian Parr, 280–2. Edinburgh: Edinburgh University Press.

Murphy, Timothy S., and Daniel W. Smith. 2001. "What I Hear Is Thinking Too: Deleuze and Guattari Go Pop." *Echo: A Music-Centered Journal* 3 (1): para. 2. http://www.humnet.ucla.edu/echo, 19 May 2015.

O'Sullivan, Simon. 2006. *Deleuze and Guattari: Thought beyond Representation*. Hampshire: Palgrave Macmillan.

Turetsky, Phillip. 2004. "Rhythm: Assemblage and Event." In *Deleuze and Music*, ed. I. Buchanan and M. Swiboda, 140–58. Edinburgh: Edinburg University Press.

6

Rakuness: Schizoanalysis and the Work of Paul Soldner

Kathleen Skott-Myhre, Dave Collins,

and Hans Skott-Myhre

This chapter begins in an experience. It is an encounter from three perspectives. Two of us experienced the event from the inside as artists and the other is a witness to the event from the outside as a spectator. The event in question was the process of producing a piece of pottery known as American raku. The process of producing raku pottery is a visually and tactilely dramatic performance in which there is an assemblage of human bodies, metal tongs, thick protective vests, bare hands, clay, metals, smoke, fire, sawdust, chemical compounds called glazes, bricks and mortar, and metal buckets. It is, in a term we will explicate further, a process of immanent alchemy. Like all artistic processes it is composed of speeds and slownesses, intensities and extensivities, connectivities and ruptures, fractures and cracks. In short it is, in the Deluezo-Guattarian (1977) sense, desiring production.

It is art as desiring production through immanent alchemy that we are proposing as a politics relevant to the current historical moment. As Deleuze (1992) describes our moment with profound prescience, it is the moment of the society of control. Or, as Deleuze and Guattari (1977) delineate it, in an articulation full of Luhmanian resonance, society composed fully of transcendent systems of communication. As the society of control, new modes of discipline and domination function at the level of code, which extends itself into the formulations of those aspects of our unconscious, as Lacan would have it, in deep structures of the virtual. This mode of subjectification operates

at the level of communication as the order word, as Deleuze and Guattari (1988) propose it, but in excess of the regimes of domination premised on digital linear language forms that produce the world as a series of taxonomic hierarchical stratifications. Because the society of control functions within the logic of absolute code, wherein code loses any direct reference to the realm of living material relations, it holds an entropic negation at the core of its mode of production. In short, it is a dialectic black hole slowly collapsing in upon itself, sustaining its existence through the appropriation of partially coded unconscious modes of desiring production to be found at the far edge of its range. Capitalist society in this mode of development, as an entropic slowly imploding system of transcendent code, requires the raw material of living unconscious relations in order to persist. In this sense, it might be said that the current mode of exploitation and appropriation now strip-mines the unconscious for the sustenance of its mode of production.

With this in mind, Deleuze and Guattari's (1988) injunction to build vacuoles of non-communication – to quit making sense and to create rather than to communicate – point to a politics premised, to ever-greater degrees, on unconscious desiring production per se. While Deleuze (1977, 1998, 1995), Guattari (2005), and Deleuze and Guattari (1988, 1977) have made a number of proposals as to how such a politics might be mounted, we want to point to schizoanalysis and art as one possible field of insurrectionary activity.

Within this broader schema, we focus, in particular, on the art of raku and Paul Soldner's (1990) relational re-subjectivication, which he calls "rakuness." Before we go further, however, we want to be clear that our proposal does not function at the level of metaphor, allegory, or analogy. We are not suggesting that politics be formulated *like* art or that the principles of rakuness should be transliterated into a metaphor for political organization and action. Instead, we are proposing art as revolt. In particular, art as a mode of subjectification, as becoming earth.

In their work on schizoanalysis, Deleuze and Guattari (1977, 378) discuss what they term "the actualization of revolutionary potentiality." They describe such actualization as "the efficacy of a libidinal break at a precise moment, a schiz whose sole cause is desire – which is to say the rupture with causality that forces a rewriting of history on a level with the real, and produces this strangely polyvocal moment when everything is possible."

In the work of Paul Soldner we find an approach to artistic production that echoes this notion of the libidinal break. When Soldner describes the way he works with clay, glazes, and the firing of his artworks in a kiln, the composition of the sets of elements involved brings idiosyncratic levels of indeterminate chaos to the process. Each aspect, from the body of the artist (his thoughts, neuronal capacities, hands, fingers, eyes, lungs, shoulders, and so on) to the composition of the clay (density, moisture, granularity), the chemical elements of the glazes, the variations in the structure of the kiln, and the differentials in the source and intensity of heat combine in only marginally predictable ways. There are, of course, generalities to the production that are predicable, such as the fact that most of the pottery produced will emerge hardened and coloured. But that is not what makes pottery art. It is the unique element of the unpredictable that creates each piece as an aesthetic universe unto itself. In Soldner's work, the effects of this process are nearly impossible to predict *in real time*. The thought and preparation that go into the production of the pottery are only a portion of what is involved because it is impossible to manipulate the outcome. This variation, however, is for Soldner a cause for celebration. As he says, "The more surprise and variation I get from the firing the happier I am … If I knew how it was going to be why do it" (Bergan 2004).

Deleuze and Guattari (1988, 378) suggest that such moments are preceded by a "subterranean labor of causes, aims, and interests working together." Such a subterranean labour, however, can lead to not only an opening and rupturing of the socius but also to a foreclosing and re-territorrializing movement that creates new forms of fascism and social control. They propose that the movement that keeps the libidinal break open is through "a desire without aim or cause that charted it and sided with it" (ibid.). Such a schiz becomes real, they argue, only through a revolutionary investment of desire that can open a deterritorialized flow that "runs too far and cuts too sharply, thereby escaping from the axiomatics of capitalism" (ibid.). The question they ask us is: "Where will the new irruption of desire come from?" (ibid).

One clear possibility that Deleuze and Guattari (2014) delineate is to be found in the assemblage of art and science. As they suggest, humans have historically used science and art to revolt against the fixity of sovereign formations. The possibility of this combination, for our purposes, lies in the capacity of science as an access point to

investigations of the architecture of the realm of extension or mate-
riality, combined with art as the exploration of the capacities of
materiality as a vehicle for the expressions of desire. This combination
opens onto the field of politics we proposed earlier, as that which
ruptures and scrambles the codes operating at the edge of the sovereign
formations of capital wherein it only loosely holds sway. These points
of convergence between the modes of the unconscious productions
of desire and the overcoding machine of capital operate as tangential
vectors. This is because if capital overcodes the living force of desiring
production too quickly it will eviscerate the very force it is attempting
to put to its own will to persist. On the other side, the line of flight
indicated by the molecular liminal productions of science as virtual
schematic and art, as a cartography of virtual expression, deploys
and unsettles the codes of the dominant atmospheric to its own ends.
Such a movement must function in the liminal space of desiring pro-
duction in order to conserve its realm of auto-poetic production at
the edge of capitalism's field of sovereign control. Deleuze and Guattari
(1977, 368, emphasis in original) propose that it is here that new
subjective formations might be formed: "The day humans are able to
behave as *intentionless phenomenon* – for every intention at the level
of the human being always obeys the laws of its conservation, its
continued existence – on that day a new creature will declare the
integrity of its existence."

The route to this radical new subjectification is to be found, they
suggest, in the collision between science as a method that "reproduces
on the outside, an interplay of forces by themselves *without aim or
end*" and art "which as soon as it attains its own grandeur, its own
genius, creates chains of decoding and deterritorialization that serve
as the foundation for desiring machines and make them function"
(Deleuze and Guattari 1977, 368, emphasis in original). This entangle-
ment of science and art in the production of pottery is both utterly
material and deeply evocative of thought and imagination both con-
scious and unconscious. As a machine of desiring production, the
production of pottery functions psychoanalytically at the level of
unconscious expression in ways that continually elude the capacities
of the conscious mind to fully apprehend or encode the experience
within the realm of the symbolic. Like the feminine in Lacan (1999),
pottery as artistic production eludes generalizable signification. The
engagement of the body with the primal elements of earth, fire, and
water constitutes an idiosyncratic nexus of ever-shifting perception.

The relation of the artist, both as an active participant in the act of shaping, glazing, and firing the clay and as the observer of the emerging pot as artistic object, never fully arrives at a fixed point. The processual infinitude composed of threads of perception, material engagement, unconscious interpellation, sensation, and the ongoing completion of attempting to translate the ineffable into language opens an indeterminate field that teeters on the edge of the psychotic and is only nervously tethered to normative apperception by the absolute materiality of the pot itself.

Gregory Bateson (N. Bateson 2011) points to the complexity of this set of relations between the symbolic and the material in his example of the table. He asks us to consider whether we know what a table is through something we perceive as the inherent quality in the table itself. He argues that, in fact, the qualities of the table are not to be found in the table but in the relation of the table to our capacities of perception. He suggests that the solidity of the table, for example, is not determined by something residing in the table itself but, rather, in the relation between the table and our hand. We come to understand the table as solid because when we bring our hand down on its surface we encounter resistance. We simply cannot push through the table with our hand. Our perception of the table is a relation between our body and the body of the table.

Deleuze and Guattari (1988) make a similar point in their discussion of a schizophrenic table. The portrayal of the table in certain schizophrenics' drawings decontextualizes it from its conventional sets of functions, both practical and social. The table simply becomes a set of possibilities implied by its compositional elements. As these elements are seen as absolute potential, absent the overcoding of the symbolic constraint of the concept of table, the table became unrelated to any human function. It became "more and more an accumulation and less and less a table" (Deleuze and Guattari 1988, 7).

If we begin to see the process of art as a set of relations that opens onto the unconscious as the realm of desiring production, then we have to account for the conditions that would allow for a state of consciousness that has the capacity for such apprehension. To think in states of consciousness, rather than modes of thought, as a way to make sense of art, as both process and engaged object of perception, opens the set of relations between the artist/perceiver to an entanglement of mind and body. Such an entanglement might well be described as a liminal form of apprehension that operates as what Gregory

Bateson (1972) calls an ecology of mind. That is, a mode of apprehension that is inclusive of an intensity and speed of engagement with all elements of a moment so that any ability to distinguish the elements into discrete categories is vitiated. Instead, there is a sense of being thrown into a space of absolute sensation replete with lightning strokes of thought that flee immediately upon being sensed. Thought functions in direct relation to sensation in the same moment that sensation opens an infinite field of thought. This is mind as a fully material experience. Such experience has no centre, although it may constellate around and through the capacities of a given body.

In this sense then, art is never a solitary endeavour, although it may often appear to be. The interplay of forces noted by Deleuze and Guattari as forces without aim or end includes the collectivity of all artists that influence the modes of production. Subjectification, as a chain of decoded and deterritorialized practices occurs, as Spinoza (2000) would have it, between bodies. It is the set of relations between artists as well as materials. In this sense, art is the lineage of production that must be rigorously practised in order to be violated. Artistic production is comprised by desiring machines of multiplicities that connect and connect, assembling little machines that break down (Deleuze and Guattari 1977).

Soldner's approach to working, collaborating, and teaching works in this way. In an approach similar to his art making, Soldner is the embodiment of an inspirational producing entity among or in the presence of his students. He prefers to not critique student's artwork and values doing over talking: "I have a different idea about teaching … leave people (students) alone, let them work themselves. And then you make damn sure you go do your work (artwork) in front of them … don't go hide in the studio some place" (Bergan 2004). This approach to the student/teacher relationship is premised on what we might term "teaching by encounter." It is the pedagogical practice of stepping into the contingent relation of what Guattari (2005) would describe as transversal mapping. Transversal mapping constitutes an overlaying of territories of production that creates zones of indiscernibility where the individual characteristics of a particular set of individual practices are entangled with those of the other. Pedagogy of this type is without aim or end outside of the surprise elements of what cannot be anticipated.

It is this combination of bodies and practices that we refer to as immanent alchemy. Given our considerations so far it should be no

surprise that our reading of alchemy is against the grain. Alchemy is historically associated with the transmutation of the baser elements into those of greater purity. This is generally considered the goal of its experimentation in both physical and spiritual practice. We are interested in removing both the teleological and transcendent aspects of traditional alchemy and introducing the notion of an immanent alchemy rooted in experimental assemblages of human thought and corporeality in relation with elements of earth itself. In doing this, we want to propose that such relations may well have the capacity to produce degrees of experiential intensity that, as Olkowski (2013, para. 4) suggests in relation to Deleuze, "belong to the experimental affirmation of the world beyond what is sensibly observable or divinely revealed, leading to a more comprehensive and intense level of thought and being." In this reading of alchemical immanence we are suggesting that earth arts that deal in stone, metals, or earth open artists in similar ways to "philosophical conceptual personae, which are not so much persons as receptacles and transmitters of forces whose power they emit as signs, as abstract blocs of affects and percepts, blocs of becoming (Olkowski 2013, para 9). Olkowski, commenting on Deleuze's work on Bacon, describes the relation between nature and the artist in terms of the event. The event, in Deleuze according to Olkowlski, is produced through the forces of nature, "following the laws of supersensible Reason … The Event consists of real, physical, and effective sensations that bypass Imagination and Understanding, and directly affect the nervous system, no intuitions or perceptions needed" (ibid.).

In *A Thousand Plateaus*, Deleuze and Guattari (1988) delineate a specific relation between the natural elements embodied in the earth and the openings of flows of matter and intuition. They define the artisan who works in metals as "intuition in action" (409). They suggest that metals and metallurgy, as a field of assemblage that opens the earth and its elements to consciousness, opens "something that is only hidden or buried in the other matters and operations" (ibid.). They propose that metallurgy exceeds artistic operations that only transform matter according to its capacity to be shaped by pre-existing templates such as the clay and the mould. In metallurgy, they note how "the materiality overspills the prepared matter, and a qualitative deformation or transformation overspills the form" (410).

Karen T. Vitelli (Vitelli and Dengate 1999) connects the advent of pottery, as an earth art, to female shamanism. She suggests that it is women in early hunter-gatherer societies who were venerated because

of their herbal knowledge about psychoactive plants as well as herbs and ointments with healing properties. Such women were seen to possess supernatural powers and were given positions of rank and power in the community. It is likely, Vitellii speculates, that these female shamans used raw clay in their treatments because of its medicinal properties. They may have also had occasion to use clay in the construction of ceremonial structures and shrines. Small hand-built air-dried containers could have held ointments and powders. Shamanic drums could also have been constructed out of clay. It is quite likely that these women healers and mystics would have used fire and smoke in their rituals and "when a molded item of clay fell into a fire and exploded or changed colors, the shaman was already attuned to reading meaning into such things and seized the opportunity – especially if her group was particularly in need of advice and guidance at that moment" (Vitelli and Dengate 1999, 192).

This small group of women were uniquely "positioned to take existing elements and combine them in socially relevant new ways" (Vitelli and Dengate 1999, 192). During times of stress for the community, these women very probably needed to expand their skills in relation to the inanimate world by using ritual and ceremony to resolve anxieties, disputes, and conflict: "If the shaman's skill in using the newly discovered drama of firing clay proved useful and effective ... the stature and social importance of the shaman potter would have helped ensure that the innovation was accepted by other practitioners of the supernatural arts and incorporated into traditional behaviour" (ibid.).

Vitelli argues that the early *potter-as-shaman* arrived at the intentional production of ceramics as an unintended consequence of ritual. The introduction of pots and pottery into use as ceremonial and finally domestic vessels and objects resulted from an attention to process, not through an intention to produce a specific product. This overspilling of materiality into the realm of ritual practice, and then its proliferation into increasingly broader realms of production, was founded in the shaman's experience of the earth's capacity. As the experiences of the shamanic encounter with clay, fire, and form became increasingly articulated, the potter emerged as one who could mediate between the contingent and the purposeful.

If we view Soldner's approach as an extension of this shamanic encounter with the socially and biologically alchemical aspects of the earth, in its form as clay, then the process of American raku becomes a question of the overspillage of materiality and affect. A clear example

of this might well be found in the American raku practice of *post fire reduction*. Post fire reduction is perhaps the most distinct technical or procedural difference between American raku and the traditional Japanese practice. This is truly the point at which the most astounding transformation occurs for the pieces inside the "reduction chamber." As the glazed pieces are pulled from the kiln at peak temperature, they are immediately plunged or buried in a dry carbonaceous particulate matter (sawdust, pine needles, grass, etc) and quickly capped to isolate them from access to oxygen. In this impossible situation, the scarcity of oxygen forces the withering combustion to search for oxygen elsewhere. The only available oxygen is in molecular form via the metallic oxides of the glazes and in the clay itself. As the oxygen is consumed, what is revealed is a lustrous metallic surface. As the combustion infiltrates the clay it becomes saturated with an excess of the volatilized carbonaceous matter, changing its appearance to a graphite blackish lustre. This alchemical transfiguration, which occurs through the contingent assemblage of multiple elements, opens a relation between the strata of the physical properties and capacities of the earth and suggests that it is in the imbedded force of the geophysical that an excess of capacity might overspill any attempt to overcode its innate qualities to a predetermined purpose.

This multiplicitous, contingent, and fluid set of relations that brings with it capacities of the earth as a set of geo-physical coordinates, read through the affects and percepts of the artist and those engaging the art as spectators, contributes to a transfiguration and production of an almost impersonal mode of subjectification. It is a hybrid formation of animate and inanimate lines of force drawing all elements of fire, air, earth, and water and composing them as affectual transitions of transformative sensation. The living bodies of artists and spectators are entangled corporeally with the physical properties and capacities of the earth. Even the artist can only tentatively conceive her/his project in advance. The living encounter of flesh and clay form a hybridized little machine that operates outside of any capacity of the artist to force it to a pre-determined schema. Even the most reductive assembly-line production of cups, bowls, and plates conceals indeterminate variations.

When we step fully into the realm of American raku, with its intentional apparatus of experimentation, we engage the realm of virtual production that holds all that is not yet. This is not an endeavour available to rational apprehension. While art is a kind of thought, it

is thought vetted through the body as material expression. To the degree that art thinks itself, it is the earth that thinks itself through the expressions of the inanimate in relation with biological sentience. It is, in a term, art as shamanic immanent alchemy.

We are reminded of the section in *A Thousand Plateaus* in which Deleuze and Guattari (1988) describe the encounter between the woodworker and the wood. They tell us that, as we approach the raw material to be shaped, it is important to take into account the fact that the entire field of endeavor is saturated with energetic lines of force composed of singularities and haecceities that lay out the terrain as both inherently sympathetic to certain configurations over others and open to intensive encounters with other elements in the assemblage. It is up to the artist, the woodworker, and the potter to open up a sympathetic resonance with the flows inherent in the encounter. They suggest that to force this relation is to lose the intuitive force of the encounter as art – that is, art as sensation.

It is in these sympathetic resonances between earth and art, as sensate encounters, that the mode of subjectification mentioned earlier holds some degree of possibility. It is in the encounter with the intensities, speeds, and slownesses of the earth's co-composition of time with human affect that human subjects open themselves onto the plane of pure production as indeterminate, dare we say, itinerant or nomadic, subjectivities.

Such subjectivities form a minor art, or an art that operates in a deviant relation to the dominant atmospherics of the *art world*. As such, it builds mobile configurations out of the bits and pieces of art implied by dominant forms but not fully explored. It doesn't so much resist or rebel against that which precedes it; instead, it turns art towards the realm of chaos or chance in order to open lines of force that rupture and fracture that which has coalesced into habitual production. Nomadic or minor art doesn't fight with tradition so much as reconfigure its unexpended capacities. In Soldner's (1990) account of raku, read as a minor form, it is an innovation made possible by the absence of a binding tradition. Soldner notes that it is his ignorance of the tea ceremony, as the overcoding force for the production of raku, that opens new capacities for experimentation.

It is notable that American raku originates as a certain kind of productive failure to apprehend the very tradition that is its genesis. The form originates in an encounter between the potter Soldner and the tradition of Japanese raku. Japanese raku is a historically rooted

practice that prepares the cups used in the Tea Ceremony, a Japanese spiritual practice. In the Japanese version, there are two forms, red ware and black ware. After being either hand-built or thrown on a wheel and bisque fired, the red ware is fired in a kiln at low temperature while the black ware is fired at a high temperature. The two forms use different glazes and firing techniques to obtain the traditional colouration. Both forms are taken from the kiln when still red hot and nearly molten and then air-cooled slowly.

American raku takes the traditional form and opens it to innovation. As Soldner (1990, 8) puts it:

> American-style raku differs in a number of ways, notably the rich black surface produced by smoking the ware outside the kiln at the end of firing. Other innovations include the quenching of the red-hot vessel in cold water, the production of brilliant and many-colored copper lustres, the forced crackling of the glaze with smoke penetration, the white line halo or ghost image surrounding a black metallic decoration, and the discovery of a copper slip that sometimes results in an unusual yellow matte surface. American raku also utilized shapes other than the traditional tea bowl. Because the tea ceremony itself was never part of American raku, American potters could be more experimental and inventive in making raku than their Japanese counterparts. Furthermore, the speed at which raku could be made allowed spontaneity and opened the way to the creation of new shapes that capitalized on the new freedom from the rigid control of the older utilitarian high-temperature tradition.

It is worth pointing out the potential appropriation-related problems regarding the semantic confusion surrounding the word "raku." In an attempt to claim usage of the word "raku" based upon its perceived meaning, versus the word's usage as a sacred traditional /national sign, Soldner (1990, 9) attended the World Craft Council Meeting in Kyoto in 1978 to air the issue.

> Because the discussion seemed to have reached an absolute dead end, and in the interest of concluding an endless debate, I [Soldner] offered to throw in the sponge. That is to say, because we could not find any commonality acceptable to both sides, I thought it was time to extricate ourselves as gracefully as

possible and go home … If American raku is so different, how did we come to call it raku? It was probably a mistake. A mistake to which I must confess my part, even though it actually happened without my knowledge. Some of the confusion arose because at the time, in 1960, we did not know much about Japanese raku.

Soldner continues to explore the translated origins/ meaning of the of the word raku and eventually develops the term "rakuness." This new term both subjectively extends the meaning of the word "raku" for Soldner and offers more than the title of a technical process, as the American term suggests. Soldner states that rakuness is "not a technique … on one hand a serendipitous event where you found something you weren't looking for on another hand it was based on something that we recognize it as being very difficult to do and yet if it's done well it looks effortless" (Bergan 2004).

Soldner recounts how his first attempts to produce raku were premised on his belief that making raku would be exciting, fun, and could be accomplished quickly. The results were less than entirely satisfactory. He found the pots ugly and vulgar. They lacked subtly in both colouration and form. He almost abandoned the effort. But he was suddenly struck by what he calls a "serendipitous hunch." His failure opened him to experimentation. Rather than continue to emulate the pre-existing form and try to perfect it, he decided to wrap the pots in pepper tree leaves and see if the smoke would improve the surface appearance. He recounts that this random intuitive innovation changed both his life and his work: "I developed an appreciation for the imperfect, for the beauty of asymmetry, and for the value of an organic aesthetic. I found a new freedom of openness and acceptance" (Bergan 2004).

This shift towards the imperfect organic aesthetic is precisely what we mean by immanent alchemy: transformation through encounters of organic difference. Such encounters cannot be predetermined but, rather, have to be sensed in the process of their unfolding. To function they must exceed any capacity to code them over any extended duration. In the Deleuzo-Guattarian sense, they open within the liminal space of the void where sensation itself is composed by "composing itself with itself, and everything holds together on earth and in the air, and conserves the void, is preserved in the void by preserving itself (Deleuze and Guattari 2014, 165).

In reflecting on his work, Soldner (1990) notes that American raku extends the boundaries of pottery through an attention to the capacities of both process and materials. In this, he notes that the aesthetic of raku is beyond process or materials. Premising raku on what he terms the organic aesthetic of Japanese Zen Buddhism, he suggests that raku refers to a feeling. He asks whether it is possible to make raku without making it by process alone and answers that he hopes so.

> If we examine the first raku tea bowls, we need to ask why did the tea master so designate it? Why indeed would a piece of pottery be described as "comfortable" as the Japanese word "raku" is usually translated in English? I have pondered the question many times and offer the following as a possible explanation. Keep in mind that it is only my speculation. It has been some four hundred years since raku pottery was first made and we have no direct record of the event. Part of my speculation concerns physical comfort and the rest considers performance comfort. (Soldner 1990, 11)

He goes on to elaborate rakuness, which he says can be found in the highest realms of competitive athletics as well as of the performing arts. He notes the way in which the process of training, pain, and dedication is somehow obscured in the performance itself. Such performance, Soldner (1990, 11) notes,

> attains such a level of effortlessness, it transcends its own process and uplifts the observer and gives meaning to human existence. It is at such a moment that we experience raku at its very best. Words cannot really describe the experience when it happens, but when it does happen we respond emotionally. It is a feeling of rakuness. Can a simple tea bowl be imbued with this quality? Yes, if it is special enough.

This notion that a performance can transcend its own process and offer a meaning that goes beyond articulation but operates affectively, we would argue, is a possible entry point into a politics of resubjectification with some capacities within the current regimes of capitalism. Soldner (1990, 11) goes on to suggest that understanding raku in this way moves it beyond any form of limited process and engages each

of us in ways that "challenge … each of us to embrace the effort needed to set our own work free."

This way of working with the elements of the earth, Soldner (1990, 11) tells us, offers new ways to imagine beauty. It disrupts notions of "symmetry, unblemished surfaces and rigid machine-like control as examples of perfect craftsmanship." Instead, rakuness is composed of "assemblages of asymmetry, accident, spontaneity, and the value of, and appreciation for, organic naturalness undominated or completely controlled by us" (ibid.). Soldner tells us that to work in rakuness requires an active appreciation and embrace of the element of surprise. Loss of intention and control facilitate the ability to sense and anticipate the capacities of the unknown. He proposes a spirit of rakuness that is premised on change, difference, and a lack of demands or expectations. This does not mean an apathetic acceptance of the status quo, however. There is no transcendent outside in rakuness. It is a process of material engagement and creation of both art and life. Instead, what is being called for is the tactical ability to "learn to accept another solution, and prefer to gamble on intuition" (ibid.).

In the book *What Is Philosophy*, Deleuze and Guattari (2014, 171), note: "The artist is a seer and becomer … he has something in life that is too great, too unbearable also, and the mutual embrace of life and what threatens it … it is always a question of freeing life wherever it is imprisoned, or of tempting it into uncertain combat" We are proposing art in this way, as politics in and of itself through the capacity for all of us to engage in becoming art and artists. In addition, we are suggesting that earth arts, in particular, traverse our current historical moment with its devastating phenomenological and ontological effects on our geophysical actuality. However, it should be noted that, very possibly, what we are all living now *is* an earth art: that is to say. all of our lives today are engaged in global immanent alchemy. If that is so, then perhaps the rakuness of Paul Soldner holds tactical hints for a politics to come.

REFERENCES

Bateson, Gregory. 1972. *Steps to an Ecology of Mind: Collected Essays in Anthropology, Psychiatry, Evolution, and Epistemology*. Chicago: University of Chicago Press.

Bateson, Nora. 2011. *An Ecology of Mind*. Bullfrog Films.

Bergan, Renee. 2004. *Playing with Fire: A Documentary.* American Museum of Ceramic Art.

Deleuze, Gilles. 1992. "Postscript on the Societies of Control." *October* 59: 3–7.

– 1995. *Negotiations, 1972–1990.* New York: Columbia University Press.

– 1998. *Essays Critical and Clinical.* New York: Verso.

Deleuze, Gilles, and Félix Guattari. 1977. *Anti-Oedipus: Capitalism and Schizophrenia.* Trans. Robert Hurley, Mark Seem, and Helen R. Lane. Minneapolis: University of Minnesota Press.

– 1988. *A Thousand Plateaus: Capitalism and Schizophrenia.* London: Bloomsbury Publishing.

– 2014. *What Is Philosophy?* New York: Columbia University Press.

Guattari, Félix. 2005. *The Three Ecologies.* London: Bloomsbury Publishing.

Lacan, Jacques. 1999. *The Seminar of Jaques: On Feminine Sexuality, the Limits of Love and Knowledge* (Book 20). NY: W.W. Norton and Co.

Olkowski, Dorothy. 2013. *Joshua Ramey: The Hermetic Deleuze: Philosophy and Spiritual Ordeal, Review.* http://ndpr.nd.edu/news/36869-the-hermetic-deleuze-philosophy-and-spiritual-ordeal/.

Soldner. Paul. 1990. "American-Style Raku." *Ceramic Review* 124: 8–11.

Spinoza, Baruch. 2000. *Ethics.* Ed. and trans. by G.H.R. Parkinson. UK: Oxford University Press.

Vitelli, Karen. D., and James A. Dengate. 1999. *Excavations at Franchthi Cave, Greece: Franchthi Neolithic Pottery. The Later Neolithic Ceramic Phases 3 to 5.* Vol. 2. Bloomington: Indiana University Press.

Male Becomings:
Queer Bodies as Aesthetic Forms in
the Post-Pornographic Fanzine *Butt*

Peter Rehberg

In the field of queer theory, the project of theorizing a realm beyond the representational is split into two different camps. One tradition follows Lacanian psychoanalysis and posits the real as negativity, impossible to reach, and registered only through its effects within the symbolic. The other tradition follows Deleuze, with his reconfiguration of the real as a site of productive creativity, which does not correspond to the realm of the psychotic, cut off from the symbolic by the logic of castration and phallus but, rather, to an immanent field of connections and expressions that exceeds the purely linguistic.

The first tradition, relying on Lacan, would be famously represented by Butler (1990), and in a different manner – formed through a de Manian lens – also by Lee Edelman (2004). The second model that turned to Deleuze found an early advocate in the French writer, theorist, and activist Guy Hocquenghem (1978) and emerged much later on with a return to Nietzsche and Bergson in the work of Elizabeth Grosz (1994). More recently, the Deleuzian school has also been one of the archives to think about affect beyond a psychoanalytic and a Foucauldian sexuality, for instance in the writings of Lauren Berlant (2011).

However, some queer scholars, such as Hickey-Moody and Rasmussen (2009), have also suggested that the tensions between a Butlerian model, on the one hand, and a Deleuzian, on the other, might not be as irreconcilable as is usually assumed. While obviously belonging to different trajectories, it might be worth looking at points

of connection and at intersections between psychoanalytic and post-psychoanalytic accounts of the relationship between representation and materiality.

Such an approach is fruitful in exploring the representations of the male body in the transnational queer fanzine *Butt*, which was published in Europe between 2001 and 2011. Specifically, I argue that, if we want to understand the forms of post-phallic male bodies in Butt, it seems necessary to critique a Butlerian account of how bodies become culturally intelligible while also connecting a Deleuzian narrative of desire and becoming more closely with notions of gender and sex.

Oscillating between pornography and art, as was typical for the post-porn of the 2000s, the pictures in *Butt* insist on the sexual value of the male body while simultaneously imagining new correspondences for its parts and forms beyond a rigid style of masculinity. They present a specific realism as a new avant-garde by locating the inventiveness of sexualities and bodies on the level of everyday culture conditioned by new media. Thus, *Butt* presents a queer reinvention of maleness as a "post-Aids" phenomenon at the intersection of digital culture, porn, and art.

In order to understand *Butt*'s contribution to rethinking the male body, I use the Deleuzian moments of both Edelman's interpretation of porn as queer event and Bersani's reading of art as a narcissistic replication of forms. By bringing Deleuze into a conversation with the representatives of the *anti-social turn* in queer theory and their critique of Butler it will be possible to understand *Butt*'s contribution to the queer visual archive as a form of *male becoming*.

QUEERING MASCULINITY AND MALENESS

Reading maleness and masculinity as queer is not an easy task. In queer theory after Butler the male was posited as somewhat beyond queerness[1] and, therefore, not turned into a topic of critical investigation. For Butler, the "drag queen" and the "tomboy" become the cultural heroes of queer studies, while J. Jack Halberstam focuses on the question of "female masculinity." Whereas female masculinity, male femininity, and lesbian subject positions promised – by means of their distance to the phallic order – to easily exemplify the anti-essentialist character of gender performances, male masculinity

instead seemed to be locked in by the naturalizing effects of a coherent gender-sex system.

To be sure, there are good reasons for the suspicion about the male body and its conspiracy with masculinity as an institutionalized form of patriarchal power. In a heteronormative culture with asymmetrical gender relations, the dissociation of fantasy from materiality is more difficult to achieve for male bodies than for female ones. Within the cultural logic of the heterosexual matrix, to be a man means to be appointed to prove the authenticity of one's gender. While masquerade and fetishistic fragmentation – technologies that generally stress the performative character of gender – belong historically to the archive of femininity, sexualizing the male body generally works through the authentication of its masculinity. For the system of masculinity, and for maleness as its effect (if we follow the Butlerian logic that binds sex to gender, and not the other way around), it is not easy to escape the threat of castration as their enabling condition. Consequently, masculinity and maleness easily turn into sites for ontologizing and fixing the gendered matrix: "there can be little play in the expression of masculinity" (Berlant 2012, 59). Or, as Halberstam (2002, 352) states: "the inevitable coupling of men and masculinity … constitute[s] a serious obstacle to new and creative thought on gender and its relationship to social change."

But precisely because the collapse of masculinity and maleness seems so inevitable and powerful, I would argue, against Halberstam, that we must work on separating the two by reading those cultural articulations that promise to reorganize the male body and invite us to think about forms of maleness that are not immediately colonized by the system of gender. Or, as Hocquenghem (2010, 67) writes about his project of rethinking homosexuality: "it should be a man with a dick, because the question is not to cut it off, but to invent a new way of using it." Moreover, one could argue that a project of queer studies that is not also hospitable to forms that negotiate the relation between maleness and masculinity (as opposed to femaleness and masculinity, or maleness and femininity) risks becoming itself anti-gay. But, how would we have access to an existence of what Eve Sedgwick calls "the indicatively male forms" (Rambus 2011, 201–2)? How can we not only queer masculinity but also reimagine maleness?

Gay sexual subcultures have been understood as a laboratory for the creation of new forms of masculinity. Gay porn, for instance,

because of its objectification of the *male* body, can always be seen as more than an example of commodification. Wolfgang Tillmans, signature photographer of *Butt*, explains this in the introduction to the second *Butt*-book: "In a world where being objectified is still the hardest thing for a man to bear, the nudity in *Butt* magazine always serves a purpose" (Tillmans 2014, 9).

Generally, there seem to be two different ways of dismantling masculinity: either by mobilizing cultural fantasies and thus loosening the connection between phallus and penis or by trying to move beyond the cultural fantasy of masculinity altogether and to focus on the materiality of a body, with regard to which it is not entirely clear whether it can still be called "male."[2]

While the first approach can be seen in a type of Butlerian or Lacanian analysis of the male parade, for instance in D.A. Miller's (1992) reading of gay men's gym bodies, the second one belongs to a Deleuzian project of understanding bodies as desiring machines, as assemblages in the process of continual becoming that can dissolve the molar in favour of the molecular. From the perspective of *Butt*'s aesthetics, both of these positions seem to not fully grasp what is at stake with the post-pornographic depiction of masculinity and maleness. For one might argue that it is somewhat hypocritical to read gay bodies and homosexual sex as parodistic play since it is the very seriousness of the embodiment of masculinity that constitutes its erotic value, as Leo Bersani (2010) reminds us. Such disillusionment about the possibilities of sexual inventiveness goes back to Hocquenghem (2010, 24), who names this ideological predicament of gay sex the "phallic existence of the queer." While the mobility of the phallus is a politically important narrative, it is far from certain that it applies to the genre of gay pornography. As Rambus (2011, 202) notes, "Mainstream gay male porn runs on the desire for masculinity, on an erotic intensification of it." Here, the question is, in what ways does the post-pornographic style of *Butt* offer an alternative to the visual regime of mainstream gay pornography and its normative account of masculinity?

And as sympathetic as I am with the second project, to undo the ideological, molar stability of masculinity in order to open up a space of libidinal or affective attachments and thus deterritorializing the body through the creative movement of desire, I am also sceptical about a queer criticism that assumes this Deleuzian form of life as an easily accessible option when we talk about pornographic

representation. To put it quite simply: theorizing desire in a post-psychoanalytical fashion should not let us forget the formative impact of gender and sex in sexual cultures and their politics.[3] How can we productively conceive of these tensions between regimes of gender representations and a potential queer mobility?

In distinction to the male masquerade of Muscle Marys or the creative proliferation of a Deleuzian desire, Bersani (2011) brings up a third position in this debate. In "Is the Rectum a Grave?" he claims that gay sexual imagery is just as obsessed with the erection of masculinity as it is with its destruction. The political valence of gayness, which, according to Bersani, is far from guaranteed, consequently relies on the mobilization of this masochistic moment. Bersani asks: How can the destruction of masculinity be turned into a non-destructive form of sexual and social life? In his perspective, the shattering of ideologically charged forms of masculinity opens up the space for an aesthetic reinvention of gender. Here, he also follows Guy Hocqenghem, who claimed that there must be a form of homosexuality beyond the heterosexual matrix – that is, a homosexual homosexuality.

Through inaccurate repetitions, pre-representational becomings, or post-representational aesthetics, Butler's performativity, Deleuze's desire, and Bersani's self-destructive masculinity negotiate the limits of the representational in different ways. The queer fanzine *Butt*, I argue, requires a dialogue between these approaches as it suggests a post-pornographic aesthetics, which cannot be reduced to one of the sexual styles associated with Butler's, Deleuze's, or Bersani's writings. *Butt* does not present pornography as a parody of masculinity, nor does it leave the male body behind in order to celebrate the variety of its emerging connections. Finally, it does not get involved in the masculine drama of a tragic sexuality either. Without simply celebrating the experimental freedom of queerness beyond gender, *Butt* insists on the materiality of the male body without turning it into a site of spectacle or drama. One might call this superficial and ordinary kindness of the bodies and sexualities in *Butt*, which constitutes their historical specificity and requires to be deciphered.

If we understand post-pornography as a cultural form that, in distinction to the paradigm of both gay and straight mainstream porn, takes changes in media technology and the new genres that follow from them (such as Realporn, Netporn, DIY Porn, Porn 2.0) in the digital era as an occasion to create new symbolic spaces and positions,

two things are achieved at once: while, as pornography, relying on bringing pictures of naked bodies into circulation (which is certainly not beyond its power), it simultaneously works on reinventing what these bodies do and what they become. While gay online porn certainly negotiates the place and the impact of masculinity, and thereby reinforces its ideological weight, it can also open up a space for a different perspective on the male body, not so much as an alternative masculinity, I argue, but as a form of male becoming.

BUTT AND POST-PORN

Butt is a gay fanzine focusing on interviews and photos, and it was published from 2001 to 2011 in Amsterdam and New York. It now exists only online as a digital archive and social network (http://www. buttmagazine.com). Gert Jonkers and Jop van Bennekom, *Butt*'s two Dutch founders, also organize parties in Berlin, London, and New York, and they sell *Butt*-branded merchandise such as calendars, T-shirts, and towels in the branches of the Californian no-label-label *American Apparel*. In 2006, the *Butt*-book came out: a best-of selection of the first five years (see Van Bennekom and Jonkers 2006), and, in 2014, a revised and extended edition was released under the title *Forever Butt*.

Butt created a new gay indie aesthetic that has become a global phenomenon and that focuses on a lifestyle that brings together art and pornography. *Butt* spawned imitators, including provocatively titled fanzines like *Kaiserin, Basso, Kink*, and *They Shoot Homos, Don't They?* Each of these fanzines emerged from an urban gay scene (e.g., Paris, Berlin, Barcelona, Melbourne) or focused on a specific sexual fetish (e.g., hair, piss) (Bronson and Aarons 2008).

Butt's photos – printed documentary-style on pale pink paper – must be read in the context of the post-porn movement (Stüttgen 2010), such as the much discussed film *Shortbus* by John Cameron Mitchell (2006), which portrays a sexual subculture in post-9/11 gentrified New York City. *Butt* works with pornographic references, without being simply porn. Rather, *Butt*'s alternative pornographic pictures – rough as well as loving – are integrated in a narrative context, suggesting different body politics and also offering a different understanding of sexuality.

In an ironically old-fashioned gesture, *Butt*'s subheading was initially simply "Magazine for Homosexuals."[4] Quite in the spirit of fan culture, *Butt* is made by homos for homos. Instead of including

lesbians and transgender people (as would be typical for queer), a mixture of styles within the spectrum of gay male sexuality is practised. Moreover, as a "Magazine for Homosexuals" *Butt* is referring to a pornographic tradition and calls for some kind of sexual realism.

Butt showcases a diversity of male bodies that does not always correspond to bodily ideals and rather demanding standards (e.g., cock size and shapes of ass). A less normative physicality is typical for *Butt*. The bodies in *Butt* are not necessarily models of fitness: skinny, fat, and muscular bodies appear side by side. A less normative physicality is typical for the pictures in the queer fanzine (although they are young, under forty-five, and mostly white).

As opposed to hyper-eroticized pumped-up porn heroes, the fetish of *Butt* could be named "realness" instead. While the claim for realness – produced by means of the pornographic action, the visual evidence of pleasure – has traditionally been part of the pornographic image, in *Butt*, pornographic realness is being translated into the "naturalness" of the male body. *Butt* suggests a culture of the ungroomed as a natural aesthetic of the imperfect.

While historically these aesthetics lead back to vintage porn, the new queer cinema, and to the style of the hipster inspired by "white trash,"[5] I also argue that the popularity of the aesthetics of *Butt* and other queer fanzines of the 2000s must be understood as a counter-narrative to 1980s and 1990s pornotopia, especially in the context of new media technology. The boys and men depicted in *Butt* share the "aesthetic of the spontaneous" of amateur porn, such as during live-stream sex chat (Paasenon 2011). *Butt*'s aesthetics of realness as natural imperfection stylizes in its remediation from online to print the most common form of contemporary pornographic representation in the form of cam-sex, sexting, and so on, as it has by now also already entered commercial porn: "With digital cameras and amateur performances, the heteronormative dispositives of hegemonic porn incessantly attempt to beef up the naturalization effects of their images, to dispense with narration and underscore their pseudo-documentary interpretation of desire as an 'event that actually took place'" (Stüttgen 2010, 12). A new sexual subculture has emerged that, in the context of new media technology, does not simply submit itself to the normalizing imperatives of traditional forms of gay pornotopia but, instead, creates new forms of bodies and sexualities.

I am interested in the ways in which this context leads to a dissociation of maleness from masculinity – that is, in what ways do we get to see bodies that count as male without being phallic? How do we

get access to a materiality of the male body in which calling it "male" does not immediately translate into "masculine"? Can maleness become the site for a different economy of bodily signs? Is there something that escapes schematization that we might still call "the body" (Butler 1993, 66)?

Before I answer these questions by showing the proximity between Bersani's and Deleuze's positions, I prepare this perspective by pointing out the limits of poststructuralist readings of embodiment and gender representation informed by a Lacanian or de Manian understanding of the symbolic, as in Edelman and Butler.

BAREBACK PORN

Even though my example of the fanzine *Butt* is quite different from his, and, in some aspects, can even be considered to represent its opposite, I start this discussion by looking at Lee Edelman's reading of bareback pornography. Edelman, of course, is not a Deleuzian. By holding on to a powerful model of symbolic representation, in his view, queerness remains the constitutive outside of rhetorical operations. He conceives of the relationship between the symbolic and its outside as one of necessary repression. Due to this economy of signs, the symbolic that relies on the queer outside as its other will also be haunted by it. The figure of the queer allegorizes that moment within a heterosexist symbolic order.

Hence it comes as a surprise that, in his analysis of gay bareback porn, Edelman (2010, 199) takes into consideration what he calls "a queer event," which allows him to imagine a "pornographic posthumanism." For Edelman the achievement of porn lies in its celebration of forms of life beyond cultural intelligibility or humanism:[6] "pornography humbles intelligence ... Like queerness pornography, of whatever stripe, denies the subject's intellectual, political, or sentimental self-totalization" (198). Given porn's fragmentary character,[7] Edelman ascribes this disruptive force to all pornography. For him, porn always includes forms of material excess. His example, the films produced for Paul Morris's *Treasure Island* label, which specializes in gay bareback porn, presents this materiality primarily in the form of "cum." In Paul Morris's bareback porn, the "cum shot" does not represent the climax of sexual storytelling, which demonstrates the symbolic and sexual victory of the conquering phallic hero; instead it indicates a different representational structure for the pornographic

world: "His porn tapes replace the value of the dick encased in its phallic armor with the value of pure expenditure, with the quantification of cum, and with the heroic stupidity of the anus, hungry to receive, to absorb, to secrete it" (Edelman 2010, 206).

What we find here is a materiality of the body as a form of overspending that is not organized by the fantasy of masculinity anymore but that can still be called "male." In this way, bareback porn enacts the risk of maleness as cultural unintelligibility, a risk that feminism has never taken, as Beatriz Preciado (2013) points out.

MALE FORMS IN *BUTT*

In contrast to bareback porn's obscenities (which can be considered to be fascinating, arousing, comical, boring, or disgusting), the fanzine *Butt* comes across as rather tame, although it does demonstrate a fetishistic fascination with some erotic and sexual details.[8] Its storytelling, however, is also framed – quite differently from bareback porn – by the portrayal of individuals.

While the title *Butt* suggests that we should read it in the context of a tradition inaugurated by Hocquenghem, if not Freud himself – namely, to see the anus as the site for non-phallic masculinities – I am not so much interested here in *Butt*'s approach to de-radicalize the disruptive power of the ass through cuteness: *Butt* not *arse*. Rather, I want to talk about *Butt*'s presentation of limp dicks since, instead of insisting on male power, *Butt* is more fascinated with the different shapes dicks can take.[9] This catalogue of forms and sizes also echoes the variety of body types presented in *Butt*. In the post-pornographic world, males come in all kinds of forms and sizes.

The archive of male bodies and their organs on the pages of *Butt* is less organized by the phallic principle of turgidity – every dick contains the promise of a big one – than as a display of a variation of forms. Or, as Shaka McGlotten (2013, 108) states about online-porn, from which *Butt* also takes its inspiration: "The site therefore makes space for the underrepresented dick, the shy, curved, or humble member."

While these forms are male, they are not phallic. Far from intending to naturalize maleness as sex by insisting – in what seems like a gesture against Butler – on its difference to masculinity as gender, I want to make the case for a materiality of sex, which shouldn't be immediately formalized as phallic. Butler herself, and others, have discussed this

possibility specifically with respect to the relationship between penis and phallus.[10] She asserts: "Insofar as the male genitals become the site of a textual vacillation [between the imaginary and the real, P.R.], they enact the impossibility of collapsing the distinction between penis and phallus" (Butler 1993, 61).

Several contradictions within the concept of the phallus lead Butler (1993, 75) to read the Lacanian phallus against Lacan as imaginary effect, endowed with a general mobility (63). While Butler's and Halberstam's respective projects aim to find the phallus elsewhere – and thereby de-essentializing it – as a form of female masculinity, I am more interested in thinking about zones of the male body that no longer appear under its sign. Not only is the phallus always in excess of its bodily referent, but the same can be said about the body as well: in its relation to masculinity as gender, maleness as sex is always excessive (Nigiann and Storr 2009, 5).

QUEER EVENT

In psychoanalytic discourse there is only a limited space for thinking about forms of the male body including the penis as non-phallic. For Lacan (as for Butler), this is, of course, a site of lack and absence, not of production. But part of the project of post-porn, in my reading, is to explore these non-phallic zones of the male body, to think of maleness as a deterritorialization or de-activation of masculinity as gender. In order to get closer to a way of thinking the materiality of maleness, I want to briefly return to Lee Edelman's example, which is not the limp dick, as in *Butt*, but the excessive display of cum.

While in a Lacanian tradition Edelman conceptualizes the material realm of collecting cum – which is what's going on in Paul Morris's movies – as negativity, beyond the representational regime, and, as such, as a queer event, he also ascribes to it the value of life: "The hunger for cum throughout Morris's work is the hunger for such aliveness, for such radically materialized essence" (Edelman 2010, 208). The obsession with cum, its collecting, reuse, and so on, as a fascination with matter beyond sexual representation cannot be thought of alone as a site of negativity or death; rather, in Edelman, it gains a rather paradoxical status: "Life and death are held in suspension" (208). Finally, in a quite Deleuzian move, he speaks of cum as it "positivizes negativity."

For Edelman we have reached a paradoxical limit here. While "Bareback sex in Morris's work attempts to approach the Real," and its presentation is a form of "positivizing negativity" through the materiality of cum, this instance is immediately named an "impossibility" (Edelman 2010, 208). This is because as soon as we ascribe meaning to the presentation of cum in bareback porn, we have already lost sight of it as a queer event: "No sooner, does cum start to signify the Real that's inherently excluded from meaning than it starts to allegorize the Real instead, effectively turning like culture itself, a profit of meaning on waste" (ibid.).

Therefore, the queer event towards which porn – and bareback porn in particular – points, though approachable, still remains forever impossible. Edelman's analysis of porn assumes an inescapable totalizing power of the symbolic production of meaning. In the process of reading, everything turns into culture, disappointingly, even bareback porn. That's why, for Edelman, we can never achieve dehumanization.

Deleuze's approach, as opposed to Edelman's Lacanian and de Manian account, relies on the shift of perspectives on Edelman's evasive queer event. While Edelman's gesture of a Nietzschean reversal – the positivization of negativity – is so ephemeral it can hardly be registered, for some queer scholars this is the moment in which a Deleuzian paradigm helps us to broaden the scope of queer theory. Hickey-Moody and Rasmussen (2009, 41) write:

> Lack produces as much as it is a response to a given state of affairs. Lack is part of a million different desiring machines that produce new material forms. With this in mind, we argue for a positive engagement with the possibilities afforded by lack and a re-assessment of approaches to theorising lack. Contemporary queer theory needs to think about what "lack" does, to trace the trajectories in thought that lack effects and to affirmatively claim the usefulness of lack as a concept.

AESTHETIC TRANSFORMATIONS

Re-evaluating lack as plenitude is an option that was already announced with the notion of excess in Edelman. Deleuze helps us to further think about this excess as a form of material production.

One of the ways this approach can be made productive for a reading of *Butt* is through the notion of aesthetics.

To put it briefly, what Lacan, Butler, and Edelman share is a denial of aesthetic autonomy. Butler shows no great interest in aesthetic discourses and their potential.[11] Her understanding of the image is taken from psychoanalysis, where it is conceptualized through its formative function in processes of identification and, as such, as a powerful means of ideology: the structuring force of fantasy. Similarly, Edelman takes his scepticism towards the image from de Man for whom the aesthetic, as opposed to the rhetorical, constitutes a form of totality.

In Bersani, however, quite to the contrary – and this is one of the affinities between Bersani and Deleuze – the aesthetic is the realm of ontology. Beyond the drama of a phallic/masochistic sexuality lies the possibility of an aesthetic self. The aesthetic presents matter and form in ways that cannot be reduced to the imaginary. Or, as Hocqenghem (2010, 44) puts it, "If I say that the phantasmatic produces a large part of our reality, I cannot believe that it occupies it completely." To speak of a maleness that appears through the aesthetic, and not through the system of gender, would mean to distinguish – against Butler – sex from gender, not to claim some sort of natural authority for it but quite the opposite: to envision the male body as a site of aesthetic reinvention.

Here, the aesthetic is not characterized by a normative formal canon with its moral mission, as in German idealism, but as a way of witnessing the creative transformation of being: with the aesthetic we can register the process of becoming. For Deleuze and Bersani the aesthetic constitutes a site of transformation.

While it would be fascinating to think further about Edelman's bareback cum in terms of aesthetic productivity, as opposed to understanding its emergence as a queer event in its negativity alone, I want to return here to my example – *Butt*. Representatives of the "antisocial turn" in queer theory, Tim Dean and Lee Edelman in particular, have been criticized for an all too narrow archive when they address the force of queer negativity. The conversation between Edelman and Berlant in *Sex, Or the Unbearable* (Berland and Edelman 2013), for instance, circles around the question of how specific archives of sexual or affective cultures also limit the possibilities for "positivizing negativities."

Cum is not the only form of material excess in porn. *Butt* shows how different body zones can function as a non-phallic male materiality: shapes of asses – *butts* – forms of dicks and balls, hairy backs, or smooth chests. With its catalogue of various male body parts and types, *Butt* works on a transition from a body that is codified as masculine to a male body and its parts beyond a rigid sense of masculinity. Male but not masculine, if we understand masculinity as the form of gender created within phallogocentrism and the heterosexual matrix.

Although at certain moments Bersani distinguishes himself clearly from Deleuze,[12] he does share with him the interest in aesthetics as a post-psychoanalytic paradigm.[13] In the context of gay sexual aesthetics, for Bersani, the self is a form, not as a defensive reaction against desire as lack but, rather, as an impersonal narcissistic self-extension beyond a tragic sexuality. The forms of the male body cannot be reduced to its cultural representations conditioned by gender norms; rather, abandoning gender leads to a release of the form: "the welcoming of a male body that is forgetting its gender" (Hocquenghem 2010, 68).

What I would like to suggest is that the alternative aesthetics in *Butt* can be read as what Bersani (2010, 48) calls a form of being as the impersonal narcissism of inaccurate replications. The sometimes cheerful, goofy, but also melancholic individual *Butt* boys at the intersection of art and porn, with their sexual-aesthetic subjectivities – which are original but without depth – and which resist both the demand for pornographic timelessness and the fascination for sexuality's destructiveness, show us a post-pornographic world by offering non-heroic forms of imperfect maleness that would not partake in the idealization of mainstream porn masculinity and its forms of exclusion but that, instead, present endless copies of nonviolent forms of male beauty.

CONCLUSION

Two modes of positing ourselves in the world: either as subjects for whom knowledge is the principle aim in a struggle to appropriate the irreducible and always potentially menacing otherness of the world, or as subjects who connect, who correspond to, and with, the world's essentially hospitable being. (Bersani 2010, 155)

This second option addressed by Bersani seemed to be foreclosed with the emergence of queer studies as what Sedgwick calls a paranoid form of knowledge and, thus, as a reaction to the HIV and AIDS crisis of the 1980s. Bersani's aesthetic selves approach those zones of being again – a project that in many ways continues Hocquenghem's pre-AIDS writings.

In that perspective, the post-porn of *Butt* from the 2000s and its affective sexualities might not just be a nostalgic return to the sexual culture prior to AIDS, "like the seventies, just without hope," as Justin Bond reasoned about the sex parties in *Shortbus*, but, rather, the re-activation of a different narrative of sexual politics and their relation to aesthetics beyond the canon of queer studies that failed to think about alternative forms of male becomings beyond masculinity.

NOTES

1 As opposed to Sedgwick, who would offer a "space for a gay male-oriented analysis that would have its own claims to make," as Richard Rambus (2011, 191) reminds us.

2 "But what have we put ourselves in the position to say about the enactment and experience of – what do we even call it – male masculinity? Is there a male masculinity for us to desire that isn't masculinist?" (Rambus 2011, 200).

3 But what does Deleuze have to say about the maleness of the body? How can we think about "the entire game of skin and muscle" (Hocquenghem 2010, 63) that *Butt*'s post-pornographic bodies enact as "neither feminine nor psychotic," as Jonathan Kemp (2013) writes about the "penetrated male"?

4 *Butt* changed its subtitle several times (Van Bennekom and Jonkers 2006, 13).

5 Despite these references to US culture, one could also ask whether *Butt*'s alternative aesthetics represent more of a European sensibility then an American phenomenon. In both cases they would posit themselves against the globalized Californian porn ideal.

6 Already here we can of course detect an affinity to a Deleuzian paradigm, which is also evident in Hocquenghem's (2010, 24) analysis of gay sex as a "refusal of anthropomorphic sexuality."

7 Paul Smith (1991, 1025) confirms that "pornographic images produce exactly an instability of identificatory positioning in the male spectator."

8 Here are some of the keywords that Bruce LaBruce (2006, 10) detected while browsing through the pages of *Butt*: "autofellatio, horsehung, gerontophilia, poppers."

9 http://www.buttmagazine.com/magazine/pictures/family-and-friends/.

10 "The Phallus symbolizes the penis; and insofar as it symbolizes the penis, retains the penis as that which it symbolizes; it is not the penis. To be the object of symbolization is precisely not to be that which symbolizes. To the extent that the phallus symbolizes the penis, it is not that which it symbolizes. The more symbolization occurs, the less ontological connection there is between symbol and symbolized" (Butler 1993, 83–4).

11 An example for this would be Butler's (1990) critique of the semiotic in her reading of Kristeva in *Gender Trouble*.

12 "I don't think … that one can finally get rid of the self. That seemed to be the goal of the 'schizophrenic' cultural politics of about twenty years ago, and now that strikes me as naive and politically irresponsible" (Bersani 2010, 172)

13 "Both Bersani and Deleuze wish to alienate us from our comforting modes of recognizability, which immobilize becoming into common sense or habit" (Tuhkanen 2002, 139).

REFERENCES

Berlant, Lauren. 2011. *Cruel Optimism*. Durham, NC: Duke University Press.

– 2012. *Desire / Love*. New York: Punctum Books

Berlant, Lauren, and Lee Edelman. 2013. *Sex, Or the Unbearable*. Durham and London: Duke University Press.

Bersani, Leo. 2010. *Is the Rectum a Grave? And Other Essays*. Chicago: University of Chicago Press.

Bronson, A.A., and Philip Aarons, eds. 2008. *Queer Zines*. New York: Printed Matter.

Butler, Judith. 1990. *Gender Trouble: Feminism and the Subversion of Identity*. New York and London: Routledge.

– 1993. *Bodies That Matter: On the Discursive Limits of Sex*. London: Routledge.

Edelman, Lee. 2004. *No Future: Queer Theory and the Death Drive*. Durham, NC: Duke University Press.

– 2010. "Unbecoming: Pornography and the Queer Event." In *Post/Porn/ Politics*, ed. Tim Stüttgen, 194–211. Berlin: BBooks.

Grosz, Elizabeth. 1994. *Volatile Bodies: Toward a Corporeal Feminism*. Bloomington: Indiana University Press.

Halberstam, Judith. 2002. "The Good, the Bad, and the Ugly: Men, Women and Masculinity." In *Masculinity Studies and Feminist Theory*, ed. Judith K. Gardiner, 344–67. New York: Columbia University Press.

Hickey-Moody, Anna, and Mary Lou Rasmussen. 2009. "The Sexed Subject in-between Deleuze and Butler." In *Deleuze and Queer Theory*, ed. Chrysanti Nigianni and Merl Storr, 37–53. Edinburgh: Edinburgh University Press.

Hocquenghem, Guy. 1978. *Homosexual Desire*. London: Allison and Busby.

– 2010. *The Screwball Asses*. Los Angeles: Semiotext/e.

Kemp, Jonathan. 2013. *The Penetrated Male*. New York: Punctum

LaBruce. 2006. "Fats and Femmes Please! An Introduction to Butt Magazine." In *Butt Book: The Best of the First 5 Years of Butt – Adventures in 21st Century Gay Subculture*, ed. Jop Van Bennekom and Gert Jonkers, 9–13. Köln: Taschen.

McGlotten, Shaka. 2013. *Virtual Intimacies: Media, Affect, and Queer Sociality*. Albany: SUNY Press.

Miller, D.A. 1992. *Bringing Out Roland Barthes*. Berkeley: University of California Press.

Mitchell, John Cameron. 2006. *Shortbus*. Fortissimo Films, USA.

Nigianni, Chrysanthi, and Merl Storr, eds. 2009. "Introduction." In *Deleuze and Queer Theory*, 1–10. Edinburgh: Edinburgh University Press.

Preciado, Beatriz. 2013. *Testo Junkie: Sex, Drugs, and Biopolitics in the Pharmacopornographic Era*. New York: The Feminist Press at the City University of New York Graduate Center.

Rambus, Richard. 2011. "After Male Sex." In *After Sex? On Writing since Queer Theory*, ed. Janet Halley and Andrew Parker, 192–204. Durham, NC: Duke University Press.

Stüttgen, Tim, ed. 2010. *Post/Porn/Politics*. Berlin: Bbooks.

Tillmans, Wolfgang. 2014. "Study of Man." In *Forever Butt*, ed. Jop Van Bennekom and Gert Jonkers, 9–11. Köln: Taschen.

Tuhkanen, Mikko. 2002. "Becoming Same: Bersani and Deleuze." In *Umbr(a): A Journal of the Unconscious. Issue on Sameness*, ed. Mikko Tuhkanen, 141–5. Buffalo, NY: Center for the Study of Psychoanalysis and Culture.

8

Deleuze and Guattari's Geophilosophy Meets 2Pac's Thug Life: Resistance to the Present

Hans Skott-Myhre and Chris Richardson

In their final book, *What Is Philosophy?*, Deleuze and Guattari (1994) reflect on what they term "geophilosophy" – that is, the relation between the earth and the concept. They elaborate the complex, continuous, and imminent relation that every area of the earth holds to the conceptual frameworks, scientific ideas, and artistic expressions produced on it, by it, and from it. It is, they say, a process of territorialization and deterritorialization; it is the production of territories and peoples and their dissolution and reconstitution. For our purposes, we propose to explore the dimension of artistic production in relation to the geography of what has been termed "the hood" in the work of Tupac Shakur, which we first began to unpack through a Bourdieusian approach in *Habitus of the Hood*.

We suggest that artistic expression, in this context, holds the capacity for what Deleuze and Guattari (1994, 108) refer to as a revolution based on creativity and "resistance to the present." The work of Tupac Shakur, although cut short by his untimely death, sustains Deleuze and Guattari's definition of art as "blocs of sensation ... [that] exists in itself ... [and] must stand on its own" (164). Shakur's work exists as artistic expression that, three decades after his death, resists the dominant imperatives of race and economic marginalization. Indeed, even after succumbing to gunshot wounds on 13 September 1996, Shakur's voice continues to resonate from car stereos, nightclub speakers, and television screens around the world. Considering the

unrelenting popularity of his music, Shakur continues to inform the way many North Americans negotiate concepts of black culture and "the hood." The complex and unsettled question of what constitutes revolt as we delve more deeply into the twenty-first century might well be informed by the simultaneous failure of Shakur's art to foment political revolution and the inability of global capitalism to fully appropriate his art as pure simulacra of the hood. In both instances, unintended and unexplored surpluses emerge.

Deleuze and Guattari's elaboration of their call for a revolt against our present moment is complex and nuanced. It is not a call for nostalgia, nor is it a call for any kind of return to an idyllic yester-year. It is not a utopic vision of the future, nor is it an outside sphere of perfect forms and ideal social structures. Indeed, they repudiate such possibilities. In the first instance, there is no past to which we can return. That which has been is only available to us in a transcendent form, as an outside, deployed as a system of rule. Similarly, they warn against utopias, which they define, much like Foucault (1997a), as spaces that specifically do not exist. The force of the past and future utopic spaces lies in their epistemological constituent capacities.

The figure of Shakur read as constituent capacity must not reiterate any sense of authenticity rooted in a nostalgia for a purer form of black artistic expression. Nor can we read Shakur as a figure that indicates a utopian possibility not yet realized. Instead, revolt is always to be found in the idiosyncratic capacity of the art itself to resist whatever the present brings forth at the moment of the encounter between the subject and the art. Shakur articulates this well when he states in "Ghetto Gospel"

> I don't trip and let it fade me, from outta the frying pan
> We jump into another form of slavery
> Even now I get discouraged
> Wonder if they take it all back while I still keep the courage
> I refuse to be a role model
> I set goals, take control, drink out my own bottles
> I make mistakes, but learn from everyone
> ------
> Never forget, that God hasn't finished with me yet
> I feel his hand on my brain
> When I write rhymes, I go blind, and let the lord do his thang

Here, Shakur refuses the possibility that we can encounter his work separate from the regimes of domination and geographies of subjugation that are the genesis of its production. The shift in modes of slavery and the frustration of capacity that leads to the discouragement of the artist constrained is redolent of the failure of the revolutionary movements of the 1960s, in which his mother was integrally involved, and which shaped his early years. The determination to create in the face of discouragement premised on the indeterminacy of specific forms of revolt shapes the artist as an unfinished bloc of sensation in his own right, touched by the force of creation that makes the artist blind to his own role in the creation of his art. It thus becomes an art built out of mistakes and the collective learning of everyone, channelled through the capacities of the singular body as a set of affects for those to come.

In *Holler If You Hear Me: Searching for Tupac Shakur*, Dyson (2001, 13) writes: "Tupac is perhaps the representative figure of his generation. In his haunting voice can be heard the buoyant hopefulness and the desperate hopelessness that mark the outer perimeters of the hip-hop culture he eagerly embraced." Dyson adds that "Tupac's ascent to ghetto sainthood is both a reflection of the desperation of the youth who proclaim him and a society that has had too few saints" (17). Thus, Shakur embodies and vocalizes a "resistance to death, to servitude, to the intolerable, to shame and to the present" (Deleuze and Guattari 1994, 110) through his cultural productions and, perhaps more important, his personal development as an artist.

Shakur's artistic productions are both profoundly personal and impersonal. It is, of course, the trajectory of his body across the geography of the hood and the music industry that opens the field of creative expression; but, as he notes in "Ghetto Gospel," it is also his encounters with other bodies that shapes his capacity for expression in particular ways. As an artist creating mixes of rhythms, both musical and poetic, that articulate his complex reading of life in the hood, Shakur traces a personal saga while, at the same time, opening the uniquely personal world of his vision to the impersonal realm of becoming. It is the becoming of the artist beyond the material transit of a particular set of productions that defines the capacity of a bloc of sensations to persist and to preserve itself over time. The ability to exceed the constraints of a particular historical moment is what gives Shakur living force beyond his time. Shakur's art as revolt is not to

be found in the particulars of its composition but in its ability to continue to evoke sensation in peoples to come – those subjects unimaginable at the time the art was produced but integrally involved in its production through encounter in the world as it emerges. In this sense, Shakur's work can never be found in the past or the future but only in the constant becoming of the present.

The process of becoming is central to Deleuze and Guattari's (1994) concept of revolution. Philosophy, science, and art are all aspects of becoming that hold revolutionary possibility. For art to be revolutionary, it must express a "future form ... that does not yet exist" (Deleuze and Guattari 1994, 108). Such revolution, they argue, will be more "geographical than historical" (110). History cannot offer us the force necessary for actual revolution because, like the outside realms of the utopic future and the nostalgic past, history is composed of "stratigraphic time where 'before' and 'after' indicate only an order of superimpositions" (58). Indeed, Deleuze and Guattari argue that it is geography that challenges the "cult of necessity in order to stress the irreducibility of contingency" (96). Contingency is, in this sense, the set of compositional relations that is always becoming that which is not yet. History is "only the set of conditions, however recent they may be, from which one turns away in order to become, that is to say, in order to create something new" (96). For art to express a future form, it cannot derive such a form from history. It must rely on the contingent assemblages provided by the compositional relations of a particular geography.

As a creator of objects that allow us to question the planes on which we construct our identities and understandings in the world, Shakur generates "blocks of space-time" (Deleuze and Guattari 1994, 191) that can inform worlds to come. As Shakur states in the 2003 documentary *Tupac: Resurrection*, "I'm not saying I'm going to change the world. But I guarantee that I will spark the brain that will change the world." Indeed, the concluding scenes of the film speak volumes to the status Shakur continues to hold as an arbiter of cross-cultural understandings of the hood and its people. Fans from New Orleans, Louisiana; Marin City, California; Sandy, Utah; Paris, France; Istanbul, Turkey; Ljubljana, Slovenia; Port-au-Prince, Haiti, and myriad other places around the world hold up T-shirts, album covers, and even tattoos that honour the late artist and his work. Not a year passes without dozens of songs mentioning Shakur and his influence. And, most important, such allusions and homages do not come only from

the hip-hop world but also from rock, country, and contemporary pop music performers.

Perhaps it is Tupac Shakur the global phenomenon that has the capacity for revolt as we enter the twenty-first century. It is the force of his art to resonate in the global hood, proliferating in refugee camps, favelas, ghettos, and other sites of production for what Bauman (2004) refers to as modernity's outcasts or Agamben (1998) terms "bare life." Bare life is that life that comprises subjects who live outside the protections of the state. They are the undocumented or radically excluded classes that can be incarcerated or killed without repercussion. Certainly, the work of Shakur presages the murder of young black men by police and the deaths of immigrants along the US-Mexico border by US border patrol agents. The world of the hood described in the work of Shakur is a world radically excluded, but a world determined to create an alternative through a refusal of the terms and conditions of the dominant society that marginalizes its members as expendable life.

To refuse the seductions of the state and its juridical machinery as the ground for a certain legitimacy of life and living requires an appeal to something beyond the terms and conditions of the nation or even capital itself. Deleuze and Guattari suggest that revolt of this kind is not reliant on the trajectories of territorialization that produce borders and ghettos. It is, instead, rooted in the immanent movements of the earth.

The earth, as opposed to history or language, "constantly carries out a movement of deterritorialization ... [it] is not one element among others but brings together all the elements within a single embrace while using one or another of them to deterritorialize territory" (Deleuze and Guattari 1994, 85). That is to say, there is no outside to the actual becoming of the fundamental materiality of the earth. This is a powerful assertion of the earth as a totality of all-becoming elements of an eco-sphere. For there to be revolutionary force, there must be an integration of all organic and inorganic forms. The practices of taxonomy and teleology distract us from the actual set of compositional relations and would have us mistake both our role and position for fixed positions unless a catalyst – perhaps the lyrics in a song on the refusal of a group to censor its performance in a Detroit arena – begins a questioning of such fixed positions.

Art then, as a form of revolt, must be an expression of the earth in its full machinic compositional aspect. Deleuze and Guattari (1994)

tell us that it must engage contingency and chaos. In fact, art must plunge into the chaos and bring back "varieties that no longer constitute a reproduction of the sensory in the organ but set up a being of the sensory, a being of sensation, on an anorganic plane of composition that is able to restore the infinite" (302). In this sense, art is not a return to a sensation we have known. Art, as a form of revolt, establishes a temporal incursion of the sensate that disrupts and opens the organism to the moment of pure sensation. However, such a moment takes place on an anorganic plane, a plane without organs, a plane that is pure sensory composition, which breaks us free from finite temporality and opens the organism to the infinite. The infinite as a fractal becoming is a specific contingent trajectory stemming out of the chaos from which it emerges. As Deleuze and Guattari put it, "it is always a matter of defeating chaos by a secant plane that crosses it" (202).

The point of intersection and entanglement of the plane without organs with the secant plane that crosses it might well be found in the life of the artist. Shakur, as the expression of the percepts and affects of lived experience, articulated in the intensities of his rhymes and rhythms a certain and particular contingent composition of the chaotic elements of a geography and a historical moment. His art – and life – plunged into the chaos to bring back a fracture, a rupture in the rhythms and articulations of domination. Perhaps his production can thus be read as the saying of the unsayable.

In his biography, Dyson (2001, 153) quotes Michel Foucault, who asks: "Couldn't everyone's life become a work of art? Why should the lamp or the house be an art object but not our life?" Dyson adds, "The interesting questions of Tupac's art – whether it furthered the artistic ideals he claimed to represent, whether it musically or lyrically measured up to the best of what the genre had to offer, or whether it suffocated in a miasma of rhetorical posturing – are hardly asked" (ibid.). This neglect of Shakur as an artist and the capacities of his work as art, Dyson argues, is due to a heavy focus on morality. Of course, the question of social convention as morality in relation to the life of the artist is a timeless preoccupation of those incapable of apprehending the chaos in art and in the artist. In relation to Shakur's artistic creations, the pithy judgment of the moralist must not over-shadow the ways in which his constructions work to stir both percepts and affects that transcend him as an individual and permeate the intersections between himself and his audiences.

Music produced by artists like Shakur may represent a fictional universe, or at least a mediated and subjective one, but the implications of these representations within the societies from which they are created are a part of an actual and material politics that we also seek to interrogate. We argue, like Deleuze and Guattari, that geo-spatial configurations are central to such work and cannot be ignored. Shakur can be seen to literally and figuratively construct spaces that join his past (in working-class communities in New York, Baltimore, and Oakland), his present (at the time of recording, primarily in upscale Los Angeles locations), and his future, which we discuss below.

This process of living art as expression takes artists through a certain kind of catastrophe during which there is no certainty that they will return from chaos. Revolutions, artistic or otherwise, must be premised on similar catastrophe. Referring to the Holocaust, Deleuze and Guattari (1994, 107) state that catastrophe consists of a "society of brothers or friends having undergone such an ordeal that brothers and friends can no longer look at each other or each at himself, without a 'weariness,' perhaps a 'mistrust'" (107). In our contemporary world, the hood may be just such a space within late capitalism. In a society premised on the denial of the traumas of the colonial enterprise and its subsequent formations, indeed a certain weariness and mistrust becomes the rule of the day. If we are to take seriously the link between geography, art, and revolution, then we must ask, what of the artists that engage this catastrophe? To be sure, there are those who tread carefully around the edges of the catastrophe and those who run away, those who would evoke a certain nostalgia for forms past or seek to valorize neocolonial retreading of fading paths of power and control. But what of the art that plunges into this chaos of catastrophe? For those who return, what do they bring back with them?

Deleuze and Guattari (1996, 110) suggest that, to understand both catastrophe and revolt, we must investigate spaces in which the abominable sufferings of others create a new people through their "resistance to death, to servitude, to the intolerable, to shame and to the present." However, they tell us that "the artist … is quite incapable of creating a people" (ibid.). All the artist can do is "summon it with all his strength." How then can the artist summon the creation of a people? Deleuze and Guattari say that works of art contain their sum of unimaginable sufferings. Such sufferings for both the artist and the others produce forms of resistance to the present. In the case of

artists, such resistances are expressions that "forewarn the advent of a people" (ibid.). Again we can see this suffering in the work of Shakur when he states, in "Ghetto Gospel":

> I stop and stare at the younger, my heart goes to 'em
> They tested, it was stress that they under
> And nowadays things changed
> Everyone's ashamed of the youth cause the truth looks strange
> And for me it's reversed, we left them a world that's cursed, and
> it hurts
> 'cause any day they'll push the button
> and all good men like Malcolm X and Bobby Hutton died for
> nothing
> Don't 'em let me get teary, the world looks dreary
> but when you wipe your eyes, see it clearly
> there's no need for you to fear me
> if you take your time to hear me, maybe you can learn to cheer me
> it ain't about black or white, cause we're human
> I hope we see the light before it's ruined
> -----------
> Tell me do you see that old lady ain't it sad
> Living out a bag, but she's glad for the little things she has
> And over there there's a lady, crack got her crazy
> Guess she's given birth to a baby

This articulation of suffering is mitigated by a call to "wipe your eyes and see it clearly." Artistic works produce themselves in infinities of deterritorializations and manifest in all these forms of lived experience and impressions of events and struggles. "Revolution is absolute deterritorialization even to the point where this calls for a new earth, a new people" (Deleuze and Guattari 1996, 101). It is here that a vision of the future through the cultural and artistic struggle of the present forewarn of a people to come. In terms of the hood, it is the (re)production of marginalized spaces – also known as the ghettos, the inner cities, or simply the wrong sides of the track – that involves a constant movement from the territories that inspire contemporary cultural imaginaries to the deterritorializations of the capitalist assemblies that commodify them.

Such art that signals the advent of a new people originates in what Deleuze and Guattari have called a minoritarian vernacular. They state:

Minorities of course are objectively definable states, states of language, ethnicity, or sex with their own ghetto territorialities, but they must also be thought of as seeds, crystals of becoming whose value is to trigger uncontrollable movements and deterritorializations of the mean or majority ... The figure to which we are referring is continuous variation, as an amplitude that continuously oversteps the representative threshold of the majoritarian standard, by excess or default ... It is certainly not by using a minor language as a dialect, by regionalizing or ghettoizing that one becomes revolutionary; rather by using a number of minority elements, by connecting, conjugating them, one invents a specific, unforeseen, autonomous becoming. (Deleuze and Guattari 2007, 106)

We would argue that Shakur's work and legacy is the artistic assemblage of just such minority elements. The conjugation of homeless old ladies, crack babies, Black Panthers, the threat of atomic annihilation, the reversed world of hope and despair for young people constructs a minor reading of the world, a certain kind of artistic habitus. Tomlinson and Burchell (1994, ix) write in their introduction to *What Is Philosophy?* that the word *voisinage*, which Deleuze and Guattari deploy frequently, "here has the general sense of 'neighborhood' but also its mathematical sense, as in 'neighborhood of a point,' which in a linear set ... is an open segment containing this point." For instance, Deleuze and Guattari (1994, 20) write that a "concept is a heterogenesis – that is to say, an ordering of its components by zones of neighborhood."

Shakur's work as artist can be located within this confluence of multiple *voisinage*s. As we argue in *Habitus of the Hood* (Richardson and Skott-Myhre 2012), Shakur can perhaps best be understood as an "Organic Gangsta Intellectual" in that he follows Gramsci's call for community representation, subversive criticism, and coalition-building. But he adds something more to the equation. In joining disparate groups such as (1) middle-class, white, suburban teenagers; (2) popular entertainers, and (3) the working-class minorities most affected by post-industrial capitalist catastrophes, he points out the absurdity in universal ideas and grand narratives that neglect these overlapping *voisinages* and draws us to a rethinking of all of our circumstances. "There is an area *ab* that belongs to both *a* and *b*, where *a* and *b* 'become' indiscernible" (Richardson and Skott-Myhre 2012, 20).

As Deleuze and Guattari (1994, 29) argue, "all these debaters and communicators are inspired by *ressentiment*. They speak only of themselves when they set empty generalizations against one another." Shakur calls them on it. He asks: "What makes me saying I don't give a fuck different than Patrick Henry saying give me liberty or give me death? What makes my freedom less worth fighting for than Bosnians or ... whoever they want to fight for this year?" (Lazin 2003). Taking his personal experiences, combining them with the mediated representations of himself and others, and finding them irreconcilable, he becomes an artist who calls into question the order words that Deleuze and Guattari argue structure the world and impose pre-existent frameworks and definitions. Shakur reappropriates "thug," for instance, arguing that "it doesn't have anything to do with the dictionary's version." He creates his vision for a new way of life in his community predicated upon a community of friends – or thugs – that have not yet existed and, in other ways, have always been a part of his experience. Thus, he delivers minor knowledges to a broader public, not fully formed, but holding the potential to be shaped and reshaped by the various communities it meets. In a similar way to Foucault's (1997b) call for an insurrection of subjugated knowledges, Shakur insists: "I think even gangster can be positive. It just has to be organized. And it has to stay away from being self-destructive ... to being self-productive" (Lazin 2013).

Deleuze and Guattari (1994, 177) write that "the victory of revolution is immanent and consists in the new bonds it installs between people, even if these bonds last no longer than the revolution's fused material and quickly give way to division and betrayal." Perhaps Shakur's Thug Life, both as concept and as lived reality, exemplifies this revolution better than any other aspect of his work. Shakur argues: "I didn't create Thug Life. I diagnosed it." In doing so, and in representing his conceptual schematic, which includes a list of rules to which thugs can subscribe, Shakur brings forth his image of a new people.[1] This new people includes thugs, gangsters, bloods, and crips, all warriors, but all conscious of existing within a plane of immanence that connects them.

As Todd Boyd argues, "I think Pac is interesting, because he's a cat who most people associate with the real in hip-hop ... and to me his life is everything other than real ... He couldn't distinguish between the real and the fictional" (quoted in Dyson 2006, 154). If we look

at this another way, we could take Boyd's comments as an articulation of Shakur becoming an artist, who, as Deleuze argues, ought to show humans how to go beyond and outside of humanity. Was Shakur a man, a saint, a criminal, an artwork, an imagined being? Perhaps the best question is to ask not *what* he was but *how* he was all and none of these things at once.

There is, however, an abiding and troubling current under the surface of our project that might well threaten to overtake it – particularly if left unchecked – and this is the question of whether one can bring a European philosopher, a French psychoanalyst and activist along with two North American academics together to comment on the work of an African American artist. This issue holds painful echoes of previous projects of cultural appropriation and misguided commentary on black culture. In a similar vein, feminists have decried Deleuze and Guattari's appropriation of women's struggles into their concept of becoming woman. It seems reasonably clear that, in the work we are referencing here, Deleuze and Guattari are unequivocal in their assertion that art, philosophy, and science are produced out of particular geographies and historical trajectories. Indeed, Nadya Tolokonnikova and Maria Alyokhina from Pussy Riot make this point in their conversation with Rosi Braidotti and Judith Butler (The First Supper Symposium 2014). When asked about the implications of the feminist struggle in Russia for feminists in North America, they break from speaking Russian and being translated into English to note with some force that the struggle in Russia is both geographically and historically specific. Whatever the trajectory for feminism in North America, while it can be informed to some degree conceptually by what happens in Russia, the Russian and North American struggles are ultimately unassimilable. Each is rooted in a singular configuration of particular elements only to be found in the specificities of a particular place and time. The question for us here is what of the entangled relations of Shakur's legacy that exceed and extend its roots and origins beyond the hood? Is Shakur also unassimilable outside the context of black masculinity within a specific geography?

The relation between art and culture, particularly as we enter the twenty-first century with the rise of global capitalism and the collapse of overt geographical colonization, opens new fields of appropriation and immanent production. As we engage labour as increasingly

immersed in the realm of the virtual, or what Hardt and Negri (2000) term immaterial labour, what happens to the question of literal geographies as foundational sites of production? With the collapse of the nation-state into what Hardt and Negri have termed Empire, millions of bodies are thrown into flows across geographies previously limited by borders and historical configurations of peoples and cultures. In the ensuing chaos of bodies colliding and borders collapsing, new geographies both material and virtual open on to definitions that exceed the capacity to contain or control them with any degree of certainty. The dominant regime of production is fully engaged in an effort to rapidly assimilate and overcode emerging new geographies of human production into the empty signifier of the money sign. As with the systems of Empire that preceded it historically, global capital holds no qualms about strip mining new modes of production and transfigured sets of relations. There is, undoubtedly, no way back.

In a world of holograms, digital exchanges, and virtual economics, what is the relation of geography, art, and culture? With the help of the same special effects studios who worked on *Benjamin Button*, *Tron: Legacy*, and *X-Men: First Class*, Shakur was resurrected at a 2012 Coachella performance alongside real-life performers Dr Dre and Snoop Dog. He performed "2 of Amerikaz Most Wanted" before his image burst into a million pieces. He also narrated his 2003 documentary *Tupac: Resurrection*, in which Director Lauren Lazin used a bricolage of video and audio recordings to allow the late artist to comment on his own life story, moving from his aspirations as a rapper to his personal experience of getting on stage before millions of people in his career. Interestingly, the tagline of the film was "This is my story," a quote from one of his interviews whose meaning changes as it enters new contexts and assemblages of artists, producers, and authorial control.

As the borders established by the European colonial project yield to the new imperatives of virtual capitalism, the relations of land and peoples garner new meanings and valences. In a mode of economy where corporations are no longer linked in any permanent way to any site of production, material geographies are opened to the contestations of the subalterns left to fend for themselves in abandoned geographies such as Detroit, Juarez, Beirut, and the West Bank – not to mention the myriad Aboriginal reserves scattered across desolate patches of North America – and, of course, the shifting configurations of the hood with which this chapter is primarily concerned. Corporate

capital outsources its machineries of production as mobile incursions that cut across these geographies, extracting resources at variable speeds and with the certainty of impermanent engagement. The question of appropriation is no longer dependent upon long-term occupation of a geography, nor is it dependent upon extraction of a resource or the imposition of a form a labour. The drug wars being waged in hoods across the Americas are exemplars of the tendency in global Empire to deploy internecine conflict to clear the remnants of a postindustrial geography and make it available for reappropriation through gentrification. War becomes a new form of labour that produces profit in the production and sale of the armaments necessary to eviscerate and destroy a particular geography and the contractors and materials to rebuild and reconfigure spaces in the image of the ruling elite. This strategy holds equally well in the realm of the arts, where the cultural forms generated through "abominable struggle" are stripped down to formulaic simulacra and recycled as cultural soylent green with all the cannibalistic implications of that term.

Under such circumstances, we argue that entangled modes of analysis, such as those we propose here, may have utility beyond the clear demarcations of the traditional relation of culture and geography. As Deleuze would have it, the question is not epistemological but ontological. Ontological, in the Deleuzo-Guattarian register, however, is never a question of being. It is always a question of becoming. That is to say, it is not an issue of what art is but of what ways is art already emerging beyond art as we know it. The property of existence for art as explicated by Deleuze and Guattari (1994) does not reside in the piece of art per se but in its effect. Or, to be more precise, in its affect – in the ability to affect and to be affected. Deleuze and Guattari (1994, 163) assert that art "preserves and is preserved in itself ... although it lasts no longer than its support and materials – stone, canvas, color and so on." The Kantian and Spinozist registers in this definition delineate art as both that which exists as immanent to its own effects by right of its ability to be preserved beyond the material elements that compose it. They go on to say: "If art preserves, it does not do so like industry, by adding substance to make the thing last. The thing became independent of its 'model' from the start ...What is preserved – the thing or the work of art – is a *bloc of sensations, that is to say a compound of percepts and affects*" (164, emphasis in original). As we have inferred above, the realm of perception and affect as feeling is in this iteration impersonal. Art, to the degree it

meets this definition, is immanent and, as such, exists in itself. The capacities of art are not experienced by the subject from the outside but stand in a constitutive relation, a mutual co-production of precept and affect. There is no outside to this relation in which the subject's perception produces art. Art as immanent to its own effects stands on its own, independent of both its creator and those who encounter it post-production. In this sense, the work of Shakur derives from the elements of its genesis, in the abominable sufferings of the hood, but is simultaneously immanent to itself. What is preserved is not the work of art evidenced in the materials but the percept and affect, the bloc of sensation as it becomes art in the making. As Deleuze and Guattari (1994, 167, emphasis in original) tell us:

> Even if the material lasts for only a few seconds it will give sensation the power to exist and be preserved in itself *in the eternity that co-exists with this short duration.* So long as the material lasts, the sensation enjoys an eternity in those very moments. Sensation is not realized in the material without the material passing completely into the sensation, into the percept or affect … By means of the material, the aim of art is to wrest the percept from the perceptions of objects and the states of the perceiving subject, to wrest the affect from affections as the transition from one state to another: to extract a bloc of sensations, a pure being of sensations. A method is needed and this varies with every artist.

After his death, as he becomes a hologram in concert venues, narrator of his own death, and prophet to disparate groups who continue to claim him as their own, Shakur represents infinite potentialities. With these posthumous events, and the seemingly infinite use of his recordings in new hip-hop albums, the artist continues to hold an important place in the representations and discourses of the hood and its people. We argue, in fact, that Shakur has become a work of art and a body without organs, who, in our popular culture, returns to that moment before definition when anything is possible. Shakur can now dance on a thousand stages at once, performing unique interactions with his audience and inspiring different messages within each context. One exciting thing about such possibilities is the infinite capacities Shakur now holds. A concern, however, is the struggle over his image and its uses that inevitably follows the death of the artist.

While his work continues to live, transform, and reappear within our changing social contexts, the battle over Shakur fought by multiple competing parties, many of whom seek to reterritorialize his image in the name of capital accumulation, intensifies exponentially.

Shakur's vision of the future, whether accurate or absurd, renders a momentary revolutionary spark that indeed holds the power to inspire those who will inherit the earth. In short, Shakur represents a substantial influence in what is already a significant mode of artistic expression. He was "the ghetto's everyman," argues Dyson (2001,107), "embodying in his art the horrors and pleasures that came to millions of others who were in many ways just like him." Shakur represented residents of the hood, their struggles, their passions, and their dreams. Simultaneously, he was a unique resident with a distinct personality and, from about the age of twenty, a crowd of paparazzi recording his every move. While Shakur's experiential lyrics are not necessarily representative of all others in the community, it is important to consider that Shakur's popularity is, in large part, attributed to the fact that he spoke for the hood, reflecting insiders' experiences back to them and making outsiders curious about a world they had never seen before. Shakur became a sort of bridge for these groups, bringing them together through his music and life to a point where *a* and *b* become indiscernible, showing them a people they could become, and creating blocs of percepts and affects that can continue to colour our ways of being today.

NOTE

1 The code of Thug Life, which Tupac presented at a truce-building picnic in California in 1992, is as follows:

Code OF THUG LIFE: 1. All new Jacks to the game must know: a) He's going to get rich. b) He's going to jail. c) He's going to die; 2. Crew Leaders: You are responsible for legal/financial payment commitments to crew members; your word must be your bond; 3. One crew's rat is every crew's rat. Rats are now like a disease; sooner or later we all get it; and they should too; 4. Crew leader and posse should select a diplomat, and should work ways to settle disputes. In unity, there is strength; 5. Carjacking in our Hood is against the Code; 6. Slinging to children is against the Code; 7. Having children slinging is against the Code; 8. No slinging in schools; 9. Since the rat Nicky Barnes opened his mouth; ratting has become accepted by some. We're not having it; 10. Snitches is

outta here; 11. The Boys in Blue don't run nothing; we do. Control
the Hood, and make it safe for squares; 12. No slinging to pregnant
Sisters. That's baby killing; that's genocide; 13. Know your target, who's
the real enemy; 14. Civilians are not a target and should be spared;
15. Harm to children will not be forgiven; 16. Attacking someone's home
where their family is known to reside, must be altered or checked;
17. Senseless brutality and rape must stop; 18. Our old folks must not
be abused; 19. Respect our Sisters. Respect our Brothers; 20. Sisters in
the Life must be respected if they respect themselves; 21. Military disputes
concerning business areas within the community must be handled profes-
sionally and not on the block; 22. No shooting at parties; 23. Concerts
and parties are neutral territories; no shooting; 24. Know the Code; it's for
everyone; 25. Be a real ruff neck. Be down with the code of the Thug Life;
26. Protect yourself at all times.

REFERENCES

Agamben, Giorgio. 1998. *Homo Sacer: Sovereign Power and Bare Life.*
 Trans. D. Heller-Roazen. Stanford: Stanford University Press.
Bauman, Zygmunt. 2004. *Wasted Lives: Modernity and Its Outcasts.*
 Cambridge : Blackwell.
Deleuze, Gilles, and Félix Guattari. 1994. *What Is Philosophy.* Trans.
 H. Tomlinson and G. Burchell. New York: Columbia University Press.
– 2007. *A Thousand Plateaus: Capitalism and Schizophrenia.* Trans.
 B. Massumi. Minneapolis: University of Minnesota Press.
Dyson, Michael Eric. 2001. *Holler If You Hear Me: Searching for Tupac
 Shakur.* New York: Basic Civitas Books.
The First Supper Symposium. 2014. *Pussy Riot Meets Judith Butler and
 Rosi Braidotti.* 21 May. https://www.youtube.com/watch?v=BXbx_
 P7UVtE
Foucault, Michel. 1997a. "Of Other Spaces: Utopias and Heterotopias."
 In *Rethinking Architecture: A Reader in Cultural Theory*, ed. N. Leach,
 330–6. New York: Rougledge.
– 1997b. *"Society Must Be Defended": Lectures at the College de France,
 1975–1976.* Trans. D. Macey. New York: Picador.
Hardt, Michael, and Antonio Negri. 2000. *Empire.* Cambridge, MA:
 Harvard University Press.
Lazin, L. dir. 2003. *Tupac: Resurrection* (motion picture). USA: Paramount.
Richardson, Chris, and Hans A. Skott-Myhre, eds. 2012. *Habitus of the
 Hood.* Bristol, UK: Intellect.

PART THREE

Auto-Ethnographies
of the Post-Identitarian

9

Thought beyond Brains: Performing Immanent Zombie Politics through Autoethnography

Joanna Perkins

In the midst of a zombie apocalypse we are struck by the problem of identification. Who are the zombies? They? Or Us? They are us? We are them? Who's who? An enemy becomes difficult, if not impossible, to identify. In the zombie apocalypse we find ourselves in a space of chaos and conflation; the critical distance between humans and zombies is blurred.

In his seminal piece, "Postmodernism, or the Cultural Logic of Late Capitalism," Frederic Jameson (1991, 87) states: "distance in general (including 'critical distance' in particular) has very precisely been abolished in the new space of postmodernism." Such a disappearance of distance clearly poses a difficulty for the enactment of the sort of critical thinking that has been a driving force of political action in the modernist era. This type of critical thought can be rooted in traditional or "vulgar" readings of Marxist ideology critique and "depends upon an untenable opposition between truth and falsity, reality and ideology, whose source might be found in the relationship of subjects to their objective position in an economic structure" (Sharp 2007, 737). Such a position naturally requires an act of distantiation of the subject. But as Jameson (1991, 87) further explains:

> We are submerged in its henceforth filled and suffused volumes
> to the point where our now postmodern bodies are bereft of spa-
> tial coordinates and practically (let alone theoretically) incapable

of distantiation; meanwhile, it has already been observed how the prodigious new expansion of multinational capital ends up penetrating and colonising those very pre-capitalist enclaves (Nature and the Unconscious) which offered extraterritorial and Archimedean footholds for critical effectivity.

Just as differentiating between zombie and human becomes unclear in a zombie apocalypse, it is unclear what differentiates true and false in late-stage capitalism. If there is no truth to ground our actions, we have no choice but to become like zombies, acting only on hunger and desire, for better or for worse. At its worst, late-stage capitalism can create a politics of consumption; what Henry Giroux (2011) describes as a "casino capitalist zombie politics." In the space of postmodern, or late-stage, capitalism, all actions appear to be devoured by the capitalist system and then repackaged back into that very same system to be sold and consumed anew (even though there's nothing new about it). Even (and perhaps *especially*) thought is consumable. And so like zombies in the apocalypse, we feed on brains in late-stage capitalism. Critical thinking falls back into a reflexive loop, consuming itself, rendering it powerless (Dean 2010). Politics appear to be dead or undead.

However, if distance is not possible we have little choice but to embrace this as the truth of our new reality, as Jameson suggests. The seemingly impending doom of the zombie apocalypse is only imagined to be on the horizon of the future. In reality, the devastating effects of late-stage capitalism are already being felt on an everyday basis. We are living in an apocalyptic world now. Instead of fighting this zombie, or capitalist, apocalypse, we must face it and see what we can do *with* it instead of against it. Thus, my chapter meditates on the question: "What kind of possibilities might an *immanent* zombie politics hold?"

In order to explore such a possibility, we must first rethink the premises of critical thinking within this new apocalyptic reality. Following Hasana Sharp (2007), I propose to rethink this problem within an immanent, Spinozist framework. Sharp explains how, for Spinoza, ideas are not a matter of truth or falsity but of force. Here, critical "thinking" goes beyond thought: thought is embodied and performed; thought is *lived*. Applying Sharp's conceptions of Spinozist critical thought, we might begin to see the ways in which zombies do "think." If extension and thought are parallel, as Spinoza posits, then

zombies necessarily think and effect ideas. Autoethnography can be seen as one way to address the issue of the distanced subject, making the subject the actual object of research, replacing a distanced critical thought with one of proximity. With autoethnography we must start with where we are at (Ellis and Bochner 2000): even if where we are at is a zombie apocalypse and we are the zombies. Like Spinozist critical thought, autoethnography it is not concerned with truth or falsity but with understanding and process, with the melding of life, thinking, and writing in order to open up new possibilities for thought and action. The effects of thinking and writing autoethnography can go beyond writing and flow into everyday actions, simultaneously rethinking and reanimating zombie politics. In this chapter I explore how autoethnography can be a useful tool for putting into practice this sort of embodied thought and, thus, a tool for performing an immanent zombie politics. First, however, I will expand on the nature of Spinozist, or immanent, critical thought, which is what drives zombie politics.

THOUGHT BEYOND BRAINS: IMMANENT CRITICAL THOUGHT

As mentioned previously, modernist methods of critical thinking, or ideology critique, hold a distant and objective subject as a prerequisite for validity. While this subject, often rooted in Cartesian dualism, has been problematic even in modernist times, it has become particularly untenable in postmodern times. An alternative subject and method of critique is clearly needed. Hasana Sharp (2007) builds a brilliant foundation for what I refer to as immanent critical thought by highlighting Spinoza's contribution to ideology critique through the Marxist philosophy of Louis Althusser. Sharp's essay interprets ideology through Spinozist metaphysics in order to clarify what immanent critical thought entails. In an attempt to more clearly illustrate what is meant here by immanent critical thought, I first give a brief overview of Spinoza's metaphysics – in particular, his conceptualization of mind-body parallelism – and how it contrasts to Cartesian metaphysics and dualism. Then, with the help of Sharp's work on ideology, I explain how immanent critical thought is a matter of force rather than validity and then explore the immanent critical subject.

Spinoza's philosophical texts, and especially his *Ethics*, were in many ways a critical response to the philosophy of Descartes. In some

ways, Spinoza builds on Cartesian philosophy, but with many subtle yet critical differences. A key divergence from Descartes's philosophy concerns the way in which Spinoza took up the concept of substance. "Substance" is a term both philosophers employ centrally in their work, and it was adapted by Descartes from Aristotelian philosophy (Lloyd 1994). In his *Principles of Philosophy*, Descartes (2010, pt. 1, sec. 51, p. 13) defines substance as a "thing that exists in such a way that it doesn't depend on anything else for its existence." He goes on to explain, however, that the term "substance" applies differently depending on whether it is referring to God or to God's creatures. God is the only substance that depends on nothing for its existence, all other substances are "things that don't depend for their existence on anything except God" (Descartes 2010, pt. 1, sec. 52, p. 13). For Descartes, mind and matter are secondary substances dependent on God alone. However, Descartes (2008, *Synopsis*, 14, 11) deems the human mind immortal and unchangeable and views it as a purer substance than the human body, which is made up of accidents and can easily perish. The horror of the zombie might be seen to reflect an investment in Cartesian dualism: a body without a rational mind ceases to be human.

In his *Ethics*, Spinoza (2000, I, prop. 14, 85; II, props. 1 and 2, 115–15) posits that there is only one unique *Substance* (*God* or *Nature*), of which mind and matter are *attributes*. Deleuze and Guattari refer to this Substance as the plane of immanence. Spinozist Substance (or God) is made up of infinite, diverse, yet parallel attributes through which Substance is expressed. An attribute expresses an essence of Substance, or a way of being (Sharp 2011). Although Substance is one unity, it is not a homogeneous entity. Attributes account for the heterogeneity of Substance by expressing infinite and diverse essences of Substance. Humans, according to Spinoza, only have access to two of these attributes – thought and extension. Further, humans are viewed as finite *modes* of Substance and express Substance through the attributes of thought and extension. A mode, then, is an entity that can express different ways of being (or attributes). A human is but one example of a mode, with access to particular types of being (thought and extension in the form of mind and body). Humans and other "things" that make up finite modes, although embedded in Substance, are also the opposite of Substance in the sense that they are not self-constitutive: they are dependent on one another for their existence as well as the infinite force of existence rooted in Substance.

What should be noted is the complex web-like structure of interrelations whereby all modes and attributes are embedded within Substance rather than separated into several unique systems of substances, as in Descartes' philosophy. Spinoza's conceptualization of Substance is immanent. Thus, humans are not set apart from Substance as made up of secondary substances but, rather, are holistic individuals expressing both mind and matter as modes of God. So what Spinoza is essentially positing is that the mind and body exist and act simultaneously – rather than that the body is a slave to the mind, as we might read Cartesian metaphysics as suggesting.

However, if the mind and the body are two aspects of the same thing, as Spinoza posits, the division between ideology and reality is complicated. Truth and falsity for Spinoza are issues of an onto-epistemological nature. An idea for Spinoza does not take place solely in a detached, rational mind – an idea occurs within the attributes of thought and extension simultaneously. "A physical thing and the idea of that thing are one and the same thing, expressed through different attributes" (Parkinson in Spinoza 2000, 58). For Spinoza, then, there is what he calls a "true idea," but it is premised on different criteria than those upon which modernist Marxists would base truth or validity. A true idea affirms everything that exists. A "false idea," for Spinoza, is what does not exist – lack. This may sound quite obscure at first, but the notion is actually quite simple, although not always easily understood. Nothing can exist beyond one Substance because Substance is infinite and immanent. In a series of propositions in part I of *Ethics*, Spinoza (2000, I, props. 13–15, 85–9) makes the mathematical argument that since Substance is infinite it is indivisible, and since it is indivisible there can only be one Substance and nothing can be conceived outside of it. Since Substance is expressed in infinite attributes, a true idea is expressed through all of these attributes. As humans we can only gain access to a true idea through the two attributes of thought and extension. A true idea, then, is not simply something that takes place in the mind alone, as we might commonly conceive of ideas; rather, a true idea includes both a thought and the affirmation of the existence of that thought on an experiential level, and vice versa (and it goes beyond even this into other attributes to which we do not have access). In other words, neither thought nor matter precede one another – their existence is simultaneous. Sharp (2007, 743) further explains: "Because they are one in substance, different attributes do not interact; bodies do not move minds and minds have no power over bodies."

Truth here, then, is connected to the essence of God, which is simply existence rather than validity. A false idea is then "absurd" for Spinoza because, since nothing exists beyond God, it would be a negation of existence. There is little value even discussing a false idea, except in theoretical terms. What exists includes both material things and immaterial or imaginary things. Using this logic, then, a unicorn (or, for that matter, a zombie) has an existence as an idea. This does not mean that a unicorn (or zombie) is real but, rather, that it exists and that the effects of this existence are real since we can affirm that we can think of a unicorn (or zombie) and that this thought process is necessarily embodied. *Ideas* of things and *actual* things are equal ontologically. Therefore, for Spinoza, ideology can be catagorized under *true ideas*, with the result that the notion of something akin to false consciousness becomes problematized, as do any efforts to transcend this false consciousness through any form of rational, objective critical thought.

Under the aforementioned critiera, zombies, though seemingly brain-dead, have a capacity to "think." If extension and thought are parallel, as Spinoza posits, then zombies necessarily think and a/effect ideas through the very force of their bodies. To live and perform oneself is to "think." While Marxist and modernist scholars at times mourn the seeming loss of distanced critical thought and look at the figure of the zombie disparagingly (e.g., see Giroux's [2011] *Zombie Politics and Culture in the Age of Casino Capitalism*), I propose that, if we consider ourselves as zombies within an immanent metaphysics, our capacities for critical thought and action can be reimagined and enacted upon new criteria.

Thought as force is not without its dangers, however. If true ideas are based on force rather than validity, then it is possible for the ideas that have the most force to be destructive rather than productive. A zombie horde is indeed capable of mass destruction and tragic annihilation. Sharp (2007, 745) elaborates:

> One might consider the attribute of thought to be a kind of ecosystem of ideas. The image of the ecosystem highlights the fact that ideas, like all living things, desire to persevere in being, and only survive in a favorable environment. Since they desire to continue to exist and to enhance their lives, like any mode, they must strive, although usually unconsciously, to link up with ideas that promote and enable their existence, regardless of their truth or falsity. Ideas exist in a kind of energetic field, and ideas

correspond to all of nature, human and nonhuman, rational and arational. One can thus imagine that in most, if not all environments, partial and confused ideas flourish, because they have more similar ideas to fortify them. Moreover, nature itself, or thought as a primordial expression of nature's power, is indifferent to human truth and flourishing.

From this standpoint, the concerns of Marxists like Jameson and Giroux around the political and ethical decay of late capitalist society remain very real and important in our apocalyptic times. However, instead of turning to objective rationality for a solution, Spinoza's theory of (human) knowledge points us towards a more intersubjective method of critical thought to help us affirm and grow more productive ideas.

There is no ideal, utopic, just "truth" for Spinoza but, instead, only a continuum of fictions or partial truths. Because humans are finite modes we can never attain complete truth. We can only have what Spinoza terms *adequate* ideas and *inadequate* ideas, which make up his continuum of human knowledge. Adequate ideas are those ideas that are complete in relation to the mind of God. Inadequate ideas are distorted and incomplete and exist in relation primarily to the isolated, individual human mind (Spinoza 2000; Lloyd 1994). Spinoza organizes human knowledge into three types of knowledge that roughly correlate with the continuum of inadequate to adequate ideas. The first is "imagination," the second is "reason," and the third is "intuitive knowledge." "Knowledge of the second and third kind, and not of the first, teaches us to distinguish the true from false" (Spinoza 2000, pt. II, prop. 42, 149) and is therefore made up of adequate ideas, or "common notions." Inadequate ideas are attributed to the imagination, which is "knowledge of the first kind [and] is the sole cause of falsity" (Spinoza 2000, pt. II, prop. 41, 149).

Imagination here refers to the knowledge we perceive through the senses and through signs – in other words, language. The senses, for Spinoza, are always confused since they relate exclusively to the individual human body. The individual human body is constantly affected and affects other bodies (both human and non-human); however, each individual human body has an idiosyncratic history of encounters that distorts all incoming perceptions. The senses for Spinoza can be seen as a mess of jig-saw puzzle pieces: if we take them as is in their randomly scattered state, we can only get a very

distorted understanding of ourselves in relation to the world around us. If we start to move these pieces around, we can start to see a different picture that can make more sense. However, this is a highly social and intersubjective process. We have to remember that not only are our puzzle pieces scattered but our set is incomplete. We need to combine our puzzle pieces with other puzzle pieces to attain a more complete set and to be able to construct more complete pictures (although a truly complete set is never actually possible, nor is a complete picture). Althusser locates the basic structure of ideology in Spinoza's imagination (Sharp 2007). It is here that objective rational thought might also be located – in the most inadequate type of thinking we have access to as humans. Although Spinoza understands the senses to be confused (especially on an individual level), without them we would understand nothing. Thus, we cannot be outside imagination – or ideology.

Although the imagination is the only type of knowledge that is prone to error in Spinoza's system, this is not to say that its use should be avoided. In fact it is impossible to do so. Although distorted, at the same time imagination provides us with all the "data" we need to understand our place in the world. So, unlike Descartes, who dismisses the body and its senses because he believes they cannot be trusted, for Spinoza the senses are of utmost importance. Similarly, language is a necessary tool for communication despite the errors into which it can lead us. Although, to a certain degree, Spinoza's types of knowledge hold different levels of importance, these ways of understanding are not organized according to a hierarchy. A hierarchy is organized in a linear formation, with each type of knowledge successively gaining importance (or, viewed the other way around, losing importance). Spinoza's types of knowledge can be seen to be composed as a more dynamic assemblage that takes thought beyond objective rationality and ideology but not out of it.

Visually, I propose that this assemblage be viewed as concentric circles: the smallest circle, imagination, is placed in the centre; a larger circle, placed over top, is reason; finally, the largest circle, intuitive knowledge, is placed over top the first two circles and encompasses them both. All three types of knowledge are necessary and inform each other; reason is informed even by imagination. For example, we can imagine things or ideas that are inadequate (we cannot help it), but through the use of reason or intuitive knowledge we can at least be aware of these inadequacies, which can help free us from such

errors. The above jig-saw puzzle metaphor serves as a perfect example of the relationship between inadequate and adequate ideas within Spinoza's theory of knowledge. I provide this metaphor in the hope that you, the reader, will be able to use it to construct a better understanding of Spinoza's theory of knowledge. But it does not give you a "complete" understanding because the idea of building a picture is quite contrary to Spinoza's theory of knowledge – it is an inadequate idea. There is no pre-established picture (or "end") to this puzzle: it always remains a process. There is no utopic satisfaction of "completing" the puzzle. The process is its own satisfaction; the process is knowledge itself, or what Spinoza considers reason. Snapping pieces that fit together is the most satisfaction we can get out of Spinoza's theory of knowledge. However, by giving you the jig-saw puzzle metaphor, even though it is incorrect to a certain degree, I have (I hope) helped you snap some new pieces together. Furthermore, because I have now made you aware of the error in my metaphor, it, in combination with an awareness of its error, becomes yet another piece you have snapped together through the use of reason. In other words, error itself is a useful part of knowledge and should not be discarded. Imagination is necessary if we are to make sense of things and be able to communicate ideas. It is imagination on its own, unmediated by reason or intuition, that is erroneous and dangerous: the smallest circle in the centre of the assemblage of Spinoza's types of knowledge is *inadequate* on its own. Similarly, one zombie is ineffectual on its own.

Instead of uncovering the "truth" or understanding an objective totality, human (or zombie) knowledge is always limited by our finite standpoint within the totality of *Nature* or *God*. However, what is critical to reiterate is that human knowledge is conceptualized relationally within this totality, so while always limited it also always retains the possibility of expanding through the increasing understanding of adequate ideas. Adequate ideas, available through the second and third kinds of knowledge, come from the interaction of several mind-bodies and from understanding the *common notions* that are shared between these mind-bodies. The more diverse mind-bodies with which we collide, the more opportunities we have to expand our adequate ideas, to affirm common notions. These mind-bodies are not limited to human mind-bodies: they comprise all mind-bodies, animate or inanimate. And so, while there may not be a truth par excellence for Spinoza, there is no simple relativism either since all bodies have some things in common through which reason can be

collectively constructed. Zombies always come in hordes, and it is only within the horde that immanent critical thought has the potential to occur. "For Spinoza ... the self is not at all the primary object of knowledge. Self-knowledge becomes a reflective dimension on our knowledge of the world" (Lloyd 1994, 56).

The key to increasing one's adequate knowledge, then, lies in understanding one's place within God, Nature, or Substance: it is to understand that one is in Ideology – to understand that one is a mode among other modes, a zombie among other zombies – in the capitalist apocalypse. It is in this intersection of Spinoza and Althusser that immanent critical thought – critical thought based on proximity – might be understood: "if we affirm that we are in thought, rather than its authors, we can gain a critical perspective upon this inevitable aspect of our modal existence" (Sharpe 2007, 748).

AUTOETHNOGRAPHY AS A TOOL FOR APOCALYPTIC TIMES

One possible avenue to affirming our zombie selves in the context of our late-stage capitalist apocalypse can be found in the method of autoethnography. Autoethnography is a highly subjective, qualitative research method that uses a personal, experiential-based self as a starting point for inquiry. Traditional scientific approaches to research, with their aim at achieving objectivity, attempt to remove such a self from research as much as possible, or at the very least to "bracket" the self out (as is more common in social scientific approaches). An attempt is made to remove bias by pushing it aside, as if linguistically taking the "I" out of the research actually removes the researcher's biases and makes him or her "objective" (Wall 2006). Autoethnography most often falls into the autobiographical genre (Ellis and Bochner 2000, 739). As Richardson (2000, 11) further comments, autoethnographies are "highly personalized, revealing texts in which authors tell stories about their own lived experiences, relating the personal to the cultural." An effective autoethnography engages the self *within* culture, not in a vacuum. As Mykhalovskiy (1996) explains, such writing is, in fact, always a collective process. It is only within the confines of a self/other dualism that the individual appears to be isolated. With its focus on the writer within her cultural context the autoethnographic method may be a useful tool for acquiring more adequate self-knowledge, which is the necessary bedrock for immanent critical thought.

Based on what I have written about autoethnography, it might strike you that this chapter is not written in a very personal or auto-ethnographical tone. My "I" has surfaced only rarely. Perhaps the choice of how I've written this piece is indicative of the zombified academic context from which I am writing. When I am writing, my distanced theoretical voice feels good and natural to me. I want to suggest, however, that the autoethnographic need not lie in a person-alized writing style but, rather, in the very processes that transpire through thinking, writing, and reading.

Wall (2006, 6) raises the point that perhaps autoethnography is not a methodology so much as it is a philosophy "aimed at restor-ing and acknowledging the presence of the researcher/author in research, the validity of personal knowing, and the social and sci-entific value of the pursuit of personal questions." Furthermore, this philosophy reaches beyond the presence of the author and out towards the presence of the reader. Autoethnographies "long to be used rather than analyzed" (Ellis and Bochner 2000, 744). An auto-ethnography is always in motion and flux as different readers come across the text, finding connections to their own lives, putting themselves into conversation with the text and the subject/researcher at its centre. The autoethnographic might be seen as not just a method of writing but as a method of reading whereby one is always observing how a text affects and changes one – a method of reading according to which one is always asking the question, "What new possibilities does it (this text) introduce for living my life?" (746). According to this criteria, all writing and reading might be seen as autoethnographic, although some will be more unconscious and/or repressed than others. The autoethnographic, then, opens up the space for our zombie selves to acquire more adequate ideas and self-knowledge – a self-knowledge that is not limited to an individual self but is open to an ever-expanding infinite self – a proliferating zombie horde.

Founded on adequate knowledge, however, this is no longer the destructive zombie horde we are used to imagining. I am writing here of a new formation of zombies. Not zombie/s based on lack and infinite consumption but zombie/s gaining a new consciousness that goes beyond brains and rationality – a consciousness that comes from, figuratively speaking, the heart. But how can a zombie follow its heart if it has no pulse?

FOLLOWING THE HEART THAT NO LONGER BEATS:
ZOMBIE CHRIST AND A POLITICS OF LOVE

In popular culture, several different types of zombie figures are
depicted. Two of the most popular and well known come from Haitian
voodoo and the film director George Romero, whose flesh-eating
zombies are most often depicted in recent popular culture. What these
zombie figures have in common is enslavement – whether it be to a
voodoo magician or to the endless desire to consume human flesh
(Kline 2012). One of the most popular zombie figures of all time,
however, is rarely depicted or referred to as a zombie. Perhaps in a
white-washed, consumerist culture the notion is too dangerous, but
the figure of Jesus Christ is the original and, perhaps, ultimate zombie
(Kline 2012). I am not referring to Zombie Christ here as a deity, and
especially not the Christ of conservative, bourgeois Christian rhetoric
who has been stripped of all ethical and political efficacy. Rather, I
would have us look at Zombie Christ as an exemplar of what Spinoza
calls a "free man." A free man has an adequate understanding of
himself and "the good that he desires for himself he desires for all
other men" (Spinoza 2000, pt. IV, prop. 68, schol., 277). According
to our criteria, the figure of Zombie Christ (whether we view him as
historical or fictional is irrelevant) expresses zombie politics par excel-
lence and what Skott-Myhre and Skott-Myhre (2007, 55) call "politi-
cal love":

> [This] means seeing love as the act of giving fully and completely
> of oneself without the worry that one would run out of oneself;
> with the knowledge that you are infinite in your creative capacity
> to produce yourself. We are talking about a love that promotes,
> enables, or gives impetus to all potential creative force. In this
> sense, love is genealogical; love doesn't come from only you, but
> all the love/creative force of the generations that allow you to
> produce yourself.

Zombie Christ is embodied and physical (if we take the Christian
account of resurrection seriously) but does not function on account
of hunger and lack, or on accout of reactionary reflexes found in other
monstrous zombie figures. Zombie Christ is driven by infinite political
love and expresses a giving of oneself that transmutes death by resitu-
ating it into life anew: death is thus just another flat line on the plane

of immanence. Spinoza (2000, IV, prop. 67, 276) tells us that "a free man ... thinks nothing less than of death, but his wisdom is a meditation on life." Zombie Christ reveals an infinite meditation on life and might be seen as the epitome of a critical subject of proximity in that it accepts even death as a means of producing oneself and has the adequate knowledge that producing oneself is always interdependent with others – with those who precede us and with those who would follow us.

Here I propose that the value of autoethnography might be found even beyond the merging of the writer and her audience, in the invisible process of the writing itself that you, the reader, do not see. Christ states that "the kingdom of heaven is within you." We can elicit many mystical interpretations of this statement, but what I would like to focus on is the word "kingdom." A kingdom implies multiplicity, a horde. The act of writing itself elicits this multiplicity. As I sit here, seemingly alone in my office, as I write I produce a zombie kingdom ... without anyone even reading this writing. It does not need to be read in order to effect change. As I write I produce myself through the words and thoughts of others who have come before me, snapping together bits and pieces of adequate ideas that have accumulated over time. I type, then read the sentence I wrote, and then I type the next sentence. I write. I read. I write. I read. I write. I read.

Who wrote this?

The distinction between writing and reading, self and other, collapses. As I write my zombie kingdom, each sentence, each revision holds a tiny death and resurrection. And this zombie kingdom does not end when I stop writing and reading; I carry it with me everywhere I go. Each sentence, each revision has now crucified and resurrected the one who wrote it, just as each footstep, each breath does the same. And then I come back and write some more. At some point all the differences become the same.

Even a heartbeat, the very essence of life, offers distinction and separateness – beat – pause – beat – pause – each differentiated from the next. But for the heart to flatline is to be spread out on the plane of immanence. It is the ringing in our ears that we hear when we are still. Each word is forgotten the moment I have typed it. I am no longer a writer, I become the Word.

While phrasing like this might elicit religious imagery, what I have written I mean literally, not transcendentally. To lose oneself in writing is to become it, to become one with the words. This type of writing

– a writing that consumes us and takes us beyond the interruption of objective, rational thought – follows the heart that no longer beats into the heart of zombie politics. A politics that is as heartfull as it is heartless. In this tiny, yet vast space, the dead is undead and lives. When we produce ourselves in this space of critical proximity we become unconsumable.

REFERENCES

Dean, Jodi. 2010. *Blog Theory: Feedback and Capture in the Circuits of Drive*. Cambridge, UK: Polity.

Descartes, Rene. 2008. *Meditations on First Philosophy: With Selections from the Objections and Replies*. Oxford, UK: Oxford University Press.

– 2010. *Principles of Philosophy*. Trans. J. Bennett. http://www.ahshistory. com/wp-content/uploads/2012/07/descprin.pdf.

Ellis, Carolyn, and Arthur P. Bochner. 2000. "Autoethnography, Personal Narrative, Reflexivity: Researcher as Subject." In *Handbook of Qualitative Research*, 2nd ed., ed. N.K. Denzin and Y.S. Lincoln, 733–68. Thousand Oaks, CA: Sage.

Giroux, Henry A. 2011. *Zombie Politics and Culture in the Age of Casino Capitalism*. New York: Peter Lang.

Jameson, Frederic. 1991. *Postmodernism, or, the Cultural Logic of Late Capitalism*. Durham, NC: Duke University Press.

Kline, Jim. 2012. "Zombie Typology." *Psychological Perspectives* 55 (4): 467–81.

Lloyd, Genevieve. 1994. *Part of Nature: Self-Knowledge in Spinoza's Ethics*. Ithaca: Cornell University Press.

Mykhalovskiy, Eric. 1996. "Reconsidering Table Talk: Critical Thoughts on the Relationship between Sociology, Autobiography and Self-Indulgence." *Qualitative Sociology* 19 (1): 131–51.

Richardson, Laurel. 2000. "New Writing Practices in Qualitative Research." *Sociology of Sport Journal* 17: 5–20.

Sharp, Hasana. 2007. "The Force of Ideas in Spinoza." *Political Theory* 35 (6): 732–55.

– 2011. *Spinoza and the Politics of Renaturalization*. Chicago: University of Chicago Press.

Skott-Myhre, Hans, and Kathleen Skott-Myhre. 2007. "Radical Youth Work: Love and Community." *Relational Child and Youth Care Practice* 20 (3): 48–57.

Spinoza, Baruch. 2000. *Ethics.* Trans. and ed. G.H.R. Parkinson. Oxford, UK: Oxford University Press.

Wall, Sarah. 2006. "An Autoethnography on Learning about Autoethnography." *International Journal of Qualitative Methods* 5 (2): 1–12.

10

When Simulation Becomes Simulacrum: "Reversing Platonism" with Deleuze in Live Role Play

David Fancy

I am standing atop a short-legged hexagonal table in an elementary school library in southeastern New Brunswick. I am wearing a trench-coat and ripped jeans, and am carrying an MP5 machine gun. I have just thrown, in as threatening a fashion as possible, dozens of copies of *Heidi* in the faces of a group of twenty Royal Canadian Mounted Police (RCMP) officers in full riot gear blocking the entrance to the library. Those at the front of the phalanx have "NATO" emblazoned on their riot shields while, behind them, twenty more snipers and members of secondary assault teams take up positions in the adjoin-ing classrooms and cafeteria visible through large interior windows in the library walls. The context is a simulated hostage-taking scenario, part of a series of such events organized in the summer of 2001 by the RCMP, in which I played the role of a hostage-taker. Other actors playing my accomplice and a group of hostages are hidden in the staff room, and a group of senior officers and staffers running the project – "invisible" to all of us involved in the fiction because of their orange safety vests – circulate throughout the venue ensuring that actors and police alike are following the rules governing the exercise and that simulated munitions are being discharged correctly.

This kind of live simulated role-play exercise can be found across a wide range of contemporary cultural and pedagogical activities, from training scenarios such as the standardized patient scenarios used in much medical training (University of Toronto 2016), to large

fictional circumstances involving historical reenactment (Reenactor. net 2016), to fantasy and war games know as cosplay or live action role play (LARPing), and so forth (Pearce, Boellstorff, and Nardi 2011). Much of the critical engagement with such types of role play productively articulates the political implications of these kinds of fictionalizations and how they engage with modulations of subjectivities in social and political fields, perhaps allowing the social and the political to be enacted and/or imagined differently (Schechner 2013; Schneider 2001; Torner and White 2015). Rebecca Schneider (2001, 2), in her work on historical re-enactment, suggests, for example, that she is particularly interested in the possibilities for "cross and inter-authorships" of histories that emerge when role players re-enact the past. Similarly, Celia Pearce writes that role play can be understood to be "a form of 'emergent authorship,' a bottom-up, procedural process leading to co-created, unexpected narrative outcomes" that can eventually shift the rules of its own game (Pearce, Boellstorff, and Nardi 2011, 2). Generally speaking, however, the philosophical underpinning of many of these discussions rests on a strangely bifurcated ontological premise, one that, at its root, presumes a strict distinction between real and fictional levels of experience. Often drawing on a Platonic residue enduring in philosophical and methodological traditions in the humanities and the social sciences, these approaches, I argue, necessarily limit – at the level of concept, analysis, and ultimately at the level of enactment itself – the *potentials* of the kinds of intervention that role play can have in developing alternative subjectivities and, by extension, affecting wider political and social arrangements.

This chapter sets out to work through the implications of the summer 2001 series of RCMP role-play training events by engaging with the notion of "the simulacra" as explored by Gilles Deleuze in an appendix of his *Logic of Sense*. In this text Deleuze (2005, 292) overturns the Platonic distinction between real and copy in favour of what he describes as "the triumph of the false pretender." The implications of such a reversal are that the so-called *real* and the so-called *fictional* are understood to be bound together in an indelible and immanent fashion at the level of ontology itself, making any attempt to give precedence to the real over the illusory an exercise in philosophical disingenuity. I explore the way in which an immanentist perspective on role play allows for an understanding of how such activities can be understood to generate more complex and efficaceous

relationships with the "non-fictional," or "real," than a bifurcated ontological model that draws such unsustainable distinctions would allow for. I focus on moments when the blurring of orders of reality between real and fictional either contributed to the intended effects of the role-play exercise or, indeed, extended these exercises in ways not predictable to event organizers. Using the notion of the simulacra, I suggest that these moments of conflation of real/fictional are not the result of the incapacity of a particular participant to distinguish between various orders of reality but, rather, are constitutive of the nature of humans' overall experience of phenomena. When harnessed with nuance in role-play settings, such indistinction can provoke social agents to imagine and enact presents (and, by extension, futures) beyond the otherwise restrictive parameters to organize existing possible subjectivities and socialities.

When we think of the police, alternative subjectivities and socialities are not necessarily the first things that come to mind. The work of the police, being intimately tied to the workings of the state, is necessarily a component in the execution of the state's main function, which, according to Deleuze and Guattari (1987, 386) is that of "capture": the state as "process of capture" works to contain "flows of all kinds, populations, commodities or commerce, money or capital, etc." in order to help sustain the state's structural commitment to modes of economic production – namely, in our current age, capitalism. Drawing on Paul Virilio's work on dromology, Deleuze and Guatarri affirm that the police are the avant-garde of the state's larger project of establishing "gravity or gravitas," a kind of relative stasis, or at least predictable movement in the face of "the fluidity of the masses, against the penetration power of migratory packs" as well as managing flows of "people, animals and goods" (ibid.). They note that "each time there is an operation against the State – insubordination, rioting, guerilla warfare, or revolution as act," a new "nomadic potential has appeared" (ibid.). In such instances, police and their more weaponized cousins – the army – are mobilized in order to control the anti-capture or nomadic potential released by the increased flows that resistant social insurrections may enact. In line with the intensification of logics of anticipation and pre-emption marking contemporary warfare (Dannerman and Ritter 2014.), as well as the increased militarization of the police in the Economic North (Dansky 2016), police are regularly drawing on the long history of war games (Martin 2015) deployed by the military in order to anticipate social

insurrectionary threats to the smooth unfolding of contemporary neoliberal capital. In the age of terror, it is not only the enemy army that needs to be anticipated and controlled, or even a mob of civilian rioters, but also, specifically, the individual who would inflict asymmetric amounts of damage on the state. One means of inflicting an amount of public and symbolic disruption or terror on the state is that of hostage taking (Tinnes 2010). A key means of training police to undertake the kinds of subtle and psychologically dexterous work necessary to negotiate the release of hostages is the simulated, or role-play, scenario.

The RCMP corporal in charge of "Exercise Joinder," in which I participated in Shediac, New Brunswick, in 2001, had undertaken specific forms of counter-terror and hostage-taking negotiation training in Langley, Virginia. As timing would have it, the seventy or so RCMP special officers attending the large hostage taking simulation in Shediac had, just days before, been deployed to manage crowds at the Third Summit of the Americas free trade talks protests occurring in Quebec City, Quebec, 20–22 April 2001. These protests, organized and undertaken by a large coalition of anti-capitalist activists, environmentalists, and concerned citizens, had involved crowds of people attempting to remove barricades placed around the meeting and negotiating rooms at the Chateau Frontenac, where an important round of trade talks was taking place. Given that the Quebec manifestations were occurring not long after the Seattle World Trade Organization meetings in 1999, which had led to a significant amount of rioting and mild property damage, the police – as an extension of the state – were mobilized to suppress the riot's nomadic flows of energy, and many people were tear-gassed and beaten. All the while, rumours of agents provocateurs among the police, substantiated in later anti-capitalist protests in Montebello, Quebec, circulated (Tremblay 2007). As such, I and another theatre studies graduate who had been brought in to participate in the simulation exercise as hostage-takers were faced with an ethical quandary. It was as a result of a personal favour to the person acting as an intermediary between the police corporal organizing the simulation and the actors participating in it that I had agreed to be involved in this and a number of previous much smaller hostage-taking exercises. Additionally, the exercise had been planned long before the events in Quebec City (which used the same officers) had taken place. That said, the Quebec City events had made it very clear to the other actor and myself that, by participating in the larger

simulation exercise, we risked simply lubricating the wheels of capital by facilitating the police's capacity to capture Deleuzian "nomadic flows" of energy. Indeed, I wondered, would participating in the event and working directly with the police who had tear-gassed non-violent protesters in Quebec City simply serve to encourage the finer operations of the state as apparatus of capture?

The fictional constraints established by the police in the previous two role-play exercises focused on the abject criminality of the perpetrator I was playing. I had used the creative licence afforded by the situation to build out complex back-stories over the course of the mock hostage negotiation sessions to draw attention to the structural constraints and potentially legitimate complaints and experiences of social minoritization that would lead a person to want to take a hostage. For example, in the first hostage-taking scenario, which took place six months earlier, I had been assigned the role of "The Con," an inmate who had taken another inmate prisoner in order to demand better living conditions. During the course of the scenario, one in which I negotiated with a number of RCMP officers in another room via telephone, I did what I could to complexify the perception of the inmate (already a convicted felon in the fiction) by drawing attention to prison overcrowding, lack of access to cultural activities and mental health support services, as well as the overbearingly punitive tone of the institution in which this character was living. Essentially "The Con" became a more complex three-dimensional character who had an awareness of conditions and contingencies with regard to the level of access to resources that might have affected his becoming a convict in the first place. Although I have no means of tracking the efficacy of such an approach, it did lead to a productive debrief session following the exercise, in which police spoke of the need to address the complex life experiences of hostage-takers as well as the need to be at least somewhat conversant with complaints pertaining to structural concerns that prisoners might bring up. Given the kinds of minor interventions we had been able to make in previous role plays, my actor colleague and I decided to go forward with the larger hostage-taking simulation with a view to, once again, providing the police participating in the simulation with a more complex set of variables than the "bad-guy-needing-to-be-brought-to-heel" model of perpetrator, which is the model that appeared to animate their discussion and planning of the exercise.

One element that had become clear in the previous exercises was the ambivalent relationship that both RCMP management and the

participating officers had with the fictional nature of the circumstances of the role-play simulation. The overall drive of the events was for the simulation to be "as real as possible" so as to enhance the authenticity and veracity of the training experience for the officers. As such, the progression of the three simulations in which I participated went from the first event, which did not involve many "props" (I was in the lighting booth of a theatre negotiating over the telephone with hostage negotiators in training who were in the technical director's office), to the second event, which took place in the parking garage of RCMP headquarters in Fredericton where I was holed up in a truck with a fictional hostage. The final event involved weapons with simulated munitions, an expensive robot that delivered food to the hostage takers when requested, and a six-hour-long negotiation timeframe. Even in the first simulation, though, one of the officers was frustrated with my character, "The Con," calling the officer all manner of rude names over the telephone during the simulation. This made for a somewhat awkward debriefing lunch at the local Pizza Delight after the event. In the face of the trainee's barely contained anger with me, the corporal running the proceedings explained to the officer: "it is all an illusion, it is all a fiction, just shake it off." The officer, not wanting to let things go but now changing tactics with his superior, asked, "Well, if it's all fake, then why are we wasting time doing it?" The corporal answered, in more detail this time: "Listen, there's a clear distinction between reality and illusion: there just is. We have the public to protect. We're on the side of reality, so don't get caught up in the story, no matter how powerful it might seem." His remarks served to conflate the fictionality of the role-play moment with the seemingly illusory nature of any eventual real-world convict's claim to have legitimate reasons for needing to take a hostage in order to move an agenda forward. Given the potential life-and-death consequences for hostages, hostage takers, and negotiators alike, the corporal's injunction was indeed a potent one.

The corporal's statements were designed to refute the trainee's concerns, which had arisen because the circumstances had felt very real for him, and they echo many of the transcendent ontological premises informing thousands of years of what Jonas Barish describes as "the anti-theatrical prejudice" operating in Western culture. In an influential text of the same title, Barish traces the way in which Plato's thought, particularly the rejection of the validity of "mimetic modes" (given their inauthentic process of copying things in the world), serves as a foundation for thousands of years of anxiety

around any fiction that would presume to emulate the real: "The drama being a mimetic art par excellence, what is alleged against mimesis in general will apply to the drama with particular force, and Plato keeps it more steadily in view than any of the other manifestations of the artistic impulse' (Barish 1981, 5). And yet Plato, like the corporal warning the trainee not be seduced by the illusion "*no matter how powerful it might seem*," nonetheless acknowledges "the power of the dramatists over the minds of his countrymen, and at the same time struggles to combat what he has learned to regard as their baleful influence" (6). Barish provides an introductory analysis of the philosophical basis of Plato's anti-theatricalism, drawing his readers' attention, through readings of *The Republic*, *Ion*, and *The Sophist*, to Plato's "profound attachment to what is stable and fixed as opposed to that which flickers or alters," before providing an exhaustive chronicle of the anti-theatrical prejudice that existed up until post-Second World War theatre. From the 1642 closing of London theatres by Puritans to the continued negative associations of terms such as "melodramatic" or "theatrical," Barish notes a sustained suspicion of mimesis's capacity to create potentially convincing likenesses of people or things, and he traces the various ways that, as he reads Plato, the ancient philosopher continuously counter-poses the real in favour of the illusory (5–37). Despite such a culturally and philosophically ingrained suspicion, it is clear that theatre, mimesis, simulation, and drama persist and, in fact, contribute significantly (if often problematically) to statecraft through performative and performance-related means, from the persona generated by politicians and their teams to the ability of images and likenesses to project and consolidate political, economic, and military power (Schechner 2013). And yet, as I suggest above, even theories more recent than Barish's that seek to explain the power of illusion, role play, and the social are still seemingly marked with the sustained influence of an apparent reliance on Platonic assumption. Rebecca Scheider's arguments about re-enactment focus on Richard Schechner's early work, in which he posits that performance is "restored" or "twice behaved behavior," a formulation that necessarily lends authenticity to the primary, or "first,"' instance, upon which the secondary behaviour or performance is based (Schneider 2001, 14). More recently, in his 2013 *Introduction to Performance Studies*, Richard Schechner (2013, 2) evokes his previous definition of performance, but he adds to it by suggesting that "there is no culturally fixable limit to what is or

is not 'performance,'" and he affirms that simulations are "perfect performatives" in that they involve no difference between copy and original (133). Although Schechner invokes the potential indistinction between the "real" and the reflexively performed "illusory," he proposes no philosophical articulation of an ontological system that would permit such an assertion.

If we are going to understand some of the potential counter-orthodox implications of role-play scenarios such as those arising from the hostage-taking scenarios without the restrictions imposed by a subtle yet pervasive Platonic and transcendental bifurcation of substance, we can benefit from engaging with a theorist who seeks explicitly to engage these restrictions by countering them at their philosophical source. In Gilles Deleuze's appendix to *Logic of Sense*, entitled "The Simulacrum and Ancient Philosophy," the French philosopher deals extensively with the anxieties around the seeming power of the illusory in Plato's work. Indeed, Deleuze (2005, 291) clearly sets out to answer the question: "What does it mean 'to reverse Platonism?'" Deleuze begins by reminding the reader that this was the task that Nietzsche set for "the philosophy of the future" – namely, the continuation of the Nietzschean program of "the abolition of the world of essences *and* of the world of appearances" (291, emphasis in original), a program not unfamiliar, Deleuze reminds us, either to Hegel or to Kant. Although he notes that Nietzsche went further than these last thinkers to upend Platonism, Deleuze wonders if Nietzsche's phrasing around the question of the abolition of essences and appearances is not in fact itself prone to "abstraction," given that Nietzsche engages the Platonic *fait accompli* rather than seeking Plato's tributary assertions and what, in fact, is driving the ancient philosopher to make such statements. Instead, Deleuze emphasizes that Plato's reversal is contingent in the first instance on bringing his *motivation* "into the light of day" and on "track[ing] it down"' the same way that "Plato tracks down the sophist" (291). Deleuze states that it quickly becomes clear that Plato himself provides major clues for the reversal of Platonism. This evidence manifests in the way in which Plato does not in fact simply distinguish *between* the world of essences – the Ideas – and the world of appearances, as some analysis would have it, but, rather, seeks to adjudicate between the veracity and authenticity *within* the various orders of worldly copies of the Platonic Ideas. Although it is certainly not an immanent ontological model, Deleuze shows that Plato's ostensibly transcendental model is in fact marked by a tendency

towards differentiation, which, he suggests, gestures towards a non-bifurcated ontological model of substance.

Deleuze (2005, 291): "In very general terms, the motive of the theory of Ideas must be sought in a will to select and choose that which would allow the thinker to 'make a difference' by 'distinguishing the thing from its images, the original from the copy, the model from the simulacrum.'" Deleuze suggests that a "superficial" (292) way of understanding this motivation for differentiation involves recognizing that such a procedure guarantees the capacity to distinguish the real from the copy, such as distinguishing between a "real" hostage and a person pretending to be a hostage. This approach contributes to the assumption of a bifurcated ontological field of essence (real) and appearance (copy) that maps generally onto the notion of "real life" (not theatre) versus "illusory existence" (theatre). Rather than allowing the reader of Plato to assume such a Manichean ontological field in the ancient philosopher's works, Deleuze shows how, in *The Statesmen*, Plato suggests that all manner of "rivals" to the true statesman – 'the doctor, the merchant, the laborer" – arise and claim, just as does the *true* statesman, that "'I am the shepherd of men"' (292). Similarly, Deleuze demonstrates how, in the *Phaedrus*, Plato is concerned to draw a distinction between true love and its false pretender, "delirium" – both of which occur in the "real world" (ibid.) The implications here are significant as the attention brought to adjudicating the levels of reality that inhere in worldly phenomena interrupt an understanding of the Platonic project that would posit it as one of drawing a strict difference between real and false. In other words, in the Platonic model some people emulating a hostage taker may be more convincing and authentic than others. Deleuze affirms that "the Platonic dialectic is neither a dialectic of contradiction nor of contrariety, but a dialectic of rivalry (*amphisbetesis*), a dialectic of rivals and suitors" (ibid.). Rather than the essence of division appearing in "breadth, in the determination of the species of a genus," it instead enacts itself "in its depth, in the selection of the lineage" (ibid.). Thus, concludes Deleuze, the dialectic of "rivals and suitors" serves "to screen the claims (*pretensions*) and to distinguish the true pretender from the false one" (ibid.). These pretenders appeal to foundations, such as in *The Statesmen*, when the definition of the statesman as "shepherd of men" is "only applied to the ancient god," and so a "criteria of selection is extracted from the myth, according to which the different men of the city participate unequally in the mythic model"

(293). In other words, humans are differentiated according to how well and to what extent they participate in the foundation, the myth, or the Idea that they seek to emulate.

Deleuze (2005, 293) explores a key implication of these varying degrees of participation, which becomes clear via the Neoplatonic triad of "the Unparticipated," the participated, and the participant." The unparticipated foundation "is that which possesses something in a primary way," which it relinquishes to be engaged in by "the participant." The participated is both "what the unparticipated *possesses* primarily" (293, emphasis added) and that which the unparticipated *gives out to* the participant. As such, the involvement of the participant in the unparticipated foundation is "only secondary insofar as [the participant] has been able to pass the test of the foundation," such as with the relationship between "Justice, the quality of being just, and just men" (293). Just men participate in Justice only via the quality of being just while Justice itself remains the unassailable foundation. In this Neoplatonic model, hostage takers participate in Criminality only in their quality of being criminal while Criminality itself remains the unassailable foundation. But, given that there are varying degrees of success and aptitude among the participants with regard to their relationship with the participated – in other words, some people are more *just* or *criminal* than others – "undoubtedly, one must distinguish all sort of degrees, an entire hierarchy, in this elective participation" (293). Deleuze wonders if there is not "a possessor of the third or the fourth rank, and on to an infinity of degradation culminating in the one who possesses no more than a simulacrum, a mirage – the one who is himself a mirage and a simulacrum?" (ibid.). This mirage or *simulacrum* is the individual who affects qualities of the just or criminal man without having any participation with Justice via the quality of justice. In Plato's vision, the simulacral person is a fake, a fraud, an illusion. Deleuze notes that the figure of the Sophist in Plato is the very "being of the simulacrum, the satyr or centaur, the Proteus who meddles and insinuates himself everywhere" (294). The Sophist is the fake copy as opposed to the true philosopher, like Socrates, who participates in the qualities of wisdom and justice through their careful emulation and embodiment. However, the ability of the Sophist to emulate Socrates, to *perform* like Socrates does, presents the opportunity for a significant and disruptive ontological insight: the supposed firm distinction between the model and the copy, the Idea and its manifestation, may not actually hold. The Sophist's capacity to emulate

Socrates to the point at which his and Socrates' arguments are indistinguishable is Plato's discovery, 'in the flash of an instant, that the simulacrum is not simply a false copy, but that it places in question the very notations of copy and model" (294).

From this insight, one that Plato himself does not pursue or elaborate upon, Deleuze (2005, 294) is able to propose that the Platonic "motivation" is actually not "to distinguish between essence and appearance, intelligible from sensible, Idea from image, original from copy, and model from simulacrum" but, rather, *to distinguish between types of images*. The first of these are copies, "secondary possessors" who are "well-founded pretenders" whose legitimacy is "guaranteed by resemblance" to the founding Idea. Simulacra, on the other hand, are, "like false pretenders, built upon a dissimilarity, implying an essential perversion or a deviation" (ibid.). Thus, with the key distinction for Plato being between what Deleuze, with further refinement, determines to be "copies-icons" versus "simulacra-phantasms," the full extent of the Platonic motivation becomes even clearer. Rather than the more straightforward dualist project of distinction between essence and appearance, the motivation is that of "selecting among the pretenders, distinguishing good and bad copies or, rather copies (always well-rounded) and simulacra (always engulfed in dissimilarity)" (ibid.). Indeed, more specifically, the project becomes one of "assuring the triumph of the copies over simulacra, or repressing simulacra, keeping them completely submerged, preventing them from climbing to the surface, and 'insinuating themselves' everywhere" (ibid.). For Plato, as an infinitely degraded version of a copy, the simulacrum is no longer marked in any appreciable way by resemblance. For Deleuze, however, the argument concerning the existing discourse of differentiation begins to unravel the bifurcated ontological substrate contributing to an anti-theatrical prejudice that understands the illusory and fictional world of performance to be inferior to the non-fictional "real." Additionally and by extension, the RCMP corporal's cautionary statements, which attempted to contain and instrumentalize the role play in a way that would further capture the work of "mimesis" for the state's control agenda, are also problematized. And yet, what are the implications for role play once tied into the state's needs to capture, as in the hostage-taking training when the situation became so "real" for some officers in the final simulation that they forgot it was a simulation? Can we understand them to have been overcome by insinuative simulacra?

The final six-hour-long simulation was organized around the hostage-taking of a group of fictional educators in a school setting. Myself and my co-hostage taker – violent thieves on the run from the law – were to have taken the hostages shortly after school let out as a last-ditch measure to evade capture. In the fiction, the RCMP SWAT officers gathered to support the deliberations of a team of negotiators, some operating on site and others working remotely via satellite uplink. The on-site negotiators situated themselves behind the phalanx of police, calling out to me with a bullhorn or calling my colleague, who was hiding in the back room with the hostages, via telephone. The conceit was that I could be alone as the "front man" given that if anything were to happen to me my fellow hostage taker in the back could harm the hostages. Staff monitoring the simulation circulated occasionally in order to accelerate or decelerate the intended narrative of the exercise, which would eventually, depending on the capacity of the negotiators in training, result in my and my colleague's standing down and being arrested by the police. A plaque bearing the RCMP seal, which I received after the event, thanking me for my participation congratulates me for my "Excellent performance as the 'Psychopathic Hostage Taker.'" Having been given the directive to behave in a "psychopathic" fashion – once again demonstrating the need of those organizing the event to pathologize any aberrant behaviours – during the first two hours of the simulation I was suitably and sufficiently erratic and unpredictably violent, following, as I was, a sheet with a bullet-pointed list of what constituted psychopathic behaviour: "superficial charm; a grandiose notion of self-worth; the need for stimulation and impulsiveness; pathological lying; the ability to manipulate others; a lack of remorse and empathy, violent tendencies." My at once affectless and hyperbolic raving was accompanied by bursts of "simunition," or plastic bullets, towards the dozens of heavily armed and shielded officers at the door of the school library. Occasionally, my character would calm down enough to respond to the encouragements of the negotiating team to engage in discussion about our requests and needs, which included, among other things, food, drink, and a piloted helicopter to take us to a wooded location from which we could stage our final and successful escape. Some initial turbulence arose in the proceedings when, after having requested pizza, the robot dispatched to bring us the meal – which we were informed later cost $1,000,000 – arrived bearing no food. Understanding the absence of pizza to be a negotiating ploy within the fiction rather than simply being the

arrival of fictional pizza, I kicked the robot over, causing some con-
sternation among the orange-vested moderators and elevating the
emotional intensity of the already stressed police force working within
the fiction. The subsequent phase of the narrative of the exercise
involved our release of a hostage after having "injured" him. We fired
off a couple of rounds of simunition in the back room for effect, then
had the hostage drag his injured leg – soaked in the RCMP-supplied
fake blood – behind him as he crawled across the school library floor,
making his way to the safe zone behind police lines. Given that my
instructions had been to generally provoke both the police and the
negotiators as much as possible in order to see if they could handle
the stress of the situation, as the hostage dragged himself across the
floor, I stood on a table, lowered my torn jeans, and "mooned" the
forty or so police present while laughing at them between my legs.
This proved to be rather too much for two of the officers who, without
waiting for orders from their superiors as protocol demanded, began
firing at me. As we had not arrived at the moment in the simulation
at which I would have been instructed to adorn my own body armour
for the purposes of protection from the plastic bullets within the
simulation, I soon found myself bleeding from very real wounds in
the back of the head and my lower back, crawling across the floor
in my own right to reach the safety of the room where we were hold-
ing hostages. By coincidence, the satellite uplink with the mobile
commands centre five kilometres down the road had been interrupted.
This being the case, the fictional fire fights and elevated series of
threats continued for about fifteen more minutes until the event
organizers at the command centre paused the event, raced up the road,
and proceeded to dress down the officers in question in front of their
colleagues before demanding that all simunition be removed from all
weapons in the facility so that neither the chain of command nor the
surface of my skin need risk being ruptured again.

The tension in the room was even higher now, amplified by the fact
that the police officers had been kept awake for more than thirty-six
hours as a means of intensifying the physical and emotional demands
the simulation would make on them. Still, given the evident lack of
impulse control on the part of the officers who fired on me, as well
as the others who were now audibly wondering from behind their
shields "just who the fuck does this sonofabitch think he is for push-
ing us and making fun of us like this" and muttering "serves the
bastard right that he actually got hurt," it struck me as necessary to

reflexively draw attention to their violent responses by mining the overlap between the simulation and the real. I started, within the context of my role and of the fiction, haranguing them for their incompetence in not following their commanding officers and shooting me, and drew attention to their actions outside of the fiction over the preceding couple of days, which involved suppressing nonviolent protesters in the streets of Quebec City. Why had they tear-gassed senior citizens, I asked? Didn't they realize the impotence of their being instruments of the state whose only role was to protect the property of those who owned the means of production? My stream of criticism was laced with the provocative and minoritizing invective they had come to know from the character I had been playing over the previous couple of hours ("Aren't you just a group of closet homosexuals who enjoy dressing up in black outfits and sodomizing each other in the change room at the police station?"). I gradually switched from being unpredictable and ersatz "psychopath" to outlining a series of demands that drew attention to the structural inequities being pointed out by the G20 protesters who had mobilized in Seattle and Quebec. Perhaps because I was still bleeding, or maybe because they were distracted with ongoing technical difficulties, the simulation organizers did not redirect me back to the given script for the day but allowed their negotiators to attempt to respond to my new set of demands, including the acknowledgment of citizens' rights to protest, the end of police brutality and of the policy of deploying agents provocateurs, and the end of the structural inequity imposed by G20 trade deals. Eventually, after two hours of in-depth discussion about issues around policing, capitalism, and state brutality towards impoverished and minoritized populations, the chief negotiator conceded: "We're just hockey dads with guns" and "there's not much we can do as we're just following orders from higher ups." Eventually, as per the established script, I lay down my weapon and was taken into custody by two of the front line officers who, once again outside of protocol, cranked the hand cuffs very tightly, managed to strain my left shoulder, and with unnecessary force threw me into the back of the police wagon where I waited with a boot on my neck for at least fifteen minutes before the RCMP corporal in charge drove in from the command centre to officially end the exercise. Concerned that I might pursue litigation as a result of my injuries, the corporal wondered, in a curious continuation of the dynamics of negotiation that had constituted the hostage-taking exercise, if I had requests for any

special attention or remuneration for my additional efforts and suf-
fering. I simply asked to speak with the officers who had shot me. He
acquiesced to my request and also gave me an RCMP silver dollar in
a small green felt-lined box produced by the Canadian mint. I spoke
alone with the officers in question for about fifteen minutes. One was
silent throughout and visibly quite angry while the second acknowl-
edged that he had lost his cool as he generally found it "frustrating
to always be dealing with people who have some complaint or other
with 'the system.'" Once it was clear I was interested in continuing
the discussion around the role of the police in the state, we engaged
the issues further. He concluded: "I've been in lots of high pressure
circumstances with perpetrators, but this situation felt more real than
many of them because we started to get to the bottom of [what] the
real issues are." His mute colleague became increasingly surly and
disengaged as the conversation continued. The next debrief was with
the negotiators, one of whom stated that the simulation had become
"more real" when I had diverted from the script: "When you became
less crazy and started talking about the protests it felt authentic to
me. It brought up for me that maybe we hadn't gone about that in
the right way, you know, going in and busting things up when really
maybe the people on the street were just making a lot of noise." Would
there be a way of doing things differently, I wondered? "Not when
the prime minister was embarrassed by the people on the streets mak-
ing him look like he couldn't control the population," he answered
with a laugh. A second negotiator suggested, though, that "the event
would have gone much better if you'd just played the criminal, kept
it simple and stuck with the script. These simulations are complex
enough already without all the extra noise."

What to make of all of this and how it elucidates Deleuze's thinking
around the primacy of the simulacral model over what he argues to
be the false binarization between essence and existence promoted by
Plato and his followers? What does the level of experiential "reality"
and "authenticity" lived by some of the police involved in the simula-
tion mean with respect to the state's apparatus of capture? Had any
of my (very minor) interventions contributed to a kindler and gentler
state apparatus? In order to begin to answer these questions it is
important to remember the moralizing implications of the Platonic
model. As with any binarization, hierachization is usually implied.
Deleuze (2005, 295) draws the reader's attention to the moral lineage
and implications of the "catechism" inspired by Platonism: "God

made man in his image and resemblance. Through sin, however, man lost resemblance while maintaining the image. We have become simulacra. We have forsaken moral existence in order to enter into aesthetic existence." Simulacra take on a "demonic character" that still manages to produce "an effect of resemblance," but "this is an effect of the whole, completely external and produced by totally different means than those at work within the model" (ibid.). Given that the simulacrum is based upon a "disparity or a difference," a dissimilarity that has been "internalized," it is not a model of the "Same from which the copies' resemblance derives." Deleuze suggests that the simulacrum's model, if it has one, "is a another model, model of the Other (*l'Autre*) from which there flows an internalized dissemblance" (ibid.). For Plato, the risks to those encountering the simulacrum and its dissembling flow are significant, as there is in the simulacrum a "becoming-mad, or a becoming unlimited" and a "becoming always other, a becoming subversive" (ibid.). Like the second negotiator with whom I debriefed, Plato is concerned about the effects of the extra "noise" generated by simulacra, and they need to be suppressed and ordered accordingly. It is by imposing a limit on the unbridled becoming of the simulacrum – making it Same and similar – and, "as for that part which remains rebellious, to repress it as deeply as possible, that Platonism aims 'in its will to bring about the triumph of icons over simulacra'" (ibid.). This successful icon-copy can be called an "imitation" to the extent that it "reproduces the model or Idea" because this kind of resemblance is understood to be "noetic, spiritual, and internal." This kind of resemblance is, however, primarily a "production ruled by the relations and proportions constitutive of the essence" (295). In the case of the third simulation in which I'd participated, the essence, I'd not participated in Criminality in a fashion that would have permitted a smoother and more predictable unfolding of the suppression of the hostage-taker. I'd simply imitated a criminal and, thus, had failed. Indeed, for Plato, "imitation," reserved for the simulacrum, "is destined to take on a pejorative sense to the extent that it is now only a simulation" and "designates only the external and nonproductive effect of resemblance" (296). These disproportionate and inaccurate effects mislead the observer and direct him or her away from the foundational and morally superior qualities of the model or Idea. Deleuze describes how Aristotle systematizes representation by particularizing it over the entire domain of phenomena, "from the highest genera to the smallest species" (297), and how

Christianity extends this gesture even further by rendering the bifur-
cated logic of representation and Sameness "infinite," to "endow it
with a valid claim to the unlimited, to make it conquer the infinitely
great as well as the infinitely small" (ibid.). By this point, the "double
exigency of the Same and the Similar" has been so inculcated into
systems of thinking, Deleuze suggests, that an extensive range of
philosophers, including Leibniz and Hegel, are unable to extricate
themselves from it (ibid.).

And yet still, as the hostage-taking scenario, the convincing imita-
tions called simulacra persist, despite the transcendental kinds of
thinking that would describe, and in the process of description attempt
to sustain, their suppression. Deleuze (2005, 298) speaks to the way
in which contemporary forms of writing in novels and film "permit
several stories to be told at once," and how such a procedure is "not
at all a question of different points of view on the supposedly same,
for points of view would still be submitted to a rule of convergence."
Instead it is a question of "different and divergent stories, as if an
absolutely distinct landscape corresponded to each point of view"
(ibid.). This resonating "series" is "a chaos perpetually thrown off
center" and, as such, is "the power of affirmation, the power to affirm
all the heterogeneous series" (ibid.). The resonance between these
series is described as a "*forced movement*" that goes beyond the series
themselves and, as such, embodies the "charactersitics of the simula-
crum" –which is ot say, when the simulacrum "breaks its chains and
rises to the surface: it then affirms its phantasmic powers, that is, its
repressed power" (298, emphasis in original). In the hostage-taking
scenario, the resonances between the various possible realities of the
hostage-taker character that exceeded the prescribed text (consisting
of pathologized and criminalized behaviours working in tandem with
the range of subjectivities and activities of the police at the G20 pro-
tests) led to unexpected outcomes for the event's participants. The
forced movement from the resonating series in the simulation led
some of the police to foreground the significance and truth-value of
the simulacral divergences, separating them from the enforced illu-
sions comprising the script of the simulation in order to posit com-
pletely different training outcomes than those anticipated by the event
organizers. Rather than issuing from a morally anchoring essence,
some participants seemed to be moving towards a recognition that
the state power upon which they drew to justify their actions and
politics was itself simulacral.

Deleuze agrees with these kinds of implications when facing the return of the simularcal repressed. He posits that it is via this resurgence of the simulacrum that two notions of the "aesthetic" that have been bifurcated by transcendental thought – the aesthetic as possible experience in the sensible world versus the aesthetic as theory art that reflects experience – are recombined. This rejoining permits so-called "real world experience" and the experimentation inherent in the work of art's use of simulacrum, previously understood to refer to different orders of reality, to be seen as having the same ontological founding. "Reversing Platonism," therefore, "means to make the simulacra rise and to affirm their rights among icons and copies" (Deleuze 2005, 299). The Platonic insistence, or a specific type of reading of the Platonic insistence on the distinction between Essence-Appearance and Model-Copy, is understood to operate "completely within the world of representation." Deleuze's extension of what he understands to be Plato's already near discovery – followed by a quick suppression – of the power of the simulacrum, is thus the subversion of the world and logic of representation in favour of the "twilight of the idols." From Deleuze's perspective, "the simulacrum is not a degraded copy"; rather, "it harbors a positive power which denies *the original and the copy, the model and the reproduction*" (ibid., emphasis in original). As such, the simulacrum represents "the triumph of the false pretender," and, by rising to the surface, it makes "the Same and the Similar, the model and the copy, fall under the power of the false (phantasm)" and thus "establishes the world of nomadic distributions and crowned anarchies." The disruptive power of the simulacrum does not assume the role of a new foundation but, rather, "engulfs all foundations" and, in so doing, "assures a universal breakdown," an "un-founding," that is a "joyful and positive event" (300). This un-founding is a kind of "'costume,' or rather a mask, expressing a process of disguising, where, behind each mask, there is yet another" (ibid.). As such, simulation is indistinguishable form the eternal return of difference in which "latent content" is opposed to a "manifest content." Platonism would attempt to control and master in a "mono-centric" fashion the "becoming-mad" of this eternal return (301) by subordinating the simulacrum, by describing it as a copy of a founding Idea. But of course, as we have seen, the notion of a founding Idea is a purely mythological one. Deleuze reminds us that "the artificial and the simulacrum are not the same thing" but are, in fact, opposed to each other: the artificial is the copy of a copy, which, Deleuze asserts,

"should be pushed *to the point where it changes its nature and is reversed into the simulacrum*" (303, emphasis in original). At the risk of forcing the metaphor, we can suggest that Platonism has attempted to hold the simulacral hostage, and Deleuze has sought to release it.

REFERENCES

Barish, Jonas. 1981. *The Antitheatrical Prejudice.* Oakland: University of California Press.

Danneman, Nathan, and Emily Hencken Ritter. 2014. "Contagious Rebellion and Preemptive Repression." *Journal of Conflict Resolution* 58 (2): 254–79.

Dansky, Kara. 2016. "Local Democratic Oversight of Police Militarization." *Harvard Law and Policy Review* 10 (1): 59–75.

Deleuze, Gilles. 2005. *Logic of Sense.* Ed. C. Boundas. Trans. M. Lester and C. Stivale. New York: Continuum.

Deleuze, Gilles, and Félix Guattari. 1987. *A Thousand Plateaus: Capitalism and Schizophrenia.* Minneapolis: Minnesota University Press.

Martin, Joseph M. 2015. "NTC: The Army's Training Oasis in the Mojave." *Army Magazine* 65 (2): 30–2.

Pearce, Celia, Tom Boellstorff, and Bonnie A. Nardi, eds. 2011. *Communities of Play: Emergent Cultures in Multiplayer Games and Virtual.* Cambridge, MA: MIT Press.

Reenactor.net. 2016. http://www.reenactor.net.

Schechner, Richard. 2013. *Performance Studies, an Introduction.* 3rd ed. London: Routledge.

Schneider, Rebecca. 2001. *Performing Remains: Art and War in Times of Theatrical Reenactment.* New York: Routledge.

Tinnes, Judith. 2010. "Counting Lives in a Theater of Terror – an Analysis of Media-Oriented Hostage Takings in Iraq, Afghanistan, Pakistan and Saudi Arabia." *Perspectives on Terrorism* 4 (5): 3–21.

Torner, Evna, and William J. White, eds. 2015. *Immersive Gameplay: Essays on Participatory Media and Role-Playing.* NC: Mcfarland and Co.

Tremblay, François. 2007. "Canada: Police Agent-Provocateurs Unmasked at Montebello Summit Protests." 4 September. World Socialist Website. https://www.wsws.org/en/articles/2007/09/mont-s04.html.

University of Toronto. 2016. Faculty of Medicine, Standardized Patient Program. http://www.spp.utoronto.ca/StandardizedPatients.

Neither Subject nor Object

David Fancy and Hans Skott-Myhre

Any work of art points a way through for life, finds
a way through the cracks.
Gilles Deleuze, *Negotiations 1972–1990*

We have now arrived at what is traditionally considered the conclu-
sion of the book. Not surprisingly given the project thus far, this
chapter does not follow the standard format of a conclusion in which
we tidy things up, connect the dots, finalize the results, or summarize/
synthesize the work done thus far. Instead, we want to take a different
approach, one founded in the philosophy of immanence we describe
in the introduction, specifically as it relates to our reading of the
aesthetic or art. That is to say, we are interested in deploying this
chapter as a certain kind of functive. "Functive" is a philosophical
term introduced by Deleuze and Guattari (1994) in their book *What
Is Philosophy?* It is defined to some degree by what it is not. It is not
a function nor does it designate something that is functional. Instead,
functives, "form a variable determined as abscissa, at the same time
as the limit forms a universal constant that cannot be gone beyond
(for example, a maximum degree of contraction). The first functives
are therefore the limit and the variable, and reference is a relationship
between values of the variable or, more profoundly, the relationship
of the variable, as abscissa of speeds, with the limit (Deleuze and
Guattari 1994, 118–19).

This chapter, as a functive, is a delineation of a set of relations
premised on variability, speed, and limits. The set of relations in this

book includes the set of entangled infinite assemblages now set into play by the elements of each chapter as they collide intratextually and extratextually, comingling themselves in unanticipated assemblages of concept and affect, having been thrown into proximity with the reader, all of the writers and all of the texts, both within the book and those brought into relation to it by reference. Of course, all of these relations comprise different sets of speeds and intensities. And these speeds and intensities compose both limits and thresholds of composition that are highly indeterminate but that are also, given the immanent ontological model fuelling all of our speculation, highly generative. The book, in this sense, opens onto an infinitude of readings to come. To paraphrase Spinoza (2000), no one knows what an entanglement of readings old and new can do.

This chapter, then, hopes to speak to a certain mode of reading social texts, not to mention all the works of art we and our authors have engaged, that refuses the conventional wisdom that a book or any other form of expression has something to say. We would argue that this book, in and of itself, has nothing to say. What can be said can only be opened in relation to a future of what is "not yet." In a sense we want propose a reading not unlike the admonition of the Taoist sage Chuangzi:

> There is a beginning. There is no beginning of that beginning. There is no beginning of that no beginning of beginning. There is something. There is nothing. There is something before the beginning of something and nothing and something before that. Suddenly there is something and nothing. But between something and nothing, I still don't really know which is something and which is nothing. Now I've just said something, but I don't really know if I have said anything or not. (Gia-Fu and English 1974, 35)

Of course, this could be read as a kind of Zen koan or parable that cancels itself, forcing the reader to abandon conventional linear thought in order to comprehend a more complex epistemology. However, we are interested in reading it as an admonition in the Taoist tradition, a caveat about drawing conclusions or attempting to reach ostensibly objective interpretations. How could we advocate for such a bad faith reading predicated on closure and finality when the chapters in this volume have stressed the processual infinity of art's own becoming?

The Taoist warning is reminiscent of a similar caution by Nancy Scheper-Hughes (1993) at the end of her ethnography about infant mortality among cane cutters in Northeast Brazil. After giving a stunningly extensive and detailed exposition about living, working, and studying the lived experience of infant mortality in this community, Scheper-Hughes suggests to the reader that perhaps having read the book they believe they understand something about the lives of these women who have experienced infant death. She then argues that, if this is what the reader thinks, they have missed the point. The point of the book is not for the reader to "objectively" understand the lives of these women but for the lives of these women to evoke an exploration of the reader's own experiences and self-understandings.

In what other way are we to imagine advancing, when Deleuze and Guattari (1994, 108, emphasis in original) assert that "we lack creation. *We lack resistance to the present*"? We would suggest that this kind of evocative reading, like the Taoist admonition above, has no definitive entry or exit point. Nor does it advocate for the romantic heroism of an individual artist but, rather, for a collective embrace of the revolutionary power of art's capacity to invent. As a post-identitarian practice of establishing multiple relationalities in the social field, a reading begins before one encounters the book and continues when the book is set aside. In a sense, any resonance the reader has with the book is already in motion before the book is engaged as a temporal object.

This is what Deleuze and Guattari (1983) refer to as pre-conscious social investments. They propose that all of our encounters are contingent collisions that are preceded by immanence as a field of virtual possibility. This field is populated by an infinite array of capacities for thought, perception, and action. The assemblage of bodies and books is composed of an unimaginable ecological relation between atoms, electrical particles, molecules, neurons, and on to galaxies. This highly complex and rich system of infinite creative force is composed and decomposed through random configurations of affinity between those elements that allow for particular bodies to persist as long as possible. Bodies, in this case, are not simply human taxonomic configurations but include larger and smaller configurations of capacity, including modes of subjectivity and forms of social organization. Obviously, the relation between the subject and society is deeply entangled. Hence we have the concept of pre-conscious social investment – that is to say, a virtual field of unconscious modes of sociality that precedes our conscious awareness of the political.

Any given encounter, then, is political in the manner Foucault (1990) would have it – as a relations of force that exceed any capacity for individual conscious apprehension. The sheer number of lines of force that comprise any subatomic second is simply beyond comprehension. However, the lines of force leave traces, echoes of their passing collisions that we comprehend as consciousness. Out of these echoes, be it via reading, assembling, or creating, we compose and decompose a world of material bodies that act and that, in acting, create a set of new virtual frontiers of infinite capacity for worlds yet to come. With its specific onto-aesthetic capacities for invention, art can rupture the pre-conscious social investments that twenty-first-century capital has been successful in territorializing. And so to write this, perform this, paint this, sculpt this, and so on has been the project engaged in this book. As we noted in the introduction, our intention has been "to interrogate the capacities of art, as Deleuze and Guattari (2014) would have it, as an encounter and opportunity for experimentation" (4), one that Deleuze and Guattari (1988, 187) remind us is necessarily open-ended:

> Art is never an end in itself; it is only a tool for blazing life lines, in other words all of those real becomings that are not produced only *in* art, and all those active escapes that do not consist in fleeing *into* art, taking refuge in art, and all of those positive deterritorializations that never reterritorialize on art, but instead sweep it away with them towards the realm of the asignifying, asubjective, and faceless.

We would suggest that the experimental field in our volume is composed of three life lines, or vectors, that skim the edges of sheer chaos that is the field of immanence. In the first term, we deploy art and the aesthetic within the Deleuzian (1995) vernacular of vacuoles of non-communication. We assemble this book as set of ineffable articulations of relations that, with any luck, exceed the capacities of capitalist logic to re-binarize and overcode the experimental assemblages that constitute the relations between and within the component elements laid out here. Certainly, bits and pieces can be appropriated, but the transversal mappings that flow across and between the writing here hold capacities for velocities and intensities that may create blockages, thresholds, and flows in excess of any possible binary regurgitation.

It is in this sense that the writings here comprise vacuoles of non-communication. After all, a vacuole is an abscess within the tissues of the nervous system of a certain body. It is the result of a disease process. In writing towards the production of vacuoles of non-communication, we aim to introduce the disease of living force as a logic of ineffability into the striated or territorialized body composed via the abstract coding of capitalist relations. Such a project is composed of a set of what Gregory Bateson (2000) would call circuit breakers within a system of communication that is in full runaway escalation. Bateson defines a runaway communication system as operating under conditions in which it is proliferating through radical and uncontrolled differentiation. According to Bateson, this is a system rapidly approaching incoherence and entropic destruction.

We suggest that twenty-first-century capitalism is functioning as just such a system in that its monetary code is beginning to metastasize, turning social fields of living relations into incoherent abstract fields of monetary appropriation. It is crucial to remember that capitalism is, at core, a set of abstract codes disseminated through proliferating sets of communication systems. In short, its force is premised on never ending circuits of communication. A circuit breaker inserts the ineffable logic of material living action into the abstract machinery of capital. That is life beyond code, beyond interpretation, beyond binary articulation.

The second vector of experimentation is centred in what we argue in the introduction is the field of sense. This is art and the aesthetic as a productive relationship with chaos per se. To write at the edge of chaos, slipping in and out of the nets of capture that Elizabeth St Pierre (2018) refers to as method, is to engage what we hope has been to write experimentally. St Pierre opens a mode of writing she calls postqualitative inquiry. This is a way of investigating social phenomena rooted in the philosophies of immanence and ontological inquiry. Instead of attempting to write an epistemological accounting that interprets cultural objects with the hope of determining their meaning, what we attempt here is to inquire into their function as an opening to a world to come. To that end, the writings here are not *descriptive* of the state of popular culture, art, or the aesthetic under global capitalist logics of rule. They step aside from description of the world as it is in order to point towards the new and different as it is emerging.

In taking this approach we abjure what St Pierre (2018, 8) delineates as the "typical markers of goodness, adequacy, validity, objectivity,

and replicability used to judge conventional social science research."
Along with St Pierre, we see these as impediments to the necessities
of experimental writing, which focuses on the creation of new and
unanticipated confluences and blockages that open fields of radical
difference, forms of experimentation that pursue the onto-aesthetic
project of disruption that is also the procedure of artistic creation. In
assembling these writings, we as editors sought work that opened
what St Pierre (2018) quotes Deleuze and Guattari referring to as
"the intensification of life" that enables "possibilities of movements
and intensities, so as once again to give birth to new modes of exis-
tence" as well as to "people that do not yet exist" (ibid.). St Pierre
specifically connects this kind of writing the field of sense. To the
degree that we have assembled work that affirms life as an open
experimental field in relation to chaos, we invite the reader to sense
whatever evocative relation he, she, or they might find here. Deleuze
(2004, 157–8, emphasis in original) reminds us of the risks of the
chaos-fearing methodologies of bad faith, or *ressentiment* (which we,
following St Pierre and others, have tried to avoid), when he com-
ments on the madness, alcoholism, and sensuality lived by artists and
thinkers whom he finds compelling:

> Are we to become the professionals who give talks on these top-
> ics? Are we to wish only that those who have been struck down
> do not abuse themselves too much? Are we going to take up col-
> lections and create special journal issues? Or should we go a
> short way further to see for ourselves, be a little alcoholic, and a
> little crazy, a little suicidal, a little of a guerilla – just enough to
> extend the crack, but not enough to deepen it irremediably? …
> How is this *politics*, this *full guerilla warfare* to be attained?

The third vector of the experimental we hope to elucidate in this
writing is the question of the form of our project as a book. Deleuze
and Guattari (1988, 1) define the book as having "neither object nor
subject; it is made of variously formed matters, and very different
dates and speeds. To attribute the book to a subject is to overlook
this working of matters, and the exteriority of their relations." While
it could certainly be argued that our book itself and its component
pieces are composed of subjects, we argue that this reading would be
an unfortunate diminishment of its capacities. Certainly, one might
use a nominalized subject as an entry point into the broader field of
sheer capacity that is the evocation of language as a call to infinite

modes of thought. This is not to say, as Deleuze and Guattari point out, that the book doesn't have points of articulation that delineate compositional elements of taxonomic and hierarchical relations. However, within the same compositional field are sets of micropolitical lines of force that unsettle and undo the axiomatic elements. The book is constantly composing and decomposing itself with every read. Of course, this is the lesson of Derrida (2016) in his work on deconstructing the text. But the text is not ever anything in particular. It is always a virtual set of capacities opened relationally as an assemblage or a multiplicity.

Here we have worked towards creating just such an assemblage – one that is, at one level, held within an array of objects such as physical print editions but also within laptops, cell phones, i-pads, and so on. This might well give the illusion that the book is an object, which we as a reader can observe and, through an objective reading, evaluate and selectively absorb. However, the book always exceeds its status as an observable object in its functive capacity as a set of speeds and slownesses that open pathways into the unconscious. We may think that we are reading this book or writing this text as fully cognizant subjects who stand outside what we write and what we read, but this is simply a convenient fiction. As conscious individuals we perform some small portion of these acts of creation, but the conscious mind really only serves as a mediative vehicle for thought and creative action. The conscious reader is a transit point for flows of unconscious desiring production. It is the unconscious as sheer virtual capacity for the world to come that writes, paints, sculpts, and acts.

Of course, the mediation of the conscious mind as an idiosyncratic assemblage in its own right is composed of what Spinoza (2000) tells us is the idiosyncratic and unique capacity of each singular body. As such, the singular force of a particular reader, writer, singer, sculptor, and so on is an essential element in how the unconscious finds open source compositional capacity. But such capacity is not to be found within the body in question but in the collisions with other bodies that elicit random virtual compositions. These compositions are always experimental and come and go with varying degrees of compositional force, with what Guattari (1995, 6) calls a "polyphonic and heterogenetic comprehension" of a process he describes as "subjectivation," which opens up to the "outside" relational composition beyond the traditional liberal humanist subject. The book is just such a collision and it creates a multiplicity of affects with each encounter.

In this, we argue, the book is not a passive recipient of our reading. Veronica Pacini-Ketchabaw, in her work on the relation between young children, classrooms, teachers, and what she terms "more than human others" (Pacini-Ketchabaw, Kind, and Kocher 2016), suggests that inanimate elements in the pre-school classroom have the force of impersonal agency. Of course, this is not agency in the enlightenment, modernist sense of the word in which the capacity for action is volitional and centred in the individual human subject. Agency here is defined as a term of immanent capacity – that is, as a set of capacities residing in an entanglement of bodies, each with its own set of constituent forces. It shifts the normative view of action as a set of temporally distinct moments in which one body acts on the other in a sequence of cause and effect. Instead, we have what might be called intensive time in which all acts and effects are simultaneous and always open onto the field of affect. Each relation between a human body and a more than human body, such as an animal or an inanimate body, is not a sequence of effects. Instead, the relation opens a field affect, as defined by Deleuze and Guattari (1983) as a transition between states. Agency as affect is a set of relations in which taxonomic and hierarchical relations are replaced with a constantly mutating set of transitions in which all the bodies involved are mutually imbricated in infinite co-evolutionary transition.

Pacini-Ketchabaw traces this dynamic through the way that each element of a classroom, from playgrounds to art supplies, holds an intrinsic set of affective capacities that are idiosyncratically triggered by random collisions with child bodies. It is an entanglement with chaos as absolute virtuality, in which the agency of the bodies from animate to inanimate finds expression in modes of affinity or antagonism. The child does not act upon the paper with the chalk. Instead, there is a little machine produced, which includes the infinitely complex assemblage of relations that encompasses all the complexities of all that constitutes the chalk, including the environmental factors of the classroom (moisture, lighting, random flows of chemicals, and so on) as well as the tremendously complex assemblage that is the body we call the child. In this, there is, compacted in the intensive time of the act, all of the history that has composed the child and the chalk as a set of unexpressed virtual capacities – and we haven't even gotten to the paper yet. This is the functive capacity of agency as immanent flow.

We argue that the "Dionysian machine" (Deleuze 2004, 263) of the book is composed in just this way and that, in this sense, the book

has agency that exceeds the ability of the human body to impose reading upon it and, thus, is similar to the creative immanence expressed and invented by a work of art. Stephen Zepke (2005, 31) describes how, in the case of engaging works of art, the affective charge released from such complex relationalities "is intoxicating, and overcomes the object experienced as much as the subject experiencing it. The identity of the object is dissolved in the the divergent series constituting the affect (art-work as an expression and not an object), and the identity of the subject is dissolved in the multiplicity of differences the affect at once infolds and unfolds (artist as force under construction and not a subject."

It follows then that "works are developed," Deleuze (1996, 195) reminds us, "around or on the basis of a fracture they can never succeed in filling." And yet this fracture is not loss or void: there is a mutuality of entangled relations in such a reading that always points to a world not yet and a people to come. Deleuze and Guattari (1994, 75) suggest that such eventualities might not be easily come by when they affirm: "It may be that believing in this world, in this life, becomes our most difficult task, or the task of a mode of existence still to be discovered on our plane of existence today." And so it is because of such potent threats and potentials that we refuse conclusion and instead open this book to its full agentic and autopoietic capacities. We have no idea what these might be, but we remain transfixed and transformed by what they might presage. We offer this reading to you, that you might read evocatively towards no particular end. Perhaps there might be surprise and unanticipated capacities that set politics as the unfolding of that which isn't yet, but is just at the edge of who we are becoming.

REFERENCES

Bateson, G. 2000. *Steps to an Ecology of Mind: Collected Essays in Anthropology, Psychiatry, Evolution, and Epistemology.* Chicago: University of Chicago Press.

Deleuze, Gilles. 1995. *Negotiations, 1972–1990.* New York: Columbia University Press.

– 2004. *Logic of Sense.* Trans. M. Lester and C.J. Stivale. London: Bloomsbury.

Deleuze, Gilles, and Félix Guattari. 1983. *Anti-Oedipus.* Minneapolis: University of Minnesota Press

– 1988. *A Thousand Plateaus: Capitalism and Schizophrenia*. London: Bloomsbury.

– 1994. *What Is Philosophy?* New York: Columbia University Press.

Derrida, J. 2016. *Of Grammatology*. Baltimore: Johns Hopkins University Press.

Foucault, M. 1990. *The History of Sexuality*. Vol. 1: *An Introduction*. New York: Vintage.

Gia-Fu, F., and J. English. 1974. *Chuang Tsu: Inner Chapters*. New York: Random House.

Guattari, Félix. 1995. *Chaosmosis: An Ethico-Aesthetic paradigm*. Sydney: Power Publications.

Pacini-Ketchabaw, V., S. Kind, and L.OL. Kocher. 2016. *Encounters with Materials in Early Childhood Education*. London: Routledge.

Scheper-Hughes, N. 1993. *Death without Weeping: The Violence of Everyday Life in Brazil*. Los Angeles: Univiversity of California Press.

Spinoza, Baruch. 2000. *Ethics*. Trans. G.H.R. Parkinson. Oxford, UK: Oxford University Press.

St Pierre, E.A. 2018. "Post Qualitative Inquiry in an Ontology of Immanence." *Qualitative Inquiry* 9 (24): 603–8.

Zepke, S. 2005. *Art as Abstract Machine: Ontology and Aesthetics in Deleuze and Guattari*. London: Routledge.

Contributors

TIMOTHY BECK, PhD, is currently a full-time instructor at the University of West Georgia. In the fall of 2019, he will be starting a new position as assistant professor of psychology at Landmark College, where he will be collaborating with students and faculty at their Center for Neurodiversity. Tim's research is situated at the intersection of science and technology studies (STS), critical disability studies, and theoretical psychology, and has been published in academic journals that include *Journal of Phenomenological Psychology, Qualitative Research in Psychology, Child and Youth Services, Subjectivity, and Disability and Society*. He is also currently under contract with Routledge Press to contribute to the book series Concepts for Critical Psychology: Disciplinary Boundaries Re-thought.

MARK BISHOP received a master of arts degree from York University in Toronto and has taught music theory at Brock University. His focus has been on the music of Olivier Messiaen, musical form, and pitch-class set analysis. His current research is concerned with the spatialization of musical gestures and the perception of such created musical space, with emphasis placed on the works of Edmund Husserl and Maurice Merleau-Ponty. Mark has also worked extensively as a freelance trombonist, musical coordinator, and arranger.

DAVE COLLINS is a professor of ceramics at the University of West Georgia.

DAVID FANCY is professor in the Department of Dramatic Arts, Marilyn I. Walker School of Performing Arts, Brock University. He

brings his theoretical and philosophical interests in immanentist thought to the intersection of a range of disciplines, including theatre studies, performance studies, science and technology studies, and critical disability studies. His work has appeared in many journals, including *Performance Research, Performance Matters, Cultural Studies/Critical Methodologies, Contemporary Theatre Review, Science Fiction Film and Television,* and *Canadian Journal of Disability Studies,* as well as with publishers such as Palgrave and Routledge. He is a working playwright and director of theatre, opera, and circus.

MALISA KURTZ received her PhD from Brock University in interdisciplinary humanities. She has published articles on postcolonial science fiction in *Paradoxa, Science Fiction Studies*, and *Journal of the Fantastic in the Arts.*

NICOLE LAND is an assistant professor in the School of Early Childhood Studies at Ryerson University in Toronto. Through her pedagogical inquiry research in collaboration with early childhood educators and children, Nicole is interested in post-developmental pedagogies and rethinking children's relations with fats, muscles, movement, and physiological sciences.

ERIC LOCHHEAD is a youth author who lives in Calgary, Alberta.

DOUGLAS ORD studies how emblematic events can make for "enigmatic heraldries" (Michel Foucault) and "quasi-causal systems" (Gilles Deleuze). From 2000 to 2017, he produced the website *Lear's Shadow,* which spun the commentary "Calvin and Eric, Dylan and Hobbes," and an e-book titled *The Strangeness of Columbine: An Interpretation* (2012). Among earlier books are *The National Gallery of Canada: Ideas, Art, Architecture* (McGill-Queen's University Press, 2003) and *Tommy's Farm* (Mercury, 1999). A collaboration with Alain Beaulieu, "The Death of Gilles Deleuze as Composition of a Concept," appeared in *Deleuze Studies* 11 (1) (2017). His most recent publication is *A Schizo-Philosopher's Colouring Book* (Guernica, 2018). His PhD research at Western University's Centre for the Study of Theory and Criticism develops another *Lear's Shadow* text, "Of Sky Signs, Avalanches, and the Synchronicity Fuse, or the Columbia Shuttlanche."

VERONICA PACINI-KETCHABAW is a professor of early childhood education in the Faculty of Education at Western University in Ontario. Her writing and research contributes to the Common World Childhoods Research Collective (tracing children's relations with places, materials, and other species) and the Early Childhood Pedagogies Collaboratory (experimenting with the contours, conditions, and complexities of twenty-first-century pedagogies).

JOANNA PERKINS completed her doctoral degree in cultural studies at Trent University in Peterborough, Ontario. Her interdisciplinary studies focused on critical psychology, education, and feminist theory through the lens of Spinozist philosophy. She has since taken her work to an audience beyond academia as the creator and founder of the online emotional empowerment boutique Sensitive Self Care.

CHRIS RICHARDSON is associate professor and chair of communication studies at Young Harris College in the Blue Mountains of Georgia. His publications include *Covering Canadian Crime: What Journalists Should Know and the Public Should Question* (University of Toronto Press), co-edited with Romayne Smith Fullerton, and *Habitus of the Hood* (Intellect Press), co-edited with Hans Skott-Myhre. He also hosts *This Is Not a Pipe Podcast*, where he interviews authors of new books in critical theory, cultural studies, and philosophy.

PETER REHBERG is head of collections and archives at Schwules Museum Berlin (The Gay Museum). He holds a PhD in German studies from New York University and has taught and researched in both the United States and Europe. He held post-doc positions at Cornell, Northwestern, and Brown and worked as DAAD (German Academic Exchange Service) professor at the University of Texas at Austin from 2011 to 2016. In 2018 he was appointed Max-Kade Visiting Professor at the University of Illinois at Chicago. Along with his academic career he also has a career in writing and journalism. He published three novels, and from 2006 to 2011 he was editor-in-chief of the gay monthly *Männer*. Informed by a strong theoretical background, in his academic writing he focuses on pop cultural topics such as post-pornography and the Eurovision Song Contest. His monographs *Hipster Porn: Queere Männlichkeiten und affektive Sexualitäten im Fanzine Butt* was just published in German with b_books. In his

current work he is pursuing questions of queer curating, migrant masculinities, and sexual aesthetics.

HANS SKOTT-MYHRE is a professor in the Social Work and Human Services Department at Kennesaw State University in Georgia. He is the author of *Youth Subcultures as Creative Force: Creating New Spaces for Radical Youth Work*; co-author with Chris Richardson of *Habitus of the Hood*; co-editor with K. Gharabaghi and M. Krueger of *With Children and Youth*; and co-editor with V. Pacini-Ketchabaw and K.S. Skott-Myhre of *Youth Work, Early Education, and Psychology: Liminal Encounters*. He has published multiple articles, reviews, and book chapters.

KATHLEEN SKOTT-MYHRE is an associate professor of psychology at the University of West Georgia. She is the author of *Feminist Spirituality under Capitalism: Witches, Fairies and Nomads* as well as the co-author of *Writing the Family: Women, Auto-Ethnography, and Family Work*. She is co-editor with V. Pacini-Ketchabaw and H.A. Skott-Myhre of *Youth Work, Early Education, and Psychology: Liminal Encounters*. She has published multiple articles, reviews, and book chapters.

Index